LEONARDO AND THE LAST SUPPER

Leonardo and
The Last Supper

ROSS KING

BOND
STREET
BOOKS
DOUBLEDAY
CANADA

The Bond Street Books colophon is a registered trademark of Random House of Canada Limited

Library and Archives Canada Cataloguing in Publication

King, Ross, 1962-
Leonardo and the Last supper / Ross King.

Also issued in electronic format.
ISBN 978-0-385-66608-4

I. Leonardo, da Vinci, 1452-1519. Last Supper. I. Title.

ND623.L5A683 2012 759.5 C2012-902367-1

Jacket design by Patti Ratchford
Jacket art: St. Matthew the Apostle, detail of *The Last Supper*/Alinari Archives
Printed and bound in the USA

Published in Canada by Bond Street Books,
a division of Random House of Canada Limited

www.randomhouse.ca

10 9 8 7 6 5 4 3

For my father-in-law
Sqn. Ldr. E. H. Harris RAF (Rtd)

CONTENTS

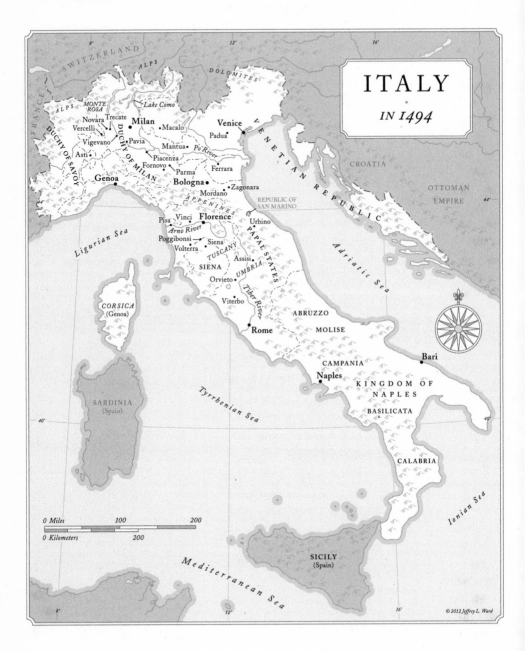

ITALY
IN 1494

SWITZERLAND

ALPS

DOLOMITES

FRANCE

ALPS

MONTE ROSA

Lake Como

Novara Trecate
Vercelli
Vigevano
Asti
DUCHY OF SAVOY
Milan
Pavia
DUCHY OF MILAN
•Macalo
Mantua•
Fornovo
Genoa
Piacenza
Parma
Fornovo
APPENINES
Bologna
•Zagonara
Mordano
Po River
Ferrara
Venice
Padua•

VENETIAN REPUBLIC

CROATIA

OTTOMAN
EMPIRE

REPUBLIC OF
SAN MARINO

Pisa Vinci **Florence**
Arno River
Poggibonsi Siena
Volterra
SIENA
TUSCANY
Assisi
UMBRIA
Orvieto
Viterbo
Urbino
PAPAL STATES
Tiber River

Ligurian Sea

Adriatic Sea

Rome

ABRUZZO
MOLISE

CAMPANIA
Naples

Bari

KINGDOM OF
NAPLES

BASILICATA

CALABRIA

CORSICA
(Genoa)

SARDINIA
(Spain)

Tyrrhenian Sea

Ionian Sea

0 Miles 100 200
0 Kilometers 200

Mediterranean Sea

SICILY
(Spain)

© 2012 Jeffrey L. Ward

HOUSE OF VISCONTI-SFORZA

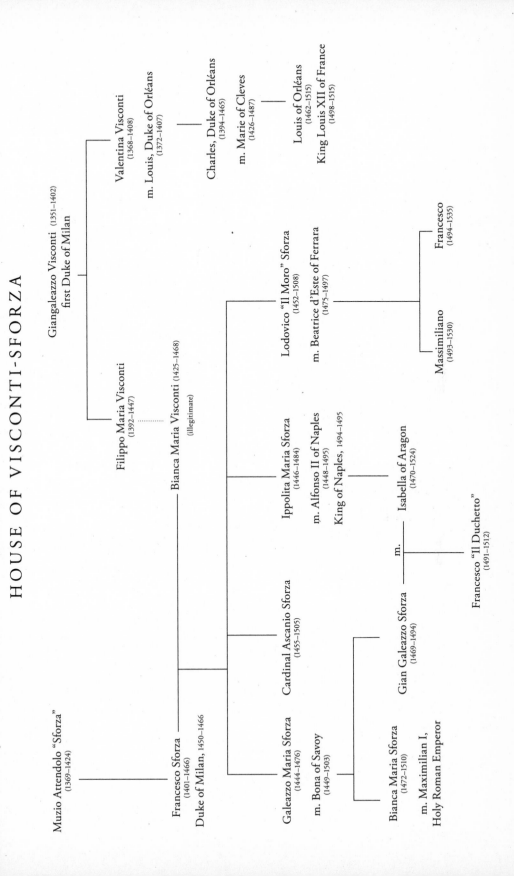

Muzio Attendolo "Sforza"
(1369–1424)

Giangaleazzo Visconti (1351–1402)
first Duke of Milan

Valentina Visconti
(1368–1408)
m. Louis, Duke of Orléans
(1372–1407)

Charles, Duke of Orléans
(1394–1465)
m. Marie of Cleves
(1426–1487)

Louis of Orléans
(1462–1515)
King Louis XII of France
(1498–1515)

Filippo Maria Visconti
(1392–1447)

Bianca Maria Visconti (1425–1468)
(illegitimate)

Francesco Sforza
(1401–1466)
Duke of Milan, 1450–1466

Lodovico "Il Moro" Sforza
(1452–1508)
m. Beatrice d'Este of Ferrara
(1475–1497)

Massimiliano
(1493–1530)

Francesco
(1494–1535)

Ippolita Maria Sforza
(1446–1484)
m. Alfonso II of Naples
(1448–1495)
King of Naples, 1494–1495

Cardinal Ascanio Sforza
(1455–1505)

Isabella of Aragon
(1470–1524)

Gian Galeazzo Sforza
(1469–1494)

m.

Francesco "Il Duchetto"
(1491–1512)

Galeazzo Maria Sforza
(1444–1476)
m. Bona of Savoy
(1449–1503)

Bianca Maria Sforza
(1472–1510)
m. Maximilian I,
Holy Roman Emperor

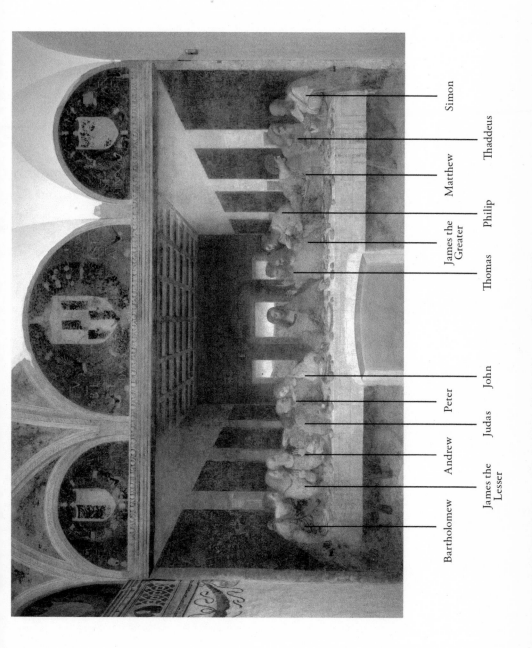

Bartholomew

James the
Lesser

Andrew

Judas

Peter

John

Thomas

James the
Greater

Philip

Matthew

Thaddeus

Simon

I wish to work miracles.
—Leonardo da Vinci

CHAPTER I

The Bronze Horse

The astrologers and fortune-tellers were agreed: signs of the coming disasters were plain to see. In Puglia, down in the heel of Italy, three fiery suns rose into the sky. Farther north, in Tuscany, ghost riders on giant horses galloped through the air to the sound of drums and trumpets. In Florence, a Dominican friar named Girolamo Savonarola received visions of swords emerging from clouds and a black cross rising above Rome. All over Italy, statues sweated blood and women gave birth to monsters.

These strange and troubling events in the summer of 1494 foretold great changes. That year, as a chronicler later recounted, the Italian people suffered "innumerable horrible calamities."[1] Savonarola predicted the arrival of a fierce conqueror from across the Alps who would lay waste to Italy. His dire prophecy was fulfilled soon enough. That September, King Charles VIII of France entered an Alpine pass with an army of more than thirty thousand men, bent on marching through Italy and seizing the throne of Naples. The scourge of God made an unprepossessing sight: the twenty-four-year-old

king was short, myopic, and so ill proportioned that in the words of the chronicler Francesco Guicciardini, "he seemed more like a monster than a man."[2] His ungainly appearance and agreeable nickname, Charles the Affable, belied the fact that he was equipped with the most formidable array of weapons ever seen in Europe.

Charles VIII's first stop was the Lombard town of Asti, where, after pawning jewels to pay his troops, he was greeted by his powerful Italian ally, Lodovico Sforza, the ruler of Milan. Savonarola may have prophesied Charles's expedition, but it was Lodovico who had summoned him across the Alps. The forty-two-year-old Lodovico, known because of his dark complexion as Il Moro (the Moor), was as handsome, vigorous, and cunning as the French king was feeble and ugly. He had turned Milan—the duchy over which he had become the de facto ruler in 1481 after usurping his young nephew Giangaleazzo—into what the Holy Roman emperor, Maximilian, called "the most flourishing realm in Italy."[3] But Lodovico's head lay uneasy. The father-in-law of the feckless Giangaleazzo was Alfonso II, the new king of Naples, whose daughter Isabella deplored the usurpation and did not scruple to tell her father of her sufferings. Alfonso had an unsavory reputation. "Never was any prince more bloody, wicked, inhuman, lascivious, or gluttonous than he," declared a French ambassador.[4] Lodovico was told to beware assassins: Neapolitans of bad repute, an adviser warned, had been dispatched to Milan "on some evil errand."[5]

Yet if Alfonso could be removed from Naples—if Charles VIII could be convinced to press his tenuous claim to its throne (his great-grandfather had been king of Naples a century earlier)—then Lodovico could rest easy in Milan. According to an observer at the French court, he had therefore begun "to tickle King Charles . . . with the vanities and glories of Italy."[6]

The Duchy of Milan ran seventy miles from north to south—from the foothills of the Alps to the Po—and sixty miles from west to east. At its heart, encircled by a deep moat, crisscrossed by canals, and protected by a circuit of stone walls, lay the city of Milan itself. Lodovico's wealth and determination had turned the city, with a population of one hundred thousand people, into Italy's greatest. A huge fortress with cylindrical towers loomed on its northeast edge, while at the center of the city rose the walls of a new cathedral, started in 1386 but still, after a century, barely half-finished. Palaces lined the paved streets, their facades decorated with fres-

Lodovico Sforza

coes. A poet exulted that in Milan the golden age had returned, and that Lodovico's city was full of talented artists who flocked to his court "like bees to honey."[7]

The poet was not merely flattering to deceive. Lodovico had been an enthusiastic patron of the arts ever since, at the age of thirteen, he commissioned a portrait of his favorite horse.[8] Under his rule, intellectual and artistic luminaries flocked to Milan: poets, painters, musicians, and architects, as well as scholars of Greek, Latin, and Hebrew. The universities in Milan and neighboring Pavia were revived. Law and medicine flourished. New buildings were commissioned; elegant cupolas bloomed on the skyline. With his own hands Lodovico laid the first stone of the beautiful church of Santa Maria dei Miracoli presso San Celso.

And yet the verdict of the chroniclers would be harsh. Italy had enjoyed forty years of relative peace. The odd skirmish still broke out, such as when Pope Sixtus IV went to war against Florence in 1478. Yet for the most part Italy's princes vied to surpass one another not on the field of battle but in the taste and splendor of their accomplishments. Now, however, the blood-dimmed tide was loosed. By enticing Charles VIII and his thunderous weapons across the Alps, Lodovico Sforza had unwittingly unleashed—as all the stars foretold—innumerable horrible calamities.

Among the brilliant courtiers in Lodovico Sforza's Milan was an artist celebrated above all others. "Rejoice, Milan," wrote a poet in 1493, "that inside your walls are men with excellent honours, such as Vinci, whose skills in both drawing and painting are unrivalled by masters both ancient and modern."[9]

This virtuoso was Leonardo da Vinci who, at forty-two, was exactly the same age as Lodovico. A Tuscan who came north to Milan a dozen years earlier to seek his reputation, he must have cut a conspicuous and alluring figure at Il Moro's court. By the accounts of his earliest biographers, he was strikingly handsome and elegant. "Outstanding physical beauty," enthused one writer. "Beautiful in person and aspect," observed another. "Long hair, long eyelashes, a very long beard, and a true nobility," declared a third.[10] He possessed brawn and vigor too. He was said to be able to straighten a horseshoe with his bare hands, and during his absences from court he climbed the barren peaks north of Lake Como, crawling on all fours past huge rocks and contending with "terrible bears."[11]

This epitome of masculine pulchritude bore the grand title *pictor et ingeniarius ducalis*: the duke's painter and engineer.[12] He had come to Milan, aged thirty, in hopes of inventing and constructing fearsome war machines such as chariots, cannons, and catapults that would, he promised Il Moro, give "great terror to the enemy." His hopes were no doubt boosted by the fact that Milan was at war with Venice, with Lodovico spending almost 75 percent of his vast annual revenues on warfare. Although visions of battle danced in his head, he actually found himself at work on more modest and peaceable tasks, such as designing costumes for weddings and pageants, fashioning elaborate stage sets for plays, and painting a portrait of Il Moro's mistress. He amused courtiers by performing tricks such as turning white wine into red, and by inventing an alarm clock that woke up the sleeper by jerking his feet into the air. Occasionally the tasks were mundane: "To heat the water for the stove of the Duchess," one of his notes recorded, "take four parts of cold water to three parts of hot water."[13]

Despite his diverse assignments, over much of the previous decade Leonardo had devoted himself to one commission in particular, a work of art that should truly have sealed his reputation as an artist unrivaled by ancients and moderns alike. In about 1482, shortly before moving to Milan, he composed a letter of introduction to Lodovico, a kind of curriculum vitae

that somewhat exaggerated his abilities. In the letter, he promised to apprise Il Moro of his secrets, casually assuring him that "the bronze horse may be taken in hand, which is to be to the immortal glory and eternal honour of the prince your father of happy memory, and of the illustrious house of Sforza."[14]

This bronze horse was the larger-than-life equestrian monument by which Lodovico hoped to celebrate the exploits of his late father, Francesco Sforza. A wily soldier of fortune (Niccolò Machiavelli praised his "great prowess" and "honourable wickedness"), Francesco became duke of Milan in 1450 after overthrowing a short-lived republican government.[15] He was the son of a man named Muzio Attendolo who, as a youngster, had been chopping wood when a troop of soldiers rode by and, eyeing his brawny frame, invited him to join them. Muzio threw his axe at a tree trunk, vowing to himself: "If it sticks, I will go." The axe stuck, and Muzio became a mercenary hired at various times by all of the major Italian princes. His strapping physique and fierce nature brought him the nickname "Sforza" (*sforzare* means to force), which, like the axe, stuck.

Francesco Sforza had been an equally brilliant soldier. He rose from soldier to duke nine years after marrying the illegitimate daughter of one of his clients, the duke of Milan, Filippo Maria Visconti. The Visconti family had ruled Milan since 1277, and as dukes since 1395. However, in 1447, after Filippo Maria died without a male heir, the citizens of Milan did away with the dukedom and proclaimed a republic. Two years later, staking his claim to rule the city, Francesco blockaded and besieged Milan, whose starving citizens eventually gave up on their republic and, in March 1450, welcomed their former mercenary as duke of Milan. Francesco did not suffer the succession problems of Filippo Maria, fathering as many as thirty children, eleven of them illegitimate. No fewer than eight sons were born on the right side of the blanket, with the eldest, Galeazzo Maria—Il Moro's older brother—becoming duke upon Francesco's death in 1466.

The Visconti family had a gaudy history of heresy, insanity, and murder. One of the more intriguing members, a nun named Maifreda, was burned at the stake in the year 1300 for claiming she was going to be the next pope. Giovanni Maria Visconti, Filippo Maria's older brother, trained his hounds to hunt people and eat their flesh. Filippo Maria, fat and insane, cut off his wife's head. Even in such company, the cruel and lecherous Galeazzo Maria

stood out. Machiavelli later blanched at his monstrous behavior, noting how he was not content to dispatch his enemies "unless he killed them in some cruel mode," while chroniclers could not bring themselves to describe various of his deeds.[16] He was suspected of murdering not only his fiancée but also his mother. In 1476 he was felled by knife-wielding assassins, leaving behind an eight-year-old son and heir, Giangaleazzo—the child duke elbowed out of the way, five years later, by Lodovico il Moro, who solved the problem of authority in Milan by decapitating the boy's regent.

Lodovico's claim to sovereignty was tenuous. Technically speaking, he was only the guardian and representative of his nephew, who had inherited the title of duke of Milan from his father. This dubious prerogative meant Lodovico was anxious to keep alive in everyone's mind the memory of his own father. He had therefore commissioned from a scholar named Giovanni Simonetta a history of Francesco's illustrious career. He was further planning to have heroic scenes from his father's life frescoed in the ballroom of Milan's castle. An equestrian monument of Francesco had been mooted as early as 1473, when Galeazzo Maria planned to have one installed before Milan's castle. The project ended with his assassination but was revived by Lodovico, who envisaged the bronze monument as the most conspicuous and spectacular of the tributes to his father.

Mercenary captains were often flattered after their deaths in paint, print, and bronze. The sculptor Donatello cast a bronze equestrian monument of the Venetian commander Erasmo da Narni, better known as Gattamelata (Honey Cat), to stand in the Piazza del Santo in Padua. In 1480 another Florentine sculptor, Andrea del Verrocchio—Leonardo's former teacher— began working for the Venetians on a statue of Bartolomeo Colleoni on horseback. Lodovico envisaged something even more grandiose for his father. As an ambassador reported, "His Excellency desires something of superlative size, the like of which has never been seen."[17]

Leonardo da Vinci once wrote that his first memory was of a bird, and that studying and writing about birds therefore "seems to be my destiny."[18] Yet horses were truly the rudder of Leonardo's fortune, and a horse was, in a manner of speaking, what had brought him to Milan in the first place. According to one source, in about 1482 Lorenzo de' Medici, the ruler of Flor-

ence, had dispatched him to Milan with a special diplomatic gift for Lodovico Sforza: a silver lyre that Leonardo had invented, and on which he could play, an early biographer claimed, "with rare execution."[19] This unique musical instrument was in the shape of a horse's head. A hasty sketch in one of Leonardo's manuscripts shows what the instrument may have looked like, with the horse's teeth serving as pegs for the strings and ridges in the roof of the mouth doubling as frets.

Given Lorenzo de' Medici's habit of conducting diplomatic relations through his artists, the story of the lyre has a ring of truth.[20] But lyre or no lyre, Leonardo almost certainly would have made his way north to Milan in order to build weapons or design the equestrian monument, opportunities he must have decided did not readily present themselves in Florence.

Leonardo received the commission for the bronze statue within a few years of his arrival in Milan. Lodovico revived the project in earnest in 1484, though Leonardo was not his first choice as sculptor. Despite Leonardo's presence in Milan, in the spring of 1484 Lodovico wrote to Lorenzo de' Medici asking if he knew of any sculptors capable of casting the monument. But Florence's two greatest sculptors, Verrocchio and Antonio del Pollaiuolo, were both busy on other projects. "Here I do not find any artist who satisfies me," Lorenzo regretfully replied. He did not endorse Leonardo, merely adding, "I am sure that His Excellency will not lack someone."[21]

For want of another candidate, then, Leonardo was given the commission, possibly quite soon after Lorenzo's response. He attacked the project with relish, albeit evidently inspired much more by the figure of the horse than by that of its rider. He made a close study of equine anatomy, and even composed and illustrated a (now-lost) treatise on the subject. He spent hours in the ducal stables, scrutinizing and drawing Sicilian and Spanish stallions owned by Lodovico and his favorite courtiers. One of his memoranda reads, "The Florentine Morello of Mr. Mariolo, large horse, has a nice neck and a very beautiful head. The white stallion belonging to the falconer has fine hind quarters; it is behind the Porta Comasina."[22]

Leonardo's statue would not simply be anatomically correct; it would also strike an energetically rampant pose. Donatello's statue of Gattamelata portrayed the mercenary leader sitting upright on a placidly pacing horse, while Verrocchio's—on which Leonardo probably worked for a year or two before leaving Florence—placed Colleoni astride a muscular beast whose left foreleg was held prancingly aloft. Leonardo planned something more astonishing, a

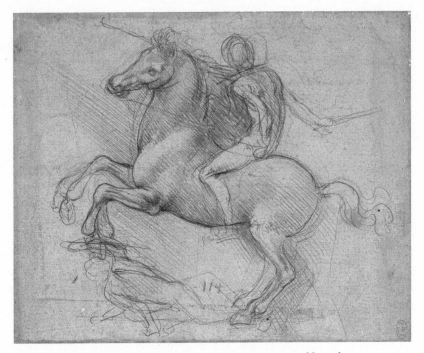

Leonardo's study for the equestrian monument commissioned by Lodovico

horse rearing on its hind legs with its front hooves pawing the air above a prostrate foe. Furthermore, his statue would be enormous. Donatello's monument was twelve feet high, Verrocchio's thirteen—but Leonardo envisaged a statue whose horse alone would be more than twenty-three feet in height, three times larger than life. It would testify to the glory of Francesco Sforza but, even more, to the tremendous and unrivaled abilities of the artist himself. Designing and casting a bronze statue of such magnitude was unprecedented. One of his contemporaries wrote that the feat was "universally judged impossible."[23] Leonardo, however, was never one to be daunted by colossal tasks. He once reminded himself in a note: "We ought not to desire the impossible." Elsewhere he wrote, "I wish to work miracles."[24]

The gigantic horse did appear to be, if not impossible, then at the very least complex and extremely challenging: something that would indeed take a miracle to perform. The project taxed even Leonardo's ingenuity. Records do not show how far he advanced in these early years, but work certainly proceeded neither swiftly nor auspiciously. By 1489, Lodovico Sforza had

begun to doubt the wisdom of giving him the commission. As the Florentine ambassador to Milan wrote home to Lorenzo de' Medici, "It appears to me that, while he has given the commission to Leonardo, he is not confident of his success."[25]

Leonardo had responded to Il Moro's doubts with a spirited publicity campaign. In 1489 he asked a friend, the Milanese poet Piatto Piattini, for a poem celebrating the equestrian statue.[26] He clearly wanted to build enthusiasm for the project—and for his own ability to execute it—at a time when Il Moro was losing faith not only in his sculptor but also perhaps in the monument itself. Piattini duly complied with Leonardo's request, composing a short poem that praised Francesco Sforza and extolled the equestrian monument as "supernatural." He also produced a second poem exalting Leonardo as "a most noble sculptor" and comparing him to ancient Greek sculptors such as Lysippos and Polykleitos.[27]

Piattini noted in a letter that though "keenly sought out" by Leonardo to produce a poem, he did not doubt that the artist had made the same request "to many others." This may well have been the case: Leonardo was certainly mounting a vigorous offensive to keep his job. Around the same time another poet, Francesco Arrigoni, wrote a letter to Lodovico observing that he had been asked "to celebrate with some epigrams the equestrian statue." His effort was much longer than Piattini's, a series of Latin epigrams rhapsodizing both the bronze horse and its ambitious author, who was once again compared to the finest sculptors of ancient Greece.[28]

Whether Il Moro was swayed by this suave publicity is impossible to know, but Leonardo was not, in fact, removed from the job. In April 1490 he wrote that he had "recommenced the horse," by which he meant he had started work on a different design, opting for a less audaciously difficult pose: the rearing attitude was abandoned in favor of a more balanced pose.[29] Around this time he began sculpting a full-scale version in clay.

Various distractions and interruptions followed. In January 1491, in order to forge an alliance with a powerful Italian family, Lodovico reluctantly shed his beautiful, pregnant mistress Cecilia Gallerani (whose portrait Leonardo had recently painted) and married Beatrice d'Este, daughter of the duke of Ferrara. Leonardo was heavily involved in the nuptials, designing costumes for the festivities, decorating the ballroom, and helping to arrange a jousting match. The following year he found himself creating a waterfall

for the new duchess's villa outside Milan. He also pursued private interests that struck colleagues at the court in Milan as eccentric. A poet named Guidotto Prestinari attacked him in a sonnet for spending his days hunting in the woods and hills around Bergamo for "various monsters and a thousand strange worms."[30]

By the end of 1493, the full-size clay model of the horse (albeit, apparently, without its rider) was near enough to completion that it was celebrated by other poets more receptive to Leonardo's genius—and ones whose verses were perhaps urgently solicited by Leonardo himself. One of them praised Leonardo's "rare genius" and exalted the "great colossus" as something the size of which even the Greeks and Romans had never witnessed. A second envisaged Francesco Sforza gazing down from the heavens and heaping compliments on Leonardo.[31]

The model was undoubtedly a marvel, but the problem of how to cast such a monstrosity needed to be faced. Leonardo would have learned a time-honored method of casting bronze more than two decades earlier in the Florentine studio of Verrocchio. A core made from clay and fashioned roughly into the shape of the statue would be coated with a layer of wax, which was then sculpted with the finer details. The wax-covered model was enclosed in a rough outer shell (made from ingredients such as cow dung) into which casting rods were inserted. This chrysalis was fired in a casting pit, at which point the melting wax drained through the rods, to be replaced by molten bronze introduced through another set of tubes. The bronze then cooled and solidified, after which the charred husk was broken open to reveal the statue. The bronze would then be "chased": smoothed and polished with chisels, files, and pumice.

Leonardo jotted numerous notes to himself when the time came to think about the casting process. He was highly secretive in his approach, reverting to code, albeit a fairly primitive one that saw him simply reversing the order of the letters in certain words: *cavallo* (horse) became *ollavac*.[32] He seemed prepared to experiment with various recipes: making casts from river sand mixed with vinegar, wetting the molds with linseed oil or turpentine, and making a paste from egg white, brick dust, and household rubbish.[33] He might even have considered using a rather unorthodox ingredient since one of his diagrams for the horse included offhand observations about the happy chemical effects of burning human excrement, which is not perhaps so eccentric if we consider that cow and horse dung were often used by sculptors.[34]

One ingredient, though, was certain: seventy-five tons of bronze had been earmarked for the monument.

By the end of 1493, Leonardo had spent as many as eight or ten years on the giant equestrian monument. He was putting the finishing touches to his clay model and deliberating the practicalities of casting in bronze when, in January 1494, far to the south in Naples, seventy-year-old King Ferdinand I, returning from his country villa, climbed down from his horse and keeled over dead. His death brought to the throne his son Alfonso, the cruel and avaricious father of Isabella, wife of the hapless Giangaleazzo, rightful ruler of Milan. The time had come for Lodovico Sforza to act.

In early October 1494, with French troops poised for their descent into Italy, Lodovico entertained the unlikely savior of his domains, Charles VIII, with a boar hunt and a banquet at his country home in Vigevano. Relations between Lodovico and Charles were cordial, in part because Lodovico took the precaution of amply providing the French king with Milanese courtesans. However, Charles was disappointed by the Italian wines and found the weather disagreeably hot.[35] Lodovico meanwhile quickly came to regard his royal guest as foolish, haughty, and ill-mannered. "These French are bad people," he confided to the Venetian ambassador, "and we must not allow them to become our neighbours."[36] The dislike of the French soon spread across his dukedom. A French statesman accompanying King Charles ruefully observed, "At our first entrance into Italy, everybody thought us people of the greatest goodness and sincerity in the world; but that opinion lasted not long."[37]

The character and intentions of the French became evident only a few weeks later, at Mordano, twenty-five miles southeast of Bologna. For the previous century, military campaigns in Italy had been relatively bloodless affairs, cautious and tactical, full of pomp and display rather than violent or heroic altercations, not unlike giant chess matches in which one mercenary, outmaneuvered by his opponent, would concede the advantage and peaceably withdraw from the field. Thus at Zagonara, where the Florentines suffered a famous defeat in 1424, the only casualties were three soldiers who fell from their horses and drowned in the mud. In 1427, eight thousand Milanese troops were bested by the Venetians in battle at Macalo; not a

single life was lost. As one Florentine observer sarcastically remarked, "The rule for our Italian soldiers seems to be this: You pillage there, and we will pillage here; there is no need for us to approach too close to one another."[38]

The French commanders who invaded Italy in 1494 took a different approach to warfare. They were equipped with siege weapons that had been shipped by boat to La Spezia on the Italian coast. These cannons were cast in bronze, unlike Italian artillery, which consisted of copper tubes covered with wood and animal hides. The French guns fired wrought iron cannonballs the size of a man's head, unlike Italian artillery, which made use of small stone balls carved by masons (even Leonardo's designs for cannons were designed to "fling small stones").[39] The French gunners were trained in special artillery schools, and their guns could be sighted with deadly accuracy. While the Italians used plodding oxen to drag their guns, teams of swift horses pulled the French gun carriages. Maneuvered quickly into position and fired with great rapidity, their artillery could wreak havoc on either city walls or ranks of soldiers on the field of battle. The fearsome weapons of Leonardo's imagination had suddenly appeared in Italy.

One of the keys to capturing the south of Italy was gaining control of a series of strategic fortresses that blocked access to the Apennines in Tuscany and central Italy. Mordano was one such fortress. It was owned by Caterina Sforza, Countess of Forlì, the illegitimate daughter of Lodovico's brother Galeazzo Maria and (despite her Sforza blood) an ally of Naples rather

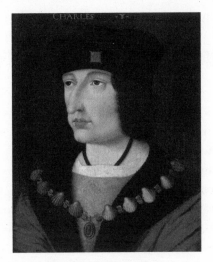

King Charles VIII of France

than Lodovico and the French. When the troops of Charles VIII appeared outside the walls in October 1494, the soldiers and civilians inside Mordano were counting on the strength of their fortifications and the usual diffidence of the enemy to engage. But when their demand to surrender was refused, the French troops quickly breached the walls with their artillery.

Sieges in Italy occasionally turned brutal if soldiers found women and defenseless civilians, rather than enemy soldiers, on the business end of their halberds. The violence had been appalling in 1472 when the warlord Federigo da Montefeltro captured Volterra on behalf of the Florentines. "For a whole day it was robbed and overrun," Machiavelli later recorded. "Neither women nor holy places were spared."[40] The French assault on Mordano—in which all the inhabitants of the castle, soldiers and civilians alike, were put to the sword—was even more shocking. News of the massacre, known as the "terror of Mordano," spread quickly through Italy. Soon the French troops even began attacking and pillaging in the territories of their ostensible allies. The French invaders, wrote a Florentine chronicler, were "bestial men."[41]

Before departing the Duchy of Milan to lead his expedition, Charles had briefly paid his respects to Giangaleazzo Sforza, the rightful duke, at the castle in Pavia where he enjoyed an aimless liberty. The two men, who were first cousins, had much in common, including reputations for licentiousness. Some observers faulted Lodovico for the intellectual and moral shortcomings of his nephew. According to a Venetian chronicler, Lodovico had made every effort "to see that the boy would never come to anything," deliberately neglecting to educate him in the art of war or in the skills required by a ruler. He even went so far as to employ people "to corrupt and deprave his childish nature" so the young duke would become habituated to "every sort of indulgence and idleness."[42] Whatever the truth of the accusation, Giangaleazzo required little encouragement. His enthusiastic indulgences took a toll on his health, and he was gravely ill by the time of the French king's visit. One day after the massacre at Mordano, he died at the age of twenty-five. One rumor had it that he expired from "immoderate coitus"; more persistent gossip claimed he was poisoned by Lodovico.[43]

Giangaleazzo's death came at an undeniably opportune moment for

Lodovico. Two days later, ignoring the hereditary claim of Giangaleazzo's five-year-old son, Francesco, and stressing present dangers and the need for a decisive ruler in such troublous times, he assumed for himself the title and seal of duke of Milan. However, just as one of Lodovico's rivals for the dukedom expired, another appeared on the scene. Il Moro's growing misgivings about his French allies were exacerbated by the presence of Charles's thirty-two-year-old cousin and brother-in-law, Louis, the duke of Orléans. As a great-grandson, like Lodovico, of the very first duke of Milan, a crazed and cruel tyrant who died in 1402, Louis was anxious to assert his own right to rule the duchy. To some observers, the handsome and dissolute Louis seemed no match for the crafty Lodovico. "He has a small head with not much room for brains," wrote the Florentine ambassador to Milan, who predicted, "Lodovico will soon get the better of him."[44] But Lodovico would need to be wary of his French namesake, an enemy who—though supposedly an ally—was potentially more dangerous than the king of Naples.

Alfonso, meanwhile, had dispatched an army northward to meet the king of France. It was commanded by a Milanese aristocrat, Gian Giacomo Trivulzio, a personal enemy whom Lodovico had exiled from the duchy. As Trivulzio's troops neared Ferrara, 125 miles from Milan, Lodovico, realizing that the time had come to beat ploughshares into swords, expropriated Leonardo's seventy-five tons of bronze. He arranged to have the metal sent to his father-in-law, the duke of Ferrara, under whose supervision a Maestro Zanin would turn it into three cannons, including "one in the French style."[45] Ferrara was one of the few cities in Italy with the capability to forge such weapons. The Castel Vecchio in Ferrara had—besides dungeons, a torture chamber, and a special room for decapitating prisoners—a foundry for casting artillery.[46] To this grim fortress Leonardo's bronze was sent.

There was, for Leonardo, a sad irony to the situation. He had come to Milan with dreams of constructing instruments of war. His notebooks from his first years in Milan teem with inventive designs for wiping out the enemy. Promising that his war machines would be "out of the common type," he prepared detailed plans for a cannon on a precision-controlled swiveling mount, a multibarreled machine gun, an armored tank mounted with can-

nons, and a spike-wheeled chariot armed with head-high rotating blades. Lodovico took little interest in these weapons of mass destruction. The relatively sedate nature of Italian warfare, coupled with the fact that the major Italian powers had avoided large-scale conflagrations for several decades, gave him little incentive to encourage Leonardo. When Lodovico suddenly saw the need for heavy artillery, the commission went to the foundries of Ferrara, and Leonardo—such was the grudging of fate—lost his seventy-five tons of bronze.

Bilked of his chance to cast the monument, Leonardo composed a desperate, angry letter to Lodovico. Perhaps it was never sent, since the surviving page was ripped down the middle, possibly by Leonardo himself after some sober second thought. Or perhaps this is the ripped-up draft of a letter that Leonardo did send to Il Moro. In any case, only a series of fragmentary complaints convey Leonardo's angry and incoherent splutter of indignation. "And if any other commission is given me by any—" it begins before breaking off. The fractured litany continues:

> —of the reward of my service. Because I am not to be—
> —things assigned because meanwhile they have—
> —which they well may settle rather than I—
> —not my art which I wish to change and—

A little farther down the page, Leonardo stated that his life had been spent in the service of Lodovico, that he held himself ever in readiness to obey, and that he understood his lordship's mind to be occupied with other things. "Of the horse I will say nothing because I know the times," he wrote, momentarily striking a conciliatory tone before proceeding to tick off his grievances about his treatment over this particular commission: his unpaid salary going back two years, the skilled workmen whom he had been forced to pay out of his own pocket, the "works of fame" he had hoped to create, and how he had been toiling at his art to "gain my living." The letter ends: "I conveyed to your Lordship only requesting you—"

Precisely what request Leonardo conveyed to Lodovico is unknown. One of the fragmentary lines "remember the commission to paint the rooms" alludes to an assignment to decorate rooms in either Lodovico's castle in Milan or his country retreat at Vigevano. For the latter, Leonardo seems to

have been planning scenes from Roman history that incorporated portraits of ancient philosophers.[47]

But Lodovico, however preoccupied with other matters, had something else in mind for his court painter. If the French invasion robbed Leonardo of the chance to cast the bronze horse, it would present him with an opportunity to create quite a different work of fame.

Portrait of the Artist as a Middle-Aged Man

The bronze horse was not the first commission that Leonardo, for various reasons, had been unable to complete. He was someone who promised much, who dreamed of impossible miracles. Yet thus far he had yielded a body of work that, however impressive, was still unhappily dispro-portionate to his talents. Despite his reputation in Milan, he had reached his forties without truly having achieved a masterpiece that would fulfil everything his astonishing talents portended. His career, in both Florence and Milan, had seen several major commissions abandoned unfinished, with the patrons dissatisfied and, in one case, litigious. Few completed works could be attached to Leonardo's name, beyond an Annunciation altarpiece in a convent outside Florence, several Madonna and Child paintings done for private patrons, and a number of portraits, likewise done for private patrons, including the one of Lodovico Sforza's mistress Cecilia Gallerani. He had also, apparently, done a painting—"the most beautiful and unusual work to be found in painting," according to an early biographer—that

Lodovico sent as a wedding present to Maximilian, the Holy Roman emperor.[1]

All of these works, the portraits in particular, were stylistically progressive and beautifully executed. A court poet wrote a poem praising the "genius and skill" with which Leonardo had captured Cecilia's likeness "for all time." Cecilia herself, evidently pleased with the portrait, called Leonardo "the master who in truth I believe has no equal."[2] Leonardo had also painted a saintly figure so astonishingly and gorgeously lifelike that its owner "fell in love with it" (as Leonardo later claimed) and begged him to remove the religious trappings so he could "kiss it without misgivings."[3]

Yet these works were tucked away in private homes, unseen by anyone but princes and courtiers, and the painting given to Maximilian was presumably in faraway Innsbruck. Leonardo had so far created nothing to garner for himself the tremendous public fame won by legendary and beloved artists of the past: something that could take pride of place in a cathedral or public piazza, and that the people could see with their own eyes, like Donatello's statue of Gattamelata in Padua, Giotto's frescoes in Assisi, or Filippo Brunelleschi's dome in Florence. His bronze horse would undoubtedly have caused wonder and excitement, but the opportunity had been lost.

By the age of forty-two—and in an era when life expectancy was only forty—Leonardo had produced only a few scattered paintings, a bizarre-looking music instrument, some ephemeral decorations for masques and festivals, and many hundreds of pages of notes and drawings for studies he had not yet published, or for inventions he had not yet built.[4] There was clearly a stark gulf between his ambitions and his accomplishments. Everyone who met him, or who saw his works, was dazzled by his obvious and undeniable brilliance. But too often his ambitions had been curtailed or frustrated. He hoped to find work as an architect, but in 1490 his aspirations were thwarted when his wooden model for a domed tower for Milan's half-built cathedral was rejected. He tried to get the job of designing and casting the bronze doors for Piacenza's cathedral, even going so far as to write the cathedral officials an anonymous letter extolling his talents: "There is no capable man—and you may believe me—except Leonardo the Florentine."[5] But no call came from Piacenza. He drew up detailed plans to redevelop Milan, dividing the city into ten districts of five thousand buildings each and including such amenities as pedestrian zones, irrigated gardens, and well-ventilated latrines. Not a single part of this plan was ever adopted

or constructed. Meanwhile, Lodovico had harbored doubts about Leonardo's abilities to complete the bronze equestrian monument, even sending to Florence at one point looking for possible replacements.

At times Leonardo was troubled by his lack of achievement. As a young man he appears to have developed a reputation for melancholia. "Leonardo," wrote a friend, "why so troubled?" A sad refrain runs through his notebooks: "Tell me if anything was ever done," he often sighs. Or in another place: "Tell me if ever I did a thing."[6]

Leonardo was born in 1452, in a square-built stone farmhouse near Vinci, an "insignificant hamlet" (as one of his earliest biographers called it) sixteen miles west of Florence.[7] His eighty-year-old grandfather proudly recorded the arrival in a leather-bound family album: "A grandson was born to me, the son of Ser Piero my son, on the 15th day of April, a Saturday, in the third hour of the night. He bears the name Lionardo."[8] He would bear, in fact, the name Leonardo di Ser Piero da Vinci, which was how, twenty years later, he registered himself in the Compagnia di San Luca, the painters' confraternity in Florence. At the Sforza court he would sometimes be known as "Leonardo Fiorentino" or—grandly Latinized—as "Leonardus de Florentia." That, at least, was how Lodovico referred to him in documents.[9] The ducal artist and engineer was therefore identified not with an obscure Tuscan village but with the glories of Florence.

Leonardo's twenty-six-year-old father, Ser Piero, was (as his honorary title implied) a notary: someone who wrote wills, contracts, and other commercial and legal correspondence. The family had produced notaries for at least five generations, but with Leonardo the chain was to snap. He was, as his grandfather's tax return stated a few years later, "non legittimo"—born out of wedlock—and as such he (along with criminals and priests) was barred from membership in the Guild of Judges and Notaries. Leonardo's mother was a sixteen-year-old girl named Caterina, and an apparent difference in their social status meant she and Piero, a bright and ambitious young man, did not marry.

Almost nothing is known about Caterina. She may have been the family's domestic servant. A case has recently been made for her having been, like many domestic servants in Tuscany, a slave from another country. A century

earlier, Florence's city fathers had issued a decree permitting the importation of slaves, provided they were infidels rather than Christians, though they were promptly baptized and given Christian names (and Caterina was a popular choice) on arrival in Florence. Well-to-do Florentines could purchase slaves—usually young women who were to be used as domestics—from lands along the Black Sea (Turks, Tatars, Circassians) as well as from North Africa. Although they cost from thirty to fifty florins, half the yearly wages of a skilled artisan, they became so plentiful in the fifteenth century that a popular song described the sight of "charming little slave girls" hanging out of windows "shaking out clothes in the morning / fresh and joyous as hawthorn buds."[10]

Intriguingly, a wealthy friend of Ser Piero, a Florentine banker named Vanni di Niccolò, owned a slave named Caterina, and following Vanni's death in 1451, Ser Piero inherited his house in Florence and served as executor of his estate. His friendship with Vanni and position as executor would have given him—so the theory goes—sexual access to Caterina. This hypothesis potentially sheds new light on another theory, that of a professor of anthropology whose team found that fingerprints identified as Leonardo's reveal the same dermatoglyphic structure—that is, the same pattern of loops and whorls—as people of Middle Eastern origin. The announcement generated headlines that Leonardo was an Arab, though skeptics claim it is difficult both to determine someone's ethnicity from his fingerprints and to be certain that the fingerprints taken from Leonardo's notebooks are, in fact, those of Leonardo.[11]

Given the dearth of information about Caterina, the theories that Leonardo's mother was a slave, or that Leonardo had a Middle Eastern heritage, must remain speculative. What is known is that Leonardo was raised in the house of his father and grandfather, and Caterina largely disappeared from his life. Children of slaves were always born free, and the church allowed them to be adopted and legitimized by their fathers. The mothers themselves were often given a small dowry and married off to someone else. In Caterina's case, a short while after Leonardo's birth she married a local kiln worker nicknamed Accattabriga. This sobriquet, meaning Troublemaker, suggests that he was not a particularly good catch. She went on to have five children after Leonardo—four daughters and a son—and lived in humble circumstances in Campo Zeppi, near Vinci. Little is known of the Accattabriga clan except that sometime in the 1480s the son, Leonardo's

half brother, perhaps a troublemaker like his father, was killed by a cross-bow in Pisa.[12]

Soon after Leonardo's birth, Piero married another sixteen-year-old, a girl named Albiera. Higher up the social scale than Caterina, she came from a well-to-do family of Florentine notaries, presumably making her a more attractive catch for the aspiring young Ser Piero. Albiera died when Leonardo was twelve, without giving Ser Piero any children. His second wife, Francesca, died in 1473, likewise childless. Leonardo would remain an only child until Ser Piero's third wife gave birth to a son in 1476, by which time Leonardo was twenty-four and no longer living at home. Ser Piero would ultimately go on to have upward of a dozen children, with a recent study claiming he produced at least twenty-one offspring.[13]

Leonardo appears to have been a much-loved child. As an eldest son he was welcomed happily into the home of his father and grandfather. No fewer than ten godparents attended his baptism, an indication that the family felt no shame about the new arrival. Although barred from the legal profession and university because of his illegitimacy, he seems to have suffered few if any other strictures or consequences. In fifteenth-century Italy, little social stigma attached to illegitimacy. The writers Petrarch and Boccaccio, the architect Leon Battista Alberti, the painters Filippo Lippi and his son Filippino, and even a future pope, Clement VII, all were born out of wedlock. Noble families set the fashion of accepting their illegitimate children. When Pope Pius II passed through Ferrara in 1459, his welcoming party consisted of eight bastards from the ruling family, including the reigning duke, Borso d'Este. Pius no doubt took a broad-minded view of the Este clan because before taking holy orders he himself had fathered several illegitimate children. "What is sweeter to a human being," he wrote to dispel his father's dismay that the children were born in sin, "both to extend his bloodline and for you to have someone to leave behind? . . . Truly, it is an enormous pleasure for me that my seed was fruitful."[14]

Ser Piero appears to have been equally delighted at the arrival of his son, though for unknown reasons he never legitimized him. Certainly Leonardo's illegitimacy gave him one distinct advantage: it allowed him to escape the legal profession in favor of more creative and wide-ranging pursuits in the same way that Petrarch and Boccaccio, subject to only the faintest moral stain, and liberated from the demands of church and guild, had been able to experiment with new forms of expression.

Leonardo's schooling was probably fairly unremarkable, hardly designed to turn him into the polymath he eventually became. Between the ages of six and eleven he would have studied at an elementary school, what the Florentines called the *botteghuzza* because its primary concern was to prepare students for the *bottega* (workshop). The teacher would have been either a priest or a notary, and the students learned to read and write, mostly in the idiomatic Italian of Tuscany. Leonardo would also have received some Latin instruction through a grammar known as the Donadello. Later in life he owned no fewer than six of these Latin grammars, one of them perhaps his original schoolbook. This ardent stockpiling of elementary Latin grammars indicates how Leonardo, though he had some ability, was by no means fluent or even particularly competent in Latin. His most serious attempt to master the language would come when he was in his late thirties in Milan, when he transcribed parts of Niccolò Perotti's widely used textbook Rudimenta grammatices. That one of history's greatest brains struggled with *amo, amas, amat* should be consolation to anyone who has ever tried to learn a second language.

At the age of eleven, students went to either a grammar school, where they studied Latin literature to prepare for a learned vocation, or an abacus school, where the weight of the teaching was on numeracy rather than literacy. Leonardo almost certainly went to the latter. Pupils at abacus schools were introduced to some literature, such as Aesop and Dante, but mathematics was emphasized in order to prepare them for careers in commerce. A good example of what students had to learn is found in the painter Piero della Francesca's *Trattato d'abaco*, which Piero claimed was a treatise on "the arithmetic necessary to merchants." Among the many exercises is one that reveals the sort of brain-twisting commercial transaction common in Italy in the fifteenth century: "Two individuals are bartering, one with wax and the other with wool. The wax is worth 9 ducats and a quarter, the barter rate is 10 and two-thirds; the other one has wool and I do not know what the thousand is worth, its exchange rate is 34 ducats, and the barter was fair. How much was the wool worth in cash?"[15]

One of Leonardo's earliest biographers, the painter and architect Giorgio Vasari, claimed that Leonardo was so astute at mathematics that "he used to baffle his master with the questions and problems that he raised."[16] Vasari never met Leonardo (he was born in 1511) and many of his stories are open to doubt. However, it seems a safe assumption that Leonardo was a curious

and gifted student, a brilliant geometer and draftsman in particular. Yet he was not overly adept at arithmetic, and he never used algebra.

Neither, it appears, did Leonardo excel at writing in Italian, let alone Latin. He once described himself as an *"uomo senza lettere"*: a man without letters. The claim was an exaggeration, and it probably refers to his lack of ability in Latin. Nevertheless, his notebooks do reveal numerous grammatical inconsistencies, misspellings, skipped words, and a general lack of linguistic rigor. Some of his errors are curious even given the haste with which he may have been making his notes. For example, copying down a list of books in his library, he wrote *"anticaglie"* instead of *"antiquarie."* On the same page he turned "Margharita" into "Marcherita." Elsewhere he mangled the name of the Persian philosopher Avicenna, writing "Avinega." Venezia he turned into "Vinegia."[17] Mitigating in his favor is the fact that the rules of spelling—like attitudes toward illegitimacy—were liberal in Leonardo's day.

Leonardo's stepmother and his grandfather both died in 1464, when he was twelve years old. Either at that time or else at some unknown point in the next few years—but by 1469 at the latest—he moved to Florence to live with his father. Ser Piero had done extremely well for himself. By 1462 he had been working as Cosimo de' Medici's notary, and by 1469 he was the official notary to the Podestà, Florence's chief law officer. Clients of his thriving practice included the nuns and friars of at least eleven convents and monasteries, and he was the notary of choice for members of the Jewish community in Florence. "If destiny bids you take the best man of law," wrote a Florentine poet named Bernardo Cambini, "look no further than da Vinci, Piero."[18] He had a grace-and-favor apartment in the Palazzo del Podestà and, after 1470, a house in the Via delle Prestanze, the present-day Via de' Gondi, a street running off the north side of the Palazzo Vecchio.

With fifty thousand people, Florence must have been an impressive sight for a young man like Leonardo arriving from Vinci. "Nothing more beautiful or more splendid than Florence can be found anywhere in the world," the scholar Leonardo Bruni had declared in about 1402. Fifty years later, a Florentine merchant, taking stock of his hometown, believed it even more resplendent than in Bruni's day, with beautiful new churches, hospitals, and

palaces, and with prosperous citizens sauntering through the streets in "expensive and elegant clothing." Florence at this time could boast fifty-four dealers in precious stones, seventy-four goldsmith shops, and eighty-three silk-weaving firms. There was, the merchant acknowledged, a further attraction: the astonishing proliferation of Florence's architects, sculptors, and painters.[19] Highly conspicuous by the time Leonardo arrived in Florence were frescoes, statues, and buildings by men like Giotto, Brunelleschi, Masaccio, Donatello, and Lorenzo Ghiberti.

Leonardo's true education began not in an abacus school in rural Tuscany but in a goldsmith's workshop in Florence when he was aged about thirteen or fourteen. He would have had little or no opportunity to indulge his artistic proclivities in the commerce-minded abacus school, but evidently his youthful sketches, made in his spare time, caught the eye of his father. Ser Piero served as the notary for the Florentine goldsmith and painter Andrea del Verrocchio, to whom, according to Vasari, he proudly showed a batch of the boy's drawings.[20] Ser Piero apprenticed Leonardo with Verrocchio, evidently unconcerned that his son would therefore become what was essentially a manual laborer. Ser Piero was a member of the powerful and prestigious Guild of Judges and Notaries in whose ranks could be found the sons of noble families and wealthy merchants. Painters, on the other hand, were part a guild that included doctors and apothecaries but also such lowly tradesmen as drapers, candle makers, hatters, glovers, grave diggers, and purveyors of cheese. Although Leonardo's career choices were restricted due to his illegitimacy, Ser Piero was more liberal in his attitude toward the boy's vocation than, say, Michelangelo's snobbish father who, according to Vasari, scolded and beat his son when he first showed an interest in working with his hands.

Apprentices in artists' workshops usually studied six or seven years under a recognized master, who offered food, lodging, and hands-on instruction in return for a fee paid by the apprentice's father or guardian. Leonardo was fortunate in his father's choice. Verrocchio enjoyed a splendid reputation as the "fountain from whom painters embibed whatever skills they have."[21] Then in his early thirties, he was the son of a brick maker who later made good as a customs inspector. Andrea seems to have led something of a wild youth: at seventeen he was arrested for killing a fourteen-year-old wool worker with a stone (he was ultimately acquitted). He may have apprenticed in the workshop of Donatello, but his main teacher was a goldsmith named

Giuliano del Verrocchio, from whom he took his name (Verrocchio means "true eye"—an apt name for an artist). He endured some lean times after striking out on his own in his twenties, going barefoot at one point when he was unable to afford a pair of shoes.[22]

Verrocchio's career kindled to life when he began working for the ruling Medici family in the mid-to-late 1460s, about the time, coincidentally, when Leonardo entered his studio. Becoming the Medici's sculptor of choice, he designed and built the tomb for Cosimo de' Medici, founder of the political dynasty who died in 1464. A few years later he sculpted the bronze-and-porphyry tomb of Cosimo's sons, Piero and Giovanni. He also created for the family two remarkable bronze statues, a *Putto with a Dolphin* and a *David*. Leonardo was in Verrocchio's workshop when these two elegant little statues were designed and cast, and in the figure of the *David*—a slim, athletic youth with tousled hair and an enigmatic half smile—it is tempting to see a portrait of Leonardo. If Leonardo was as beautiful as all his early biographers attest, Verrocchio could have naturally modeled the valiant young giant killer on his handsome apprentice. However, the absence of any youthful portrait of Leonardo with which to make a comparison means the identification must remain speculative.

Leonardo stayed in Verrocchio's workshop for at least six or seven years. He spent the better part of a decade, therefore, learning the trade secrets essential to a painter and sculptor: everything from how to tint a piece of paper or make a pen from a goose quill, to the best method of applying gold leaf or casting bronze. Like the other apprentices, he assisted the master on works such as Verrocchio's altarpiece *The Baptism of Christ*, done for the monks at the abbey of San Salvi in Florence. Legend has it that Leonardo painted one of the two kneeling angels in this altarpiece, turning out a figure so sublime that as Vasari recorded, Verrocchio "would never touch colours again, he was so ashamed that a boy understood their use better than he did."[23] Leonardo may well have executed the angel with the flaxen curls, and he would indeed become a painter far superior to his master, whose true talent was in sculpture rather than painting. Alas for the myth, Verrocchio did not in fact throw away his paint box in despair, since years later he was at work on an altarpiece for the cathedral in Pistoia.

Another Verrocchio painting on which Leonardo worked was *Tobias and the Angel*, for which he contributed the eager little dog—a creature with a wavy silver coat—as well as the fish and the golden ringlets over Tobias's

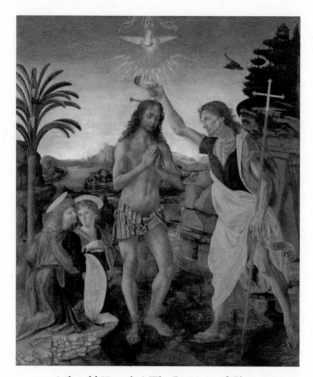

Andrea del Verrocchio's The Baptism of Christ

ears.[24] Leonardo had a fascination with curly hair. His own hair, as one early biographer attests, was long and curly, and his beard "came to the middle of his breast, and was well-dressed and curled."[25] He evidently took pride in his appearance. Besides his well-dressed hair and curled beard, he had a taste for colorful clothing. Florence was renowned for its luxurious textiles—silks and brocades with names like *rosa di zaffrone* (pink sapphire) and *fior di pesco* (peach blossom). But most of these exotic fabrics were exported to the harems of Turkey because sumptuary laws—regulations against ostentatious dress—meant Florentines necessarily favored more sober colors. Not so Leonardo, whose wardrobe in later life, an audacious mix of purples, pinks, and crimsons, flouted the dictates of the fashion police. One list of his clothes itemized a taffeta gown, a rose-colored Catalan gown, a purple cape with a velvet hood, a coat of purple satin, another of crimson satin, a purple coat of camel hair, dark purple hose, dusty-rose hose, black hose, and two pink caps.[26]

Leonardo appears to have been, in all things, unregimented and inde-

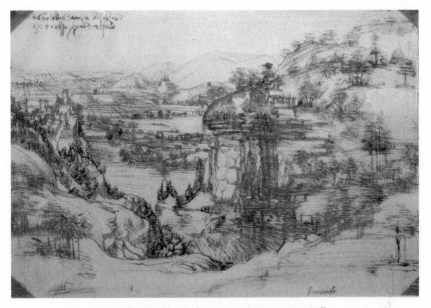

Leonardo's first known drawing, of the Arno River Valley

pendent, willing to disregard fashion, tradition, and precedent. Something else that made him unique was his enthusiasm for depicting the world of nature beyond the bounds of human activity. His first known drawing, done in the summer of 1473, when he was twenty-one, showed an elevated view of the Arno Valley outside Florence: sharp promontories of hill and rock rearing above a plain. The sketch was probably done as a study for the background to a painting, since he seems to have been entrusted with the landscape backdrop in Verrocchio's *Baptism of Christ*, which features a mass of sheer cliff thrusting upward from a valley floor. The drawing is celebrated as the first landscape in Western art: the first time that someone regarded the features of the natural world, devoid of human presence, worthy of reproduction. Leonardo carefully dated his sketch: "The day of Our Lady of the Snows, 2 August 1473." On the reverse of the paper he wrote: "*Sono chontento*" (I am happy). In the Tuscan hills, studying rock formations and watching birds of prey rising on thermals, Leonardo may indeed have been the happiest.[27]

Rocks, like ringlets, fascinated Leonardo. He spent much time tramping around the hills—the hobby mocked by the poet Guidotto Prestinari. This interest in topography was scientific as well as aesthetic. His notes record observations on the layers of soil and rock in the Arno Valley, such as the deposits of gravel near Montelupo, a conglomerate of tufa near Castelfiorentino,

and layers of shells at Colle Gonzoli.[28] His rambles were so famous by the time he lived in Milan that he once received a sack full of geological samples from mountain men: "There is to be seen, in the mountains of Parma and Piacenza," he wrote, "a multitude of shells and corals full of holes, still sticking to the rocks, and when I was at work on the great horse for Milan, a large sackful of them, which were found thereabout, was brought to me into my workshop by certain peasants."[29] Such was Leonardo's reputation, his eccentric pursuits known by the peasants as far away as Parma and Piacenza.

Leonardo was living and presumably still working with Verrocchio in 1476, when he was in his midtwenties. Why he should have lodged with Verrocchio rather than in his father's more ample accommodation is a mystery, since also sharing Verrocchio's house were the goldsmith's scapegrace younger brother, Tommaso, a cloth weaver, and his sister, Margherita, and her three daughters.[30] Had Leonardo fallen out with his father, who following the death of his second wife had recently married for a third time? Ser Piero's latest bride, Marguerita, was, at the tender age of fifteen, almost a decade younger than Leonardo. In 1476 she gave birth to a boy, Antonio: Ser Piero's first legitimate child. She would produce five more (including a daughter who died in infancy) before dying in the late 1480s—at which point Ser Piero married for a fourth time and resumed his tally.

Italian literature of the day is full of stories of disputes between fathers and sons. These disputes were a consequence, in part, of a legal system that did not require fathers to emancipate their sons and give them legal rights until they were well into their twenties. The poet and storyteller Franco Sacchetti wrote that "a good many sons desire their father's death in order to gain their freedom."[31] Leonardo mentioned this intergenerational battle in a surprisingly churlish letter written many years later to his stepbrother Domenico following the birth of Domenico's first child—"an event," wrote Leonardo, pen dripping with condescension, "which I understand has given you great pleasure." He put something of a dampener on the celebrations with the observation that Domenico was imprudently congratulating himself "on having engendered a vigilant enemy, all of whose energy will be directed toward achieving a freedom he will acquire only on your death."[32] It is impossible to know how much Leonardo's sentiments were formed by writers

like Sacchetti—a copy of whose famous collection of stories was in Verrocchio's workshop—and how much by his own experiences with Ser Piero.

Leonardo probably lived with Verrocchio because he enjoyed the older man's company. Verrocchio was an intelligent and literate man with sophisticated and wide-ranging interests. Vasari claimed that he studied geometry and the sciences—subjects that appealed to Leonardo—and that he was also a musician. Leonardo, too, was a musician, playing the lyre "with rare execution" and even giving music lessons to pupils.[33] He may even have learned his musical skills from Verrocchio: a lute appears on a list of possessions in the master's workshop. This list also mentions a Bible, a globe, works by Petrarch and Ovid, and Sacchetti's book of humorous short stories.[34]

All of these sorts of items would later appear in Leonardo's own studio in Milan, and these possessions are a testament to, among other things, his sustained interest in the intellectual milieu first discovered in Verrocchio's house and workshop. Indeed, they suggest that the older man, with his manifold pursuits, was Leonardo's mentor in matters more than just how to grind pigments or hold a stylus. Leonardo arrived in Florence as a country boy from Vinci with only the rudiments of an education. Verrocchio probably smoothed off some of the young man's rough edges with—perhaps—evenings of recitals on the lute or discussions of Ovid's poetry.

But the influence no doubt also went deeper. Verrocchio must have been the one who first awakened Leonardo's interest in things such as geometry, knots, and musical proportions—and their application to artistic design. His tomb slab for Cosimo de' Medici is a labyrinth of geometrical symbols whose dominant image, a circle within a square, would reappear in Leonardo's *Vitruvian Man*. Meanwhile the two interlocking rectovals in Verrocchio's design for the tomb are repeated in one of Leonardo's ground plans for a church. Verrocchio designed the slab between 1465 and 1467: around the time when Leonardo entered his workshop. It is easy to imagine the young apprentice studying the intricate design and realizing that mathematics was not merely (as he had learned in his abacus school) a tool for commercial transactions but rather a visible expression of the world's beauty and truth.

Leonardo also seems to have had another home in Florence. Verrocchio's Medici connections, coupled with Leonardo's obvious talents, opened the

door on a rare opportunity. The fact that Leonardo lived with and worked for Lorenzo de' Medici is affirmed by one of Leonardo's earliest biographers, an anonymous Florentine known (after the Biblioteca Gaddiana, where his manuscript was once kept) as the Anonimo Gaddiano. This manuscript, written in the 1540s, claimed that as a young man Leonardo stayed with Lorenzo the Magnificent, "and with his support he worked in the gardens of his palace in San Marco in Florence."[35]

Lorenzo's sculpture garden was a kind of informal open-air museum through which he hoped to foster the talents of young artists (the adolescent Michelangelo would be admitted in 1489). Besides ancient statues and bronzes, Lorenzo and his curator, a sculptor named Bertoldo, assembled paintings and drawings by artists such as Brunelleschi, Donatello, Masaccio, and Fra Angelico. What work Leonardo did for Lorenzo in return for his salary is unclear, but he would have been able to make a close study of both ancient statuary and modern works of fame.

Equally important, the sculpture garden gave Leonardo access to Lorenzo the Magnificent, the most powerful man in Florence and a wealthy and astute patron of the arts. Lorenzo was probably at least partly responsible for one of Leonardo's first independent commissions. Early in 1478 he was chosen by the Signoria, Florence's ruling council, to paint an altarpiece for the chapel of San Bernardo in the Palazzo della Signoria (now the Palazzo Vecchio). Meanwhile he began several other projects. Toward the end of that year he made a note that he was starting "two Madonna pictures."[36] The patrons for these Madonnas are unknown, but for another work he had a very important client: he was hired to design a tapestry for King John II of Portugal. Again, Lorenzo or someone in his circle may have helped secure this commission, since King John had connections at the Medici court.[37] Taking as his subject Adam and Eve in the Garden of Eden, Leonardo produced a design that later impressed Vasari: "For diligence and faithfulness to nature," he wrote, "nothing could be more inspired or perfect."[38]

At some point in the 1470s, Leonardo found work with the affluent Benci family, executing a portrait of a young woman, Ginevra de' Benci. Ser Piero served as the Benci clan's legal trustee, but Leonardo's Medici connections no doubt also helped secure this portrait commission, since Ginevra's father and grandfather both had been managers of the Medici bank, and Lorenzo himself composed sonnets in Ginevra's honor.[39] The man who probably commissioned the work, though, was the Venetian diplomat Bernardo Bembo, who

during two embassies in Florence in the 1470s established a close relationship with Lorenzo de' Medici and an even closer one, apparently, with Ginevra.

Another commission came Leonardo's way in July 1481 when he was hired to paint an Adoration of the Magi for the Augustinian church of San Donato a Scopeto, outside the gates of Florence. Ser Piero no doubt played a vital role in securing the commission since he was the notary for the monks of San Donato a Scopeto. However, the contract for the altarpiece was a strange and complex one for which Leonardo may not have thanked his father. It stipulated that Leonardo should complete the altarpiece within two years, or at most in thirty months; if he failed to deliver, the monks reserved the right to terminate the contract without compensation and take possession of the work, such as it might be. His remuneration was a one-third share in a small property outside Florence originally owned by a saddle maker, the father of one of the monks. Oddly, he was also obliged to provide from his share of the property a dowry for the saddle maker's granddaughter, a seamstress named Lisabetta.[40]

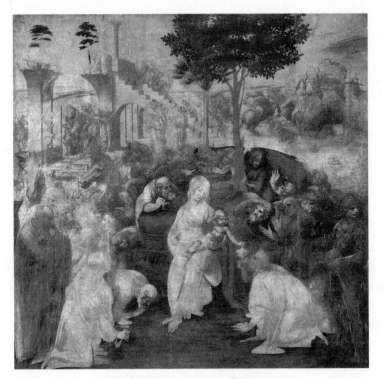

Leonardo's The Adoration of the Magi

Success in Florence, then, seemed to beckon. On the verge of his thirties, Leonardo looked to be establishing himself as a successful workshop master in the stamp of Verrocchio, securing numerous commissions—and very prestigious ones at that—through both his talent and his connections with powerful friends. He probably hired apprentices of his own at this point.

But his work did not proceed auspiciously. Most of these commissions met with unhappy fates. The seamstress Lisabetta did not get her dowry, or at least not from Leonardo. Nor did the monks receive their Adoration of the Magi. Despite further incentives (the monks sent him a bushel of wheat and then a cask of red wine) he failed to complete the work, which remained in a state of frantic and mesmerizing incompletion. Leonardo did, however, finish for the monks another, lesser task. They engaged him to paint one of their sundials, for which he received in return a load of firewood.

Other of Leonardo's works also went unfinished or undelivered. For some reason, the tapestry design for the king of Portugal was never sent to Flanders, where it was to have been woven in gold and silk. Nor did Leonardo bring to completion his altarpiece for the chapel in the Palazzo Vecchio. His failure to deliver this latter work to the Signoria, the men who employed his father, may have involved Ser Piero in some awkwardness and embarrassment, as did, no doubt, his inability to furnish the dowry and complete the Adoration for the monks of San Donato. His tardiness and delinquency—caused by a combination of distractions, experimentation, a quest for perfection, and a general intellectual restlessness—appear to have been well developed at this early stage of his career. A Florentine poet named Ugolino Verino, surveying Leonardo's career from the vantage point of the mid-1480s, tut-tutted that he "barely managed to complete a painting in ten years."[41]

<center>❁</center>

However bad it may have looked to his disappointed patrons, Leonardo's failure to complete his work was not the result of incompetence or a lack of resources. Rather, he was frustrated by the extremely high standard he set for himself in his quest for a new visual language. He looked much more closely at the world than his contemporaries, wishing to integrate its features more naturalistically into his art.

A good example of how Leonardo worked can be seen in the painting of a Virgin and Child with a cat that he planned in about 1480. The painting

itself was never done, or else has long since been lost, but his scattered sketches show that he repeatedly—and almost obsessively—rehearsed the pose of a toddler holding a cat. Verrocchio used terra-cotta statuettes as models for the Christ Child in his paintings. Leonardo, however, was determined to capture life more accurately and realistically. Since his drawings of the child with the cat date from the late 1470s or early 1480s, it is tempting to see in these vignettes one of Leonardo's infant half brothers, Antonio (born in 1476) or Giuliano (born in 1479), wrestling with the family cat. Antonio and Giuliano were almost certainly the models for two Madonna and Child paintings that he did finish, *Madonna of the Carnation*, done between about 1476 and 1478, and the *Benois Madonna*, painted a year or two later. In each case Leonardo depicts a Christ Child whose unfocused eyes and clumsy grasp were surely based on his actual observation of babies.[42]

Leonardo believed the painter required a vast store of resources, especially deep powers of observation, since he was to reproduce in his works "all that the eye can see"[43]—such things as the effect of the wind on trees, or shadows on clouds, or how objects looked underwater. The sight of sun and shadow playing across people and objects obsessed him. He planned to write a treatise on light and shade that would account scientifically for subtle atmospheric effects such as mist and reflected light. The motions of the human body also absorbed him. A sixteenth-century biographer reported that in order to be able to paint joints and muscles realistically Leonardo dissected corpses, "indifferent to this inhuman and nauseating work."[44] No artist had ever peered so deeply into the physical features of men and their world, or struggled so intensively to capture them in paint.

Leonardo was relentlessly inquisitive, seeking answers to a wide variety of phenomena. His notebooks are filled with reminders to ask questions of friends and acquaintances: how a tower in Ferrara was constructed, how the people in Flanders "go on the ice" in winter, how the capon hatches the eggs of the hen.[45] He also made his own firsthand investigations, occasionally ones requiring vigor and courage. From the Po Valley near Milan the giant hulk of the 15,203-foot Monte Rosa can be seen rising in the distance, and at some point Leonardo climbed toward one of the summits of this great massif, thereby becoming one of history's first mountaineers.[46] Ascending the jagged slopes to understand, among other things, why the sky was blue, he marveled at how the world looked different at high altitude, with the thin atmosphere making the sun look brighter and the sky darker.[47]

Leonardo was not content, therefore, to work according to the tried-and-trusted styles of the day, looking at the world with the same eyes as everyone else and churning out altarpieces little different from what painters had been doing for the previous fifty years. Instead, he continually experimented, setting himself almost impossible tasks. He wanted to create entirely unique and different visual forms: ones inspired not by earlier paintings but by the world around him. Many of his contemporaries were highly competent technicians who could create elegant and pleasing works of art to satisfy their patrons. But they did not climb up mountains or study the muscles of corpses. Leonardo had a deeper and more exhilarating vision of the world, and a more ambitious and exacting conception of how art might capture and interpret it.

In about 1482—the precise date, and even the exact year, is uncertain—Leonardo left Florence, armed with his silver horse-head lyre and his letter of credentials. The unfinished commissions smoldered behind him, but in Milan, despite the fresh start, he did little to mend his ways.

Leonardo's long letter of credentials to Lodovico Sforza reveals a certain amount of reinvention. He failed to mention that he was Verrocchio's pupil, nor did he describe any of his paintings (completed or otherwise) or the fact that he had done work for such important patrons as the king of Portugal, Bernardo Bembo, the Florentine Signoria, and Lorenzo de' Medici. He clearly hoped for a career change in Milan: he wanted to work as an architect and military engineer rather than as a painter. He therefore boasted of his abilities to execute projects (bridges across rivers, tunnels under moats) for which, in reality, he had at best limited experience and, at worst, none whatsoever.

No evidence indicates that Leonardo actively participated in any of these sorts of engineering schemes in Florence. One early source claimed that his expertise in hydraulic engineering was what originally brought him to Milan. Impressed by certain dams constructed by Leonardo along the Renello River, Lodovico supposedly hired him to combine two canals and look after the city's sewers and floodgates.[48] This early experience cannot be verified—and the identity of the "Renello River" is impossible to ascertain—but Leonardo would hardly have made audacious claims for engineering

skills if he had no competence or ability. In fact, the design for one of his war machines may have predated his departure for Milan: a wheeled gun carriage that allowed a cannon to adjust its aim through both a vertical calibration and a horizontal pivot. Furthermore, his notebooks reveal that while still living in Florence he drew designs for (but probably did not actually construct) a crossbow, waterwheels, and numerous gears, cranks, and screws, all of which could have had a wide application. These designs testify to his striking ability to visualize solutions to complex technical problems; all that was wanting was the opportunity to implement them.[49]

Leonardo once wrote that "mechanical science" was the "noblest and the most useful" of all the disciplines.[50] His fascination with mechanics and the kind of breathtaking engineering projects to which he aspired possibly dated from—or at least was spurred by—one particular experience in Verrocchio's workshop. In May 1471, when Leonardo was nineteen, Verrocchio and his team hoisted a two-ton copper ball some three hundred feet into the air to the top of the lantern crowning the dome of the cathedral in Florence. This marvelous feat of engineering clearly enthralled Leonardo, who made drawings of the gears in the Brunelleschian hoists used to perform the task. Painting altarpieces for local politicians or obscure bands of monks must have paled in comparison to such a spectacular undertaking.

Leonardo evidently believed that Milan, with its much larger population, held more opportunities for engineering than Florence. Yet work in these fields was not swiftly forthcoming. His first known project in Milan, arranged in the spring of 1483 by the Confraternity of the Immaculate Conception, was yet another painting: an altarpiece for a chapel in the church of San Francesco Grande. The commission was at least a prestigious one. Located in one of Milan's oldest and wealthiest neighborhoods, San Francesco Grande housed more relics than any other Milanese church. Among its treasures was the head of St. Matthew and a piece of wood from the room in which Christ ate the Last Supper.[51]

The confraternity, founded in 1475, was a religious group composed of wealthy laymen who worshipped together and advocated the doctrine of the Immaculate Conception. Having recently acquired their chapel and seen its ceiling frescoed, they now wanted an altarpiece. For the previous three years a woodworker had been busily constructing the enormous frame into which would be set painted decorations as well as carved statuettes and reliefs.

Leonardo was hired to execute the altarpiece alongside a pair of brothers,

Evangelista and Ambrogio de Predis, the latter of whom was Lodovico Sforza's court painter. The most important part of the commission was to be a central panel depicting (as the contract particularized) the Madonna in an ultramarine blue mantle flanked by two prophets, with the Christ Child seated on a golden platform and God the Father, also in ultramarine blue, hovering overhead. The fact that Leonardo was deemed the major partner in this enterprise is indicated by the stipulation that this centerpiece was to be "painted by the Florentine."[52]

Although Leonardo did not find his desired employment building doomsday weapons, within a year of his arrival in Milan he had nonetheless secured a highly prestigious commission. Then two years later, Lodovico, on behalf of Matthias Corvinus, the king of Hungary, engaged Leonardo to paint a Madonna.[53] Sadly, he stayed true to his habit of leaving contracts unfulfilled and patrons disgruntled. Nothing is known of the Madonna painted for Corvinus, while the commission for the confraternity's altarpiece became a sorry saga of delays, recriminations, and legal proceedings. Leonardo and the two brothers were contracted to finish the altarpiece on time for the Feast of the Immaculate Conception in December 1483—a deadline giving them a little more than seven months. Something of Leonardo's reputation for belatedness must have been known to the confraternity because they inserted into the contract a special clause stating that if he left town without completing his share of the work he would receive no further payment.

Perhaps not surprisingly, Leonardo and his partners failed to deliver. The exact date that Leonardo completed his panel—the work now known as *The Virgin of the Rocks*—is not known, but as much as a decade later it had still not been handed over. By the early 1490s the two parties were in dispute, with Leonardo and Ambrogio (Evangelista had since died) appealing to an authority, probably Lodovico Sforza, to complain that their payment of eight hundred lire had been exhausted on the materials. The contract had made allowances for a bonus to be paid once the job was finished, but the assessors, a Franciscan friar and two members of the confraternity, offered only an extra hundred lire: the painters wanted a bonus of four hundred lire. In their appeal, Leonardo and Ambrogio mentioned a third party (whose identity has never been known) willing to purchase the altarpiece from them at a more advantageous price. There was a certain highhandedness and even arrogance to their complaint, which stated that the members

of the confraternity were unfit to pronounce on the painting "because the blind cannot judge colours."[54]

The wealthy and powerful men in the confraternity must have been taken aback by such a haughty attitude in mere painters. Patrons generally regarded painting as something too important to be left to the artists. Painters were craftsmen working in strict accordance to the wishes of their employers, who were always their social betters. A few years earlier, Leonardo's contemporary Domenico Ghirlandaio, a reliable and established painter with an excellent reputation, was hired by Fra Bernardo di Francesco, prior of the Foundling Hospital in Florence, to paint an altarpiece of the Adoration of the Magi. The contract repeatedly stressed that Fra Bernardo, not Ghirlandaio, was to be judge and jury in the matter of appraising the content and quality of the work. Every particular was to be done "according to what I, Fra Bernardo, think best," and the painter would receive his payment only "if it seems to me, the abovesaid Fra Bernardo, that it is worth it." Fra Bernardo reserved the right to get a second opinion on the finished article, and if the assessment was unfavorable, Ghirlandaio would receive "as much less as I, Fra Bernardo, think right."[55]

Ghirlandaio was happy to fulfill his patrons' various demands. Not so Leonardo, who evidently did not enjoy working to order. His frustration with the members of the confraternity is understandable, but their reticence about a bonus for *The Virgin of the Rocks* came about partly, no doubt, because Leonardo had failed to stick to the description provided in his contract. The Christ Child does not appear on a golden platform nor does God the Father hover overhead. The members of the confraternity did not simply want a pretty picture to hang in their chapel: they wanted a work of art that would illustrate and reinforce their belief in the doctrine of the Immaculate Conception of the Virgin: that is, that the Virgin Mary, unlike everyone else, was born free from the stain of original sin (and that she was conceived asexually by means of a chaste kiss between her parents). This doctrine was new and highly controversial, with the Franciscans in support and the Dominicans violently objecting. The Feast of the Immaculate Conception was recognized only as recently as 1476 in a papal bull issued by Sixtus IV, a Franciscan. The members of the confraternity, whose sole purpose as a group was to support and defend this doctrine, had no wish to see a painter improvising with his design in a way that ignored or meddled with their theological beliefs.

The members of the confraternity were probably also shocked at the sight of something so daring and new. Leonardo had failed to finish the Adoration of the Magi, a composition that if brought to completion would have been unlike anything seen in Italy. The startling promise of this work, with its attention to bodily movement and natural detail, was fulfilled in his mesmerizing *The Virgin of the Rocks*. Leonardo swept away the stock gestures and expressions used by artists to convey their meanings, giving his figures life and movement through a delicate ballet of motioning hands—the foreshortened left hand of the Virgin, the pointing forefinger of the angel— and skillfully calibrated postures.

Leonardo also created a truly fantastical setting for his figures. The contract mentioned mountains and rocks in the background, but he conjured an eerie, primeval landscape in which the distant, vertiginous drops of his 1473 Arno Valley sketch reappear, this time in closeup, in the hefty arches and priapic columns of rock forming the grotto where the scene takes place. It is a landscape whose eerie beauty was inspired by Leonardo's close scrutiny of topographical features. A professional geologist studying the painting in 1996 celebrated the work as a "geological tour de force because of the subtlety with which Leonardo represents a complicated geographical formation."[56] In the foreground he painted, with the same naturalistic detail, plants such as columbine and St. John's wort.[57] The scene was given an overall unity through a subtle modulation of light and shadow, with the figures seen in a diffused, dusky light, as if through a smoky filter.

It was a virtuoso performance. Leonardo had finally created a magnificent work of art, a large altarpiece that should have been prominently displayed in one of Milan's most important churches. And yet, because of the dispute with the confraternity, it remained in his studio, unappreciated and largely unseen. Twenty-five years would pass before an altarpiece—albeit with a different central panel, painted much later by Leonardo—was finally delivered to San Francesco Grande. What happened to the first version, and whether another buyer purchased it from the painters in the 1490s, has never been known for certain. For all intents and purposes, this painting— unquestionably the greatest altarpiece of the fifteenth century—vanished from the view of history until 1625, when it surfaced in the collection of the kings of France.[58]

Such disputes left Leonardo at times exasperated and embittered. He did not regard humanity with the same repugnance as his contemporary

Niccolò Machiavelli, who wrote in *The Prince* that the majority of men were "ungrateful, fickle, liars and deceivers."[59] But his notebooks register peevish complaints in which he projected an image of himself as someone who has been wronged, betrayed, or unjustly treated. "All the ills that are or ever were," reads one of these passages, "if they could be set to work by him, would not satisfy the desires of his iniquitous soul." Or again: "I know one who, having promised me much, less than my due, being disappointed of his presumptuous desires, has tried to deprive me of all my friends." Sometimes he made clear his suspicion not of individuals but of people in general, at one point launching a tirade against people who are "nothing else than a passage for food and augmentors of excrement." They pass through life leaving nothing behind, he sneered, but full latrines.[60]

Early in his career, Leonardo was short of neither friends nor benefactors, having worked for two of the most illustrious princes in Italy, Lorenzo de' Medici and Lodovico Sforza. But his unwillingness to compromise his art for the sake of a contract was giving him a reputation as a difficult and unreliable artist that may have threatened future commissions. More to the point, he had yet to create his work of fame. As the French guns rolled through Italy and his bronze floated down the river to Ferrara, the debt that his genius owed the world still remained to be paid.

The Cenacolo

The horses in Lodovico Sforza's stables displayed on their harnesses a motif of a Moor holding aloft a globe of the world. Beneath was the motto: "As long as he wills it."[1] This emblem seemed appropriate in the autumn of 1494. Lodovico did indeed seem to be all-powerful, holding the fate of the world—or, at any rate, of Italy—in his hands. A Venetian chronicler marveled at his success and aplomb: "All that this man does prospers, and all that he dreams of by night comes true by day. And, in truth, he is esteemed and revered throughout the world and is held to be the wisest and most successful man in Italy. And all men fear him, because fortune favours him in everything that he undertakes."[2] But Lodovico was not only feared: he was also disliked. After his dealings with the French and his treatment of his nephew, few trusted him, and no one knew what he might do next.

King Charles VIII was also enjoying success in his undertakings: so much that one of his ambassadors marveled that "God himself" must have been guiding and protecting the young king so "that he might make him his in-

strument to scourge and chastise these Italian princes."[3] His relentless ex-
pedition into Italy continued apace, with his troops reaching the Florentine
frontier before the end of October.

The French needed possession of Florence's fortresses, dotted through the
Tuscan countryside, in order to secure their flank as they descended deeper
into Italy. When the Florentines, siding with King Alfonso of Naples, failed
to accommodate, the French attacked the first of the fortresses, Fivizzano.
Once again the French savagery shocked the Italians. The garrison was
wiped out, the town sacked and burned, and, in a repeat of Mordano, the
inhabitants slaughtered. On the last day of October, Piero de' Medici, Lo-
renzo's son and the new ruler of Florence, speedily acquiesced to the French
king's demands, surrendering the fortresses and offering free passage through
Tuscany. When news of this capitulation reached Florence, "tremendous in-
dignation flared up all over the city," as Guicciardini wrote, and within days
the Medici—who had ruled the city for sixty years—fled into exile.[4]

Lodovico had returned to the French camp on the day following his
nephew's funeral, but within days he was back in Milan. He proceeded to
busy himself with the paperwork necessary for officially assuming his new
title. Technically speaking, the title of duke of Milan could only be granted
as an imperial privilege by the Holy Roman emperor, within whose territo-
ries (in name, at least) Milan lay. In 1395 the emperor Wenceslas had granted
Giangaleazzo Visconti, the first duke, "pre-eminence and comprehensive
jurisdiction and power" in Milan, to be exercised on the emperor's behalf.[5]
A later emperor, Frederick III, had not been favorably disposed to the
Sforza dynasty, and so neither Francesco nor his son Galeazzo Maria—
though they ruled with absolute power and called themselves dukes—was
ever officially invested with the title.

Determined to quash the claim of the duke of Orléans and establish the
Sforza as a princely dynasty, Lodovico began courting Maximilian so that
his title would be legitimate. The emperor was happy to entertain Lodovico's
claim, not least because a year earlier he had married Lodovico's niece, Bi-
anca Maria. The marriage was not a happy one: Maximilian was dismayed
by his bride's habit of eating her dinner on the floor. However, her dowry of
four hundred thousand ducats, paid from Lodovico's coffers, disposed him
to overlook both his wife's table manners and five-year-old Francesco's
claim to the dukedom.[6]

Besides his title, Lodovico was also thinking about the glorification of

his family. Much of his art patronage, not least the bronze equestrian monument to his father, had been aimed at exalting the Sforza name. He now turned his attention to another grand project. The bones of his family members were scattered around various locations in the duchy, sometimes with a singular lack of ostentation. Lodovico's great-grandfather, Giangaleazzo Visconti, who died in 1402, was humbly interred behind the high altar of the Certosa di Pavia, a monastery twenty-five miles south of Milan whose foundation stone he had laid in 1396. Distinguished visitors to the Certosa were sometimes conducted by the monks onto a ladder for a peek at these bodily remains, which one such guest reported "were no sweeter than nature permitted."[7]

Giangaleazzo Visconti had intended the Certosa to be a mausoleum for himself and his family, but the project was curtailed by a lack of funds, a tardy building schedule, and Giangaleazzo's premature death from the plague. In 1494, Lodovico decided to honor his great-grandfather with a more dignified and appropriate sepulcher, hiring a sculptor to carve an effigy of Giangaleazzo and create bas-reliefs on his sarcophagus. Already he had been lavishing attention on the Certosa itself. He engaged an architect to complete the facade and, after sending an agent to Florence in 1490, commissioned altarpieces from Filippino Lippi and Pietro Perugino.

Lodovico was also contemplating his own last resting-place. At some point around 1492 he began planning a Sforza mausoleum for himself and his descendants. The location he selected was the church of Santa Maria delle Grazie in Milan, built between 1468 and 1482 by the grandson of the architect of the Certosa in Pavia. Funds and land for the church, situated on the city's western edge, had originally been provided by one of Francesco Sforza's military captains, but Lodovico assumed the responsibility sometime after his death. In 1492 he began aggrandizing and beautifying the church, knocking down the east end and laying the first stone for a large new extension. Soon afterward he asked his secretary to bring together "all the experts to be found in architecture" to design the church's facade.[8]

Leonardo da Vinci may have been one of these experts. His interest in architecture remained undiminished since his design for the dome of Milan's cathedral had been rejected a few years earlier. At some point he drew up plans for both a tribune and what appears to be a funerary monument.[9] His notebooks allude to conversations with the German masons working on the cathedral, and he once made a note revealing his eagerness to acquire

Bird's-eye view of Santa Maria delle Grazie

a certain book on ecclesiastical architecture: a book "treating of Milan and its churches which is to be had at the last stationer's on the way to Corduso." Not least, he was a close friend of Donato Bramante, an architect who certainly was involved in the rebuilding of Santa Maria delle Grazie.[10] However, Leonardo's involvement was, if anything, minimal. Instead, Lodovico had something different in mind for him.

The church of Santa Maria delle Grazie was part of a complex of buildings making up a Dominican convent: besides the church, there was a sacristy, a cloistered garden, cells in which the friars prayed and slept, and a refectory where they took their meals. These buildings, like the church, were recent constructions and required decoration if they were to be worthy of the Sforza name. Leonardo may have dreamed of constructing tanks and guns, of placing a dome on Milan's half-built cathedral, or of completing the world's largest bronze statue. But he was going to do none of these things. Instead, he was going to paint a wall.

✦

For the previous two centuries, the Dominicans, or the Order of the Friars Preachers as they were officially known, had been, along with the Franciscans, the most active religious order in Italy. They were certainly the most visible. Dominican friars in their distinctive black-and-white habits could

be seen in cities and towns all over Italy, preaching from the pulpits in their churches or to throngs in the piazzas in front of them.

The Dominicans originated early in the thirteenth century, after Dominic, their founder, traveled through the Languedoc region of southern France at the time of the Cathar heresy. Dominic was determined to counter these heretics, against whose austere lives and simple devotion the pomp and bluster of successive popes had fallen flat. He advocated fighting fire with fire: zealous preaching and an ascetic lifestyle. "Zeal must be met by zeal, humility by humility," he famously reproached a trio of richly dressed, self-important papal legates whose latest mission to the Languedoc had failed.[11] In 1217 the pope granted Dominic authority to found his order, calling him and his followers the "invincible athletes of Christ."[12] The Dominicans became the church's spiritual enforcers and, after 1232, the papal inquisitors. When Maifreda Visconti announced that she would be crowned pope in Milan on Easter Sunday in 1300, the Dominicans rooted out her followers, interrogated them, and burned them at the stake. More recently, when four women in Turin were burned as witches in 1494, the inquisitor was a Dominican.[13]

Their eager devotion earned the Dominicans their punning nickname, the Domini canes: the Hounds of the Lord. It was a nickname they embraced. Fresco decorations in their churches, such as in Santa Maria Novella in Florence, sometimes featured packs of black-and-white-spotted dogs. The dogs were an allusion not only to their punning nickname and two-tone habit, but also to the legend of Dominic's mother, who supposedly dreamed, while pregnant, of giving birth to a black-and-white hound bearing a torch in its mouth. "When the dog came forth from the womb," *The Golden Legend* reported, "he set fire to the whole fabric of the world."[14]

The Dominicans did indeed set the world alight, serving as the church's intellectual luminaries. "The bow is first bent in study," stated a Dominican maxim, "and then it sends the arrow in preaching." This emphasis on teaching and learning meant the Dominicans came to occupy the great theological chairs at the universities in Paris, Oxford, and Bologna. By the fifteenth century, two Dominicans had been elected pope, while many others became famous throughout Europe as preachers and writers. The Dominicans also produced the greatest scientist of the Middle Ages, the German bishop Albertus Magnus, known as Doctor Universalis in honor of his extraordinary breadth of knowledge. The greatest Dominican of them all, after Dominic himself, was the Angelic Doctor, Thomas Aquinas,

author of the *Summa theologiae*, a treatise that ambitiously encompasses, in 1.5 million words, "the things which belong to the Christian religion."[15]

Aquinas did not, apparently, look particularly ascetic, since he was tall and fat and enjoyed a good dinner. Dominic, on the other hand, had been exceptionally abstemious. *The Golden Legend* reports that he always gave his body "less than it desired," and that while pursuing his studies in Spain he went for ten years without a glass of wine.[16] Following his example, the Dominicans devoted themselves to lives of prayer, study, and preaching. The life of a Dominican was a severe and exacting one even by the standards of the Middle Ages. They took vows of obedience, chastity, and poverty, and raised their money by begging. From the middle of September until Easter, and on all Fridays throughout the year, they ate only one meal a day. Their clothing was made from scratchy wool, their beds were hard, and they slept in communal rooms. When they traveled, they walked rather than rode, often barefoot, and without carrying money. In order to become one with the sufferings of Christ, they flagellated themselves: one of Fra Angelico's frescoes in the Dominican convent of San Marco in Florence shows a kneeling Dominic dutifully scourging himself before an image of the crucified Christ.

The Dominicans were the most vocal of the religious orders, often preaching to large audiences in the open air of the city. For most hours of the day, however, the friars observed a strict silence, the better to concentrate on their thoughts and studies. Even meals were eaten in silence. The prior of Santa Maria delle Grazie after 1495, Vincenzo Bandello, wrote a work, *Declarationes super diversos passus constitutionum*, which described the ritual according to which the friars took their communal meals. At the prescribed hour, they made their way to the refectory, which was known as the *cenacolo* (from the Latin *cenaculum*, the room in which the Romans dined). First they stopped in a small adjacent room where they washed their hands—the only part of their bodies they ever cleaned (it was believed that bathing relaxed the body and therefore stimulated lust). Then they waited in silence on benches before filing into the *cenacolo* itself, which at Santa Maria delle Grazie was a lengthy, narrow dining hall perpendicular to the church, 116 feet long by 29 feet wide, its perimeter lined with tables. It was an austere and gloomy place, its only windows high overhead on the west wall. The friars would kneel to pray before a crucifix on the far wall before taking their places on the outside of the tables, facing inward. At the back, beneath the crucifix, sat the prior.

After prayers for the blessing of the table, the servers would arrive with food from the monastery kitchen. The fare was of such a humble quality that priors were urged to avoid the temptation to dine outside the monastery, where no doubt they would have enjoyed a better table. Painters working for friars often complained of the appalling diet. Paolo Uccello supposedly fled from a church where he was working after he was given nothing to eat but cheese. Davide Ghirlandaio once dumped soup over a friar and bludgeoned him with a stick of bread to protest the poor quality of the meals provided for him and his brother. Certainly meat was off the menu. Dominic, following the Rule of Saint Benedict, had abstained from flesh, which, like baths, awakened concupiscence: Aquinas explained that pleasurable foods such as meat "stimulate our sexual appetites" and produce a "greater surplus for seminal matter."[17]

The punishment for breaking silence without permission was missing the next meal, though if the prior desired some conversation over dinner he might give one or two friars license to speak. More usually, as the friars ate their meal they listened to one of their number—the person known as the *lector in mensa*, or reader of the table—read aloud from the Bible or another religious text such as *The Golden Legend*, which had been composed by a Dominican. And since the middle of the fourteenth century, friars in some monasteries (and nuns in some convents) could enjoy another stimulus to contemplation as they ate their silent meal. Frescoes were often painted on the refectory walls, and the subject matter—unsurprisingly, given the location—was usually food. Painters sometimes showed Abraham preparing food for the angels (a scene from Genesis 18) or the miracle of the loaves and fishes. The most common scene, though, was the Last Supper, so much so that Last Supper paintings came to be known as *cenacoli*, a reference to the location where they were painted. Monks and nuns therefore had the opportunity, as they broke bread together, to identify with the apostles supping at the table in their own dining room in Jerusalem.

Lodovico Sforza had in mind just such a painting for the refectory of Santa Maria delle Grazie. And so into the midst of the Dominican friars—this band of devout, studious, and abstemious men—came Leonardo da Vinci.

The exact date that Leonardo received his commission to paint a Last Supper in the refectory of Santa Maria delle Grazie is not known. Since the archives of the convent were destroyed, crucial details about the commission have been lost. The most logical scenario is that it was given to him either at the end of 1494 or the very beginning of 1495, in the wake of the lost opportunity to cast the bronze horse. It is not known for certain that Lodovico Sforza rather than the Dominican friars originally engaged Leonardo. However, with his personal interest in the monastery—where, in a show of piety and humility, he dined every Tuesday and Saturday—Lodovico seems the more likely candidate. A few years later, referring to the commission, he made explicit reference to agreements signed by Leonardo.

These agreements were undoubtedly the lost contract. A patron never entrusted an artist to execute a work without first coming to a legal agreement covering such things as the subject matter, the price, the materials, and the deadline. Lodovico would hardly have engaged Leonardo, a dilatory and even unreliable worker whose career was strewn with abandoned projects, without a contract to offer guarantees and concentrate his mind on the task at hand. However, as the men in the Confraternity of the Immaculate Conception had discovered to their cost, not even the most ironclad legal document could keep a painter like Leonardo from improvising or procrastinating.

A commission to paint a wall was not the most obvious assignment for Leonardo. In fact, he was an odd choice for the job. His letter of introduction to Lodovico had stressed in great detail his supposed expertise in military engineering. It concluded with the vague and almost casual remark that he could "carry out . . . in painting whatever may be done, and as well as any other."[18] Bluff and bluster aside, Leonardo truly was, even by 1482, a painter who, properly motivated or inspired, could do as well as any other when it came to portraits or altarpieces. His *Virgin of the Rocks*, painted in the years after he wrote the letter, loudly proclaimed his astonishing talents.

Yet Leonardo did have a particular limitation when it came to painting. His teacher, Verrocchio, had been a master of many accomplishments, able to work in marble, brass, bronze, and copper. However, Verrocchio's experience of painting was confined to working with tempera on wooden panels—and even his work in this area was sparing. Most altarpieces and portraits were still done in tempera. The panel was constructed from a series of glued-together planks, often poplar wood, that were then coated with layers of glue size and a gypsum-based primer. The tempera (from the Latin *temperare*,

to mix) was made by blending powdered pigments with a liquid binder, usually egg yolk. In order to keep the paint wet longer, artists sometimes added honey or the juice from the fig tree, and the viscosity of the paint could be lessened with the addition of vinegar, beer, or wine.

Paintings done on the walls of chapels or refectories were generally done not in tempera but in the special technique known as fresco. Despite his versatility, Verrocchio never painted in fresco and therefore, presumably, never passed along its secrets to Leonardo. Nor had Leonardo ever worked in fresco. Patrons commissioning frescoes during Leonardo's time in Florence in the 1470s and early 1480s had turned to painters such as Sandro Botticelli and Domenico Ghirlandaio. The latter was an especially enthusiastic and prolific frescoist. A report prepared by an agent for Lodovico Sforza, who tried to hire Ghirlandaio to paint at the Certosa di Pavia, declared that he was "a good master on panels and even more so on walls . . . He is an expeditious man and one who gets through much work."[19]

The word "expeditious" could not be used to describe Leonardo. His lack of experience in fresco—as well as, perhaps, a reputation for not finishing what he started—may have been a factor in his absence from the team of young painters sent to Rome by Lorenzo de' Medici in the summer of 1481 to fresco the walls of the newly constructed Sistine Chapel. The members of this team, which included Botticelli and Ghirlandaio, had far more experience in fresco than Leonardo.

Fresco was renowned as the most difficult painting technique to master. Vasari claimed most painters could become adept in tempera or oil, but only a select few mastered fresco, which was, he declared, "the most manly, most certain, most resolute and durable of all the other methods."[20] The word "fresco" comes from the Italian *affresco*, whose root, *fresco*, means "fresh": an allusion to the fact that the frescoist, rather than mixing his pigments with binders, ground them in water and added them to wet plaster, which absorbed them as it dried, uniting with them chemically and thereby sealing them in a vitreous layer on the wall's surface.

The technique was ingenious and, as Vasari pointed out, durable. However, it presented many logistical difficulties, not least because the frescoist often worked on a large scale, sometimes high up in a building and in an awkward location. Also, the frescoist had only a very limited number of hours to apply his paints to his daily patch of fresh plaster before it dried, which forced him to work quickly. Finally, he was restricted in his range of

colors, able to use only those pigments that could withstand the alkalinity of the plaster. Many of the brightest blues and greens—ultramarine, azurite, malachite—could be added only if they were mixed with binders and then applied to the plaster after it dried. This supplementary technique, known as painting *a secco*, had the disadvantage that tempera added to dry plaster was much less durable than water-based pigments added to a wet surface. Most patrons therefore preferred artists to avoid painting *a secco*. Filippino Lippi's contract with the banker Filippo Strozzi for a fresco cycle in the Strozzi Chapel in Santa Maria Novella, begun in 1487, had stipulated, for example, that the artist work exclusively in fresco.

Not only did Leonardo have no experience in the exacting technique of fresco, but he also had never worked on such a large painting. After abandoning several altarpieces unfinished, he was suddenly charged with covering the north wall of the refectory with a painting fifteen feet high by almost twenty-nine feet wide.

Painting the wall of the refectory was a major commission, especially because (as seems to be the case) it came from the duke. Yet it seems possible that Leonardo balked at this commission. His fragmentary letter of frustration to Lodovico—in which the staccato phrases included "things assigned," "not my art," and "if any other commission"—may well have concerned this new assignment at Santa Maria delle Grazie. Although he complained in the letter about his expenses and a lack of payment, his protests were actually less about the equestrian monument ("Of the horse I will say nothing") than about some other matter that distressed him. In another fragmentary letter, written to Lodovico a short time later, Leonardo complained of being compelled to do lesser jobs for the duke rather than another commission, evidently more important, presumably the equestrian monument. "It vexes me greatly," he wrote, "that having to earn my living has forced me to interrupt the work and to attend to small matters, instead of following up the work which your Lordship entrusted to me."[21]

Was decorating the refectory of Santa Maria delle Grazie one of the "small matters" Leonardo found himself obliged to execute in lieu of either the bronze horse or another commission? His disappointment at forfeiting the bronze horse would have been compounded by the fact that he was suddenly given a project for which he lacked the necessary specialist expertise. On top of that, the mural commission was a poor replacement. It is unclear where Lodovico intended the equestrian monument to stand, but it would

certainly have been placed in a highly prominent location, possibly the piazza in front of the Castello: somewhere, in any case, where everyone in Milan (and everyone who visited Milan) would see it. But with that project withdrawn, Leonardo was presented with the task of decorating a tucked-away room where a band of friars ate their dinner.

If Leonardo's angry letters represented attempts to avoid the mural project, they were unsuccessful. He must soon have realized that keeping favor with the devious Il Moro meant acquiescing to his wishes. He probably also recognized that the mural represented an opportunity to exercise his talents in painting on a grander scale than ever before.

The year 1494—the "most unhappy year for Italy"—ended with King Charles VIII and his French troops inside the gates of Rome. Charles had stayed for eleven happy days in Florence, occupying the Medici palace and making a series of architectural modifications, adding various passageways so he could slip discreetly away to visit his latest mistress. After leaving Florence, he had moved south to Siena and then Viterbo. From there he turned his attentions to Rome, issuing a proclamation in the middle of November stating that he merely wished for free passage through Roman territory. But he was "every day becoming more insolent," according to Guicciardini, "as a result of successes much greater than he had ever dared to hope."[22] Even the king's allies were chastened by his effortless triumphs, with both Lodovico Sforza and the Venetian Senate fearing French ambitions in Italy would not be satisfied with the conquest of Naples.

Rome and its surrounding territories, known as the Papal States, were ruled by the pope, who was not only a spiritual leader but also a secular ruler with powers of taxation and legislation over a million people. Charles made strong hints that he would depose the reigning pope, Alexander VI, a worldly man with a well-earned reputation for corruption and dissipation, should His Holiness not accommodate his requests for the keys to castles and the crown of Naples. As the French began their march on Rome, Alexander began suffering fainting fits. He had originally declared for Naples in the conflict, stating that he was bound to Alfonso "by the closest ties of blood and friendship" and vowing to defend him against the invaders.[23] But now he vacillated between defiantly resisting the French—he claimed he would rather

die than become the slave of the French monarch—and then meekly pondering whether he should seek terms. He remained undecided as French troops entered Roman territory and began overrunning one town after another. They even captured his fleeing mistress, Giulia Farnese, on the road outside Rome.

In Rome itself, the people, anxious for the pope to appease the French, were in a state of terror and rebellion. Rome was threatened with starvation as the French fleet, blockading the Tiber, prevented the provisioning of the city. The privations were especially hard on the priests, who, according to a cynical Venetian observer, were "accustomed to every delicacy."[24] The pope, closeted in the Vatican with his Spanish bodyguards, began preparing to flee the city, even packing up his bed linen and dinner service. Finally, "observing this young prince advance so briskly" (as one of Charles's ambassadors wrote), the pope decided to open the gates of Rome.[25]

Charles originally planned to enter Rome on the first of January, but when his astrologer informed him that a more favorable conjunction of the planets would occur one day earlier, he rode through Rome's northern gate, the Porta del Popolo, on the last day of 1494. It took six hours for the French soldiers, along with Swiss and German mercenaries, to stream through the gate behind him. They were followed over the cobbles and through the puddles by thirty-six bronze cannons: a deadly reminder of what awaited the Romans should they try to resist.

The barbarians were within the gates of Rome. "In all the memory of man," lamented an envoy from Mantua, "the Church has never been in such evil plight."[26]

CHAPTER 4

Dinner in Jerusalem

L eonardo would have known the story of the Last Supper from various
painted versions of it in Florence. He would also have known it from
the Bible, a copy of which appeared in a list of books in his possession that
he made in the mid-1490s. Intriguingly, this was probably the copy that he
bought, according to another of his memoranda, in late 1494 or early 1495,
at exactly the time when he was starting his work in Santa Maria delle Gra-
zie. His Bible was almost certainly the well-known and widely available
Italian translation, Niccolò di Malermi's *Biblia volgare historiata*, first published
in Venice in 1471 and available in ten editions (complete with hundreds of
woodcut illustrations) by the early 1490s. Leonardo appears to have acquired
this Bible with the express purpose of making a study of the Gospel ac-
counts of the Last Supper.[1]

Leonardo could have read in his new Bible four individual versions of the
Last Supper, including two eyewitness accounts. The authors of the four
Gospels—Matthew, Mark, Luke, and John—each provided his own narra-

tive. As with other episodes in the life of Christ, there are strong parallels in the first three accounts, whose works are known as the synoptic Gospels. They include many of the same events, often told in the same order and with similar phrasing—resemblances that lead scholars to believe they were composed interdependently. Although differences exist between and among the authors of the synoptic Gospels on specific details of the Last Supper, Matthew, Mark, and Luke are more in accord with one another than they are with John, whose Gospel offers considerably more information on various points. There are no real contradictions, only a difference in emphasis, levels of detail, and the orders of certain events.

The two eyewitnesses who wrote accounts of the Last Supper were Matthew and John. Matthew's was consistently regarded as the earliest of the four Gospels, hence its position at the beginning of the New Testament. Matthew was one of the select group of followers known as the apostles: the twelve men whom Christ, after climbing a mountain in Syria, called to a special mission to preach with him. "And he gave them power to heal sicknesses," reports the Gospel of Mark, "and to cast out devils" (Mark 3:15). The apostles were present during Christ's triumphant entrance into Jerusalem on the back of a donkey, and they were not only participants in the Last Supper but also witnesses to both the Resurrection and, forty days later, the Ascension, when Christ rose through a cloud into heaven. Christ's last words to his apostles were an injunction: "But you shall receive the power of the Holy Ghost coming upon you, and you shall be witnesses unto me in Jerusalem, and in all Judea, and Samaria, and even to the uttermost part of the earth" (Acts 1:8). Writing the Gospels was part of this mission of witnessing to the wider world.

In the synoptic Gospels, accounts of the Last Supper begin immediately after Judas goes to the high priest and strikes the deal to betray Christ, whose powers the priests and the Pharisees resent and fear.[2] Matthew alone enumerates Judas's fee as thirty pieces of silver, with Mark and Luke merely noting that the high priest and his cronies agreed to give him an unspecified sum. John, on the other hand, makes no mention of a financial motive. Instead, he provides Judas with quite another reason for betraying Christ.

Passover is approaching: the festival in which the Jews ritually slaughter and eat a male lamb to commemorate their deliverance from the avenging angel and their liberation from captivity in Egypt. The apostles ask Christ where they should prepare for the feast. According to Matthew, Christ

instructs them to locate "a certain man" in the street in Jerusalem and say to him: "The master says, My time is near at hand." Mark and Luke add the detail that this stranger can be recognized because he will be carrying a pitcher of water. "Follow him," Mark reports Christ as telling them. "And wherever he shall go in, say to the master of the house, The master says, Where is my refectory, where I may eat the pasch with my disciples? And he will show you a large dining room furnished."

When evening falls, Christ sups with his apostles inside this large dining room. The supper takes place either on the feast of the Passover or, in John's account, during preparations for it (he makes clear that the meal is prior to the actual festival). In any case, the Crucifixion that follows is symbolically linked—especially in Luke and John—to the slaughter of lambs for the feast. This striking parallel emphasizes how the lamb sacrificed by the Jews to save their firstborn from the Egyptians prefigured the "Lamb of God" who redeemed the world through his own sacrifice.

In their wonderfully lapidary styles, the synoptic Gospels describe what happens during the meal, albeit with varying orders of events. Matthew reports that while they are eating Christ says, "Amen I say to you that one of you is about to betray me." The apostles, deeply troubled by the announcement, ask, "Is it I, Lord?" To which Christ responds, "He that dips his hand with me in the dish, he shall betray me." When Judas inquires if Christ is referring to him, Jesus calmly replies, "You have said it."

Following swiftly on the heels of this revelation comes the institution of the Eucharist. "Take and eat," Christ tells them as he breaks the bread. "This is my body." Taking the chalice, he gives thanks and says: "Drink all of this. For this is my blood of the new testament, which shall be shed for many unto remission of sins." Matthew includes the charming detail that the meal ends with Christ and the apostles singing a hymn together.

Mark follows Matthew very closely, likewise placing the announcement of the betrayal immediately before the institution of the Eucharist. Luke, on the other hand, reverses the order of the two events. In his version, Christ breaks the bread and shares the wine before making the announcement of the betrayal. The communion appears to be under way, in fact, when Christ startles them with his dramatic declaration. "This is the chalice, the new testament in my blood, which shall be shed for you," he tells them before immediately adding, "But yet behold: the hand of him that betrays me is with me on the table." The apostles then begin to "inquire among themselves"

who could do such a thing. However, in Luke's account the apostles are actually more concerned with something else, because there is suddenly "a strife amongst them" about who is the greatest. Luke provides no description of Judas dipping his hand in the same dish as Christ, and in fact during the meal Judas is never identified as the traitor, though Luke has earlier noted his treacherous dealings with the priests and magistrates.

John's account of the events is somewhat different from the preceding Gospels. His was the last of the Gospels to be written down. The fourth-century historian Eusebius claimed that Mark and Luke had already composed their Gospels when John, who had been proclaiming his Gospel orally, decided to supplement their accounts with more details about Christ's early ministry.[3] His account of the Last Supper is likewise more detailed, though in his version the supper itself—which is clearly not the Passover meal—is finished very quickly. When the meal is over, Christ rises from the table, girds himself with a towel, and (despite the protests of Peter) shows his humility by washing the feet of the apostles: an episode not mentioned in the other Gospels. His washing of their feet provides the occasion for his first (metaphorical) announcement of the betrayal: "You are not all clean," he says meaningfully. He then suggests that they ought in the future to wash one another's feet, before making his point once again: "He that eats bread with me shall lift up his heel against me." Soon afterward, troubled in spirit, Christ suddenly makes his point more frankly and unambiguously: "Amen, amen, I say to you, one of you shall betray me."

These words echo those of the other Gospels, but John adds some of the most brilliantly dramatic passages in the entire Bible. As in the other Gospels, there is initially some confusion, consternation, and self-scrutiny as the men turn to one another, "doubting of whom he spoke." John then provides further information about the responses. Leaning on Christ's bosom is "one of his disciples, whom Jesus loved." Modesty forbids John from identifying this beloved disciple, who is mentioned several more times in the chapters that follow, but it is John himself who becomes known through these references as the "beloved disciple." "For this same St. John the Evangelist is he whom Jesus specially loved," explained St. Augustine, "inasmuch as he lay on His Breast at supper."[4]

The bewildered apostles demand clarification. Typically, it is Peter—blunt spoken and bighearted—who asks John, still leaning on Christ's breast: "Who is it of whom he speaks?" John asks on behalf of the others: "Lord,

who is it?" Christ offers the same reply as in the first two Gospels: "He it is to whom I shall reach bread dipped"—whereupon he dips the bread into the dish and hands the sop to Judas.

At this point John introduces an element entirely absent from the first two Gospels and only alluded to in passing by Luke. Before describing the Last Supper, Luke mentions how, as the high priest and the scribes debated how they might put Jesus to death, "Satan entered into Judas," who then approached them with his promise to deliver Christ into their hands. John's account is more elaborate. Unlike the others, he does not mention that Judas has already been involved in treacherous dealings with the high priest. If he has not made his traitorous bargain, then Judas must be as baffled as the others by the accusation of betrayal and then—even more—by the presentation to him of the dipped bread. John has firmly made the point that Judas is a bad sort, claiming in the previous chapter that he is a thief who has been filching from the communal purse with which Christ entrusted him. Even more obviously, John shadows forth the betrayal when he describes how Christ, a full year earlier, addressed his newly selected apostles with the words: "Have not I chosen you twelve? And one of you is a devil." Lest there be any doubt about the culprit, John hastily adds, "Now he meant Judas Iscariot, the son of Simon, for this same was about to betray him." There is certainly a strong foreshadowing of coming events, but no mention by John, at the time of the Last Supper, of any perfidious dealings with Christ's enemies.

A notable difference between John's version of the Last Supper and that given in the synoptic Gospels is that John makes no mention of the institution of the Eucharist. Elsewhere, however, his Gospel abounds in reflections on the Eucharist. He explicitly mentions, in his account of the Passover feast one year earlier, the prospect of salvation through the body and blood of Christ. Following the miracle of the feeding of the five thousand, Christ tells the grateful multitude that he is "the bread of life" and that anyone who "eats my flesh and drinks my blood abides in me, and I in him" (6:48, 56). This statement causes shock and consternation, with even Christ's closest adherents finding the proposition difficult: "This saying is hard," they candidly admit. Indeed, as John reports, many of his disciples "walked no more with him." One of the disciples who deserted him was, apparently, Mark, which explains why he was not present at the Last Supper a year later.

In John's account, Christ does not distribute the "bread of life" at the

Last Supper. Instead, he offers only the single piece of dipped bread, which Judas then eats. Judas's act of consuming the bread received from Christ's hand turns the scene into an unholy counterpart to the Communion because, as John says, "after the morsel, Satan entered into him." Christ then addresses Judas directly: "That which you do, do quickly." Confusion reigns once again. This injunction puzzles the other apostles as much as his earlier statement about the betrayal, with some of them mistakenly thinking Christ has just charged Judas, as holder of the communal purse, with the task of buying things necessary for the upcoming Passover feast.

Judas, however, now knows exactly what Christ means, and what he must do, and he quickly disappears into the night. He will reappear several hours and five chapters later, with a band of soldiers and servants from the high priest and the Pharisees armed with "lanterns and torches and weapons." The stage is set for the next dramatic act.

Leonardo would have seen a number of representations of the Last Supper in and around Florence. Artists throughout Europe had been visualizing this biblical episode for more than a thousand years. One of the oldest surviving examples is a mosaic from the basilica of Sant'Apollinare Nuovo in Ravenna, done in the first half of the fifth century as part of a cycle showing scenes from the life of Christ. Over the ensuing centuries, the Last Supper was depicted in illuminated manuscripts, carved in ivory and stone, woven into tapestries, and at the cathedral in Chartres in the middle of the twelfth century it appeared in a beautiful stained-glass window.

The vast majority of these representations followed the Gospel of St. John inasmuch as they showed the tender vignette absent from the synoptics: John reclining on Christ's bosom. However, much artistic license was enjoyed. The scenes sometimes told as much about contemporary dining habits as they did about the Bible. Byzantine scenes, such as that in Ravenna, often conjured up a luxurious banquet with aristocratic-looking figures reclining on a *sigma*, a horseshoe-shaped couch, and leaning their elbows on bolsters (this was the way the Romans ate: dining chairs were a later invention). A Last Supper at Naumburg Cathedral, carved from stone in about 1260, showed the other end of the social spectrum: what looks like a group of uncouth and guzzling peasants.

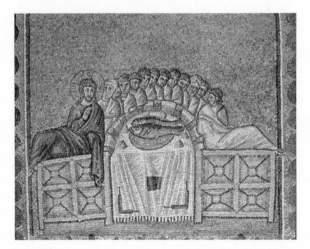

Mosaic of the Last Supper in the basilica of Sant'Apollinare Nuovo in Ravenna

Scenes of the Last Supper became ever more plentiful and conspicuous in fourteenth-century Italy, especially in the newly rediscovered medium of fresco. It was usually included as part of a Passion Cycle or scenes illustrating the life of Christ, but by the middle of the fourteenth century the episode was sometimes removed from this context and given a new prominence in a particular location: the refectories of convents and monasteries. Thus the nuns or friars would have sat at a table directly beneath a fresco of the apostles at their own table in Jerusalem. Last Suppers henceforth became common in—but by no means limited to—the refectories of monasteries.

One of the finest examples of a Last Supper in a refectory setting came in the middle of the fifteenth century. A community of cloistered nuns, the Benedictine sisters in the convent of Sant'Apollonia in Florence, commissioned Andrea del Castagno, sometimes known (because of his series of paintings of conspirators executed by the Medici) as Andreino degli Impiccati, or Little Andrea of the Hanged Men. He created in the nuns' refectory a near-perfect illusion of three-dimensional space, a boxlike extension of the refectory that allowed the nuns—in what was becoming a familiar opportunity—to eat their meals in the realistic presence of Christ and the apostles. In Castagno's version, the scene is a pacific one. John leans sleepily against Christ while the other apostles talk calmly among themselves or sit alone with their thoughts. The apostle who sits third from the left stares

contemplatively into space, while the one second from the right even has a book propped open on the table.

Leonardo probably never saw Castagno's *Last Supper*. Its location in a convent of enclosed nuns meant that for four hundred years, until the dissolution of Sant'Apollonia in the 1860s, very few people outside this small religious community ever set eyes on it (and it was fortunate to survive the convent's stint at the end of the nineteenth century as a storage facility for the Italian military). However, Leonardo would certainly have seen several others in Florence, including another Last Supper (now lost) that Castagno painted in the hospital of Santa Maria Nuova. Domenico Ghirlandaio—that "expeditious man" who completed so much work—painted two Last Suppers during Leonardo's final years in Florence, one in 1480 for the Umiliati monks at the Church of the Ognissanti, and another two years later in the guest refectory in San Marco. These, too, were scenes of calm discussion and, in the case of one or two of the apostles, impassive daydreaming. Ghirlandaio gave his figures slightly more interaction movement than Castagno, especially in the Ognissanti fresco, where several heads lean intently forward and Peter purposefully grips his knife. Like so many other artists, he showed John leaning on the bosom of Christ, an indication that like them he was following the account given in John's Gospel.

There was a good reason why Castagno and Ghirlandaio, among others, interpreted the Last Supper—which the Gospels reveal to have been a

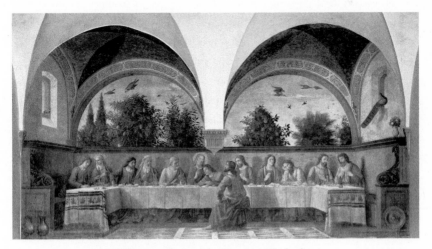

The Last Supper *by Domenico Ghirlandaio*

mise-en-scène of agitation and puzzled astonishment—as a scene of tranquil reflection. Convents and monasteries were places of silence. The importance of silence was stressed in the cloister of San Marco, where the first image that greeted friars and visitors alike was Fra Angelico's fresco of Peter of Verona with his finger to his lips. Silence was preserved in the cloisters, the church, and the dormitory. To keep the friars on their toes, each convent had an officer, the *circator*, whose job was to move quietly among the brothers "at odd and unexpected moments" to see if they were growing slack.[5]

The nuns enclosed in Sant'Apollonia inhabited this same world of silence and meditation, and the refectory where Castagno did his work was meant to be a still and quiet room. The rules observed by Benedictines stressed that meals in the refectory were to be taken in silence but for the voice of the person reading the sacred text: "During meals," wrote Saint Benedict, "there should be complete silence disturbed by no whispering, nor should anyone's voice be heard except the reader's."[6] Castagno probably showed a book-reading apostle (who wears a notably cross expression) as a reflection of the nun who would have been reading aloud to the other sisters. His quiet and pensive dinner table promoted the way the enclosed nuns of Sant'Apollonia were expected to behave both in the refectory and in their strictly cloistered lives more generally.

A Last Supper was never an easy proposition, even on spacious refectory walls. The artist had somehow to fit around a table thirteen separate figures through whom he would illustrate either the moment when Christ instituted the Eucharist or announced, to general incomprehension, that one of the number would betray him. Painters like Castagno and Ghirlandaio had created compelling scenes through a subtle choreography of hands and expressions, ones that duplicated the hushed and reflective mood prevailing in the refectories.

Leonardo, however, probably saw in these delicate gestures and gently furrowed brows few tokens of the exuberant life that he himself hoped to capture in his own art. He also would have glimpsed little of the drama that he would have read about in the Bible's version of these events. The story is, after all, extraordinarily emotive. Thirteen men sit down to dinner to observe a solemn feast: a charismatic leader and his band of brothers, carefully selected and endowed with special powers. They are gathered in the middle of an occupied city whose authorities are plotting against them, waiting for their moment to strike. And in their midst, breaking bread with them, sits a traitor.

This was not a scene to which tapestries or stained-glass windows could do justice, or one that might provoke quiet and unruffled contemplation. Something else was called for.

Perhaps no one in history ever drew so much as Leonardo, or felt such a compelling need to record on paper everything he saw. His unrelenting activity was described by one source who claimed that whenever Leonardo went for a walk he tucked into his belt a little sketchbook in whose pages he could register "the faces, manners, clothes and bodily movement" of the people he saw around him.[7] Close observation of people going about their daily business—and then capturing their features and postures as accurately and realistically as possible—was essential to Leonardo's art. In one of his notes he urged would-be painters to "go about, and constantly, as you go, observe, note and consider the circumstances and behaviour of men in talking, quarrelling or laughing or fighting together."[8]

The sight of an artist studying and sketching his fellow citizens in the marketplace or public square would have been quite unusual. Artists normally found models for their paintings in their own workshops, simply arranging their apprentices in the desired poses. Alternatively, they took postures and facial expressions from sculptures, from previous paintings, or from model books that helpfully provided details of how the body moved and looked in various poses. Leonardo, however, considered it an "extreme defect" for a painter to copy the poses or faces used by another artist.[9] He therefore took his studies out of doors and into the open air, where he could observe how real people moved and interacted.

For many years Leonardo had lived in a city—Florence—whose exuberant street life allowed him ample opportunity to witness this kind of stimulating activity. One of his contemporaries called Florence the "theatre of the world."[10] Florentines gathered to socialize in the streets and piazzas, and on bridges such as the Ponte Vecchio. Songs and skits were performed in the open air during the Carnival, and in the piazzas teams of men, twenty-seven per side, played games of *calcio*, a violent and primitive version of football. Florence's marketplace was a hive of activity. The poet Antonio Pucci described it as a world in itself, a place of spice merchants, butchers, money-lenders, ragmen, gamblers, and beggars. Also on the scene were female

vendors "who quarrel all day long . . . swearing badly / and calling one an-other whores."[11] The other women to be seen in Florence's streets were the whores themselves, who were required by law to wear long gloves, high-heeled slippers, bells on their heads, and a yellow ribbon.

One particular aspect of Florentine city life that seems to have intrigued Leonardo was the phenomenon known as the *sersaccenti delle pancacce* (know-it-alls of the benches).[12] These were the men from all walks of life who sat and gossiped on the many stone benches lining Florence's streets, piazzas, and even the base of Giotto's campanile and the facades of the great palazzos. One of the most prominent locations was the *ringhiera*, a stone platform (from which we get the word "harangue") that was added to the Palazzo Vecchio in 1323 so the city fathers could address the populace. The discussions by the know-it-alls occupying these benches were sometimes impressively learned. The scholar and diplomat Giannozzo Manetti supposedly learned to speak Latin merely by eavesdropping on particularly erudite conversations, while men sitting on the benches in front of the Palazzo Spini once appealed to Leonardo for help explicating a passage of Dante. For the most part, though, the conversation was less edifying. A song from 1433 began: "Who wants to hear lies or little stories, come to listen to those who stay all day long on the benches." Another writer lamented that the people on the benches were repositories of "envy and suspicion, enemies of all good."[13]

Leonardo was intrigued by the pictorial possibilities of Florence's gossiping bench sitters. He must have walked through the streets, notebook in hand, watching the gestures and expressions of these men as they went about their "talking, quarrelling or laughing or fighting together." He was fascinated with the interplay between and among people, such as when one person spoke and others listened: something he could have witnessed whenever speeches or announcements were made from the *ringhiera*. One of his memoranda considered how to depict a scene where one man addresses a group. "If the matter in hand be to set forth an argument," he wrote, "let the speaker, with the fingers of the right hand hold one finger of the left hand, having the two smaller ones closed; and his face alert, and turned towards the people with mouth a little open, to look as though he spoke." As for the audience, they should be "silent and attentive, all looking at the orator's face with gestures of admiration," with the older men depicted "sitting with their fingers clasped holding their weary knees" or else, with legs crossed, supporting their chins in their hands."[14]

Leonardo's sketches of men in public conversation in Florence

Leonardo reproduced these dynamics of speaking and listening in some of his sketches. In about 1480, around the time he began his *The Adoration of the Magi*, he made a small sketch of three figures seated on a bench. The trio's postures are interesting. The man in the center, a *penseroso*, cups his chin in his right hand and his right elbow in his left hand, while two seated figures on either side lean close as if in commiseration; the man on the right puts a comforting arm around his downcast friend.[15] Similar drawings followed as he produced a series showing seated men in animated conversation striking casual and artless poses. Some of these might have been done as studies for his *Adoration of the Magi*, since all date from the early 1480s. Leonardo certainly planned a hubbub of movement and incident for his painting. His unfinished work shows an energetic jumble of figures tightly grouped in a horseshoe around the Virgin and Child: kneeling, clutching, contorting, and gesticulating as they press forward for a view.

As Leonardo made one of his sketches, another scene took shape in his mind. On the reverse of one of his drawings for figures in the *Adoration* he sketched several groups of figures, most seated and either listening or holding forth in conversation. Although some of these figures, too, may have been destined for the *Adoration*, Leonardo's imagination took him elsewhere.

On the lower right-hand side of the page he loosely sketched five men sitting together on a bench. The man in the middle holds passionately forth, grasping the hand of one companion while thrusting a finger at another. His friends either listen intently, attempt to interrupt, or—in the case of the figure to his left—dreamily ignore him.

The scene is one Leonardo could easily have witnessed on the benches around Florence. But the act of drawing these seated figures in lively interaction appears to have sparked something in his mind. The lower left of the page features a lone figure, bearded and seated at a table, who is drawn to the same scale as the bench sitters. As he turns to his left he points to (or reaches for) a dish that sits in front of him. He is unmistakably a Christ figure, and the dish is unmistakably the one in which—as numerous other artists had shown before—Christ dips the sop he will give to Judas, identifying him as the betrayer. Leonardo's animated bench sitters clearly reminded him of the apostles in a Last Supper.

By the early 1480s Leonardo therefore began examining—in no more

Leonardo's sketch of five men seated on a bench

than a few deft flicks of his quill pen—how he might show Christ and his apostles gathered around the table at the moment Christ announces the impending betrayal. His interest in the spirited exchanges meant the subject had a natural appeal to him, and the brio he gives their movements and expressions suggests that he wished to surpass the versions he had seen in Florence.

Nothing indicates that Leonardo was commissioned to paint a Last Supper in Florence in the early 1480s. His sketch was merely a prototype—impulsive and possibly soon forgotten. A dozen years would pass before the opportunity came to transform his vivacious bench sitters into something new and extraordinary.

One indication of how Leonardo began thinking about composing his *Last Supper* for Santa Maria delle Grazie is found in the pages of a small notebook begun in the early 1490s. Almost uniquely for the time, he sometimes planned his paintings (or works he hoped to paint) not only by means of sketches but also through meticulous descriptions of what a particular scene could or should look like. Often the scenes described are ones of tumult—battles, storms, floods, and fires—that go beyond sets of instructions to would-be painter and become horrifying visions of mankind's helplessness before the lethal energies of a chaotic nature. However, his primary concern was always the realistic depiction, based on actual observation, of gesture and expression.

For example, his prescription for a battle scene involved arrows and cannonballs flying through the air and soldiers "in the agonies of death" rolling their eyes and grinding their teeth, with his dedication to persuasive verisimilitude extending to instruction on how the nostrils of the defeated troops must be depicted.[16] A passage on how to paint a flood resembles the screenplay for a disaster movie: mountains topple into valleys, water foams over farmland carrying a detritus of boats and bedsteads, and terrified people cluster on hilltops and fight with animals (including lions) for the few spots of dry land. He imagines many people committing suicide to escape the horror of the waves: "Some flung themselves from lofty rocks, others strangled themselves with their own hands, others seized their own children and violently slew them at a blow. Some wounded and killed themselves with their own weapons."[17]

Leonardo's small notebook provided equally detailed directions for how to make a scene such as a Last Supper convincing. On one page he offered a blow-by-blow account of the individual reactions at a dinner table to a speaker (not identified in the text with Christ). The page has no accompanying drawings that might specifically identify it as a description of a Last Supper, and the gestures of eleven rather than twelve men are described. Nonetheless, the context is self-evident:

> One who was drinking and has left the glass in its position and turned his head towards the speaker. Another, twisting the fingers of his hands together, turns with stern brows to his companion. Another with his hands spread open shows the palms, and shrugs his shoulders up his ears, making a mouth of astonishment. Another speaks into his neighbour's ear and he, as he listens to him, turns towards him to lend an ear, while he holds a knife in one hand, and in the other the loaf half cut through by the knife. Another who has turned, holding a knife in his hand, upsets with his hand a glass on the table. Another lays his hand on the table and is looking. Another blows his mouthful. Another leans forward to see the speaker shading his eyes with his hand. Another draws back behind the one who leans forward, and sees the speaker between the wall and the man who is leaning.[18]

Painting for Leonardo was all about capturing the small and telling details of the kind he recorded, according to legend, in the sketchbook at his belt—in particular, facial expressions and bodily movements. In his treatise on painting he claimed that the artist had "two principal things to paint: that is, man and the intention of his mind. The first is easy; the second difficult, because it has to be represented by gestures and movements of the parts of the body."[19] This passage shows how he smoothly translated his observations into the context of a Last Supper. He outlined the distinctive reactions of these participants in terms of both their physical actions (lifting or upsetting a glass, holding a knife, recoiling backward, or leaning forward) and their facial expressions (furrowed brows, shaded eyes, and the *bocca della maraviglia*, or mouth of astonishment). He froze the moment in time so the spectator would see the dinner guests in midgesture, with the loaf of bread "half cut through" and the drinking glass still at the lips. The effect, as he planned it here, would impress itself on the viewer through actions

and expressions ranging across a whole gamut of emotions, such as anger, amazement, and bewilderment—all communicated to the viewer through a language of gesture.

This dinner table scene would not be a solemn and meditative tableau such as that frescoed by Castagno for the nuns of Sant'Apollonia. Instead, it would capture all of the drama and excitement of the Gospel verses on the Last Supper.

CHAPTER 5

Leonardo's Court

Soon after receiving his commission for the mural in Santa Maria delle Grazie, Leonardo would have begun work in his studio, making a series of sketches. His studio—in which the clay model of the giant horse still loomed—was appropriately grand for a *pictor et ingeniarius ducalis*. In his notes Leonardo advised painters to have a small rather than a large studio: "Small rooms or dwellings discipline the mind, large ones weaken it."[1] There was often a gap, however, between what Leonardo wrote and what he did. Rather than a small studio, he occupied spacious rooms in a castle.

Leonardo's studio and living quarters were found in the Corte dell'Arengo, which was sometimes known as the Corte Vecchia, or "old court." It had been home to the Visconti rulers of Milan before—toward the end of the fourteenth century—they moved across the city to their massive new fortress, the Castello di Porta Giovia. The Corte dell'Arengo stood in the very heart of Milan, immediately south of the half-built cathedral, onto whose

piazza its gates opened. It was a medieval castle, complete with towers, courtyards, and moats. After the Viscontis decamped, it fell into a state of dilapidation until in the 1450s the architect Filarete "restored it to health" (as he boasted) "without which restoration it would soon have ended its days."[2] Francesco Sforza moved his court into the renovated palace, and at his command the walls were frescoed with portraits of ancient heroes and heroines. Following Francesco's death in 1466, his son Galeazzo Maria took possession, hosting sumptuous banquets and pageants there before, like the Viscontis before him, moving his court to the Castello di Porta Giovia. Lodovico, too, preferred the grand fortress of the Castello (which in time would come to be known as the Castello Sforzesco). The Corte dell'Arengo was therefore surplus to ducal requirements, and Leonardo, needing a large space in which to work on his equestrian monument, was given rooms there in the late 1480s or early 1490s. *La mia fabrica,* he called it: my factory.[3] Here, possibly in one of the courtyards or the great hall itself, he raised his twenty-four-foot-high clay model.

The Corte was both lavish and commodious. Yet it must have been a gloomy place through whose corridors stalked the ghosts of the mad, tragic Visconti tribe, such as Luchino, poisoned by his third wife in 1349, or Bernabò, poisoned by his nephew in 1385, or even Francesco's wife, Bianca Maria, poisoned (according to gossip) by Galeazzo Maria in 1468. Adding to the bleak air of ill omen was the fact that the Corte had been for extended periods the quarters of the usurped Giangaleazzo and his angry, anguished wife, Isabella. Theirs had not been a happy home. "There is no news here," one Milanese courtier wrote to an envoy in Mantua in 1492, "saving that the Duke of Milan has beaten his wife."[4]

Leonardo would have ushered inside the forbidding walls of the Corte dell'Arengo a much livelier spirit. When not promoting the virtues of a small studio, his writings celebrate the painter's atelier as a place of culture and refinement. His notes for a projected treatise on painting describe a "well-dressed painter"—probably an idealized version of himself—who adorns himself with "such garments as he pleases" as he works away at his art. "His dwelling is full of fine paintings, and is clean and often filled with music, or the sound of different beautiful books being read, which are often heard with great pleasure."[5] A lover of books and music, Leonardo may well have stocked his studio with readers and musicians, and he himself probably

played the lyre and sang. Vasari claimed that Leonardo employed "singers and musicians or jesters" as he worked on the *Mona Lisa*: hence, he claims, her famous smile, which is one of contented amusement.[6]

In his advice to young painters, Leonardo extolled of the benefits of living an isolated life. The painter or draftsmen, he insisted, needed to be solitary: "While you are alone you are entirely your own master, and if you have one companion you are but half your own."[7] However, Leonardo was far from solitary in his quarters in the Corte dell'Arengo, since he always had a team of assistants living and working with him, much in the same way that he and his fellow apprentices had lived and worked with Verrocchio. One of his memoranda remarked that he had six mouths to feed, and this number generally accords with other of his memos that faithfully document the comings and goings of various assistants.[8] Leonardo would certainly have needed a large team to help him with the casting of the bronze equestrian monument.

Leonardo's helpers paid a monthly rent and performed household tasks in return for their studies and general upkeep. One of his helpers at this time was a "Maestro Tommaso," who in November 1493 made candlesticks for him and paid nine months' rent.[9] Tommaso was probably the Florentine known as Zoroastro, the son of a gardener named Giovanni Masini. The eccentric Tommaso claimed, however, to be the illegitimate son of Bernardo Rucellai, one of Florence's richest men and the brother-in-law of Lorenzo de' Medici. Tommaso knew Leonardo in Florence and evidently followed him to Milan. His dabbling in the occult arts brought him the nickname Zoroastro, while a costume he decorated with nuts (probably for one of Leonardo's theatrical performances) earned him a less exalted moniker: Il Gallozzolo (The Gall-Nut). Tommaso also worked as a fortune-teller, hence yet another of his nicknames, Indovino (Diviner). Leonardo had nothing but scorn for the arts of alchemists and necromancers, whom he called "false interpreters of nature" whose sole purpose was to deceive. He can have had little sympathy with Zoroastro's pursuits, and he put him to work making candlesticks, grinding colors and doing the household accounts.[10]

Another of Leonardo's notes recorded that in March 1493 "Giulio, a German, came to live with me."[11] He listed three other names immediately after Giulio's: Lucia, Piero, and Leonardo. These, too, were probably helpers, with Lucia no doubt serving as his housekeeper and cook. Later that year, Giulio the German was still with Leonardo, making fire tongs and a lever for the

master, and paying a monthly rent. Then, a few months later, an assistant named Galeazzo arrived, paying Leonardo five lire per month.[12] Galeazzo's father must have had business dealings in Holland or Germany, since he paid the boy's rent in Rhenish florins (which were worth slightly less than Florentine florins). Five lire per month was steep at a time when a little more than double that amount would rent a small house in Florence for an entire year.[13] But of course Galeazzo's father was paying more than merely his son's rent: he was paying for him to be trained by one of the greatest artists in Italy. Yet even Leonardo's reputation was not always enough to concentrate their minds, and occasionally he was forced to rouse his young men from their beds and chivvy them along. In his notebooks one of them wrote (rather like a child writing lines on a chalkboard): "The master said that lying down will not bring you to Fame, nor staying beneath the quilts."[14]

Another tenant briefly shared Leonardo's lodgings. One of Leonardo's memoranda from this time stated, "Caterina came on 16th day of July, 1493."[15] Some biographers like to interpret this laconic announcement as the arrival in Leonardo's house of his mother, come to Milan in her declining years (she would have been fifty-seven in 1493) to be reunited with and cared for by her famous son. The appeal of this scenario is obvious: separated from her infant son and then married off to the Troublemaker, the ex-slave (as she perhaps was) finally finds comfort in the bosom of her celebrated son. However, another of Leonardo's memos, from six months later, recorded a payment of ten soldi to Caterina, which suggests that she was a domestic servant or, at any rate, performing tasks for which he paid her a wage.[16]

The relationship, whatever it was, turned out to be short-lived, because within a few months Caterina was dead. In a rather passionless bit of accounting, Leonardo itemized the amount he spent on her funeral. Pallbearers, eight clerics, a doctor, and several gravediggers: all received their due from Leonardo's purse. He also paid for candles, a pall over the bier, tapers for the funeral procession, and two soldi for the ringing of a church bell.[17] This funeral was quite modest at a time when moralists and civil authorities in many parts of Italy attempted to curb what one writer denounced as the "ruinous costs and useless customs" of funerals.[18] Funerals had become ruinously expensive for the simple reason that they were an important demonstration of family status and honor. One Florentine of Leonardo's generation, burying his father, proudly observed that he had staged "a public celebration in keeping with the rank he and I merited."[19]

Caterina's humble funeral was certainly not in keeping with the rank of the mother of an artist and engineer to Lodovico Sforza. Even so, the fact that Leonardo himself reached into his pocket for the funeral of a woman who had worked for him for less than a year suggests either that she had no family or (and perhaps we can be sentimental after all) that she was indeed his mother.

One important piece of advice that Leonardo intended to pass along in his proposed treatise on painting was the necessity of young painters keeping good company. He was adamant that painters needed to avoid the "chatter" of others and give a wide berth to companions who might be "highly mis-chievous."[20] Yet Leonardo himself had a highly mischievous companion: a young boy named Giacomo.

Child labor was common in Renaissance Italy, with virtually all boys working in one capacity or another by their early teens, if not earlier.[21] Painters, like other artisans such as carpenters or stonemasons, often em-ployed an errand boy—known as a *fattorino*—to perform various menial tasks about the house or shop in return for room and board. Some of them, such as Pietro Perugino, who began his career as a *fattorino* for a painter in Perugia, went on to become artists themselves.

Leonardo took one such *fattorino* into his studio in the summer of 1490. "Giacomo came to live with me on the feast of Saint Mary Magdalene, 1490, aged 10 years," he recorded. Giacomo's full name was Gian Giacomo Caprotti da Oreno, but his unruly behavior in Leonardo's studio quickly earned him a nickname: Leonardo began calling him Salai, Tuscan slang for demon or devil. Things went wrong very quickly. "The second day I had two shirts cut out for him," Leonardo wrote in a long letter of complaint to the boy's father, "a pair of hose, and a jerkin, and when I put aside some money to pay for these things he stole 4 lire, the money out of the purse; and I could never make him confess, though I was quite certain of the fact." The boy's transgressions did not end there. On the following evening, Leonardo went to dinner with a friend, a distinguished architect, and Gia-como, invited to the table, made a memorable impression: "Giacomo supped for two and did mischief for four, for he broke three cruets and spilled the

wine." Leonardo vented his fury at the boy's behavior in the margin of the letter: "*ladro, bugiardo, ostinato, ghiotto*"—thief, liar, obstinate, glutton.[22]

More was to come. Some weeks later, one of Leonardo's assistants, Marco, discovered that a silverpoint drawing had gone missing along with some silver coins. Conducting a search of the premises, he found the money "hidden in the said Giacomo's box." No one was safe from Giacomo's light-fingered predations. A few months on, early in 1491, Leonardo designed costumes of "wild men" for a pageant in honor of Lodovico Sforza's wedding. Giacomo, who accompanied Leonardo to the costume fitting, spotted his chance as the men undressed to try on their outfits: "Giacomo went to the purse of one of them which lay on the bed with other clothes . . . and took out such money as was in it." Shortly thereafter, another silverpoint went missing.[23]

What did Giacomo do with his ill-gotten gains? Like any other ten-year-old, he took himself off to the sweet shop. This we know from Leonardo's aggrieved account of the circumstances surrounding the disappearance of a Turkish hide for which Leonardo had paid two lire, and from which he was hoping to have a pair of boots made for himself. "Giacomo stole it of me within a month," he wrote, "and sold it to a cobbler for 20 soldi, with which money, by his own confession, he bought aniseed candies."[24]

We might expect Leonardo to have announced, at the end of this grave catalog of crimes, that young Giacomo had been shown the door. But in fact he was not. While most of Leonardo's apprentices and assistants came and went at regular intervals, Giacomo remained with him for many years. This was not necessarily due to any reformation of character on Giacomo's part. He seems always to have been wayward, fractious, and demanding. In the pages of one of the notebooks is the statement—not, apparently, written in Leonardo's hand—that reads "Salai, I want to make peace with you, not war. No longer war, because I surrender."[25] If Leonardo did not write these weary lines, then they must have been penned by one of Leonardo's other apprentices. The tone suggests, as does the brazen theft of Marco's money, that Giacomo was a cause of considerable friction among the others in the studio.

Not only was Giacomo allowed to remain in the studio; the larcenous *fattorino* was clearly treated by Leonardo as a favorite. Indeed, Leonardo lavished gifts on him from the outset, making sure he was dressed, like his

master, in beautiful clothing. In the first year alone, Giacomo's wardrobe cost Leonardo twenty-six lire and thirteen soldi, the annual wage of a domestic servant.[26] These articles included an astonishing twenty-four pairs of shoes, as well as four pairs of hose, a cap, six shirts, and three jerkins.[27] Undated notes written sometime later recount how Leonardo bought Giacomo a chain and gave him money to purchase a sword and have his fortune told.[28] "I paid to Salai 3 gold ducats," reads another, "which he said he wanted for a pair of rose-coloured hose with their trimming." Giacomo, like his master, evidently favored pink tights. A week or two later, more purchases: "I gave Salai 21 braccia of cloth to make a shirt, at 10 soldi the braccio."[29] Thus, the material alone cost 210 soldi, or more than 10 lire—half the annual wage of a domestic servant.

Why this sticky-fingered little clotheshorse managed to keep his place in the Corte dell'Arengo is fairly simple. Giacomo held a great physical attraction for Leonardo, who was bewitched by the boy's appearance, especially his curly hair. According to Vasari, Salai was "a very attractive youth of unusual grace and looks, with very beautiful hair which he wore curled in ringlets and which delighted his master."[30] Giacomo seems to have served as a model for Leonardo. No definitive image of him exists, but art historians refer to a distinctive face that appears repeatedly in his drawings—that of a beautiful youth with a Greek nose, a mass of curls and a dreamy pout—as a "Salai-type profile."[31]

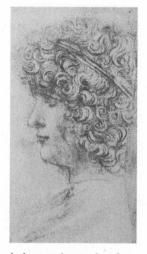

A Leonardo drawing showing the Salai-type profile.

Leonardo's relationship with Giacomo seems to have drawn little comment in his own lifetime. However, decades later, in about 1560, a painter named Gian Paolo Lomazzo, who turned to writing when he went blind, composed (but did not publish) a treatise called *Gli sogni e ragionamenti* (*Dreams and Arguments*). This work imagined a conversation between Leonardo and the Greek sculptor Phidias. Lomazzo was born in 1538, almost two decades after Leonardo's death, so he had no actual knowledge about the relationship between Leonardo and Salai, apart from hearsay and speculation (he claimed to have spoken with some of Leonardo's former servants).

In the dialogue, Leonardo is seduced by Phidias into self-revelation, confessing that he loved Salai "more than all the others." This disclosure prompts Phidias to inquire if the relationship was physical: "Did you perhaps play with him that backside game that Florentines love so much?" Leonardo enthusiastically confesses that he did: "And how many times! Have in mind that he was a most beautiful young man, especially at about fifteen."[32] According to Lomazzo's account, Leonardo's passion for the beautiful Salai therefore reached its peak at about the time work began on *The Last Supper* in Santa Maria delle Grazie.

In the fifteenth century, Florentines were so well-known for homosexuality that the German word for sodomite was *Florenzer*. By 1415 the sexual behavior of young Florentine men had caused the city fathers such concern that "desiring to eliminate a worse evil by means of a lesser one" they licensed two more public brothels to go with the one they had opened with similar aspirations a dozen years earlier.[33] When these establishments failed to produce the desired results, and still "desiring to extirpate that vice of Sodom and Gomorrah, so contrary to nature," the city fathers took further action.[34] In 1432, a special authority, the Ufficiali di Notte e Conservatori dei Monasteri, or Officers of the Night and Preservers of Morality in the Monasteries, was formed to catch and prosecute sodomites. Over the next seven decades, more than ten thousand men were apprehended by this night watch. Although burning at the stake was the official punishment for sodomites, most offenders were let off with a fine. Repeat offenders might find themselves in the *gogna*, the stocks on the outer wall of the local prison.

One of the men apprehended by the Officers of the Night, in 1476, was Leonardo. At several locations around Florence, such as on the wall of the Palazzo Vecchio, the city fathers installed receptacles known as *tamburi* (drums) or *buchi della verità* (holes of truth). Into these openings Florentines

could deposit anonymous accusations concerning crimes of any sort. Floren-
tines who fell foul of this system of denunciation were the goldsmith Lorenzo
Ghiberti (accused in 1443 of being illegitimate), Filippo Lippi (accused in 1461
of fathering a child with a nun), and Niccolò Machiavelli (accused in 1510 of
sodomizing a prostitute named La Riccia). In April 1476, Leonardo's name
turned up in one of these holes of truth. Along with three other young men,
he was accused of having sexual relations with a seventeen-year-old named
Jacopo Saltarelli. The denunciation explained that Saltarelli "has been a
party to many deplorable affairs and consents to please those people who re-
quest such wickedness of him." The anonymous accuser provided the name
of "Leonardo di Ser Piero da Vinci, who stays with Andrea de [sic] Verroc-
chio," as one of four men who "committed sodomy with the said Jacopo."[35]

The charge was repeated two months later—this time in elegant Latin—
but Leonardo was never charged because the anonymous accuser failed to
come forward, and no other witnesses corroborated the story. The charges
were eventually dropped and the case was dismissed. Most biographers and
art historians are quick to convict. A husband-and-wife team, authors of a
widely used textbook, claimed the accusation "was almost certainly true" be-
fore adding—bizarrely—that Leonardo's homosexuality explained "his
proneness to abandon things half done."[36] Questions of procrastination aside,
Leonardo was almost certainly homosexual by the standards of later centu-
ries. Freud was no doubt correct when he stated that it was doubtful whether
Leonardo ever embraced a woman in passion.[37] Two years after the Saltarelli
affair, Leonardo wrote a partially legible declaration in his notebook: "Fiora-
vante di Domenico at Florence is my most beloved friend, as though he were
my . . ."[38] A nineteenth-century editor of Leonardo's writings hopefully filled
in "brother," but the relationship may well have been more intimate.

Within a year or two of the Saltarelli affair, Leonardo appears to have been
involved in one more scandal in Florence. In a letter to Lorenzo de' Medici
composed early in 1479, the ruler of Bologna, Giovanni Bentivoglio, raised the
issue of a young apprentice recently exiled from Florence and then jailed in
Bologna because of the "wicked life he had followed" during his time in Flor-
ence. Details of the youth's crimes are unspecified, though he had fallen into
what Bentivoglio called *mala conversatione*—bad company. He may have been
little different from the many unruly young toughs, who, as one Florentine
lamented, "threaten barkeepers, dismember saints, and break pots and
plates."[39] What made him distinctive, however, was the name by which Ben-

tivoglio referred to him: Paolo de Leonardo de Vinci da Fiorenza. This formulation—with its use of the patronymic "de Leonardo de Vinci"—might suggest that Paolo was Leonardo's son. That scenario is impossible, however, since if Paolo was, say, sixteen years old in early 1479—the very youngest he is likely to have been—the maths require Leonardo to have been eleven when his "son" was born. If Paolo was older than sixteen, then Leonardo would have been even more startlingly precocious.[40]

A far more plausible scenario is that Paolo was an apprentice who began working and studying under Leonardo after he struck out on his own following his long apprenticeship with Verrocchio. Apprentices often adopted (or were referred to by) the names of their masters. Verrocchio was a case in point: born Andrea Michele di Cioni, he dropped his father's name and used that of his masters, the goldsmiths Francesco and Giuliano Verrocchio. Less certain is whether Leonardo was in any way involved in Paolo's "wicked life," or indeed whether Paolo's wicked life involved "that vice of Sodom and Gomorrah." Banishment to Bologna was not the usual punishment for sodomites, though the moral tone of the letter suggests that sexual misconduct of some variety was among Paolo's transgressions. In any case, Paolo's malfeasance, whatever it involved, no doubt redounded to his master's discredit, and the young miscreant's example may lurk in the background of Leonardo's advice about keeping oneself from bad company.

The Corte dell'Arengo would have been a scene of intense activity at the end of 1494, as Leonardo's work on the gigantic horse gave way to the project for Santa Maria delle Grazie. Before painting either a panel or a mural, an artist needed to make dozens if not hundreds of drawings. These ranged from *primi pensieri*—the artist's brainstorming "first thoughts"—to full-scale drawings that served as templates for the final work. Work on the mural therefore involved Leonardo in vast and intensive labors with paper, pen, and ink as he worked out the details of his composition and then prepared to begin work on the wall itself.

Leonardo was a superb draftsman. One look at his adolescent doodlings supposedly convinced Verrocchio to hire him on the spot. A century later, Giorgio Vasari would marvel at Leonardo's "beautiful and detailed drawings on paper which are unrivalled for the perfection of their finish."[41] At a

time when other artists merely saw drawings as a means to an end, Leonardo evidently took pride in his sketches. At some point in the 1480s, probably soon after his arrival in Milan, he drew up a list of the drawings in his possession. They made for a varied collection, encompassing "a head of the Duke" (presumably Lodovico), three Madonnas, multiple drawings of Saint Sebastian and Saint Jerome, compositions featuring angels, portraits of women with braided coiffures, men "with fine flowing hair," and the head of a gypsy girl.[42]

According to one source, Leonardo used a stylus when he sketched in the little notebook he kept at his belt.[43] A stylus was a metal-tipped drawing instrument widely used by artists before the invention of the pencil (graphite was not discovered until in 1504, and the wooden-cased graphite pencil appeared only in the second half of the seventeenth century). For drawing with a stylus, artists used paper specially coated with a ground made from, among other things, powdered bone. One fifteenth-century recipe recommended incinerated table scraps, such as chicken wings, whose ground-up ashes were sprinkled thinly on the paper or parchment and then brushed off with a hare's foot.[44] With the paper thus prepared, the artist went to work on its granular surface with his stylus, which was usually made from silver and sharpened to a point, and which, as it was drawn across the surface, left particles behind; these traces quickly oxidized, producing delicate lines of silvery gray.

Leonardo also used various other media for his drawings: chalk, pen and ink, lead point, and charcoal. Characteristically, he experimented with various drawing techniques. He advised wetting the tip of the stylus with spittle, and his notes record that he tried treating his paper with such things as powdered gall nuts, candle soot, and the herb calves' foot.[45]

How Leonardo developed his pictorial ideas through countless drawings can be seen in the case of his *Adoration of the Magi*, for which he produced numerous sketches in the early 1480s, both of individual figures and others gathered in groups. Many of his drawings for this work were done with a stylus but then, in a technique rare in Florentine workshops, touched up with a pen: that is, with a goose quill dipped in ink.[46] Working rapidly on small leafs of paper, he created a series of drawings exploring possible poses for Joseph, Mary, the Christ Child, and the Three Kings. He probably had models (such as his apprentices) strike a variety of postures for him in his studio, or else he quickly dashed off likenesses of Florence's most animated bench sitters. The figures in his sketches clasp their hands, kneel on the

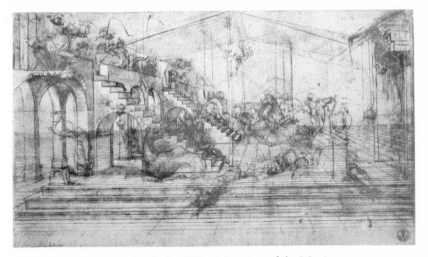

Leonardo's sketch for The Adoration of the Magi

floor, tilt their heads, shade their eyes, cross their arms or ankles, and jack-knife their bodies. Leonardo once wrote that there were "18 actions of man," which included running, reposing, standing, sitting, kneeling, lying down, and "carrying or being carried"—and he seemed determined to fit all eighteen into his *Adoration*.[47]

These sketches for the *Adoration* culminated in a remarkable metal point sketch over which Leonardo traced with a pen and in places—in order to embellish the work still further—gave a wash of ink. Though done on a piece of paper only six and a half inches high by a little less than eight inches wide, the sketch imagines in the Bethlehem manger an entire frenetic world. The Holy Family and the Three Kings are nowhere to be seen. Instead, Leonardo devoted himself to the creation of a frenzied background: spectral figures scrambling up staircases and hanging over archways, horses rearing and bucking, and even a seated dromedary surveying the action. These squirming figures are contained within a grid of perspective lines that explode outward from an off-center focal point at the nose of one of the rearing horses.

Leonardo proceeded in exactly the same way as he began designing his mural at Santa Maria delle Grazie. One of his earliest drawings for the project was done on a sheet of paper roughly eight inches by ten inches. The flurry of pen strokes at the top of the page shows very little detail, merely conjuring a line of ghostly figures in cursory outline—but the figures are recognizably

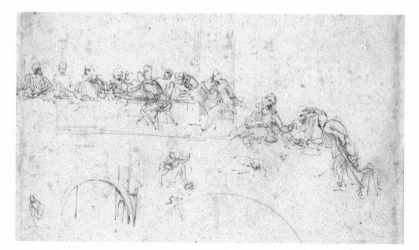

Leonardo's sketch for The Last Supper

Christ and the apostles seated at a long table. Leonardo's take on the subject in this *primo pensiero* was fairly conventional, since he followed painters like Castagno and Ghirlandaio in placing Judas on the near side of the table, opposite the others. Also like Castagno and Ghirlandaio—and like virtually all other artists tackling a Last Supper—he placed John asleep in the bosom of Christ.

This positioning indicates that Leonardo, like so many of his predecessors, was at that point following the Gospel of St. John rather than the synoptics. To the right and lower on the sheet, he sketched on a slightly larger scale a detail of the central motif of Christ, John, Judas, and one other apostle, exploring how Judas would reach across the table to take the sop of bread from Christ. This gesture by which Christ announces his betrayer, given in three of the four Gospels, is a common feature of Last Suppers, evident from Giotto and Duccio through Castagno and Ghirlandaio. At this point, then, Leonardo was thinking along traditional lines, but his vision would gradually change as he worked and reworked his composition.

Leonardo's drawings survive in a far greater profusion than those of any other artist of his age. Even so, fewer than a dozen studies for *The Last Supper* survive from the scores he must have created during the winter of 1494–95.

Unquestionably the finest—and one of the finest of all Leonardo's drawings—is a head and shoulders sketch of one of the apostles, St. James the Greater.

St. James the Greater (so-called to distinguish him from another apostle named James, known as St. James the Lesser) was the brother of St. John. Leonardo's study for him was sketched on a sheet of paper roughly ten inches high by six and a half inches wide. It shows the apostle, a young man, in three-quarters profile: a much harder portrait to execute than one full face or in half turn. Leonardo had done three-quarters profiles before, such as the kneeling angel in Verrocchio's *Baptism of Christ*, the angel in *The Virgin of the Rocks*, and the portrait of Lodovico's mistress, Cecilia Gallerani. The science of perspective and the study of anatomy had given artists the confidence and ability to depict faces and bodies from a variety of different angles, and therefore to provide both the illusion of movement and a striking individuality in their sitters. The three-quarters view made a change from the profile portrait, the most typical type of portrait painted during the fifteenth century. Inspired partly by the images of emperors on Roman medallions, the profile portrait was not intended to be an illustration of an individual's unique facial characteristics so much as a depiction of the subject in a specific social or political role.[48] On the other hand, a face turned in three-quarters profile, exposing the facial contours at an apparently more casual and fortuitous angle, was conducive to a more distinctive and revealing portrait.

Leonardo complicated the pose of his apostle by tipping the head a few degrees forward so that St. James is slightly foreshortened from above. He looks downward with his lips parted in a startled rictus and his deep-socketed eyes—the features to which Leonardo gave the most attention—riveted by something directly in front of him. His left hand with its bent wrist, barely visible, suggests the model has his hand on the neck of a musical instrument. This pose suggests, in turn, that the model was a musician, possibly someone to whom Leonardo (so accomplished on the lyre) gave music lessons. Leonardo clearly concentrated on capturing the facial expression, and yet this expression is difficult to read. Is the young apostle saying something? Or gasping in astonishment? Is he attracted or repelled by what he sees? The ambiguity of movement and expression in this sketch will run in a persistent susurration throughout Leonardo's painting.

St. James the Greater is another of the young men "with fine flowing hair" that Leonardo delighted in drawing and painting. Yet the crown of St. James's head is denoted by only a few wavy lines, and indeed the drawing

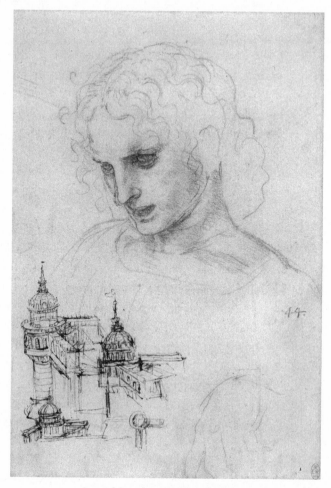

Leonardo's study of St. James the Greater

is not completed in any way. However deft and striking, it cannot be included among the beautiful and detailed drawings that Vasari extolled as "unrivalled for the perfection of their finish." It was simply one of many stages by which Leonardo gradually defined the pose and expression of one of the apostles—but it is a virtuoso performance nonetheless.

That Leonardo did not highly esteem this drawing—and that later, more finished drawings of St. James undoubtedly existed but have, alas, long since been lost—is suggested by the fact that he reused the paper: he sketched an architectural design for a castle in its lower left-hand corner. Leonardo was loath to waste, often filling his sheets of paper, front and

back, with numerous unrelated drawings done months or even years apart. On the reverse of one sheet of paper covered with architectural diagrams he wrote himself a list: cap, scissors, soup plate, silk shoelaces.[49] The back of another sheet, a large one measuring twelve and a half by seventeen and a half inches, teems with a broad range of diagrams and ideas: everything from engineering plans and geometrical diagrams to the leaves of an arum lily and a doodled lock of curly hair. All these drawings—and there are more than fifteen separate (and sometimes overlapping) images on the reverse—testify to both Leonardo's diversity of interests and his frugality with his stationery supplies.[50]

Leonardo's study of St. James the Greater was done in the distinctive medium of red chalk. The extreme scarcity of his drawings for his *Last Supper* makes generalizations difficult, but surviving drawings seem to indicate that by the early 1490s he had partially abandoned metal point in favor of chalk. According to one source, he also used pastels to make drawings of the heads of both Christ and the apostles, but none of these has survived.[51] Metal point had the disadvantage of being an inflexible and ultimately rather inexpressive medium, since pressure on the stylus did not vary the intensity of the color or the breadth of the line. Chalk and pastels were different. Black chalk, made from shale found in northern Italy, was used in drawings by the time of Leonardo's apprenticeship. However, it was still such a new medium that one fifteenth-century artists' handbook could give it no name, identifying it only as "a certain black stone which comes from Piedmont."[52]

Leonardo used black chalk in a few surviving studies for *The Last Supper*, but he seems to have favored—and even pioneered—the use of red chalk. Made from clay mixed with iron oxide and hematite, red chalk had been used by the ancient Romans for their wall paintings. Leonardo was, however, the first artist of the Italian Renaissance known to have used it. He exploited its distinctive properties—its blood-red color, perfect for flesh tones, and its hardness, ideal for sketching fine details—to create many remarkable drawings of everything from the human figure to mountain ranges to the wreaths of smoke rising over burning buildings in Milan. It was his medium of choice as he worked on the equestrian monument: his hopes and plans for the bronze horse were recorded in a diminutive, ruddy script.

Leonardo's drawing of St. James the Greater reveals, like all of his sketches, a characteristic feature. Artists created areas of shadow in their drawings or engravings by making repeated parallel strokes, either perpendicular or oblique: the technique known as hatching. Leonardo's style of hatching was distinctive because, contrary to most artists, who drew their parallel lines from the lower left to the upper right, /////, Leonardo executed his from the lower right to upper left, \\\\\.

The reason for this individual style was simple: Leonardo was left-handed. As a *mancino*, or southpaw, it was easier and more natural for him to draw these backward-leaning hatch marks than to follow the more conventional method. The individuality created by his left-handedness extended, famously, to his handwriting, since he often (though not always) wrote in reverse, from right to left. A friend who knew him well attested that he both drew and wrote left-handed, and that his script "could not be read except with a mirror or by holding the back of the sheet against the light. As I understand, and can say, this is the practice of our Leonardo da Vinci, lantern of painting, who is left-handed."[53] This reversed handwriting gives him the most famous and distinctive calligraphy in history. Who else can be recognized so immediately from his handwriting? This idiosyncratic style reinforces the image of Leonardo as eccentric and unique: someone who inverted the accepted rules and conventions in order to pursue his own individual path.

Contrary to popular misconception, Leonardo's looking glass script was not a code. A less foolproof code is difficult to imagine, since all one needed to do to crack it (as Leonardo's friend pointed out) was to hold the paper up to a mirror. Moreover, Leonardo had no wish to conceal his writings from the world, because he hoped to publish them. For example, his notes for his treatise on painting, though written entirely in reverse, were clearly meant for dissemination to the wider world. The earliest known sample of his handwriting—the inscription on his 1473 sketch of the Arno Valley—reveals him writing in reverse even as a young man. There is no reason why he should have wished to encrypt this particular inscription, which merely records the date on which he made his sketch. Rather, as a *mancino*, a right-to-left movement across the page came more naturally to him than a movement in the opposite direction. It also no doubt helped him avoid the hazard of all southpaws: smearing wet ink.

Art historians over the years have pondered why Leonardo should have

written and drawn with his left hand. The nineteenth-century translator and editor of Leonardo's notebooks speculated that he was a *mancino* because he lost the use of his right hand in either an accident or a fight, an opinion cautiously supported by A. E. Popham, an English expert on Leonardo's drawings. Popham believed Leonardo may have been deprived of the use of his right hand in an unspecified childhood accident.[54] A more creative theory was offered by Marie Bonaparte, the great-grandniece of Napoleon and the woman to whom Sigmund Freud, treating her for an inability to achieve orgasm, uttered the immortal question: "What does a woman want?" For Madame Bonaparte, the reason for Leonardo's left-handedness was only too obvious: as a child he had refrained from masturbation, leading to left-handedness and an extreme disgust of sexuality.[55]

Leonardo undoubtedly wrote left-handed not because of either a hand-mangling childhood adventure or an extreme disgust of sexuality. There seems little reason to doubt that he was simply born left-handed, like roughly 10 percent of the population today. The percentage was probably even lower in Leonardo's day—making him even more unique—since parents were taught to free the child's right hand first from the swaddling clothes in hopes that the child would begin using and strengthening the right rather than the left hand.[56] Leonardo's parents either declined to follow this practice or the training had no effect. By contrast, Michelangelo and his friend Sebastiano del Piombo, though naturally left-handed, learned to write and draw with the right hand, possibly at the behest of a schoolmaster or parent.

Another *mancino* whose schoolmaster did not demand this kind of compliance, Raffaello da Montelupo, testified that the sight of someone writing with his left hand tended to draw a crowd. A sculptor and architect who worked with Michelangelo, Raffaello claimed that "many were astonished" when they saw him write with his paper tipped at a ninety-degree angle and his left hand at work with a pen. Once, when he signed a legal document, the dumbfounded notary summoned ten colleagues to witness the amazing performance.[57] Leonardo's left-handedness, as well as his facility in writing backward, no doubt added to his own mystique as someone who worked differently from everyone else, at an angle to the rest of the world.

CHAPTER 6

The Holy League

King Charles VIII entered Naples in February 1495, four months and nineteen days after setting forth from Asti. His triumph, achieved with a scarcely believable facility, was virtually complete. As a French statesman accompanying the king noted, the invasion of Italy "was performed with so much ease, and so little resistance, that our soldiers scarce ever put on their armour during the whole expedition."[1]

Charles had left Rome in the middle of January, after a two-week occupation during which he did some sightseeing among the ruins and attended a Mass at St. Peter's. Casting about on his arrival for a comfortable abode, he had settled on the Vatican—"a very fine house," he enthused, "as well furnished and adorned as any palace or castle I have ever seen."[2] He was given an audience with the pope, who, after much bickering over protocol, cautiously emerged from his hiding place in the Castel Sant'Angelo to receive the French king's somewhat restrained obeisance. A comical scene ensued in which, as the audience concluded, the pope refused to replace his biretta

until the king first donned his own hat.[3] Charles then lingered briefly in the Eternal City, making vague and unconvincing noises about reforming the church. In Milan, Lodovico Sforza was unimpressed: "His Most Christian Majesty," he acidly remarked, "had better begin by reforming himself."[4] Finally, Charles set off to claim his new throne in Naples.

King Alfonso had once predicted that his sins would bring down misfortunes on his head. Those misfortunes had now arrived. As fortress after fortress fell to the French, he was seized with such fear and panic that during the night he cried out that he could hear the approach of the enemy, and that even the stones and trees shouted, "France, France."[5] The shade of his father appeared to him, prophesying disaster. He was also visited by the ghosts of his murdered political enemies. Abdicating in favor of his son Ferdinand II, he loaded five galleys with manuscripts, tapestries, and casks of wine, and fled to a monastery in Sicily. Twenty-five-year-old Ferdinand put up a brief show of defiance before abandoning Naples and escaping to the island of Ischia. On 22 February, Charles entered the city as a liberator and conquering hero. He immediately made himself popular with the people of Naples by slashing taxes and allowing the continuation of slavery.

Lodovico Sforza's original objective—that of ridding himself of the threat from King Alfonso—had been spectacularly met. But the duke found alarming the ease and speed of the French conquest of the Italian peninsula. Equally troubling was the fact that French troops still occupied Pisa, Siena, and various fortresses in both Tuscany and the Papal States, and that they seemed in no hurry to depart. Most disturbing of all, Charles's cousin, Louis of Orléans, would-be claimant to the Duchy of Milan, was biding his time at Asti, a mere sixty miles southwest of Milan.

Within a week of Charles's arrival in Naples, Lodovico began laying plans for evicting from Italy the invaders that he himself had invited. "Naples is lost," he wrote to the Venetian Senate, "and the French king has been joyfully welcomed by the people. I am ready to do whatever the Republic desires. But there is no time to waste; we must act at once."[6] The Venetians, hitherto neutral, were prepared to listen to Lodovico's entreaties. As Guicciardini wrote, after seeing Charles's army proceed "like a thunderbolt" through Italy, they, too, "began to consider the misfortunes of others as dangers to themselves."[7]

Charles had earlier pledged himself to launch a crusade against the Turks after conquering Naples. However, once in his new kingdom he began to

think better of an arduous overseas adventure. He and his soldiers preferred to remain in the fleshpots of Naples, "giving themselves over to pleasure."[8] By then a strange and debilitating new disease had announced itself: one that the French soldiers called the "Neapolitan disease" and that the Neapolitans called the "French disease." Guicciardini graphically described the horrors of the boils, ulcers, and intense pains in the joints and nerves. "This disease killed many men and women of all ages," he wrote, "and many became terribly deformed and were rendered useless, suffering from almost continuous torments."[9]

Two years later, when it had become widespread across both Italy and France, a physician from Ferrara described this "disease of an unusual nature" in a treatise insistently entitled *De morbo Gallico (On the French Disease)*. He noted how the contagion had either been imported by the French into Italy, or else "Italy had become infested by this disease and by the French arms at the same time."[10] Philosophers and physicians would argue how exactly the disease was contracted, and whether or not it had come to Europe on board Columbus's galleons. But virtually all were agreed that this dreadful pox (eventually christened syphilis) was a punishment inflicted by God on a wayward society. As the court physician in Ferrara despaired, "We also see that the Supreme Creator, now full of wrath against us for our dreadful sins, punishes us with the cruellest of ills."[11]

Leonardo was not the only artist preparing to begin work in Santa Maria delle Grazie in 1495. A local painter named Giovanni Donato da Montorfano was hired—probably by Lodovico Sforza—to paint a Crucifixion scene on the wall opposite the one where Leonardo was to work. Two teams of painters would therefore be at work in the refectory at the same time.[12]

A Crucifixion scene was almost as common in a convent refectory as a Last Supper—so common, in fact, that in the 1580s a painter marveled at how artists and patrons found the subject an appropriate accompaniment to meals.[13] In the refectories of Florence, Last Suppers were often specifically paired with Crucifixion scenes. Taddeo Gaddi's *Last Supper* in Santa Croce was painted beneath a massive Crucifixion, also by Gaddi, featuring St. Francis clasping the foot of the cross. In Sant'Apollonia, Andrea del Castagno frescoed an image of Christ on the cross (along with an Entombment and a

Resurrection) directly above his *Last Supper*. These scenes allowed the monks and nuns to identify with Christ's sufferings and, as they were exhorted, to contemplate the mysteries of Christ's life, death, and resurrection. As one text stressed, the true disciple of Christ must "seek to carry Jesus Christ's cross in his mind and in his flesh, so that he may truly say and feel within himself the word of Paul the Apostle . . . *Christo confixus sum cruci*, that is, I am nailed to the cross with Christ."[14]

There may have been another reason why Montorfano was given the commission to fresco a wall in the same room as Leonardo. Patrons were beginning to pair artists off against each other, arranging competitions between or among artists in an attempt to inspire them to greater glories. In 1408, the wardens of Florence's cathedral commissioned three sculptors, Donatello among them, to carve marble statues of the Evangelists to adorn the facade, with the understanding that the fourth block of marble, and the commission for the fourth Evangelist, would go to the victor. (The competition fizzled when the sculptors lingered so long over their work that the wardens ran short of patience and gave the block of marble to a fourth sculptor.) Later, when Pope Sixtus IV arranged to have a team of painters fresco the walls of the Sistine Chapel in the early 1480s, he turned the commission into a contest by offering a prize to the artist whose work he judged the best. According to Vasari, the winner was Cosimo Rosselli, whose gaudy display of gold and ultramarine, though ridiculed by the other painters, impressed the pontiff, a man with unsophisticated artistic tastes.[15]

Lodovico may well have hoped to prompt Leonardo, notorious for his slow progress, into completing his work in a more timely manner. Yet if the two commissions were planned as part of an informal contest, the competitors were unevenly matched. Little is known of Montorfano's life other than that he came from a family of Milanese painters long patronized by the Sforza family. A relative named Baptista, probably an uncle, did decorations for Galeazzo Maria in the Castello di Porta Giovia in the early 1470s.[16] Giovanni himself probably trained with his father, Alberto, after which he appears to have worked with his brother Vincenzo. His commissions included frescoes in several Milanese churches.

Although a capable craftsman, the thirty-five-year-old Montorfano was certainly not a painter of the caliber of Leonardo. He worked in a more antiquated style, blissfully unconcerned with the Florentine's attention to naturalistic details or his innovations in movement and expression.

However, Montorfano possessed one significant advantage over the man working at the opposite end of the refectory. As his commissions in various of Milan's churches reveal, by 1495 he had extensive experience in fresco, while Leonardo had never before attempted the difficult task of painting on a plaster wall.

<center>❦</center>

"We must act at once," Lodovico Sforza had urged the Venetian Senate, and within weeks he had laid plans to drive the French invaders from Italy. Late in the evening on the last day of March 1495, after engaging in what a French ambassador deplored as "artifice and deception,"[17] Lodovico compacted a powerful confederacy—a "Holy League"—against the French.

The other members of the Holy League were Pope Alexander VI, the Holy Roman emperor Maximilian I, and Ferdinand and Isabella of Spain. These powers pledged to defend Christendom against the Turks, to preserve the dignity of the church and the rights of the Holy Roman Empire, to respect and protect one another's territories, and to evict the foreign invaders—to wit, the French—from the Italian peninsula. To this final end, the signatories engaged Francesco II Gonzaga, the Marquess of Mantua, to lead a forty-thousand-strong army against the French. The French ambassador to Venice, learning the terms of the Holy League, trembled for the safety of his king: "I was extremely troubled and concerned for my master's person," he wrote, "as I feared that he and his whole army were in great danger."[18]

No such concerns clouded the placid horizons of Charles and his army, still enjoying their blissful sojourn in Naples, where the French king (as his ambassador to Venice noted disapprovingly) "minded nothing but his pleasures and his ministers attended to nothing but their own advantage."[19] Charles was effusive about the many delights of his new kingdom. One of the treasures that Alfonso took with him on his escape to Sicily was a collection of seeds from the royal gardens. It would have been small consolation for him to know that Charles truly appreciated these horticultural delights. "My brother," he wrote to the duke of Bourbon, "this is the divinest land and the fairest city that I have ever seen. You would never believe what beautiful gardens I have here. So delicious are they, and so full of rare and lovely flowers and fruits, that nothing, by my faith, is wanting, except Adam and Eve, to make this place another Eden."[20]

Eventually, realizing he needed to retreat from Italy before the Holy League could collect their forces for an assault, Charles was forced to quit his Neapolitan Eden. On 20 May, after helping himself to some of Naples' historic treasures, including the bronze gates of the castle, he and half his army quit the city. The remainder, some thirteen thousand men, he left behind in an attempt to hold the conquered kingdom in his name. He began marching north toward Rome, which he reached on the first of June, claiming to be coming "as a good son of the Holy Church" and requesting an audience with Pope Alexander VI.[21] He had been crowned with much pomp in Naples a fortnight earlier, but without the consent of the pope, the suzerain of Naples, the ceremony had no real meaning. He therefore wanted papal sanction and an official investiture as king of Naples.

Alexander, however, had already headed for the Tuscan hills with twenty of his cardinals, leaving Charles little choice but to depart from Rome after three days. He continued north, and at Poggibonsi, near Siena, he was met by one of his few friends left in Italy, Girolamo Savonarola. The friar berated him for having disappointed God by failing to reform the church, "which, by my mouth, He had charged you to undertake, and to which He had called you by so many unmistakeable signs." Ever willing to foretell doom, Savonarola gave Charles an urgent warning. Failure to heed God's commands would bring down on his head "far more terrible misfortunes."[22]

Lodovico Sforza was suffering his own misfortunes as Charles and his army entered the Apennine passes on their dangerous journey homeward. The summer had begun hopefully for Lodovico after he compacted the Holy League in the spring. He still appeared to be the man who (as the insignia on his harnesses boasted) held the fate of the world in his hands. On 26 May, a huge celebration was staged for him in Milan. Mass was celebrated in the cathedral, after which he emerged through its doors to appear beneath a crimson awning embroidered with mulberry leaves—one of his personal symbols—and raised for the occasion on the piazza outside. After more than a dozen years of plotting and maneuvering, the day had finally arrived for Lodovico to receive his official sanction from the Holy Roman emperor as the duke of Milan.

Lodovico's diploma from the emperor had arrived, conveniently and

perhaps not entirely coincidentally, a few days after the Holy League was signed. Now, in Milan, Lodovico staged a magnificent ceremony for himself. A German bishop and Maximilian's chancellor took turns reading out the imperial privileges granted by their master, after which they conferred on Lodovico the ducal cap and mantle, and placed into his hands a scepter and the sword of state. Lodovico then moved in procession with his duchess, Beatrice, to the basilica of Sant'Ambrogio to give thanks for his accession to the ducal throne. Beatrice, who had recently given birth to their second son, Francesco, described the occasion to her sister as "the grandest spectacle and noblest solemnity that our eyes have ever beheld."[23] Following the ceremony in Sant'Ambrogio, she and Lodovico returned to the Castello for a punishing round of feasting.

Leonardo was probably involved in these celebrations. At Lodovico's court he was "the arbiter of all questions relating to beauty and elegance, especially in pageantry."[24] In 1490 he had enjoyed a great triumph with his elaborate stage set for a pageant, *The Feast of Paradise*, produced by Lodovico in honor of the wedding of his nephew Giangaleazzo to Isabella. Leonardo was selected for such projects not only for his dedication to "beauty and elegance" but also for his talent for achieving spectacular and surprising visual effects through virtuoso engineering. "His genius for invention was astounding," marveled one writer.[25] No plans or drawings for *The Feast of Paradise* survive, but an eyewitness described how Leonardo designed a complex scenography depicting Paradise in the form of an elevated golden orb surrounded by seven planets, the twelve signs of the zodiac, and "a great number of lights representing stars." At the climax of the performance, the planets descended—evidently by means of some sort of high-wire trickery—to present Isabella with the play's libretto.[26]

Leonardo must have worked on many such productions if Beatrice's secretary was correct in his claim that new spectacles were staged every month at Lodovico's court.[27] One year after *The Feast of Paradise*, Leonardo assisted in the decoration of the ballroom in the Castello for Lodovico's own nuptials, and in designing the "wild man" costumes for actors—the men whose purses young Salai stole—participating in an accompanying festival. Leonardo enjoyed creating spectacles that shocked, especially through the presentation of darker themes. For one pageant he engineered an intricate mechanism by which the side of a mountain swung open to reveal Pluto and his demonic minions frolicking in their fearsome underworld. "When Pluto's paradise is

opened," reads one of his notes, "then there will be devils, who play on pots to make infernal noises. Here will be death, the furies, Cerberus, many cherubs who weep. Here fires will be made of various colours."[28]

Leonardo's interest in the monstrous and the incendiary was evident from a young age. One of his earliest artistic productions, according to legend, was a wooden buckler—a small shield—given to him by his father to decorate for a local peasant. Young Leonardo assembled in his bedroom "a fearsome and horrible monster" composed of dead lizards, snakes, crickets, locusts, and bats. As this heap of scales and wings rotted and stank, he meticulously painted his monster on the shield, showing it emerging from a cave and shooting smoke from its nostrils and fire from its eyes. When he was finished, he darkened his room and summoned his father. At first terrified by the sight of the ferocious monster, Ser Piero ultimately found the creation "indescribably marvellous and he was loud in his praise of Leonardo's ingenuity."[29]

Leonardo is known, of course, for the "beauty and elegance" of his work. "Leonardo is the one artist," swooned the connoisseur Bernard Berenson, "about whom it may be said with perfect literalness: Nothing that he touched but turned into a thing of eternal beauty."[30] Yet Leonardo also dwelt on the fantastical and the grotesque, on what might be called infernal beauty. At times he even seems to have believed such things were more powerful and seductive than beauty, science, and reason.

This compulsion for the mysterious and infernal appears in one of his earliest known writings, an intriguing passage composed sometime in the late 1470s. The story he related was probably based on a personal experience of wandering the hills near Vinci, but it quickly takes on symbolic dimensions. He began with a description of how, filled with "eager desire," he explored a terrain of "gloomy rocks" in search of "various and strange shapes" in the landscape. Before long he came to the mouth of a great cavern, before which he stood astonished. He then had a decision to make. "Bending my back into an arch," he wrote, "I rested my left hand on my knee and held my right hand over my down-cast and contracted eye brows: often bending first one way and then the other, to see whether I could discover anything inside, and this being forbidden by the deep darkness within, and after having remained there some time, two contrary emotions arose in me, fear and desire—fear of the threatening dark cavern, desire to see whether there were any marvellous thing within it."[31]

The bottom of the page is reached, but the story—what could be called "The Cave of Fear and Desire"—apparently continued. Leonardo inscribed at the foot of the page the symbol, a loop shaped like the number 6, that he employed to indicate that a passage continued overleaf or on another page. However, the back of the sheet merely deals with scientific problems. The conclusion of the story has never been found, leaving us ignorant of whether his desire overcame his fear, and of what marvelous things he might have glimpsed in the dark and rocky deeps of the grotto.

The allure of fear and danger is explored in one of Leonardo's other writings, composed in the late 1480s.[32] Written in the form of a letter to a friend named Benedetto, it gives a long account of a population terrorized by a giant: a creature with a "black visage," "swollen and bloodshot eyes," and a nose "turned up in a snout with wide nostrils" from which thick bristles protrude. Leonardo speaks as a survivor of the horrific tragedy in which this "raging fiend," to whom every desperate human onslaught "was as nothing," cut a deadly swath through his helpless Lilliputian attackers. He stresses the vanity and uselessness of human defenses: rational efforts at protection prove hopeless against the malevolent terrors of the frenzied giant. "O wretched folk," he wrote, "for you there avail not the impregnable fortresses, nor the lofty walls of your cities, nor the being together in great numbers, nor your houses or palaces!"

The moral of the story seems to be the futility of keeping chaos and catastrophe at bay through the kind of engineering in which—ironically—Leonardo himself specialized. No human ingenuity, he stressed, could master the unstoppable energy of the giant. The only hope was to abandon civilization and escape to "tiny holes and subterranean caves." Here the lucky few survivors, relinquishing their humanity, would live "after the manner of crabs and crickets."

This story may have been the outline for one of Lodovico's masques or pageants, or else simply an amusing literary exercise to read aloud to Milanese courtiers or close friends. Leonardo made clear, however, that his story was a tragedy: mothers and fathers are deprived of their children, women of their companions, and never "since the world was created" has such weeping and lamentation been heard. He concluded on a disturbing personal note that sends the story veering into an even darker realm. The narrator, it turns out, has not escaped or survived after all. "I do not know what to say or do," Leonardo wrote, "for everywhere I seem to find myself swimming

head down within the mighty throat and remaining disfigured in death, buried within the huge belly."

"The Cave of Fear and Desire" reappears here as the mouth of the ravening giant into which Leonardo has peered too closely. He identifies so intensely with his fearsome monster that he imagines himself dead and disfigured inside its belly. Leonardo had become a victim of what Joseph Conrad called the "fascination of the abomination": the hypnotic power of dangerous, mysterious, and destructive forces that operate beyond the reach of human knowledge.[33] The fantastical and grotesque, in Leonardo's story, have comprehensively trampled the rational and scientific.

Leonardo's productions in Milan functioned, behind their stunning visual effects, as Sforza propaganda. The set for *The Feast of Paradise*, for example, had included none-too-subtle details such as portraits of Lodovico's ancestors suspended in a frieze and entwined with garlands. Leonardo also involved himself in another branch of Sforza propaganda by designing emblems for Lodovico. All aristocratic families adopted heraldic symbols and then zealously applied them at every conceivable opportunity. For the Medici in Florence it was the *palle*, the crimson balls that were the principal components of their coat of arms. For the Visconti, it was a coiled serpent devouring a man, an image adopted by the Sforza when Francesco married into the family.

Individual members of aristocratic families took to adopting their own personal symbols or *imprese*: pictures of plants, animals, or objects—accompanied by a motto—that were meant to symbolize a person's virtues. Lorenzo de' Medici, in honor of his poetic pursuits and in a punning allusion to his forename, took the laurel tree. Lodovico likewise drew heraldic inspiration from his name. His middle name had originally been Maurus, but a childhood illness prompted his mother to invoke the protection of the Virgin by rechristening him Maria. Yet Lodovico's eclipsed middle name lived on, forming the basis for endless puns, nicknames, and emblems. Maurus translates as both mulberry and Moor, and Lodovico exulted in both meanings. Mulberries and Moors were symbolically deployed in virtually all of his pageants. His wedding festivities in 1491 had featured a troop of twelve blacked-up Moors parading before a triumphal chariot

commanded by the figure of a Moor seated triumphantly on a globe. A consequence of Lodovico's passion for such imagery was that slaves from Africa became fashionable at the Milanese court, with one chronicler claiming that all Lodovico's courtiers kept a Moorish slave in their retinue.[34]

Leonardo seems not to have devised Moor imagery for Lodovico, but he did compose a sixteen-word literary exercise, a kind of intellectual doodling into which he managed to cram the word "moro" no fewer than five times: *"O moro, io moro se con tua moralità non mi amori tanto il vivere m'è amaro"* (O Moro, I shall die if with your goodness you will not love me, so bitter will my existence be).[35] Leonardo enjoyed this sort of wordplay, which he often combined with riddle-like drawings. While at Lodovico's court he drew a series of pictographs, or images that worked as rebuses, or clever visual puns.[36] Puns of this sort discreetly featured in some of his paintings, as for example in his portrait of Ginevra de' Benci, where a juniper (*ginepro*) stands in the background as a visual play on the young woman's first name.

There seems to have been an entire industry designing emblems and slogans in Milan, and in the spring of 1495 Lodovico undoubtedly took more than his usual interest in heraldry. For, having been officially invested by Maximilian with the dukedom, he was at last able to add the imperial eagles to his coat of arms. Moreover, he wanted his new coat of arms to appear above Leonardo's painting in Santa Maria delle Grazie. The convent was already in the process of being covered with Sforza insignia, marking it out as an institution specially patronized by Lodovico. The exterior wall featured terra-cotta shields on which various of his devices, such as the Visconti vipers, were proudly displayed. Adorning the outside wall of the apse designed by Bramante was another Sforza emblem, a pair of hands wielding an axe to chop a log: a reference to Muzio Attendolo's brief career as a woodcutter.

On the north wall of the refectory, immediately beneath the ceiling vaults, were three crescent-shaped spaces; here Lodovico instructed Leonardo to paint—as symbols of dynastic authority—three heraldic shields. These three coats of arms, those of himself and his two young sons, were probably the first things that Leonardo painted in the refectory. Their existence is yet more evidence that Lodovico was indeed the man who commissioned Leonardo to paint the mural—and that the mural was meant to be, among other things, a celebration of the ducal family and yet another example of Sforza propaganda.

After doing numerous designs and compositional sketches for the mural,

Leonardo probably began his actual painting in the refectory—on these three lunettes—around the time of Lodovico's official investiture. There was, however, a sudden irony to these emblems, since the House of Sforza, within days of the investiture, faced a deadly threat to its existence.

At the end of May, Louis of Orléans, pretender to Lodovico's dukedom, advanced into Milanese territory from his base in Asti. He was at the head of an army of seventy-five hundred men, "as fine a body of troops . . . as ever were seen in the field."[37] What followed was a triumph even greater than Louis could have imagined. When his soldiers appeared before the walls of the city of Novara, the citizens promptly opened their gates and received their invaders, according to one account, "with all imaginable demonstrations of joy."[38] This most dangerous enemy, at the head of a strong army and welcomed by Lodovico's own subjects, was now only twenty-five miles west of Milan.

Lodovico should have been able to count on help from allies such as the Venetians. By attacking a Milanese possession, Louis risked the wrath of the Holy League. However, Lodovico feared more than the duke of Orléans. He was badly shaken by the actions of the people of Novara. Their loyalty to Lodovico had clearly been eroded by the high taxes and loans they were forced to pay for his extravagant building projects, the huge dowry lavished on the emperor, and the loans and payments to Lodovico's various allies. Dissatisfaction with Lodovico's rule was quickly spreading across the duchy. The people of Pavia—a city second in importance only to Milan—appealed to the duke of Orléans to enter their city and deliver them from Lodovico. Meanwhile, if Louis chose to enter Milan, wrote one observer, "he would have been received with more joy."[39]

Fear that his own subjects were turning against him caused Lodovico to panic. He immediately left his country home at Vigevano, where he had been prolonging his celebrations, and returned to Milan. In terror of insurrection and reprisals, he locked himself away in the Castello, refusing to see anyone. He even seems to have suffered a stroke. Two friars reported back to their convent in Venice: "He is in bad health, with one hand paralyzed, they say, and is hated by all the people, and fears they will rise against him."[40]

As Lodovico cowered in the Castello, Louis swung south with his army,

advancing on the Milanese army's camp at Vigevano. The Milanese soldiers were commanded by a captain loyal to Lodovico, his cousin Galeazzo Sanseverino. However, as Louis's army approached, Sanseverino and his men began preparing for a rapid evacuation. The loss of Vigevano, his birthplace and favorite retreat, would have been a humiliating blow to Lodovico. But Louis evidently determined that discretion was the better part of valor. Rather than attacking Vigevano, he led his forces back toward Novara. At Trecate he was met by some of the "chief citizens of Milan" who urged him to invade their city. Offering their children as hostages to Louis as tokens of their faith and allegiance, they assured him that he would meet with success in the enterprise. The people of Milan, they declared, both the common people and the nobility alike, "desired the destruction of the house of Sforza."[41]

The duke of Orléans's attack on Novara had been well-timed. He knew Lodovico would be unable to count for immediate assistance on the forty-thousand-strong army of the Holy League. Francesco Gonzaga was moving south to intercept Charles VIII and his army, which had reached a point seventy-five miles southeast of Milan. The French king had managed to cross the Apennines with his artillery as well as five thousand mules laden with gold and other booty. However, his army, reduced by desertion and disease to ten thousand men, was not the same one that had swept down the peninsula a few months earlier. Effortless conquerors of so many Italian cities, the French finally looked vulnerable. Barely had Charles descended the mountain passes than his troops were pursued by Gonzaga's formidable army. "Here I am," Gonzaga boasted in a letter to his wife, "at the head of the finest army Italy has ever seen, not only to resist, but to exterminate the French."[42] Among Gonzaga's troops were fifteen hundred stradiots recruited by the Venetians in Albania and Greece: "stout, hardy fellows," they dressed like Turks, slept with their horses, and used scimitars to chop off the heads of their enemies.[43] Savonarola's prophecy of terrible misfortunes appeared about to be fulfilled.

Maximilian eventually came to Lodovico's rescue, dispatching a contingent of Swiss and German soldiers. The Venetian Senate also offered help, sending to Milan several thousand stradiots. Not everyone in Venice wished to see Lodovico successfully defended: one Venetian remarked that the best

thing would be for the stradiots to use their scimitars on Lodovico.[44] These foreign reinforcements did, however, prove Lodovico's saviors, forcing Louis and his army to retreat inside the walls of Novara. Although over in the space of a few weeks, the episode had been disconcerting and ominous. It can have been small consolation to Lodovico that his rescuers were neither his own subjects nor his own army, but rather foreigners from across the Alps and, in the case of the stradiots, the Adriatic.

A short time later, on 6 July, Francesco Gonzaga intercepted Charles's army at Fornovo, a dozen miles southwest of Parma. The French forces were drastically outnumbered, while heavy rains rendered their deadly artillery ineffective. Yet at the very moment when Charles's men were brutally exposed for the kill, the Italian forces, seeking treasure rather than blood, abandoned their formations and made straight for the booty-laden French baggage train. They were quickly followed by the stradiots, who, not wishing to miss their chance at plunder, threw down their scimitars and likewise began rifling the French wagons. Laden with spoils, the Italian forces beat a hasty retreat, hotly pursued by French menservants and grooms who, showing a livelier spirit of valor than their enemies, took up the hatchets with which they chopped firewood and, according to an eyewitness, attacked the looters and "knocked out their brains."[45] Charles lost many of his own possessions in the battle, including his helmet and sword, as well as a trophy of undoubted sentimental value: a book containing nude portraits of the many young ladies who had granted him their favors during his Italian campaign.

Although the Battle of Fornovo lasted fewer than fifteen minutes, it resulted in horrendous casualties that made it the bloodiest battle fought on Italian soil in two centuries. The Holy League lost three thousand soldiers, while a thousand French lay dead. The bloodbath concluded with the spectacle of French camp followers, "several pimps and wenches," stripping the dead of their possessions.[46] The Holy League claimed victory, and in honor of the occasion Francesco Gonzaga ordered Andrea Mantegna to paint his *Madonna of Victory*. No one was fooled, however. The ill-disciplined performance of the Italian forces—"the finest army Italy has ever seen"—had been a terrible and embarrassing disgrace. "The palm of victory," wrote Guicciardini, "was universally accorded to the French."[47] Meanwhile, the armies of both Charles and Louis remained on Italian soil, each within striking distance of Milan.

CHAPTER 7

Secret Recipes

As Leonardo prepared to start his mural in Santa Maria delle Grazie, one of the first things the Dominican friars would have noticed happening in their refectory was the building of a scaffold. To paint the coats of arms of Lodovico Sforza and his two sons on the wall of the refectory, Leonardo needed to construct a system of scaffolding that allowed him to ascend to a height of more than thirty feet.

This necessity of climbing ladders and working at altitude, often on awkward surfaces, was one of the reasons that a sixteenth-century artists' handbook declared that fresco was not for "timid painters or irresolute persons."[1] Removed from the conveniences of his studio, the frescoist experienced physical discomfort and even risked a fall. Michelangelo would severely injure his leg in 1541 when he plunged from his scaffold as he frescoed *The Last Judgment* on the altar wall of the Sistine Chapel (he recovered, he claimed, thanks to self-medicating with Trebbiano wine). Much worse was

the fate of Barna da Siena, who plummeted to his death while frescoing a Crucifixion in the Collegiata in San Gimignano.[2]

Leonardo was intrigued by the mechanics of scaffolding. A few years later in Florence, according to Vasari, he invented some sort of scissor mechanism for a scaffold: "an ingenious scaffolding that he could raise or lower by drawing it together or extending it."[3] No drawings or descriptions of his scaffold for Santa Maria delle Grazie survive, though presumably it was less sophisticated. However, like all frescoists he would have provided room enough on the platform to accommodate himself and his assistants, and to allow himself to step back from the wall to appraise his work. He would also have needed a scaffold that caused a minimum amount of disruption to the friars, who, after all, needed to eat their meals in the room where he worked.

Once the scaffold was built, Leonardo would have begun plastering the north wall of the refectory in preparation for painting. The usual method of frescoists was to apply successive layers of lime plaster to a wall or vault, both before and then during their painting. The first coat, the *arriccio*, was a roughcast that smoothed over irregularities in the masonry. It also needed to be coarse enough (sometimes brick dust was added) to provide an adhesive surface for the smoother final coat, the *intonaco*, on which the painter worked. These layers of plaster should be laid, stressed a handbook by Andrea Pozzo, by "an expert and active mason."[4] Although Leonardo must have hired a mason, he may have hoped to involve himself in the preparation of the plaster, experimenting with the addition of ingredients such as sawdust, gesso (a mixture of plaster and size), and textile fibers. "One can also use gesso, sawdust, cloth clipping and glue, and make good plaster," one of his notes reads. "Or else: tow trimmed with blades as at the fulling-mill, gesso and glue. It is good."[5] He was clearly interested in creating a coarse plaster with an adhesive surface. However, the plaster applied to the wall of the refectory was fairly standard, consisting of lime blended with pulverized quartz and local river sand. It was troweled to a thickness of 1.5 to 2 centimeters, with the plaster in the middle of the wall—where Christ and the apostles would feature—slightly coarser in consistency.[6]

The friars would inevitably have been inconvenienced as this work began. For several weeks on end, the refectory, which was poorly ventilated, must have had an unpleasant stink. Pozzo observed that the lime in the *arriccio*

"exhales a bad smell," making it "very injurious to the health."[7] Once it was applied, the artist needed to wait for it to dry, a process that in cool weather might take a month or two. When it finally dried, the second layer, the *intonaco*, could be added and the painter was ready to start.

Frescoists worked in a very precise manner. At the start of each working day, the mason troweled the *intonaco* on to a small patch of wall to which the artist added his pigments before it dried. Pozzo succinctly described the process. "It is called fresco painting," he wrote, "because the painting must be performed on it while the plaster is still damp; and for this reason, the plaster must not be spread over a larger portion of the surface than can be painted in one day."[8] A fresco was therefore created section by section, day by day, with the painter working swiftly on small fields of wet plaster. As Pozzo pointed out, a fresco needed to be executed "with greater quickness and celerity" than any other type of painting.[9]

Frescoists generally did not paint freehand on the wet plaster. One of the keys to fresco was the use of cartoons (from *cartone*, a heavy paper or pasteboard) to transfer the design to the wall. The cartoon, a full-scale template for the fresco, was created by scaling up the smaller designs, usually via a grid of proportional squares, and transferring them to a master cartoon made (depending on the size of the fresco) from a few to dozens or more pasted-together sheets of paper. This large cartoon, which for Leonardo's *Last Supper* would have been almost thirty feet wide, was cut up into smaller sections, which were then attached to the wall immediately after each patch of the *intonaco* was applied. The design on the cartoon was transferred to the wall in one of two ways: either by using a stylus to trace over the charcoal drawing and leave incisions on the wet plaster, or else by pricking the cartoon with hundreds of pinholes and then striking it with a pounce bag filled with powdered charcoal, leaving a dotted outline on the *intonaco*. The painter then removed the cartoon and began following either the incisions or the dotted lines.

Fresco therefore entailed a huge amount of time-consuming preparatory work before the first brushstroke of paint could be laid: designing and building the scaffold, mixing and troweling the plaster, and transferring designs from the cartoons, which were themselves the product of countless preliminary drawings and as many as several hundred sheets of paper (one famous surviving cartoon, Raphael's for *The School of Athens*, a twenty-five-foot-wide fresco painted in the Vatican Apartments in about 1510, was made from 195 sheets of glued-together paper).

Despite Leonardo's love of challenges, his lack of experience in this dif-
ficult medium would have given him pause. Furthermore, this technique of
painting—of expeditiously adding pigments and then moving on to an
adjacent section—was ill-suited to his manner of working. He was not
someone who worked with "quickness and celerity." The diary kept by Ja-
copo da Pontormo as he worked in the church of San Lorenzo in Florence
gives a good sense of how the frescoist progressed. "On Thursday I painted
those two arms," he recorded. "On Friday I painted the head with the rock
below it. On Saturday I did the trunk of the tree, the rock, and the hand.
On the 27th I finished the leg ... On Tuesday I began the torso ... On
Thursday I did an arm. On Friday, the other arm. On Saturday, the thigh."[10]

It is difficult to imagine Leonardo working in such piecemeal fashion.
He was not someone who finished an arm on Friday and then on Saturday
happily moved on to paint the thigh. He preferred to work at a more lei-
surely pace than fresco required, concerning himself with subtle effects—
modulations of color or transitions of light and shade—that fresco's
requisite speed of execution made virtually impossible. His portraits and
altarpieces were painted with prodigious deliberation. He manipulated his
paint with great care, blending and texturing the pigments. To achieve his
unique effects of light and shade, he even dabbed and smeared the wet paint
with his fingertips. Fingerprints can still be seen on several of his paintings,
such as his portraits of Ginevra de' Benci and Cecilia Gallerani—evidence
of his attempts to soften the women's features, as well as of the painstaking
efforts he made to achieve his extraordinary visual effects.[11]

Leonardo's lack of experience in the medium, as well as its unsuitability
for his particular genius, were probably two of the objections behind his
frustrated and fragmentary letter to Lodovico protesting about a commis-
sion that was "not my art." However, evidently reconciled to the project, he
decided to proceed, typically, in an experimental fashion, albeit not in the
time-honored style followed by the legendary painters whose frescoes he would
have seen in Florence.

<center>⁂</center>

Leonardo was fascinated by the possibilities of working with oil paint. His
notebooks contain numerous references to different types of oils. He seems
to have experimented with making oils from walnuts, linseeds, mustard

seeds, juniper needles, and the gum of cypress trees. His studio must at times have resembled an apothecary's shop or alchemist's laboratory, with oils oozing from presses and bubbling in pots. He even tested out ways of getting rid of the "evil smell" of certain nut oils by mixing them with vinegar and reducing them over a flame. He had no end of advice on the subject: "And if you want the oil to be good and not to thicken," reads one of the instructions in his treatise for painters, "put into it a little camphor melted over a slow fire and mix it well with the oil and it will never harden."[12]

Compared with egg tempera, oil paint was still, relatively speaking, a new and somewhat experimental technique. Vasari mistakenly claimed that oil painting was invented in the first half of the fifteenth century, but in fact the process of using oil as a vehicle for pigment was described as early as the twelfth century in a Latin treatise by a German monk known only by the pseudonym Theophilus Presbyter. However, painting in oil achieved no widespread currency until improvements in the technique were made in Flanders in about 1410 by Hubert van Eyck. The court painter to the duke of Burgundy, van Eyck perfected a method of suspending his pigments in a mixture of linseed and nut oil blended with resins and lavender oil. His renown for this innovation was such that the bones of his arm and hand were preserved like relics near the church in Ghent where he was buried beneath the sobering inscription: "I was called Hubert van Eyck. I am now food for worms."[13]

Making generalizations about medieval Italian painting is difficult due to the fact that fewer than 5 percent of all works painted in the fourteenth century have survived.[14] However, anecdotal evidence suggests that oil painting was known in Italy at least since the early fourteenth century. In 1325, a pupil of Giotto named Giorgio d'Aquila was provided with a supply of nut oil when the duke of Savoy hired him to paint a chapel at Pinarolo—but when the oil failed to meet Giorgio's standards, he sent it to the duke's kitchen to be used for cooking.[15] Van Eyck's innovations entered Italy by means of Antonello da Messina, who worked for a time in Bruges, and whose tomb in Venice (where he died in 1479) proudly recorded that "he was the first who conferred splendour and durability on Italian painting by the mixture of colours with oil."[16] Antonello supposedly passed the secret to Domenico Veneziano, who, according to one of Vasari's taller tales, was murdered by a rival—none other than Andrea del Castagno—who was jealous of his painterly feats. In Vasari's version, Castagno gained Venezia-

no's confidence by entertaining him with carefree evenings of serenading pretty girls with lutes. After Veneziano finally divulged the secret of oils, Castagno beat him over the head with a lead pipe.[17]

Alas for the story, Castagno died of the plague in about 1457, several years before Veneziano. There is probably no more truth in the story that Giovanni Bellini tricked Antonello into revealing the secret by turning up at his studio disguised as a Venetian nobleman who wished to have his portrait painted, then watched carefully as Antonello went to work.[18] However apocryphal these stories, there is no doubt that throughout much of the fifteenth century the technique of mixing pigments with oils—of finding both the right oils and the right mixture—was a jealously guarded workshop secret.

Verrocchio, who worked only in tempera, did not concern himself with this newer technique. Leonardo, though, was interested in oil paint even as an apprentice. The face and curly head of the kneeling angel in Verrocchio's *Baptism of Christ*—widely accepted as Leonardo's handiwork—were done in oil rather than tempera. For his portrait of Ginevra de' Benci, done in the mid-1470s, he used both oil and tempera paints, but a decade and a half later, in the portrait of Cecilia Gallerani, he used oils exclusively. The superiority of oils for capturing certain optical effects, together with Leonardo's proficiency in the technique, appears to have been recognized by the members of the Confraternity of the Immaculate Conception, whose 1483 contract with Leonardo and the de Predis brothers repeatedly stressed that both the figures and the landscape background of the altarpiece should be done in oils.

Oil paint had a number of distinct advantages over egg tempera. Most obviously, pigments blended with oil looked richer and glossier than those mixed with tempera. Oils allowed an artist a greater range of color values and tonal gradations because they could be blended either on the palette or (as Leonardo's smudging fingerprints attest) on the pictorial surface itself. An artist could also vary the ratio of oil to pigment, resulting in a wide range of consistencies, anything from thin, translucent layers of color to dense impastos. He could heat his oil before the pigment was added to create a more viscous paint, or he could reduce the viscosity by adding camphor or other oils. Unlike tempera, oils did not change color as they dried. They also dried more slowly, permitting the artist to rework his painting by making as many corrections as he might desire—one of the many other properties that undoubtedly appealed to Leonardo.

As the legends of espionage and murder suggest, a painter working in

oils required a great amount of tradecraft. He needed to understand the specific properties of his various pigments: which ones worked best in oil and which in tempera. He also needed to decide which oil—linseed, walnut, poppy—to mix his pigment with, and whether he wanted to heat the oil over a flame or by standing it in the sun. To these ends Leonardo, with his pestles, mortars, and bubbling pots, conducted his various experiments.

Painting with oil had allowed Leonardo to capture the startling visual effects that were winning him his reputation as a painter: the moody half lights and misty atmosphere of *The Virgin of the Rocks*, the soft-focus facial expressions in his portraits of Ginevra de' Benci and Cecilia Gallerani. His aptitude and experience in oil rather than fresco led him to consider painting his *Last Supper* in a technique different from the usual one: that is, by working with oils on a dry wall.

This method was new and largely untested, though its effectiveness had been affirmed by the architect and polymath Leon Battista Alberti. In his *De re aedificatoria (On the Art of Building)*, written in the 1440s, Alberti offered instructions for fresco painting to which he appended an intriguing coda: "It has recently been discovered that linseed oil will protect whatever colour you wish to apply from any harmful climate or atmosphere, provided the wall to which it is applied is dry and in no way moist."[19]

Leonardo owned a copy of Alberti's work, one of the most famous architectural treatises of the fifteenth century.[20] More to the point, he would have known the works that Alberti was talking about. Alberti was almost certainly referring to the murals of Domenico Veneziano, who in the late 1440s (around the time Alberti was writing) worked with oil paints on a dry wall in the Portinari Chapel in the hospital of Santa Maria Nuova in Florence, an experiment repeated in the same chapel a few years later by Veneziano's supposed rival and murderer, Andrea del Castagno.[21]

Although neither painter's work survives, Leonardo would undoubtedly have seen them (he had a bank account at Santa Maria Nuova) and appreciated their novel technique. He must also have known the mural that Paolo Uccello and Antonio di Papi painted using oils in the refectory of the Florentine church of San Miniato al Monte. This mural, a Crucifixion scene done in the mid-1450s, does not survive, but documents from San Miniato are clear about the oil, which the pair used "even though they were not obliged." The men in charge of the decorations were so pleased with the result that the painters received a bonus.[22]

The examples of these painters, together with Alberti's statement and his own innovative nature, would have given Leonardo the inspiration and confidence to tackle his *Last Supper* by using oils on a dry wall. In fact, he was prepared to go one better, mixing his pigments not only with oils but also with egg yolk to create an "oil tempera."[23] In essence, he took tempera paints and mixed emulsifying oils into them. The process was so novel— there is no known precedent—that he must have spent a good deal of time beforehand experimenting in his studio in the Corte dell' Arengo, trying to perfect the right recipe.

Leonardo's approach to his mural would therefore deviate from that of Montorfano, who was working on his fresco of the Crucifixion a little more than a hundred feet away. Leonardo created an entirely different surface on which to paint. Once his first coat of plaster dried, he covered it with a thinner, slightly granular layer of calcium carbonate mixed with magnesium and a binding agent probably made from animal glue.[24] Once this preparation layer had dried, he added an undercoat of lead white: a primer coat, in effect, to seal the plaster and enhance the mural's luminosity.[25]

Leonardo must have known that this strategy of using a lead white primer was a risky one. Made by combining strips of lead with vinegar and horse manure, white lead was the most widely used pigment in history, and for many centuries it was the white of choice in European art. Its use was inadvisable in frescoes, however, since as it oxidized it transformed into lead dioxide and turned a brownish color. Evidence of this transformation could be seen in Cimabue's frescoes in the Lower Basilica of San Francesco in Assisi, where the whites darkened with disastrous consequences, inverting the original contrasts. Leonardo must have believed the pigment would be stable if mixed with oil or applied with a binder, such as egg tempera, or if it were added to a dry wall rather than to wet plaster.

There was another risk to using lead white, especially in such large quantities. Lead is, of course, poisonous. Its toxic nature had been known at least since the time of the ancient Romans, when the architect Vitruvius noted that it was "hurtful to the human system": plumbers, he noticed, had a "deep pallor."[26] Lead poisoning was an occupational hazard for painters. Raphael and Correggio may have suffered from it, while James McNeill

Whistler was certainly a casualty: he fell ill in 1862 while painting *The White Girl*. Van Gogh, who used to lick his pigments (lead has a sweetish taste), was probably yet another victim. The madness and melancholy for which so many painters became notorious was attributed by many—such as Vasari, who himself suffered periods of depression—to their sedentary and cerebral lifestyle; however, it may in fact have had something to do with the poisonous pigment on the tips of their brushes.[27] Few painters before or since have used as much lead white as Leonardo did when he painted in Santa Maria delle Grazie—though he appears not to have displayed any symptoms of lead poisoning.

Once this primer of lead white had been spread, Leonardo prepared to go to work with his paints, adding them to the snow-white, bone-dry wall. How exactly he began transferring his designs is not entirely clear. It is uncertain whether he used cartoons and, if so, how extensively, for no cartoons survive—but then cartoons, by their very nature disposable and inevitably damaged by their application to the wall, very rarely survived. In places Leonardo took a stick of red chalk and sketched outlines and patterns directly onto the undercoat of white lead.[28] Elsewhere on the wall he made underdrawings by using a brush and painting freehand with a black paint. He also incised lines into the plaster, possibly using a cartoon. However, when the time came to paint he did not always follow these incisions, revising and improvising as he went along. Nonetheless, there are few signs of dramatic changes or hesitations. Nor are there any of the telltale pinpricks that would indicate the use of a cartoon.[29]

Once Leonardo found what he believed to be the right recipe for his "oil tempera," he began adding his paints in successive layers, allowing one to dry before adding the next: a process impossible in fresco. He often used four or five separate coats of different colors to build shapes and create tones, sometimes starting with a darker pigment in the background and then augmenting and highlighting it with paler, semiopaque colors. When he painted the sky in the background, for example, he first used azurite (a mineral-based pigment) to which successive layers of lighter blue were added to give the illusion of depth. He also took special care with the flesh tones, using three or more pigments. For some faces he began with a base coat of lead white, followed by a black to which he added vermilion, then more lead white, and finally yellow ocher and yet another layer of vermilion.[30] The layering of paint, the leisurely and deliberate process it entailed, the ability

it gave him to rework areas—all of these things were characteristic of painting with oils on a wooden panel rather than on an immense plaster wall. He even used a series of translucent glazes to heighten the colors.[31]

Leonardo intensified his colors in other ways too. He used many pigments that were incompatible with fresco, especially bright blues and reds such as ultramarine, azurite, and vermilion. The frescoist was limited in his palette because mineral-based pigments were unable to withstand the action of the lime. They could be mixed with a binder such as egg white and then added to the wall, and indeed many painters worked in this way (Michelangelo later used extensive passages of ultramarine in his *Last Judgment* in the Sistine Chapel). However, the eventual discoloration of the binder meant that ultimately the colors would turn into (as one treatise cautioned) "ugly daubs."[32] The frescoist was therefore advised to stick to those pigments—the duller ochers and umbers—that were compatible with lime plaster and did not require mixing with a vehicle other than water.

Leonardo, however, clearly wanted his mural to have the chromatic panache of an altarpiece painted in tempera or oil rather than this more limited range of tones necessitated by fresco. He understood like no one before him the way colors interacted: how one color could affect, or was affected by, the one beside it. "The surface of any opaque body," he wrote, "is affected by the colour of surrounding objects."[33] He realized, that is, the way colors change their intensity and hue depending on what colors surround them. For example, he noted that a red appears more intense if placed next to a white or a yellow rather than next to purple. He therefore discovered the law of complementary colors, observing that colors were the most intense if "surrounded by their strongest contrasts."[34] He was centuries ahead of his time with this observation. Only in the nineteenth century would the law of "simultaneous contrasts of colour" (as it was dubbed by the French chemist Michel-Eugène Chevreul) be developed further. In 1839, Chevreul devised a color wheel (now a mainstay of the school art room) that showed how intense, vibrant contrasts could be achieved by juxtaposing colors 180 degrees apart—a perception ultimately leading to the pointillism of Georges Seurat and then the violent, clashing colors of the postimpressionists.[35]

One of Leonardo's other observations on the relativity of color is notable: "A shadow is always affected by the colour of the surface on which it is cast."[36] Arguably, the implications of this observation—that shadows are not black but rather tinged with color—were not understood or explored

until it became one of the key perceptions of impressionism, neatly defined by an American critic as the "blue-shadow idea."[37] Leonardo even had a recipe for making blue shadows, a pigment composed of verdigris mixed with lac, a gummy reddish substance derived from insects.[38]

In any case, Leonardo's choice of technique and materials guaranteed that the friars of Santa Maria delle Grazie would eat their meals in the midst of a dazzling show of color.

※

Leonardo's accounts show that, faced with a major project, he purchased his pigments in bulk. A few years later in Florence, while working on another mural, *The Battle of Anghiari*, he bought two pounds of cinnabar, four pounds of a yellow pigment, six of a green one, twenty pounds of German blue (made from the mineral azurite), and forty pounds of linseed oil in which to suspend his pigments. The total cost was 120 lire, or 30 florins, the annual wage of a low-paid manual worker such as a female weaver.[39]

The pigments for *The Last Supper*, a mural smaller in size than *The Battle of Anghiari*, would presumably have been roughly half that sum. Since the contract for *The Last Supper* has been lost, all details about the materials specified or the expenses allowed (for paint, plaster, and scaffolding) are unknown. However, Leonardo's experience with the Confraternity of the Immaculate Conception—when his entire salary went (so he claimed) on paints and other materials—must have persuaded him to give the contract some careful scrutiny.

The highest quality pigments came from Venice, and artists' contracts sometimes made allowances for artists to travel from as far away as Florence and Siena to supply themselves.[40] An artist could buy the raw materials for pigments (such as cinnabar for reds or malachite for greens) and make the colors himself by grinding them into a powder in the workshop. Alternatively, he could buy his pigments ready-prepared from a specialist purveyor. No records indicate where or from whom Leonardo purchased his pigments for *The Last Supper*, though for *The Adoration of the Magi* he bought prepared pigments from the monks of the convent of San Giusto alle Mura, who were renowned for their skill in manufacturing colors (other customers included Botticelli and Michelangelo).

Leonardo's purchases from the monks of San Giusto alle Mura were one

of the conditions of his contract. However, he seems to have preferred purchasing the raw materials himself and then—unsurprisingly—experimenting with his own mixtures and preparations. One of his recipes for a white pigment stated: "Put the white into an earthen pot . . . and let it stand in the sun undisturbed for 2 days." A yellow pigment could be created, he noted, by dissolving ground-up orpiment, a yellowish mineral, with another mineral, realgar, in the corrosive solution known as aqua fortis (a mixture of nitric acid and water). A flesh tone could be made from grinding up reddish crystals from a place he called Rocca Nova, and a green from mixing verdigris and lemon juice. Alternatively, a "fine green" could be made from combining verdigris with either aloes, plant gall, or the herb turmeric.[41]

When the time finally came to paint the wall of the refectory, Leonardo would have climbed to the very top of his scaffold. Frescoists almost always painted from top to bottom in order to avoid dripping paint onto completed areas. Leonardo was probably no exception, and so the first things he painted in the refectory would have been the three heraldic shields in the lunettes immediately beneath the ceiling vault: the emblems of Lodovico Sforza and his two male heirs. Lodovico's coat of arms would soon be a familiar sight in and around Milan. He was planning to have them carved in marble and placed on the city gates as well as on all public buildings. It was an enterprise that he claimed lay "close to my heart."[42] But the first place they appeared in all their glory seems to have been the refectory of Santa Maria delle Grazie.

These three heraldic shields have deteriorated drastically and are difficult to read, not least because they were painted over in about 1700, partially rediscovered seventy-five years later, and then fully uncovered only in the middle of the nineteenth century. However, the shield in the upper left—in all likelihood the first thing painted by Leonardo—is clearly that of Lodovico's eldest son, Massimiliano. The name of the boy, who was born in January 1493, reflected Lodovico's shifting allegiances and expanding political ambitions. He was originally named Ercole in honor of his maternal grandfather, Ercole d'Este of Ferrara, but within the year Lodovico had him rechristened Massimiliano to ingratiate himself with the emperor Maximilian. Since the boy bore the title duke of Pavia, his coat of arms showed both the Visconti viper and the eagles of Pavia.

Massimiliano's younger brother, Francesco, named for his paternal grandfather, was born almost exactly two years later, in February 1495, at

around the time Leonardo was beginning work in the refectory. The new-born was celebrated on the shield in the upper right-hand corner of the room. The heraldic imagery is almost entirely lost, but the words DVX BARI—that is, duke of Bari, young Francesco's title—are still legible. Lodovico and his wife were commemorated in the center, in the largest of the three lunettes. Once again, the heraldic imagery is difficult to read, although both the imperial eagle and the Visconti viper are present, while Beatrice would have been represented by the white eagle and the fleur-de-lis that adorned the Este family crest.

Leonardo enjoyed inventing mottoes and clever *imprese*, but producing these three heraldic shields would have been an unimaginative task. He enlivened the images by surrounding each with a wreath of palm fronds adorned with grasses, acorns, and oak leaves, and fruit such as apples, apricots, and pears. In the central lunette he even added blackberries, olives, and quinces. These details he painted with naturalistic precision (even the veins in the leaves of the pear branches are carefully painted) despite the fact that they are over thirty feet from the floor and would have been difficult if not impossible to see in the dim light of the refectory. He also added gold detailing to the coats of arms, creating the illusion, through a sense of depth, that actual shields were suspended high on the wall.

The three heraldic shields were not the only ones that Leonardo planned for the refectory. Lodovico, who thought so often of his ancestors, was also

The central lunette above The Last Supper *displaying the Sforza coat of arms*

thinking about his posterity, and of how the refectory of Santa Maria delle Grazie could be turned into a kind of Sforza family gallery. To that end, Leonardo added two more shields in the lunettes on the walls adjacent to where he was about to paint his *Last Supper*. These were left blank, awaiting the birth of further Sforza heirs.* The gesture was an optimistic one at a time when the House of Sforza faced such dangerous threats. One thing must have occurred to Leonardo as he began work: should Lodovico fall from power, the commission was certain to be canceled.

Leonardo painted the Sforza coats of arms with the help of an underdrawing. He scored the wall with a stylus, creating an outline (possibly with the help of a cartoon) that he proceeded to reinforce with charcoal. The freehand charcoal sketch reveals backward hatching: a sure sign that Leonardo himself drew it. However, in time-honored workshop fashion, he almost certainly delegated some of the painting to various of his assistants.

Whether working on panels or frescoes, artists always assigned the lesser tasks, such as background scenery and repetitive details, to their assistants or apprentices. Michelangelo's famous claim that he worked alone on the vault of the Sistine Chapel, "without any help whatever, not even someone to grind his colours for him," is demonstrably untrue.[43] Patrons accepted that not every inch of a fresco could be painted by the hand of the master, but their contracts usually stressed that the head of the workshop should be responsible for the most important, conspicuous, and difficult aspects. Luca Signorelli's 1499 contract for frescoes in Orvieto Cathedral was typical in its insistence that Signorelli himself was to paint "the faces and all parts of the figures from the middle of each figure upwards."[44] The contract also specified that Signorelli was to mix his pigments himself, an indication of the difficulty and importance of this tedious and time-consuming task.

The precise identity of Leonardo's assistants is not known for certain, apart from Salai. The little terror was by now fifteen and working as Leonardo's faithful if undistinguished helper. Gathered about Leonardo in Milan, however, were more talented assistants, a small group of young

* The shield on the wall of the lunette on the east wall was destroyed by an Allied bomb in 1943.

painters who formed a kind of School of Leonardo. They included a wealthy young Milanese nobleman, born about 1467, named Giovanni Antonio Boltraffio. Another of Leonardo's pupils, also born around 1467, was Marco d'Oggiono. Each had suffered the occupational hazard of working with Leonardo: Salai stole silverpoint drawings from both of them.

Boltraffio and Oggiono had struck out on their own by the mid-1490s, working together in Milan on an altarpiece for the newly built oratory attached to San Giovanni sul Muro. They absorbed their master's style so thoroughly that at one time this altarpiece was attributed to Leonardo himself. Leonardo had a close working relationship with both men, to the point of providing drawings and designs for them to work with (as perhaps was the case with their altarpiece for the oratory). He could easily have called upon them for assistance with his mural. No document records their presence in his workshop at this time, but absence of evidence is not necessarily evidence of their absence.

The notebooks do record the presence of other assistants. Ever the dutiful accountant, Leonardo registered numerous payments to various members of his household and studio in the Corte dell'Arengo: Gian Pietro, Benedetto, Giovanni, Gian Maria, Bartolomeo, and Gherardo.[45] Gian Pietro was probably Giovanni Pietro Rizzoli, later known as Giampietrino, a young Milanese painter who is known to have worked in Leonardo's studio.[46] The identities of the others are unclear. Recorded in Leonardo's laconic accounting and spare of other details, their names are not easily identifiable as painters. It is unlikely that all were involved in the execution of the mural. However, several of them, such as Benedetto and Giovanni, were clearly skilled craftsmen of some sort, able to earn a sizeable income in the space of a few short months. If they were experienced frescoists, they must have regarded Leonardo's plans for the refectory with incredulity and amazement.

"Trouble from This Side and That"

Charles VIII and his troops reached the safety of the fortress at Asti in the middle of July 1495. They were ragged, exhausted, and ill provisioned, having been reduced to drinking stagnant water from ditches and eating nothing but bread—"and that none of the best"—following their flight from Fornovo.[1] Ten months earlier, Asti had been the setting for Charles's first meeting with Lodovico Sforza. On that occasion, Charles was entertained by Lodovico with singers, dancers, and musicians, while Beatrice astonished the flower of French chivalry with the beauty of her gown, whose bodice (according to one breathless French report) "was loaded with diamonds, pearls and rubies, both in front and behind."[2] But now the two princes were at war, with Charles awaiting the arrival of twenty thousand Swiss mercenaries so he could renew his assault.

Lodovico could at least take heart that his rival for the lordship of Milan, the duke of Orléans, was faring badly. Having been forced to retreat into Novara following his bold feint at Milan, Louis and his troops were

now besieged, surrounded by a combined force of Venetian and Milanese soldiers. Lodovico did not plan to attack Novara. He lacked the artillery, and in any case he had no wish to see one of his own cities destroyed by cannon. Instead, he decided to starve Louis and his troops, who had fled inside Novara in such a panic that, in a drastic oversight, they failed to provision themselves. The Holy League's soldiers diverted the water that powered the mills inside the town, leaving the French troops unable to grind their small store of grain. The soldiers were starved of information as well as food, since Lodovico, ever the master of deception, sent into Novara forged documents claiming that Charles had died in the field at Fornovo. Morale inside the walls was not helped by another rumor: that Charles was too busy trying to seduce Anna Solaro, the daughter of a local lord, to trouble himself with their plight.[3]

The siege of Novara lasted through the summer of 1495 and into the autumn. The town quickly plunged into the most dire misery. "Every day some were starved to death," wrote a French chronicler.[4] From Asti, Charles dispatched a train of pack animals in hopes of provisioning the town, but it was easily captured and the supplies confiscated.

At length, there was hope for the besieged troops. With both winter and the Swiss mercenaries fast approaching, Francesco Gonzaga began to make overtures to Charles, first of all returning the sword and helmet captured at Fornovo, along with the album of the king's amorous conquests. Charles expressed his thanks and, through his ambassador to Venice, let it be known that he, too, desired peace. Negotiations were opened, with Lodovico initially taking a hard line. But he needed peace much more than he wanted war, and the evacuation of Novara was quickly agreed. By the time the siege ended, after three months and fourteen days, two thousand of Louis's troops had perished of starvation and disease. A French ambassador was shocked by the sight of the survivors—"so lean and meagre that they looked more like dead than living people; and truly, I believe never men endured more misery."[5] Hundreds more died on the roadsides as they evacuated Novara, and a dozen miles away, at the French outpost of Vercelli, the dung heaps were stacked with corpses.

Louis was eager for revenge against Lodovico. Immediately after the evacuation, according to a shocked French ambassador, he "began to talk of fighting again."[6] As the twenty thousand Swiss mercenaries finally arrived

in the French camp, he urged Charles to cease negotiations and turn his army loose on Milan.

These political events may have temporarily distracted Leonardo from his work in Santa Maria delle Grazie. No situation was so dire that Lodovico could not see fit to summon a bit of pomp and circumstance, and once more Leonardo—"the arbiter of all questions relating to beauty and elegance"—may have been enrolled into service.

In August, during the siege of Novara, Lodovico presided over a review of the Holy League's army, a spectacular parade that witnessed the Milanese troops marching under a gigantic banner featuring the familiar figure of a Moor holding an eagle in one hand and strangling a dragon with the other. "It was indeed," wrote a Neapolitan scholar who watched the review, "a stupendous sight." There was an unfortunate hitch in the proceedings when the horse carrying Lodovico stumbled and fell, throwing him to the ground and muddying his finery. "This was held to be an evil omen," observed one chronicler, "and was remembered afterwards by many who were present that day."[7]

No evidence reports that Leonardo was involved in the siege of Novara or in the diversion of the town's water supply. However, his interest in hydraulic engineering—and his experience with everything from canals and fountains to water-powered alarm clocks—would have made him a natural choice. His letter of introduction to Lodovico had touted his expertise in "guiding water from one place to another." While in Lodovico's employ he had made a study of the canals in the countryside around Vigevano, where the main channel, the Naviglio Sforzesco, lay at the heart of a large and complex network of waterways. Determined to improve the area's navigation and irrigation, he offered detailed suggestions about the construction and operation of mills, sluices, and locks.

One assignment Leonardo was probably given around this time was the fortification of the Castello in Milan. Military architecture was yet another of his interests. He owned a copy of the *Trattato di architettura civile e militare* by Francesco di Giorgio Martini, the most sought-after military engineer in Italy. His copy still exists, its sketches and marginal annotations testimony

of his close and avid reading of the text. Francesco was probably a kind of boyhood hero of Leonardo's: the man who, as a designer of military hardware, first inspired his interest in war machines. In 1490 he met Francesco when the two of them consulted on the central dome for Milan's cathedral. They then traveled together to Pavia, riding there on horseback and staying together at an inn while they consulted with engineers about Pavia's cathedral. Leonardo's interest in fortifications must only have increased after 1494, when the French artillery starkly revealed the extreme vulnerability of Italian fortresses.

Leonardo's notes confirm that he conducted a thorough survey of the Castello's defenses with a view to improving them and making the refuge impregnable. "The moats of the Castle of Milan . . . are thirty braccia," stated one memorandum (one braccia being twenty-three inches). "The ramparts are sixteen braccia high and forty wide . . . The outer walls are eight braccia thick and forty high, and the inner walls of the castle are sixty braccia." He wrote that such fortifications "would please me entirely" were it not for the fact that the embrasures—the small apertures at which, he noted, "good bombardiers always aim"—were in line with secret passageways inside Castello's walls. If these weak spots were breached by the artillery, the invaders would pour into the fortress and "make themselves masters of all the towers, walls and secret passages."[8] If Lodovico read these words in the aftermath of Novara, they must have sent a chill down his spine.

Activities such as safeguarding the state and foiling its enemies would undoubtedly have given Leonardo more pleasure and prestige than painting a mural in the refectory of Santa Maria delle Grazie. His letter to Lodovico had emphasized his ability to invent and deploy deadly "instruments of war." Yet for a dozen years his ideas had largely been ignored as he was required instead to amuse courtiers with gadgets and pageants. Then suddenly the Italians had been humiliated in battle, with their castles and cannons proving worthless against the French assault, and with Lodovico, at the first whiff of gunpowder, forced to cower inside his castle. Leonardo must have believed that with the peninsula at war and Lodovico menaced by powerful enemies, he would at last be given the opportunity to build his war machines.

Leonardo seems to have been involved in another project in 1495: one that apparently took him back to Florence, a city drastically changed from the days of his apprenticeship. Over the years he had probably made occasional (but undocumented) return visits to the city, which lay only 150 miles to the southeast. Although his old master and friend Verrocchio had died in 1488, his father was still alive. Ser Piero, now sixty-nine, had married for the fourth time, and his house in the Via Ghibellina (to which he had moved in 1480) was filled with babies. He now had eight children besides Leonardo: six boys and a pair of girls. All but the two eldest, Antonio and Giuliano, had been born since Leonardo's departure for Milan. The youngest, Pandolfo, was only a year old, and in 1495 Leonardo's latest stepmother, a thirty-one-year-old named Lucrezia, was pregnant with yet another child.

If Leonardo did return to Florence, it was not for artistic reasons. He received no painting commissions from any Florentine patrons during his Milan years, in part, no doubt, because of his reputation for belatedness. He did, however, hope to involve himself with the Florentine business community, in particular the wool merchants. Florence had a thriving cloth industry, and Leonardo designed numerous machines for the textile trade, such as hand looms, bobbin winders, and a needle-making machine that he calculated would produce forty thousand needles per hour and revenues of a mind-boggling sixty thousand ducats per year. All of these inventions he no doubt hoped would find their place in Florentine industry. In about 1494 he drew plans for a weaving machine, and in the same pages he outlined a project for a canal by which, he claimed, Florence's Guild of Wool Merchants could transport their goods through Tuscany and, by extracting revenues from other users of the canal, boost their profits in the process. These pursuits reveal the breadth of Leonardo's interests, the scope of his ambitions, and the depth of his conviction that there was no task that could not be improved through technology and invention. None of his plans seems, however, to have tempted the hardheaded merchants of Florence.[9]

What appears to have brought Leonardo back to Florence in 1495 was the change of government and the possibility of an architectural commission. Florence had declared itself a republic and adopted a new constitution following the expulsion of the Medici at the end of 1494. The power vacuum caused by the expulsion was swiftly filled by Girolamo Savonarola, who claimed to enjoy undisputed authority as God's mouthpiece. He advocated establishing a popular assembly composed of all Florentine males

over the age of twenty-nine. Such an expansion of government meant that a large new council hall needed to be built.

Vasari recorded that opinions on the construction of the hall were solicited from various artistic worthies, among them Leonardo and a young Michelangelo. The latter was only twenty years old at this time and, in truth, unlikely to have been consulted. In fact, Michelangelo was not even in Florence in 1495, having left for Bologna after the fall of the Medici. Vasari may have been more accurate regarding Leonardo's involvement. Yet if Leonardo hoped to secure the commission—the details of which were decided only after "much discussion"—he was disappointed. The job went instead to Simone del Pollaiuolo, known as Il Cronaca, a man who was, as Vasari pointedly remarked, "the devoted friend and follower of Savonarola."[10]

Leonardo might have had another reason for visiting Florence at this time: to operate as a spy against his native city. In his notebooks, someone—not Leonardo—scribbled a partially legible phrase, a "memorandum to Maestro Lionardo" that exhorted the painter to "produce as soon as possible the report on conditions in Florence," and in particular how Savonarola "has organized the state of Florence."[11] Leonardo was evidently to report back to someone in Milan on the political condition of Florence: in effect, to pass on information about Savonarola and the new republican government, presumably to Lodovico Sforza. He was ordered to pay particular attention to the city's fortifications, for example, how the forts were armed and garrisoned, which suggests that an attack or an invasion was being planned.

No report from Leonardo survives, so it is unclear whether or not he operated as the duke's secret agent in Florence. However, the assignment would not have been surprising in light of the poor relations between the two states. Florence had remained steadfast in its alliance with the French and, despite offers of military assistance from the other signatories, declined to join the Holy League. The French still occupied Pisa and various of Florence's fortresses, but the Florentines clearly had more faith in the French than in Lodovico, whom they rightly suspected of aspiring to the lordship of Pisa. During the summer, in fact, Lodovico had dispatched a team of archers to Pisa to help the Pisans resist Florentine efforts to reclaim the city. He also hoped to undermine Savonarola's influence. "I am doing things to turn people here against him," reported his ambassador to Florence.[12]

Lodovico, meanwhile, had reason to be wary of both Savonarola and the Florentine alliance with France. When the Dominican friar met with

Charles VIII in June, he assured him that the entire city was on the French side. The entire city also seemed to be on Savonarola's side. A Florentine shopkeeper noted in his diary that people of Florence were so devoted to Savonarola that they would have jumped into the fire if he asked.[13] Upward of twelve thousand people flocked into the cathedral to hear his spellbinding sermons. His message was not a cheerful one. "I announce to you," he declared from the pulpit in 1495, "that all Italy will be convulsed, and those who are most exalted will be most abased. O Italy! Trouble after trouble shall befall thee. Troubles of war after famine, troubles of pestilence after war, trouble from this side and that."[14]

A portrait of Savonarola by one of his followers, showing his fierce aquiline features partially obscured by a cowl, bore the inscription: "This is a picture of Fra Girolamo Savonarola, a prophet sent by God." The intentions of this prophet were clear. As one of his followers put it, he wished to "purge our whole city of vices and fill her with the splendour of virtue."[15]

If Leonardo did indeed visit Florence in 1495, he could scarcely have sympathized with certain of Savonarola's plans for purging Florence of vice. The friar's opposition to vanity and luxury meant he sought to enforce sumptuary laws against ostentatious and "lascivious" clothing. He also deplored the study of pagan authors by humanist scholars. "Plato, Aristotle and the other philosophers are fast in Hell," he blithely informed Florence's enthusiasts of classical learning. Then in December 1494 he had called for the stoning and burning of sodomites. This appeal was quickly followed by an increase in anonymous denunciations of the kind that in 1476 saw Leonardo hauled before the court. Although the government rejected the death penalty for sodomites, the situation would soon become more menacing and dangerous as, early in 1496, Savonarola began mobilizing groups of white-robed children, his *fanciulli*, to search out and denounce sodomites. "The boys were held in such respect," one citizen reported, "that everyone avoided evil, and most of all the abominable vice."[16]

This, clearly, was no longer the Florence of Lorenzo the Magnificent. Swayed by Savonarola, the Florentines were rejecting the values that over the previous century had given the city its unsurpassed reputation for intellectual and artistic excellence: the passion for the classical cultures of ancient Greece and Rome, the preoccupation with secular as well as transcendental values, the belief that a man might fulfill himself other than through the army or the church, and the conviction that the nude body

(revealed in a work of art like Donatello's bronze *David* or Botticelli's *Birth of Venus*) was a site of beauty rather than shame. It must have been a relief for Leonardo to return to his castle in Milan.

※

The Holy League had been intended to endure for twenty-five years. In fact, thanks to Lodovico Sforza, it lasted barely six months. In the middle of October, Il Moro effectively switched sides in the conflict. Evidently regarding the French a greater threat than the Venetians or the pope, he made a separate peace with Charles VIII, who denounced the duke of Orléans's claim to Milan in return for Lodovico's promise that "he would serve the king to the utmost of his power."[17] To that end, Lodovico promised not to help Alfonso's son Ferdinand II recover his kingdom in Naples, to give free passage to French armies on their way to Naples, and even to provide troops and ships for Charles when and if he returned to do battle with Ferdinand. He also promised to fight against Venice—should the Venetians object to these arrangements—on behalf of the French.

Lodovico's actions understandably enraged the Venetians, who regarded him as a traitor. Meanwhile, suspicions lingered between Lodovico and Charles. Lodovico clearly had little intention of honoring his commitments, and a French ambassador, finding the duke reluctant to provide the requested ships for the renewed assault on Naples, began complaining about his "treacherous way of dealing." Lodovico, for his part, did not trust Charles. According to the ambassador, he "told me plainly at last he could repose no confidence in our king."[18] When Charles proposed a conference in order to confirm the terms of the peace, Lodovico replied that he would meet the French king only if a river separated their respective camps, making a barrier between them.

In the French camp, opponents of the peace between Lodovico and Charles—most notably the duke of Orléans—took heart from these latest proceedings. Louis was also encouraged by other events of a more tragic nature. Charles's heir was his only son, three-year-old Charles Orland. The dauphin was, according to one courtier, "a very handsome and precocious child, and not alarmed at those things wherewith children are usually frightened." But in December he contracted measles and died. The French

court was plunged into mourning, with the eighteen-year-old queen dis-
tressed almost to the point of madness. Some courtiers, however, could not
help noticing that Louis "rejoiced at the dauphin's death, for he was (after
him) next heir to the throne."[19] Lodovico's deadly rival was now a heartbeat
away from the French throne.

Every Painter Paints Himself

Leonardo was always on the lookout for people with interesting and expressive facial features. He once made a study of noses, finding (with typical exactitude) that they came in ten different shapes: "straight, bulbous, hollow, prominent above or below the middle, aquiline, regular, flat, round or pointed."[1] This interest was no doubt heightened as he began his work in Santa Maria delle Grazie because of the need to find models for thirteen different figures. If some of the stories about him are true, various residents of Florence and Milan were immortalized in his paintings—including in *The Last Supper*—without realizing it.

Leonardo's punctilious approach to facial features was described in a work published in 1554 by a writer named Giovanni Battista Giraldi, whose story has some credibility because his father knew Leonardo and watched him paint in Santa Maria delle Grazie. Giraldi claimed that whenever Leonardo wanted to paint a figure, he first considered "its quality and its nature": such things as whether the figure was to be happy or sad, young or

old, and good or evil. Having determined these details, he would take himself off to a place "where he knew persons of that kind congregated and observed diligently their faces, manner, clothes and bodily movements."[2]

This account is amplified by Vasari, who recounted how Leonardo was "always fascinated when he saw a man of striking appearance, with a strange head of hair or beard." Spotting such a character in the streets, Leonardo would "follow him about all day long," impressing the unique features on his mind so that when he returned to his studio "he could draw him as if he were standing there in the flesh."[3]

Leonardo found no shortage of fantastic faces in Milan, producing a famous series of grotesque heads—drawings of men and women with comically and sometimes horrifically deformed features—around the time he began working on the mural. If we believe the evidence of the drawings, Milan was a veritable rogues' gallery of toothless nutcracker men and pug-nosed women in ludicrous headgear. A number of his caricatures show men with conspicuously jutting chins. The models for them evidently suffered from pathologic mandibular prognathism—also known as the "Habsburg jaw"—a hereditary condition in which the lower jaw outgrows the upper, resulting in an elongated chin. This condition would feature in varying degrees in the faces of Judas, Peter, and Simon in *The Last Supper*.

Leonardo's interest in fantastic faces was not a simple voyeuristic attraction to physical freaks. He wanted to create faces that were more diverse, unique, and authentically expressive than those painted by his predecessors and contemporaries. Too many painters relied on stock facial expressions: stereotypical representations of emotions such as grief, fear, and piety. "A painter who takes no account of these varieties," he wrote, "always makes his figures on one pattern so that they might all be taken for brothers."[4]

Fantastic faces were one of the keys to capturing and conveying realistic varieties of expression. Leonardo believed that over time a person's characteristic traits stamped themselves on his or her physical features, making the face a reliable indicator of temperament and moral character. "The face," he wrote, "shows some indications of the nature of men." At times he was quite specific about how these indications appeared on the face. For example, one could tell if a person was cheerful from features such as "the marks which separate the cheeks from the lips," while bestial and angry men were revealed by "great reliefs and hollows" in the face. Less fathomable

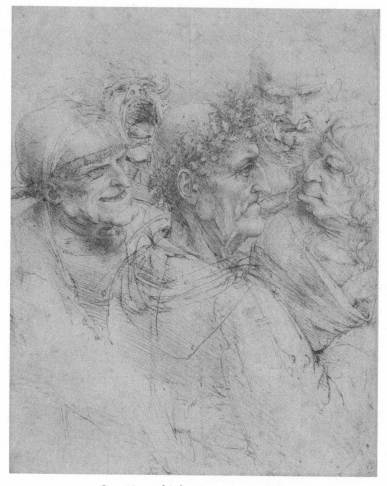

One of Leonardo's drawings of grotesque heads

is his claim that horizontal lines on the forehead indicate "men full of concealed pride or public lamentations."[5]

Knowing which features corresponded with which temperaments would obviously help a painter reveal different character traits and emotional states. In this context, selecting the right model for Judas, a man whose face, by this logic, would surely bear the imprint of his wicked nature, was clearly of the utmost importance. Giraldi described how Leonardo went about finding a model for Judas whose face would be "fitting to such villainy." For more than a year he haunted a certain neighborhood on the outskirts of Milan, the Borghetto, "where all the vile and ignoble people live, wicked

and villainous for the most part," in search of an ill-favored reprobate who would do justice to the subject.[6] Whatever the truth of this story, Leonardo did produce a sketch of Judas, whose face is not exactly villainous. The drawing shows an older man with raised eyebrows, a hooked nose, a prominent chin, and a pronounced jaw muscle.

Just as Leonardo made notes about particular horses in Milan while planning his equestrian monument ("The Florentine Morello of Mr. Mariolo, large horse, has a nice neck and a very beautiful head"), so, too, he recorded where to observe people whose looks intrigued him. "Cristofano da Castiglione at the Pietà has a fine head," he wrote with reference to an employee of the Monte di Pietà, a charitable institution that loaned money at low rates of interest. Another note reads, "Giovannina, fantastic face, is at Santa Caterina, at the hospital."[7] Santa Caterina was the Augustinian convent of Santa Caterina da San Severino (later known as Santa Caterina alla Chiusa), which in April 1495 made arrangements with the duke to move from a rundown building to a new location beside the Porta Ticinese, on the southwest side of Milan. Leonardo must have come to know Giovannina, presumably one of the nuns, through his involvement with Lodovico's secretary, Marchesino Stanga, who negotiated the property transfer. Stanga may have used Leonardo to inspect either or both of the properties, which would explain how he came to meet Giovannina.[8]

Leonardo's notebooks include the names of several people whom he evidently considered as models for Christ in *The Last Supper*. "Alessandro Carissimi da Parma, for the hand of Christ," reads one of his notes.[9] Little is known about Alessandro, though he came from a prominent aristocratic family with strong Sforza connections.[10] Someone else, meanwhile, would serve as the model for Christ's face. On another page, under the heading "Christ," Leonardo specifies a man in the entourage of someone he calls the "Cardinal of Mortaro." He actually meant Mortara, a town southwest of Vigevano, where Lodovico (one of whose titles was Count of Mortara) had a castle. The College of Cardinals included no such person as the Cardinal of Mortara, but Leonardo was almost certainly referring to Lodovico's younger brother, Ascanio Sforza, a powerful cardinal with numerous benefices. Among other things, Cardinal Sforza (who narrowly missed becoming pope in 1492) was the administrator of the see of Pavia, in which lay Mortara and its various churches.

While identifying this "Cardinal of Mortaro" is simple enough, the man

in his entourage—the potential model for Christ—is distinguished, with frustrating brevity, only as *"giova cote."*[11] This phrase might refer to a Giovanni Conte, to a Count Giovanni, or else to *il giovane conte* (the young count). One candidate credibly put forward by an Italian scholar is a military man named Giovanni Conte, a captain of the militia who later entered the service of Cesare Borgia.[12]

If this particular Giovanni Conte did serve as Leonardo's model, there was a certain irony in the image of Christ, the Prince of Peace, coming courtesy of a soldier who would later serve under one of Italy's most brutal warlords. Moreover, Giovanni's employer at the time he caught Leonardo's eye, Ascanio Sforza, was a notoriously worldly cardinal who dressed in armor and commanded a private army of two thousand soldiers. One of the wealthiest of all cardinals, he astonished Rome with the magnificence of his court, and so lavish was one of his parties that a chronicler dared not describe it, he claimed, lest he be mocked as a teller of fairy tales.[13]

Leonardo's references to Alessandro Carissimi da Parma and an aide-de-camp to Cardinal Sforza reveal that he chose some of his models from among the upper echelons of Milanese society. As the ducal painter and engineer, he rubbed shoulders with Milanese high society, and his notes record the names of various social luminaries.[14] He almost certainly used some of these figures as his other models. One visitor to Leonardo's studio would later report that the apostles in *The Last Supper* were "portraits from the life of eminent Milanese courtiers and citizens of the times."[15] This statement, coming from someone who discussed the painting with Leonardo, must be taken seriously. Also, it would have been typical of Lodovico to use the painting to celebrate luminaries of the Sforza court and, by extension, himself.

The most famous of all the courtiers in Milan was Lodovico's military captain, Galeazzo Sanseverino. If Leonardo were making the mural into, among other things, an exaltation of Milanese high society, a picture of the dashing Galeazzo was a must. He was one of the dozen sons of Roberto Sanseverino, a mercenary captain from Naples known universally as Signor Roberto. Lodovico's first cousin and onetime supporter, he eventually switched sides, backed Il Moro's enemies and on three occasions tried to

overthrow him. Galeazzo proved more loyal. In 1489 he was betrothed to Lodovico's illegitimate daughter Bianca (she was seven years old at the time) and afterward served as his commander and faithful friend. The perfect figure of chivalry, he appeared at jousts and tournaments in a suit of golden armor and bearing a golden lance with which he effortlessly unseated opponent after opponent. Leonardo had been designing costumes for one of these very jousts when "in the house of Messer Galeazzo" Salai stole the purse of the undressed footman.

Galeazzo appears to have been happy to assist Leonardo with his work. When Leonardo designed the bronze statue he was given access to Galeazzo's stables to study the exotic breeds. Some of his drawings of horses are captioned: "Messer Galeazzo's Sicilian horse" and "Messer Galeazzo's big genet," a reference to a Berber horse known as a *giannetto*.[16] Whether Galeazzo himself ever served Leonardo as a model is impossible to ascertain since no portraits of him are known to exist.

Another figure almost as celebrated and conspicuous as Galeazzo Sanseverino was the architect Donato Bramante. Born Donato d'Angelo Lazzari, he was known as Bramante—which means "wishing" or "craving"—because of his grand ambitions and epicurean tastes. "I cared not what I spent on good living," he supposedly declared.[17] Like Leonardo, who shared these extravagant tastes and ambitions, he was an outsider in Milan, a farmer's son from the village of Monte Asdrualdo, near Urbino. Like Leonardo, too, he was blessed with a dazzling and apparently effortless brilliance. The most conspicuous mark of his genius was at Santa Maria delle Grazie, where he attached a magnificent cylindrical appendage to the east end of Solari's original church. He was also involved in plans to rebuild the cathedral in Pavia, and in 1495 he was designing in Vigevano a central piazza so large that he demolished much of the town.

Bramante would have been a natural and attractive candidate for a model for Leonardo's *Last Supper*. He and Leonardo were close friends. Leonardo in one of his notes referred to Bramante as "Donnino," while Bramante dedicated a book of poetry to Leonardo, calling him a *"cordial caro ameno socio"* (cordial, dear, and delightful associate).[18]

Leonardo may have wished to commemorate Bramante on the wall of Santa Maria delle Grazie for one reason in particular. While Leonardo had no prior experience in fresco or wall painting, Bramante actually began his career as a painter. One of his many specialties in Milan was frescoing the

fronts of palaces and villas. He also frescoed a series of philosophers, known as *Men at Arms*, for the Casa Panigarola in Milan, and between 1490 and 1493 he had created for Lodovico a fresco in the Castello known as *Argus*.

Given his extensive experience, Bramante may well have offered Leonardo assistance or advice as he began work on his own mural project. At the very least he could have helped Leonardo with the design and construction of the scaffold, the same task that a dozen years later he was assigned by Pope Julius II when Michelangelo began work in the Sistine Chapel. Vasari's description of the scaffold that Leonardo built for himself a few years later in Florence—with a scissor mechanism that allowed its platform to be raised or lowered—was probably inspired by Bramante, who designed drawbridges. One of Leonardo's notes, accompanied by a diagram of crisscrossed poles, reads, "The structure of the drawbridge shown me by Donnino."[19]

Raphael later included Bramante's portrait in two separate frescoes in the Vatican Apartments, most famously as Euclid in *The School of Athens*. Around the same time, Michelangelo portrayed him as the prophet Joel on the vault of the Sistine ceiling, and his pupil Bramantino, in a tapestry made for the castle in Milan, showed him carousing at a feast: a tribute, no doubt, to his reputation for good living.[20] Even more reliably, his likeness was also depicted in profile on a medallion struck by Caradosso in about 1505. Executed some ten to twelve years later, these portraits show him to have been handsome and balding, with unruly curls and slightly aquiline features.

Michelangelo's painting of the prophet Joel on the ceiling of the Sistine Chapel

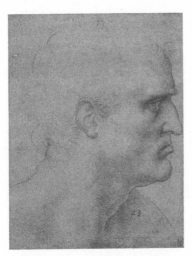

Leonardo's study for the apostle Bartholomew

If Leonardo did depict Bramante as one of the apostles, the most obvious choice, based on the evidence of these likenesses, is Bartholomew, the apostle standing at the far left. Leonardo's red chalk study for Bartholomew shows a good-looking man on whose windswept curls male-pattern baldness is in the process of taking its toll. He has a strong brow, a pronounced nose, an intense, intelligent expression, and a jaw set in steely determination. The model is clearly a man in middle age: Bramante turned fifty in 1494. In the mural, Bartholomew's hair is restored and he wears a beard, details that slightly obscure his likeness to Bramante. However, this figure who leans forward with his hands on the table, vigorous and alert, must still have been recognizable to Milanese courtiers as the famous architect.

Another model Leonardo apparently used in *The Last Supper* was—in the venerable tradition of Florentine workshops—himself. In the days of his apprenticeship there was a proverb attributed to Cosimo de' Medici: "*Ogni pittore dipinge sé*" (Every painter paints himself).[21] The phrase became a kind of truism for Leonardo. "I have known some who in all their figures," he wrote, "seem to have portrayed themselves from life, and in these figures are seen the motions and manners of their creator."[22]

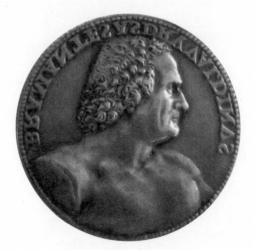

The Caradosso medal (reversed) featuring Donato Bramante's profile

Certainly many painters sneaked their self-portraits into their works as a kind of signature. The swart, handsome features of Domenico Ghirlandaio and the podgy face of Pietro Perugino can be seen peering out from the crowd scenes in various of their frescoes. Some Florentine painters, such as Filippo Lippi and Sandro Botticelli, seem to have repeatedly painted themselves into their works, lending their facial features and head shapes to various of their figures (the evidence suggests that Lippi had a round face and prominent ears). These self-portraits were not necessarily the consequence of narcissism, unconscious or otherwise; they may simply have resulted from the sheer convenience of the artist looking into a mirror and enlisting himself as a model.[23]

Leonardo believed such a practice was to be avoided, stressing that painters should try to avoid producing in their work faces "which have some resemblance to your own."[24] Ironically, however, he was accused of filling his own works with self-portraits. In the 1490s, a poet attached to the Sforza court, Gasparo Visconti, lampooned an unnamed artist in a work called "Against a Bad Painter." He complained that this painter's favorite subject was himself because he "holds firmly in his mind his own image, / And when he paints others, it often happens / That he paints none other than himself." According to Visconti, this artist tended to reproduce not only his own face— "however handsome it may be"—but also his own "actions and ways."[25]

Leonardo is usually understood as the target of Visconti's attack. How-ever, it is difficult to know exactly what paintings or self-portraits the poet was referring to—though there are at least two candidates for Leonardo self-portraits in *The Last Supper*. Certain faces do recur in Leonardo's paintings and, even more so, in his drawings. Two in particular are memorable. The first is an angelic youth with curly hair and an androgynous face, the second a more virile figure, a fierce-looking older man with a hooked nose and jutting chin. It is hard to distinguish Leonardo—who was in his midforties when Vis-conti's verses were written—in either of these distinctive types.

Visconti wrote his verses around the time Leonardo was working on *The Last Supper*. If he was indeed thinking of Leonardo, his objections must have arisen from what he saw as the painter's excessive self-portraiture in the mural—the fact, presumably, that Leonardo used himself as the model for various of the apostles, even down to having them imitate, with their ges-tures, his own "actions and ways."

Visconti was a friend of Bramante and also, no doubt, of Leonardo: the poem's tone is one of good-natured ribbing rather than vehement critique, and Leonardo even owned a copy of Visconti's sonnets. Visconti had the advantage—denied to us today—of knowing exactly what Leonardo looked and acted like. Leonardo's actual physical appearance is yet another of his enigmas. We have few clues as to what Leonardo looked like at the time of *The Last Supper*. Details about his taste for purple capes and pink hats may be gleaned from his clothing inventories. A handwritten list dating from a de-cade after *The Last Supper* indicates that by his midfifties, at the latest, he wore glasses and, in bed, a nightcap.[26] But of his facial features and general appearance—beyond the comments on his physical beauty given by various early biographers (none of whom ever actually saw or met him)—we have virtually nothing.

Leonardo is known to have executed at least one self-portrait: a Floren-tine poet claimed to have seen one done in charcoal, but the work has long since vanished.[27] The only figure in one of his paintings with any credibil-ity as a self-portrait is the figure in the lower right-hand corner of his *Adora-tion of the Magi*: a handsome, brooding man set apart from the fray who averts his attention from the kneeling Magi and the Christ Child to look at some-thing beyond the bounds of the picture. But since the altarpiece was never finished the features remain frustratingly obscure.

Lack of knowledge about Leonardo's physical appearance has not deterred

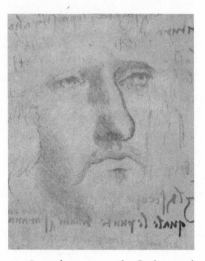

A possible self-portrait of Leonardo on a page of his Codex on the Flight of Birds

art historians from putting forward various candidates for self-portraits. Leonardo spotting has become a popular pastime, and his features have been identified in everything from his famous *Vitruvian Man* drawing (done in the late 1480s) to a needle-nosed character who looks out with a lazy-eyed stare from beneath the lines of mirror script on a page of his *Codex on the Flight of Birds.*[28] However, some thirty years would pass after the *Adoration* self-portrait before Leonardo definitively reappeared, this time in a red chalk drawing by one of his assistants, probably Francesco Melzi. Sketched in about 1515, it shows Leonardo in profile: a regal, classically handsome figure in middle age, with a Greek nose and wavy, flowing hair, slightly receding, and a long beard. This is surely the portrait that inspired later writers, such as Vasari and the Anonimo Gaddiano, to enthuse over Leonardo's grace and beauty.

The most famous of all Leonardo portraits is the supposed self-portrait of an old man in red chalk, beneath which some unknown person later inscribed in black, now barely legible: "*Ritratto di se stesso assai vecchio*" (Portrait of himself in fairly old age). The cataracts of hair and beard feature again, though Leonardo—if it is indeed him—now appears beetle browed, bald on top, and considerably older. Only discovered in 1840, the drawing was widely accepted in the nineteenth century (and still is by many today) as Leonardo's self-portrait. However, it is now believed to date from the 1490s, from around the time, in fact, that Leonardo painted *The Last Supper*. If this

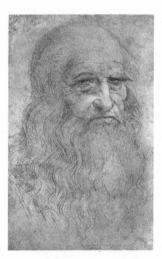

Supposed self-portrait of Leonardo as an older man, in red chalk

dating is accurate, the drawing cannot possibly be a self-portrait, since it shows a man in his sixties or seventies, certainly not one in his forties.[29]

Whether an actual self-portrait or not, this drawing served to kill off the image of the painter prevalent in the sixteenth century: that of an athletic, fun-loving, and strikingly attractive man with long eyelashes and a taste for pink tights. It fostered instead a picture of Leonardo as a gray-bearded magus: serious, studious, and scientific. It was a Leonardo made safe for the steam age.

By the beginning of 1496, Leonardo was, typically for him, at work on several other projects besides *The Last Supper*. Some were initiated by Lodovico, while others were the result of Leonardo's more personal enthusiasms.

Although Leonardo longed for military commissions, Lodovico still regarded him first and foremost as an interior decorator and stage designer. Sometime in 1495, as work at Santa Maria delle Grazie commenced, the duke engaged him to paint the ceilings of several *camerini*, or "little rooms," in the Castello. The commission was probably mooted more than a year earlier, since the ripped-up letter to Lodovico had urged the duke to "remember the commission to paint the rooms." These rooms were part of a covered bridge, the Ponticella, recently constructed by Bramante to span the

moat and provide a quiet retreat for Lodovico and Beatrice. Leonardo prob-
ably began painting the vaults at the end of 1495, since in November of that
year, according to a document, the ceilings had been given their base color
and were ready for decoration.[30]

At virtually the same time, Leonardo received another commission from
Lodovico. He spent the end of 1495 and the first weeks of 1496 preparing
the stage set and costumes for yet another theatrical, a five-act comedy by
Baldassare Taccone on the theme of Jupiter and Danaë. The play was per-
formed at the end of January in the palace of Lodovico's cousin Gianfran-
cesco Sanseverino, one of Galeazzo's eleven brothers. Leonardo once again
engineered spectacular visual and aural effects, making a star rise above the
stage "with such sounds," as Taccone's stage directions stipulated, "that it
seems as if the palace would collapse." Aerial displays featured prominently,
with Mercury flying down from Mount Olympus by means of a rope and
pulley. There was also a role for an *annunziatore*, or heavenly messenger, who
presumably performed similar aerial acrobatics.[31]

Much as he must have enjoyed designing these spectaculars, Leonardo
was also working on a project that was undoubtedly of more interest to
him. Mercury twirling above the heads of the audience is a reminder of his
long-standing interest in flight. He was fascinated by the possibility of hu-
mans passing into and through different elements such as water or air. Soon
after arriving in Milan he began designing a boat that could travel under-
water—in effect, a submarine. It was no doubt inspired by (and even based
on) a similar vessel designed by a pupil of Bramante named Cesare Cesari-
ano, who claimed to have made a boat that made subaqueous voyages in the
moat beside Milan's castle and in Lake Como.[32]

Most of all, though, Leonardo studied the mechanics of flight. He made
close studies of how birds and insects flew, trying to determine how hu-
mans might harness technology to take flight themselves. As a young man,
he spent much time on riverbanks and beside ditches, watching moths, drag-
onflies, and bats. Sometime in the early 1480s he drew a dragonfly, writing on
the margin of the page: "To see four-winged flight, go around the ditches and
you will see the black net-wings."[33] Another dragonfly appeared in his note-
books a few years later, when he was living in Milan. The sheet of paper in-
cluded sketches of a bat, a flying fish, and what appears to be a butterfly or
moth. He was particularly intrigued by the flying fish. As he pointed out with
a note of wonder, the flying fish was able to flit through both water and air.[34]

Leonardo soon began putting his observations to practical ends. Inspired by the dragonfly, he designed a bizarre contraption that would have required a pilot rapidly and repeatedly to squat like a human piston while at the same time frantically cranking a windlass connected to four paddle-like wings.[35] Another early design represented an attempt to refine a giant flapping wing. His inspiration this time was the bat, which he believed offered the best model. "Remember that your flying machine must imitate no other than the bat," he wrote in a note to himself, "because the web is what by its union gives the armor, or strength to the wings."[36]

Sometime in the late 1480s, Leonardo drew a diagram for yet another device, a helical contraption that applied to aeronautics the principle of the Archimedean screw. Variations on this rotating helix had been used for over a thousand years to pump water, and Leonardo was familiar with it from his hydraulic projects. Transferring its principles to flight, he imagined a machine that would achieve liftoff by boring its way through the air. His drawing shows a central mast rising from a platform and encircled by spiraling sails, which he stipulated should be made from linen sized with starch. The motive power is unclear, though this rotating spiral could never in his wildest aeronautical dreams have been manned. The sails may have been rotated by the wind, rather like the vanes of a windmill, until the machine rose miraculously skyward. Its rotary motion has often led it to be described (inaccurately) as the prototype for the helicopter.[37]

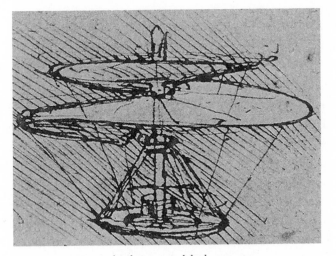

Leonardo's drawing of a helical contraption

A year or two later, Leonardo drew another diagram of a flying machine. This time he envisioned a pilot strapped prone to a board and operating foot pedals that flapped a pair of overhead wings by means of a system of pulleys. His inspiration for the design of these wings was, as his notes make clear, raptors such as the kite. He even referred to this flying machine as the *uccello*, or bird, and notes and drawings on the reverse of the sheet outlined details of a wing made from cane and starched silk, to which feathers would be glued. He included the observation that the test flight should be conducted over a lake to reduce the risks of a fall, and that the pilot should be equipped with a wineskin to use as an emergency flotation device. However, it is difficult to imagine the furiously pedaling pilot ever achieving liftoff, let alone plunging Icarus-like from the sky.[38]

If this *uccello* never reached the flight-testing stage, Leonardo's next prototype, incredibly, appears to have done so. The flying machine on which he was working as he began his *Last Supper* was a more refined version of the *uccello*. This time he reduced the weight of the device, envisaging his pilot harnessed to a pair of articulated wings activated by foot pedals attached to a system of cables and pulleys. The pedaling motion once again consisted of the pilot rapidly bending and straightening both legs simultaneously.

These wings seem no more promising than the previous prototype, but a page in Leonardo's notebooks dating from the mid-1490s suggests that he and his "miraculous pilot" were planning a test flight from—terrifyingly—the roof of the Corte dell'Arengo.[39]

<center>⁂</center>

Leonardo was not the first to have these flights of fancy. He must have known at least some of the stories of various intrepid birdmen who had tried—and inevitably failed—to fly through the air. One of the earliest known attempts at human flight was that by Abbas Ibn Firnas, a physician and poet in Moorish Spain, in 875. Launching himself into the air with a pair of wings made from a silk cape reinforced with willow wands and covered in eagle feathers, he traveled a short distance before crash-landing and breaking his back. His feat was replicated a century and a quarter later in Persia, with even more disastrous results, by a student named al-Jauhari, who was killed after he donned a set of wings and leaped from the roof of a mosque. Around the same time, in England, a Benedictine monk named

Eilmer of Malmesbury, "mistaking fable for truth" (as a chronicler put it), tried to fly like Daedalus. He fastened wings to his hands and feet, then jumped from the top of a church tower. According to the chronicler, he flew for more than two hundred yards before losing control and crashing. He suffered two broken legs "and was lame ever after."[40]

The propulsion systems for these birdmen were simply the desperately flapping arms of the pilots. However, by the thirteenth century, mechanical wings were under investigation. The Franciscan friar Roger Bacon, a polymath known as Doctor Mirabilis, made notes on the mechanics of flight, speculating confidently on the possibilities of crank-operated flying machines. In about 1260 he maintained that "flying machines can be constructed so that a man sits in the midst of the machine revolving some engine by which artificial wings are made to beat the air like a flying bird." He claimed that such devices "have long since been made, as well as in our own day," including one by a "wise man" of his acquaintance, though any records of these machines have been lost.[41]

One of Leonardo's notes records his hunt for a printed edition of "Rugieri Bacho."[42] Perhaps inspired by Bacon's description, he appears to have constructed his own mechanical flying machine in great secrecy on the roof of the Corte dell'Arengo: "Barricade the top room," reads one of his notes, "and make a large and tall model."[43] He evidently planned to launch his prototype from the top of the castle, a place "more suitable in all respects than any other place in Italy." The site was presumably advantageous because of its height and perhaps the air currents. But there was one disadvantage: he was concerned about workmen on the nearby cathedral (whose domed tower was being constructed) watching his machine take shape. He therefore found a sheltered spot on the roof where he believed he could work unobserved by prying eyes: "And if you stand upon the roof at the side of the tower the men at work upon the *tiburio* will not see you."[44]

Leonardo may have been worried about prying eyes because he planned a death-defying flight as a surprise during one of Lodovico's numerous festivals. A few years later, in 1498, as entertainment for a marriage feast, a mathematician from Perugia, Giovanni Battista Danti, would, according to legend, fashion a pair of wings and launch himself from the city's tallest tower. To the amazement of the spectators, he sailed across the piazza before his steering mechanism malfunctioned and he crashed onto the roof of a church, breaking a leg but escaping with his life.[45]

No contemporary documents record that Leonardo's *uccello* ever took flight. A half century later Gerolamo Cardano, whose father knew Leonardo in Milan, claimed the painter "tried to fly but in vain."[46] Cardano failed to tell where and when the test flight occurred, or why the test was unsuccessful, but a launch from the top of the Corte dell'Arengo seems unlikely. Leonardo's researches into human aviation were far more sophisticated and advanced than any of the previous ones. He was also more mindful of safety, projecting the use of not only the wineskin lifejacket but also the equivalent of airbags: he hoped to lessen the impact of a crash by means of a series of bags "strung together like a rosary" and fixed to the pilot's back.[47] Even so, it is difficult to imagine his test flight having a happier outcome than those of earlier bird-men, especially if the launch pad was the parapet of a castle in the middle of a crowded city.

Leonardo at this point, in the mid-1490s, was full of optimism about the possibilities of flight. The reverse of the page detailing his plans for a flight from the Corte dell'Arengo shows a sketch of Europe (copied from Ptolemy's *Cosmographia*) to which he added the words: "In the dream of the conquest of air the immense field open to the miraculous pilot." All of Europe, in other words, lay at the feet of the miraculous pilot. But the year 1496 marks a temporary end to Leonardo's studies of flight. After devoting himself to the subject for more than a dozen years, he abruptly ceased his investigations, possibly because of some catastrophic design failure, or else simply due to an awareness that his prototypes were simply not airworthy.

Leonardo would resume his studies some eight years later, back in Florence, when he began his *Codex on the Flight of Birds*. A note on the inside cover testifies to his continued hopes for human aviation: "The great bird will take its first flight on the back of his great swan, filling the universe with wonders; filling all writings with his fame and bringing eternal glory to his birthplace."[48] The "great swan" refers to Montececeri, a mountain outside Florence named for large birds, *ceceri*, that in turn took their name from a protuberance on their beaks shaped like a chickpea (*cece*). Here, above the rock quarries of Fiesole, Leonardo evidently hoped to launch one of his flying machines. Yet if his flight ever did occur, it failed to fill all the writings with his fame: no documentary evidence exists to support it.

CHAPTER 10

A Sense of Perspective

One of the first things Leonardo did after laying his base coat of lead white on the wall of Santa Maria delle Grazie was to hammer a nail into the plaster. This nail marked the very center of the mural, the point on which all lines and all attention would converge: the face of Christ.

A small hole is still visible in the right temple of Christ, like an eerie prevision of the crown of thorns. For Leonardo the nail marked what he called the "diminishing point": the location on which all lines of sight "tend and converge."[1] Rediscovery of the laws of linear perspective revolutionized art during the fifteenth century. Artists learned to create spatially realistic scenes by making lines perpendicular to the picture plane (known as orthogonals) converge on a vanishing point, and by calculating the graduated scale at which horizontal lines (or transversals) recede into the distance. Leonardo wrote extensively on perspective, which he called "the daughter of painting." He described it as the phenomenon by which "all objects transmit their image to the eye by a pyramid of lines."[2] The eye was the vertex of

this visual pyramid, and the artist's job was to capture in a painting precisely the diminution of scale and spatial relationship between objects seen by the eye in nature.

Leonardo created the most famous perspective drawing in history in the early 1480s when he made a pen-and-ink study for his *Adoration of the Magi*. It shows a geometrically rigorous mesh of lines through which swarm, in chaotic contrast to this rigid net, a host of ghostly human and equine figures. He must have done a similar drawing for *The Last Supper*, establishing how the orthogonals (such as the beams on the ceiling and the edges of the table) converge on the right temple of Christ. This drawing would then have been scaled up to create cartoons. But any perspective drawing of *The Last Supper*, like the cartoons and so many other sketches done for the mural, have long since vanished.

The only trace of Leonardo's efforts to generate his perspective scheme are the nail hole and, radiating outward from it, the lines in the wall marking the orthogonals. The use of a nail and incised lines reveal how he was using a classic fifteenth-century fresco technique pioneered by the Florentine painter Masaccio in works such as *The Holy Trinity* (in Santa Maria Novella) and *The Tribute Money* (in the Brancacci Chapel). In both frescoes Masaccio fixed a nail into the point in the wall at which the orthogonals were to converge; he then attached a long string to the nail, stretched it tight, and "snapped" it into the wet plaster, leaving behind a radiating pattern of orthogonals that are still visible today.

The architectural space that Leonardo created for Christ and the apostles—a narrow, tapestry-hung room with a coffered ceiling and three windows—reveals something intriguing about his approach to design. He longed for (but was so far denied) architectural commissions. However, he had firm ideas about how to organize architectural space, and in *The Last Supper* he painted architectural features that were arranged according to musical harmonies worked out two thousand years earlier by Pythagoras.

As a musician who played and designed stringed instruments, Leonardo was sensitive to the potency of musical harmonies. Like a number of his contemporaries (Verrocchio among them) he believed these harmonies could be translated into optical space. A correspondence existed, as he saw it, between how we hear sounds and how we see objects: "I give the degrees of the objects seen by the eye," he wrote, "as the musician does the notes heard by the ear."[3] He was paraphrasing Leon Battista Alberti, who wrote that the

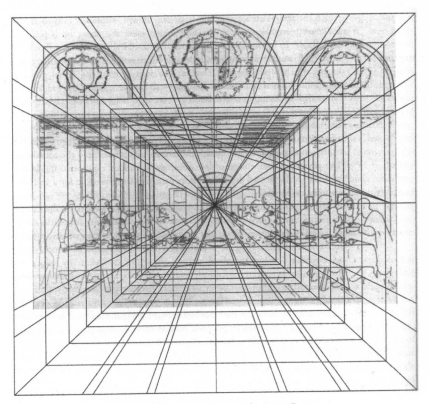

Leonardo's perspective scheme for The Last Supper

same musical harmonies that please the ears "can also fill the eyes and mind with wondrous delight," and that artists and architects therefore ought to apply the ratios of musical harmonics to their own creations. Leonardo was familiar with one such application: Verrocchio's tomb slab for Cosimo de' Medici, whose symmetrical geometrical forms have been found to express musical proportions.[4]

An indication that Leonardo intended to use harmonic ratios to structure pictorial space comes from a sketch for *The Last Supper*—the one showing Christ offering the sop of bread to Judas—on which he jotted a series of numbers in a column. His notation reads 3.4.6.- 6.3-6-4 = 32. He would have known from various sources that the musical scales could be expressed numerically, since pitch depended on variables such as length and weight of a musical instrument or its constituent parts. For example, if you cut a string in half, its pitch will be an octave higher than the note produced by

the whole string, with the octave therefore expressed by the ratio 1:2. Meanwhile two thirds of the whole length produces the tonal interval of a fifth (expressed by the ratio 2:3) and three quarters of the string a fourth (3:4).

Leonardo used these ratios in the module by which he designed the room in which Christ and the apostles sit, turning musical notes into a kind of visual music. The architectural features of his painting seem to be organized, at any rate, according to a series of units related to the tonal intervals. As one scholar has pointed out, the sequence of twos, threes, fours, and sixes on Leonardo's drawing are intended to represent the ratios of, respectively, the fourth and fifth within the octave (3:4:6), the octave (3:6), and the fifth (4:6).[5]

The Last Supper does appear to reveal an arithmetical progression. For example, if the total width of the refectory wall is divided into twelve units, that of the coffered ceiling at the front of the picture plane is six units, giving a ratio of 1:2 (an octave). The width of the rear wall in the painting is four units, while that of the windows is three (that is, if the measured width is that between the centers of the two flanking windows rather than from their outside edges). Thus we have (with only a little bit of fudging) the ratios 12:6:4:3. Similar ratios can be found in the relationships between the tapestries on the wall in the painting. They are of unequal breadth, with those toward the rear of the room increasing according to the ratios 1:½:⅓:¼—offering (this time without any fudging) the mathematical intervals 12:6:4:3.[6]

The influence of Verrocchio and Alberti lay behind this musical calibration of optical space. Leonardo probably did not believe, like some of his contemporaries, that these ratios were inherently divine. But, like Alberti, he no doubt believed that their application could bring "wondrous delight" to the eyes as well as to the ears.

Leonardo's method of working makes it impossible to determine where exactly on the wall he first began painting. Frescoists normally worked their way systematically across a wall or vault, painting adjacent patches of plaster on consecutive days, working (as Pontormo's diary revealed) on the right arm on Thursday, the left arm on Friday, and a thigh on Saturday. Leonardo had no desire to work in these discrete units. He approached the wall

in the same way that he tackled his panel paintings, on which his style was to work slowly and deliberately, layer by layer, touching and retouching, carefully contemplating the effects as he progressed.

The outlines of the entire scene would first of all have been sketched roughly on the base coat in charcoal, either transferred from cartoons or else drawn freehand with reference to sketches. The outlines of the apostles' heads, like the ceiling beams, were emphasized with a stylus. When the time came to paint, he proceeded at a pace that was sometimes leisurely, sometimes frantic, and he no doubt worked on several areas of the mural at once, ranging from one end of his scaffold to another in the course of a single day.

An eyewitness account of Leonardo's work in Santa Maria delle Grazie confirms this unorthodox approach. The eyewitness was Matteo Bandello, the young nephew (he was born in 1485) of the prior of Santa Maria delle Grazie. Matteo later became a popular writer of humorous novellas in the tradition of Boccaccio; one of his stories, *Giulietta e Romeo*, first published in the 1550s and then translated into English in 1567, was the source for Shakespeare's play. Another of his novellas would be taken up by Lord Byron.

One of Matteo's stories features Leonardo as the narrator: he puts into Leonardo's mouth the various misadventures of the talented but libidinously wayward painter Filippo Lippi. The story is prefaced with Matteo's remarks about his personal experience of watching Leonardo at work in Santa Maria delle Grazie. His stories are full of comical exaggerations and improbably fanciful conceits, and the circumstances of his account—a novella published many years later—must make us cautious about its veracity. However, the description of Leonardo's unpredictable and apparently dilatory working habits has an undeniable ring of truth.

"Many a time," Matteo began, "I have seen Leonardo go to work early in the morning and climb on to the scaffolding." On these occasions, he claimed, Leonardo was the picture of industry, working "from sunrise until the dusk of evening, never laying down the brush, but continuing to paint without remembering to eat or drink." On other days, Leonardo arrived early for work, though much less painting got done. Instead, he studied the mural for hours on end without touching his brushes, "considering and examining it, criticizing the figures to himself." On still other days he would break off work at the Corte dell'Arengo, where he was still (Matteo

claims) working on "the stupendous horse of clay," and arrive in the refectory at noon. He would clamber onto the scaffold, swiftly apply only a touch or two of paint, "and then go elsewhere."[7]

Matteo himself made no judgment on Leonardo, but this capricious regime evidently left his uncle, the prior, Vincenzo Bandello, frustrated and aggrieved. Vasari tells the story that Bandello, who wished to see Leonardo toiling "like one of the labourers hoeing in the garden," complained to Lodovico about the painter's slow and unpredictable progress. For Bandello as for many other people at the time, an artist was a mere craftsman, someone paid to cover a certain number of square feet of wall per day. (Borso d'Este, the grandfather of Lodovico's wife Beatrice, literally paid his frescoists by the square foot.) Leonardo took another view of his task: he believed that originality and creativity were more important than economics or square feet. He explained to Lodovico that "men of genius sometimes accomplish most when they work the least," adding that they are "thinking out inventions and forming in their minds the perfect ideas which they subsequently express and reproduce with their hands."[8]

Vasari's story is probably apocryphal, but Leonardo certainly did not regard himself as someone who worked to order like a laborer hoeing the garden. Perhaps, too, Bandello and his friars were baffled and angered by Leonardo's unusual approach, which meant the unsightly scaffold—along with the smell of oil and paint—would be a fixture in their refectory for an indefinite period. The difference between Leonardo's eccentric style and the more usual method was underscored by the performance of Giovanni da Montorfano at the other end of the refectory. Montorfano had succeeded in quickly covering his wall with a Crucifixion scene. Teeming with color, his fresco featured more than fifty figures, not only Christ and the two crucified thieves but also Roman soldiers on horseback, grieving women, and various Dominican worthies such as St. Dominic and St. Catherine of Siena. In the background was a multitowered castle, fluttering banners, and a rocky landscape. On a tablet at the foot of the cross he proudly painted his name: GIO. DONATVS MONTORFANVS. Above, he added the year: 1495. After as little as a year on the job, Montorfano had completed his work. By the beginning of 1496 there were no obvious signs that Leonardo would soon make an end of his own wall.

Although Leonardo had painted the infant Christ numerous times, *The Last Supper* marked the first time he painted the adult Christ. The notes about Alessandro Carissimi da Parma and the man in Cardinal Sforza's entourage allow us to disregard Vasari's story that Leonardo was "unwilling to look to any human model" for Christ because he believed no one had the requisite grace and beauty.[9] Painting the head of Christ would nonetheless have been a daunting task, not least because of its prominent location at the very center of the mural. Years later, Lomazzo would claim that Leonardo's hand trembled whenever he tried to paint Christ's face. The story is not entirely incredible. Painters of religious scenes were often deeply moved by their task. Fra Angelico, a Dominican friar, was said to have wept as he painted his frescoes. "Whenever he painted a Crucifixion," claimed Vasari, "the tears would stream down his face."[10] But the tremor in Leonardo's hand—if the story has any truth—probably had more to do with the momentous nature of his assignment and the conspicuous location of the Savior's head than with any iconoclastic reservations about depicting the face of Christ.

Lomazzo is also the source for the story that Leonardo despaired of creating perfect features for Christ. He therefore turned for advice, Lomazzo says, to a friend, the painter Bernardo Zenale, who told him it would be impossible to create features more perfect than those he had already given to both James the Greater and James the Lesser. Zenale advised Leonardo to "leave the Christ imperfect" since he would "never be able to accomplish the Christ after such apostles."[11]

These anecdotes about Leonardo's trepidations, along with paint loss in the mural, ultimately gave rise to the mistaken belief, first expressed by Vasari, that Leonardo deliberately left the head of Christ unfinished, "convinced he would fail to give it the divine spirituality it demands." Recent cleaning has shown that the face of Christ in Leonardo's *Last Supper* was, in fact, highly detailed.[12] Leonardo did not need to leave the head unfinished because he was a master at capturing divine spirituality. In *The Virgin of the Rocks*, the faces of the Virgin and the angel are animated by an inscrutable otherworldly allure, and Leonardo applied to the face of Christ—with its downcast eyes and mournful features—this same numinous resplendence.

Leonardo in concentrating the focus of viewers on the face of Christ was following a fifteenth-century artistic tradition that has been called the "Catholic vanishing point": the practice of situating the vanishing point at

a particularly sacred site such as the eucharistic wafer or even the womb of the Virgin Mary (a technique one art historian has dubbed "uterine perspective").[13] He also made Christ conspicuous in a number of other ways. For one thing, Christ is significantly larger than many of the other apostles: he is as tall as Bartholomew (the last figure on the left) even though Bartholomew is standing. So subtle in Leonardo's hands that we barely notice it, this technique is a throwback to earlier centuries, when painters arranged their figures in what art historians call "hieratic perspective"—the practice by which figures are enlarged according to their theological importance (which explains why so many medieval paintings show enormous Madonnas surrounded by pint-sized saints and angels).

Besides occupying the center of Leonardo's painting, Christ is spatially isolated from the apostles, all of whom are bunched together as they physically touch their neighbors or lean across one another in partial eclipses. Leonardo further highlighted Christ by placing him against a window that opens onto a landscape of clear sky and bluish contours—by giving him, in effect, a halo of sky. The effect is dazzling, even despite the paint loss, as the warm tones of Christ's face, hair, and reddish undergarment advance while the cool blues of the landscape recede: a prime example of Leonardo's knowledge of the push and pull of colors. For the blue mantle over Christ's left shoulder Leonardo used ultramarine, which was, along with gold, the brightest and most expensive of all pigments. One fifteenth-century treatise on painting called it "a colour noble, beautiful, and perfect beyond all other colours." A single ounce could cost as much as eight ducats, more than the annual rent paid on a house by a poor worker in Florence. So expensive was ultramarine (the only known supply came from Afghanistan) that unscrupulous thieves sometimes scraped it from paintings. Because of its beauty and expense, it was used to color the most prestigious and venerated parts of a painting, most notably the mantle of the Virgin Mary.[14]

The colors of Christ's reddish undergarment were equally bright and deliberately intensified. Leonardo generally laid his colors on a base coat of lead white spread across the entire wall. For this red garment, however, he covered his white primer with a carbon-based black pigment to create a dark foundation. He then added vermilion, followed by a semitransparent red lake, a pigment created by extracting the red dye from old textiles. This was a trick he knew from panel painting: adding pigments over black en-

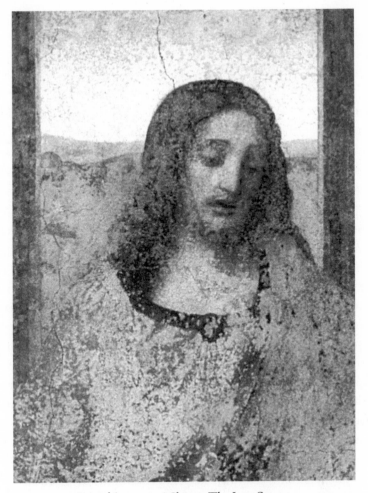

Leonardo's portrait of Christ in The Last Supper

hanced and deepened their color. Finally, a second layer of vermilion was added over the red lake.

Vermilion was the most brilliant of all the reds, and its appearance on the wall of Santa Maria delle Grazie would be all the more striking because it was a pigment that like ultramarine could not be used in fresco. Vermilion was made from cinnabar, a brick-red mineral the ancient Romans believed came from the blood of dragons crushed to death under the weight of elephants. Like most mineral-based pigments, it was, as Andrea Pozzo wrote, "quite incompatible with lime."[15] Indeed, the layering of five separate

coats of paint, carefully manipulated to intensify their values, was something else completely unknown to fresco.

<p style="text-align:center">✿</p>

Leonardo's model for Christ, possibly the soldier Giovanni Conte, appears to have been a young man. Leonardo did something distinctive to his features: he gave him a beard. Jesus had a beard, of course—or so everyone believed. For many centuries, painters and sculptors had been unanimous in showing Christ with a beard. Versions of the Last Supper from Giotto to Ghirlandaio imagined Jesus, without exception, in a beard.

Jesus had not always been depicted with facial hair. No description of his appearance is found in the Bible, beyond the unflattering prophecy of Isaiah that "there is no beauty in him, nor comeliness" (53:2). The early Christians, converted from paganism and wishing to portray the Savior in the Roman catacombs, borrowed the handy images of Apollo and Orpheus, both of whom were beardless.[16] This clean-shaven, godlike Christ was not to last. By the fourth century the vital, beardless Christ had made way for one whose plain and even ugly appearance, complete with a beard and haggard features, was in keeping with both the church's asceticism and St. Augustine's insistence on the virility of facial hair. "The beard signifies the courageous," he declared. "The beard distinguishes the grown men, the earnest, the active, the vigorous."[17]

Apparently authoritative sources emerged by the Middle Ages to endorse the notion of a bearded Christ. In 1384, the Byzantine emperor gave to a Genoese merchant a miraculous portrait of a bearded Christ that according to the legend had not been made by human hands. Other miraculous portraits such as the Veronica Cloth and the Shroud of Turin—pieces of fabric on which the features of Christ were supposedly imprinted—convinced the pious that they possessed actual images of Christ's features. The former was in the Vatican, the latter in the collection of the dukes of Savoy, and both clearly depicted a man with a beard. The Holy Face on the Veil of Veronica was widely disseminated; not only was it exhibited to the faithful on principal feast days, but it was also reproduced on both the Roman ducat and the badges given to pilgrims visiting Rome.[18]

People in the fifteenth century further believed they knew what Christ looked like because they possessed, besides these miraculous images, an

eyewitness account of his appearance. This was the so-called Lentulus Letter, a report to the Roman Senate by Publius Lentulus, predecessor of Pontius Pilate as governor of Judea. Lentulus briefly and matter-of-factly mentioned how Christ healed the lame, raised the dead, and was hailed by his disciples as the Son of God. He then moved on to his real business, which was to offer a detailed description of this prodigy's physical features:

> He has an impressive appearance, so that those who look on him love and fear him. His hair is the colour of a ripe hazelnut. It falls straight almost to the level of his ears; from there down it curls thickly and is rather more luxuriant, and this hangs down to his shoulders. In front his hair is parted into two, with the parting in the centre in the Nazarene manner. His forehead is wide, smooth and serene, and his face is without wrinkles or any marks. It is graced by a slightly reddish tinge, a faint colour. His nose and mouth are faultless. His beard is thick and like a young man's first beard, of the same colour as his hair; it is not particularly long and is parted in the middle. His aspect is simple and mature. His eyes are brilliant, mobile, clear, splendid. He is terrible when he reprehends, quiet and kindly when he admonishes. He is quick in his movements but always keeps his dignity. No one ever saw him laugh, but he has been seen to weep. He is broad in the chest and upstanding; his hands and arms are fine. In speech he is serious, sparing and modest. He is the most beautiful among the children of men.[19]

Publius Lentulus never existed, and the Lentulus Letter was a forgery composed in the twelfth or thirteenth century—but painters of the Middle Ages were not to know that. The scholar Lorenzo Valla denounced it as "knavishly forged" as early as 1440, but by then it had firmly fixed the image of Christ that was to survive through the fifteenth century and beyond: that of a serenely handsome man with shoulder-length, nut-brown hair, a middle parting, and a well-tended beard.[20]

The Lentulus Letter is curiously anomalous in that it presented an image of a bearded Christ at a time when facial hair was strictly forbidden to the Christian clergy and increasingly scarce on the chins of laymen. In 1119, the Council of Toulouse threatened with excommunication any priest who wore a beard, and Pope Alexander III, who reigned 1159–81, allowed archdeacons to employ force to shave any beard-wearing priests. This legislation

against clerical beards remained in force throughout the Middle Ages, and by the fifteenth century, in Italy at least, beards were virtually extinct on laymen as well as clergy. The great princes of Leonardo's time, such as Lorenzo de' Medici and Federigo da Montefeltro, were clean-shaven; so too was Lodovico Sforza and all members of the Sforza clan. Ghirlandaio's frescoes in the Tornabuoni Chapel reveal that eminent Florentines, from wealthy bankers to humanist scholars, were unanimously clean-shaven. Ghirlandaio's numerous self-portraits indicate that he, too, was on close terms with his barber; likewise Perugino, Botticelli, and Raphael. George Eliot is completely accurate in *Romola*, her novel of Renaissance Florence, when she has a barber take out a pair of clippers to deal with a bearded visitor from Greece: "Here at Florence," the barber informs him, "we love not to see a man with his nose projecting over a cascade of hair." Nor did they love to see facial hair in Milan or Rome. Even most Jews in fifteenth-century Italy were clean-shaven, looking so much like gentiles that in times of persecution they were obliged to differentiate themselves (as in Milan between 1452 and 1466) by means of a yellow badge; not the Star of David but rather *il segno del O*, a piece of yellow cloth in the shape of a circle.[21]

A beard for fifteenth-century Italians was a sign of exoticism and impassioned religiosity—of the foreign worlds of Islam and Eastern Christendom. However, even the great Greek scholar from Constantinople, John Agyropoulos, shaved off his beard when he arrived in Florence, an act the Florentines called his *Latinizzamento*, or Latinization. Among the few Italians who wore beards were the self-styled prophets and holy hermits who appeared in Italian cities in the last decades of the fifteenth century, such as the one known as "Guglielmo barbato" (bearded Guglielmo), who preached in Rome in the 1470s, "predicting," according to a poet, "all evil at the top of his lungs."[22]

One of the few other Italians of Leonardo's era to wear a beard was Leonardo himself, as the red chalk drawing testifies. However, this sketch postdates by some twenty years his work in Santa Maria delle Grazie, and during the 1490s there is evidence neither for nor against a beard-wearing Leonardo. The probability is that—the popular image of the bearded seer notwithstanding—he was clean-shaven throughout his years in Milan.

Leonardo, as we have seen, purchased a Bible as he began his commission in Santa Maria delle Grazie. He seems to have taken biblical history very seriously, applying to religion the same forensic insight that he turned on every other subject that crossed his path. At one point in his notebooks he interrupts his inquiries about whether the "marine shells" (what we now know as fossils) discovered at high elevations in the mountains could have been carried from the seashore (as one theory had it) by Noah's Flood. "Here a doubt arises, and that is: whether the deluge, which happened at the time of Noah, was universal or not." Could forty days and forty nights of rain, he wonders, really have covered the surface of the entire earth to the height at which the shells were found? If so, where did the water go? And could cockle shells, which he calculated traveled only a few feet per day in a swift current, really have made a 250-mile journey from the Adriatic to the top of the Dolomites in only forty days? "Here, then, natural reasons are wanting," he decides. "Hence to remove this doubt it is necessary to call in a miracle to aid us." Not even the Bible—which he called the "supreme truth"—was spared his incessant questions and curiosity.[23]

Leonardo may have conducted other researches into his subject besides reading the Gospel versions of the Last Supper. One report of his studies for *The Last Supper*, composed long after the fact, comes from a French curator and scholar named Aimé Guillon de Montléon. In 1811, Guillon claimed that when Leonardo painted Christ's costume in *The Last Supper* he colored it crimson "in accordance with a piece of the true dress of the Saviour preserved as a relic in the basilica of Santa Maria Maggiore in Rome."[24] Guillon provides no documentation, and he is almost certainly confused or mistaken. Santa Maria Maggiore possessed a relic of the Virgin's cloak (and another of her breast milk) but not one of Christ's coat, the *tunica inconsutilis* (seamless garment) woven by Mary, worn by Christ throughout his life, and diced over by the Roman soldiers beneath the cross. That particular relic was claimed by both the cathedral of Trier in Germany and the parish church of Argenteuil, outside Paris.

Leonardo would have entertained with much skepticism these various reliquaries in Santa Maria Maggiore. He once wrote a riddle posing the question of how a thousand years after their deaths the dead could "give a livelihood to many who are living." His answer was that friars "live by saints who have been dead a great while."[25] Guillon was correct, however, in assuming that Leonardo concerned himself with historical accuracy. On at

least one occasion he showed an interest in relics, church history, and the human and historical side of his religious subject. In 1503, while living in Florence and working on several Virgin and Child paintings, he contacted one Maestro Giovanni, an official at the Franciscan basilica of Santa Croce. Leonardo's letter no longer exists, but he evidently inquired about certain documents supposedly held at the church: letters dating from the time of the Virgin Mary. Maestro Giovanni, after consulting a Maestro Zacaria, was happy to confirm to Leonardo, courtesy of an "authentic record preserved in this church," that St. Ignatius of Antioch wrote a letter to the Virgin and "received an answer and corollaries—he having lived at her time."[26] Leonardo had obviously heard about this cache of letters and was making inquiries about them, as if hoping that seeing letters or "corollaries" from the Virgin would help with his depiction of her.

Although Leonardo certainly disapproved of certain ecclesiastical practices, he seems not to have entertained serious doubts about the "supreme truth" of the Bible itself. His reputation as a man devoid of religious beliefs originated with the 1550 edition of Vasari's *Lives of the Artists*, which depicted him as an eccentric unbeliever prone to heretical notions. The actual story is more complicated. Nothing in Leonardo's own writings or actions supports a charge of heresy. His dissections, for example, would not have troubled the church authorities. It is a popular misconception that opening a cadaver was prohibited by the church. Autopsies and dissections were, on the contrary, extremely common in medieval and Renaissance Italy. The first recorded autopsy in Italy took place in 1286, and over the following centuries bodies from all ranks of society were regularly dissected and studied, not just in medical schools but often as a funerary practice performed by the attending physician at the request of the family of the deceased. One of Leonardo's contemporaries in Florence, the physician Antonio Benivieni, performed autopsies and dissections on at least 160 bodies, cutting up nuns, aristocrats, and children.[27]

Nor are Leonardo's doubts about the operations of Noah's Flood either heretical or an anticipation, as some have argued, of modern paleontology. Stephen Jay Gould has acknowledged that many of Leonardo's writings, such as those on fossils, "emit a wondrous whiff of modernity." However, he goes on to show that in fact Leonardo's observations about fossils and the Flood "could not have been more squarely Renaissance or late medieval." Far from anticipating nineteenth-century paleontology, his writings

about cockles and mountaintops are actually part of an attempt to prove the medieval idea that the body is a microcosm of the earth.[28] His writings therefore correlate breathing with the ebb and flow of the sea, and compare the heartbeat to the astronomical unit of time. We are a very long way from Charles Darwin.

Potentially more inflammatory than Leonardo's dissections are some of his comments on astronomy. He was interested in astronomy throughout his life, at one point hoping to produce a telescope to aid his celestial observations: "Construct glasses to see the moon magnified," reads one of his notes.[29] Another of his notebooks contains the following sentence written in uncharacteristically large letters: "*Il sole nó si move*"—the sun does not move.[30] This statement goes unexplained. It might appear to be an indication of his heliocentrism and a challenge to the geocentric view of the universe accepted by the church: the sort of heterodoxy, in other words, that got Galileo admonished by the church authorities in 1616 and then put on trial in 1633. However, the Leonardo scholar Carlo Pedretti has argued that it actually has nothing to do with astronomy but might in fact be a memo referring to a pageant or theatrical performance.[31]

Elsewhere Leonardo described—again with no undue explanation—the relative positions of the sun and the earth: "The earth is not in the centre of the sun's orbit nor at the centre of the universe."[32] Once again Pedretti is skeptical. He points out that Leonardo is actually implying that the earth is not in the center of the sun's orbit because it is not the only planet in the solar system.[33] Likewise, an expert on Leonardo's scientific thought, Martin Kemp, believes the comment is not a statement of heliocentrism but rather is best understood in terms of his discussion of the centers of gravity of the earth and its sphere of water.[34]

Leonardo's interest in astronomy seems to have been limited to physical observations rather than mathematical calculations. Nothing in his own writings indicates that he attempted—as Copernicus, Kepler, and Newton later did—to measure the orbital motions of heavenly bodies in order to reach conclusions about planetary behavior. Furthermore, his drawings in the *Codex Leicester*, done in about 1508, reveal that he held entirely traditional views about the structure of the universe.

Vasari ultimately revised his story about Leonardo's heretical leanings. Eighteen years later, in his second edition of *The Lives of the Artists*, he not only dropped all mention of heretical speculations but also stated that Leonardo,

as he neared death, "earnestly resolved to learn about the doctrines of the Catholic faith and of the good and holy Christian religion."[35] The reason for this dramatic *volte face* in Vasari's account was that in 1566 he met Francesco Melzi, and the faithful Melzi, Leonardo's longtime companion, presumably both disabused and enlightened him.

Melzi may have exaggerated Leonardo's devotion. However, a leading Leonardo scholar has asserted that his Christian beliefs were "basically orthodox."[36] Indeed, Leonardo's scientific studies, far from raising doubt and skepticism, appear to have deepened his religious beliefs. His anatomical investigations in particular were responsible for his belief in a divine maker. Sectioning cadavers prompted him to describe the human body as a "wondrous instrument invented by the consummate master," and his anatomical writings urge us to "praise the first builder of such a machine." No matter how marvelous the human body, "it is as nothing compared to the soul which resides in this dwelling."[37]

Leonardo did not believe that the soul could be anatomized like the corpse, nor could events such as miracles be understood through human reason. Martin Kemp has argued that for Leonardo a sharp distinction needed to be drawn between faith and reason. For Leonardo, God and the soul cannot be comprehended by reason or experiment, but that does not mean that he rejected them: he simply regarded them, Kemp argues, as "rationally indefinable."[38] God was best approached and understood, Leonardo believed, through a study and appreciation of his works. He once wrote, in a defense of painters who worked on religious holidays, that "a true understanding of all the forms found in the works of Nature . . . is the way to understanding the maker of so many wonderful things and the way to love so great an inventor."[39] Peering into the secrets of nature was therefore an act of worship rather than one of heresy.

Leonardo's writings do, however, show an undeniable strain of anticlericalism: an opposition to some aspects of organized religion, friars in particular. He took a dubious view of the religious orders, with one of his notes reading, simply: "Pharisees—that is to say, friars."[40] He called them, in effect, self-righteous hypocrites. This hypocrisy is elaborated in one of his notes, a riddle in which he asked: who gives up labor and poverty to live in

great wealth in splendid buildings, "declaring that this is the way to make themselves acceptable to God?"[41] His riddle voices the anticlericalism that runs from Dante, who placed Pope Nicholas III upside-down in a pit in the eighth circle of hell, through Chaucer's description of the Pardoner with his bag of fake relics, to the numerous complaints in the fifteenth century about indulgence hawkers and other unscrupulous clerics "who pay little attention to the spirit but a great deal to the money."[42]

Beyond Vasari's story about Vincenzo Bandello, nothing attests to any dispute between Leonardo and the friars, and so it is impossible to say whether the experience of working among the Dominicans of Santa Maria delle Grazie was responsible for any of these sentiments. Leonardo's anticlerical views, however, had their limits, and he could regard friars with affection and, in one special case, with great admiration. A more charitable attitude toward monks appears in one of his jokes. Leonardo loved jokes and humorous stories. He owned several books of funny (and often indecent) stories, such as an edition of Poggio Bracciolini's *Facezie* (Jests). He evidently planned to produce his own book of funny stories, because around the time he worked on *The Last Supper* he wrote out a series of fables, jokes, and riddles—funny stories and intellectual puzzles with which he diverted Lodovico's bored courtiers.[43]

One of Leonardo's best jokes concerns two monks and a traveling salesman. Priests and nuns were figures of ridicule and derision in Sacchetti's *Trecentonovelle* and Boccaccio's *Decameron*, which contain numerous tales about corrupt and lascivious priests. Indeed, most writers of these funny stories were unabashedly anticlerical: they depicted convents as hotbeds of vice and corruption, and monks as greedy and licentious hypocrites. However, Leonardo's story is unusual in that it portrays monks in a more favorable and sympathetic light.

His joke is actually a very funny one. Two Franciscan friars are journeying through Italy when they stop at an inn. Here they meet a merchant, also traveling on business. As the inn is a poor one, the food is meager: nothing appears at dinnertime but a small roast chicken. The merchant craftily points out that due to the time of the season and the rules of their order, the friars must not eat any meat—and so he greedily eats the whole chicken himself while the famished friars make do with scantier rations. They exact their revenge the following day when, leaving the inn and traveling together, one of them agrees to carry the merchant across a river on his shoulders. In

midstream the friar asks his passenger if he has any money on his person. "You know I have," replies the merchant. "How do you suppose that a merchant like me should go about otherwise?" The friar informs him that the rules of his order forbid him from carrying money—at which point he drops the merchant into the river. The story ends happily, with the merchant, smiling and blushing with shame, peaceably enduring the friars' revenge.[44]

CHAPTER 11

A Sense of Proportion

L eonardo enjoyed making lists. His notebooks include many catalogs and inventories evidently made on the occasions he packed up his belongings for a trip or a move. He also composed lists of things he hoped to learn or acquire. Quite often the two lists got jumbled together, making for some strange juxtapositions. In one such list he made himself a note to get Avicenna's work on "useful inventions" translated, before going on to itemize such artistic necessities as charcoal, chalk, pens, and wax. Then he abruptly added, "Get a skull." The list rounds off with mustard, boots, gloves, combs, towels, and shirts. Another list combines his ambition to learn the multiplication of square roots with a reminder to pack his socks.[1]

If these possessions and ambitions were haphazardly itemized, Leonardo took much greater care when listing his books. He once declared that he was not "a literary man," but in fact he was well-read and owned a well-stocked library. Lacking much in the way of a formal education, he was one of history's great autodidacts. By the time he started moving in courtly circles

in Milan, he evidently felt the need to burnish his learning. In the late 1480s he began copying out in a small notebook the longest of all his lists, a lexicon of words—some foreign, some Latin, some technical—intended to boost his vocabulary. His list is more than fifty pages long, running to some nine thousand words and allowing him to impress Lodovico's courtiers with words the likes of "archimandrite" (leader of a group).[2]

Leonardo admitted that "presumptuous persons" could be justified in saying he was not a man of letters. "My subjects are to be dealt with by experience rather than by words," he asserted in his defense.[3] And yet his notebooks quote or mention an astonishing array of authors: not only ancient writers such as Plato, Pliny, Virgil, Lucretius, Livy, Quintilian, and Plutarch—among numerous others—but also the medieval Islamic mathematician Thabit ibn Qurra, the physicists Richard Swineshead and Biagio Pelacani, the Franciscan John Peckham, and Leon Battista Alberti. Once again there is a gulf between what Leonardo said and what he did. He was every bit as interested in book learning as he was in firsthand experience. However, he aspired to take nothing on the authority of others. Even the Bible was not spared his forensic scrutiny.

Leonardo eagerly hunted down copies of books he wished to purchase or read, frequently recording where they could be found or from whom they might be borrowed. "A book, treating of Milan and its churches, which is to be had at the last stationer's on the way to Corduso," reads one of his notes. Another book he hoped to borrow from a local doctor: "Maestro Stefano Caponi, a physician, lives at the Piscina, and has Euclid *De Ponderibus.*" His notebooks are peppered with these memoranda as he tracked down one volume after another. "The heirs of Maestro Giovanni Ghiringallo," he noted, "have the works of Pelacano." Another promising lead he follows was Vincenzio Aliprando, "who lives near the Inn of the Bear," and who owned a book on Roman architecture. Leonardo also sourced his books from libraries: "Try to get Vitolone which is in the library at Pavia and which treats of mathematics." On the same page he added, "A grandson of Gian Angelo's, the painter, has a book on water which was his father's."[4]

Leonardo set about collecting books after his move to Milan, and in about 1495 he meticulously copied down the titles of forty books in his possession. This list encompassed works of a very wide variety. His library was stocked with treatises on surgery, agriculture, and warfare—such works as we might expect to find on his shelves—but also with books by ancient Ro-

man authors such as Pliny, Livy, and Ovid. These works shared space with volumes of a more whimsical nature. Indeed, his library appears to have been divided equally between serious scientific volumes and more humorous or lighthearted offerings. One of the books he owned was Luigi Pulci's *Il Morgante maggiore*, a burlesque poem (part of which was later translated by Lord Byron) about a giant who eats camels and picks his teeth with a pine tree. He also had a copy of the fanciful travel stories of Sir John Mandeville (who describes an island of sixty-foot giants and a bird that can carry an elephant in its talons) and a collection of Aesop's fables.[5] Another list made a decade later shows that by then his collection had swollen to 116 volumes, meaning he must have purchased, on average, seven or eight books each year.[6]

Perhaps the most fortuitous of all Leonardo's book purchases was made around the time he received the commission for *The Last Supper*. At the end of 1494 or beginning of 1495 he bought a copy of Fra Luca Pacioli's *Summa de arithmetica, geometria, proportioni et proportionalità* (*Summary of arithmetic, geometry, proportions and proportionality*). He paid 119 soldi for the work, almost double what he paid at the same time for his Malermi Bible.[7] The book was hot off the press in Venice: clearly Leonardo was not willing to waste time searching for the volume in libraries or borrowing secondhand copies from local doctors. The book did not disappoint, and within a year he had convinced Lodovico Sforza to bring the friar to Milan as yet another dazzling adornment for the court.[8]

The Franciscan Order had produced a number of great philosophers and scientists. Most notable was Roger Bacon, who anatomized the brain and called himself a "master of experiment."[9] Fra Luca Pacioli was the latest of these intellectual luminaries. In the eyes of many of his contemporaries, he was one of the great wonders of the world. "How many excellent qualities are in the man," exulted one writer, "how much genius, how great a memory, what an abundance of material and profound appreciation of learning." He was compared to Aristotle and Homer, and celebrated as "a man of the rarest pattern and almost unique . . . It is not possible to recount the many glories of the man's learning." For another admirer, Pacioli was simply "a wonder of our times."[10] History remembers him with a more unassuming moniker: the "Father of Accounting."

Luca Pacioli was born in 1445 in the Tuscan town of Borgo San Sepolcro (today Sansepolcro), forty-five miles southeast of Florence. He was educated by Franciscans before serving an apprenticeship, first with a local merchant and then probably (though no hard evidence exists) with the most famous son of Borgo San Sepolcro, the painter and mathematician Piero della Francesca. Pacioli later described Piero as "the reigning painter of our time,"[II] but the two men shared mathematics rather than painting in common. Piero had written his *Trattato d'abaco*, a book on "the arithmetic necessary to merchants," at the request of a family of wealthy Borgo merchants. Pacioli, too, became a mathematics teacher to the merchant class, moving to Venice as a young man to teach the three sons of a businessman named Antonio Rompiasi.

After Rompiasi's death in 1470, Pacioli followed a peripatetic regime, traveling around Italy and giving lessons and lectures on mathematics. In Rome he met the architect Leon Battista Alberti, and in Urbino he became tutor to Guidobaldo da Montefeltro, son and heir of the duke. In about 1477 he took his vows as a Franciscan, later returning to Borgo San Sepolcro, where he composed his treatise on mathematics, the *Summa de arithmetica*. When he returned to Venice to oversee its publication, an artist named Jacopo de' Barbari captured him in a portrait. Barbari showed Pacioli's Franciscan habit cinched at the waist with a cord (the three knots symbolize his vows of poverty, chastity, and obedience) and his head covered with a cowl. His face, however, is clearly visible: that of a middle-aged man with fleshy

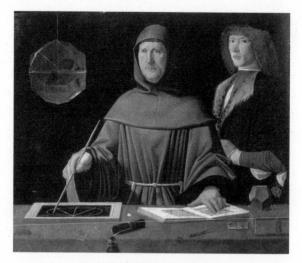

Luca Pacioli, by Jacopo de' Barbari

cheeks and a double chin. To a handsome young man who stands beside him, wearing a haughty glare, he gives a geometry lesson, complete with chalkboard, textbooks, and two models of polyhedra, one of which is made of glass, half-filled with water, and suspended in midair.

One of the textbooks shown in the painting is Euclid's *Elements*. The other is Pacioli's own *Summa de arithmetica*. As its cumbersome name suggests, this was an encyclopedia, an exhaustive, six-hundred-page-long compendium of arithmetic, algebra, and geometry. As the introduction stated, the book offered "complete instructions in the conduct of business." It was most famous for its exposition of the system of double-entry bookkeeping used by Venetian merchants—hence Pacioli's reputation as the Father of Accounting, the Father of the Balance Sheet, and the Father of Profitability.[12]

The work's mind-numbing disquisitions on business accounting may explain the supercilious boredom on the face of the young man by Pacioli's side. Leonardo, on the other hand, was a great enthusiast for such mathematical treatises. By the 1490s he owned no fewer than six books entitled *Libro d'abaco*—handbooks of mathematical instruction and calculation. He was introduced to mathematics at his abacus school in Vinci, where, according to Vasari, he had baffled his master with questions. Later he became adamant about the importance of the subject. "Let no one read my principles who is not a mathematician," he famously declared (less famous is the fact that the principles he was referring to were his theories of how the aortic pulmonary valve worked).[13] Ironically, he himself was a poor mathematician, often making simple mistakes. In one of his notes he counted up his growing library: "25 small books, 2 larger books, 16 still larger, 6 bound in vellum, 1 book with green chamois cover." This reckoning (with its charmingly haphazard system of classification) adds up to fifty, but Leonardo reached a different sum: "Total: 48," he confidently declared.[14]

Pacioli was paid by Lodovico to give public lectures in mathematics. However, the prestige he brought to the Sforza court came not from his expertise in double-entry bookkeeping so much as from his interest in, among other things, polyhedra like the ones shown in the Barbari painting. A polyhedron (from the Greek "many faces") is a multifaceted geometrical shape such as a tetrahedron (a pyramid), an octahedron (a diamond), or an icosahedron, which is composed of twelve pentagons and twenty hexagons, and looks like a soccer ball. Plato, Euclid, and Archimedes all described the properties of these and other polyhedra, and interest in them revived during

the fifteenth century. The Florentine artist Paolo Uccello used polyhedrons in his paintings (particularly in the form of the padded, doughnut-shaped hat known as a *mazzocchio*) and in a design he created for a mosaic on the floor of the basilica of San Marco in Venice. Pacioli was the latest enthusiast for these kinds of geometrical acrobatics. He claimed to have made glass models of sixty polyhedra while in Urbino (though no record of them has ever been found) and he would make a set in Milan for Galeazzo Sanseverino, to whom he was probably introduced by Leonardo.

Leonardo and Pacioli quickly became friends. Later they would live together in Florence, and Pacioli probably shared space with Leonardo in the Corte dell'Arengo in Milan. Leonardo clearly believed there was much he could learn from the friar, whom he no doubt bombarded with questions. "Learn the multiplication of roots from Maestro Luca," reads one of his notes.[15]

The two men had more in common than merely a love of mathematics. Like Leonardo, who amused courtiers with robotic creatures and tricks such as turning white wine into red, Pacioli appears to have become a kind of highbrow jester at the Sforza court. Soon after arriving in Milan he began work on a treatise called *De viribus quantitatis* (On the Powers of Numbers). It contained not only brain-twisting problems in algebra that Pacioli probably demonstrated and solved before the court, but also numerous magic tricks. Pacioli's manuscript described such ingenious feats as:

How to Make an Egg Walk over a Table
How to Make an Egg Slide up a Lance by Itself
How to Make a Cooked Chicken Jump on a Table
How to Eat Tallow and Spit Fire
How to Make Worms Appear on Cooked Meat

The secret behind making cooked chicken jump on the table was to mix quicksilver with "a little bit of magnetic powder," pour the contents into a sealed bottle, and then tuck the bottle inside a chicken "or other cooked thing, which must be hot, and it will jump." He made worms appear on cooked meat by chopping up the strings of a lute "in great lengths, just like natural worms," and then concealing them inside the meat. As the meat is roasted, the strings, "made from gut, will slowly twist and they will appear to be worms and those that see them will get sick."[16]

To such entertainments did the "wonder of our times" devote himself. He may have been assisted in some of these recipes by Leonardo, who likewise enjoyed pranks and spectacles. One of Leonardo's notes gives instructions on how to "make a fire which will set a hall in a blaze without injury." The trick involves evaporating brandy in a sealed room, suspending powder in its fumes, and then entering the room with a lighted torch. "It is a good trick to play," he observed. He was also known for inflating sheep intestines with a bellows so they filled the entire room, forcing his guests to crowd into a corner. "He perpetrated hundreds of follies of this kind," reported Vasari.[17]

If Leonardo and Pacioli spent some of their time diverting bored courtiers with these sorts of tricks, they also shared loftier concerns. Soon after Pacioli arrived in Milan, 'the two men began collaborating on the friar's magnum opus.

One of Leonardo's most famous drawings was done a few years before he began work on *The Last Supper*. Carefully sketched in pen and ink, it shows a naked man flapping his arms and legs as if making a snow angel. He is standing inside a square that is intersected by a circle. In his neatest mirror script Leonardo explained the point of the drawing: if you open your legs far enough to reduce your height by one fourteenth and at the same time "spread and raise your arms till your middle fingers touch the level of the top of your head," your navel will be at the center of your outspread limbs and the space between your legs will describe an equilateral triangle.[18]

Through this apparently bizarre postural exercise Leonardo evoked the ancient Roman architect and engineer Vitruvius, and consequently his famous drawing is known as *Vitruvian Man*. In *The Ten Books on Architecture*, composed around the time of the birth of Christ, Vitruvius described an experiment in geometry, proportion, and the human body: "For if a man be placed flat on his back, with his hands and feet extended, and a pair of compasses centred at his navel, the fingers and toes of his two hands and feet will touch the circumference of a circle described therefrom." The body likewise yields a square, Vitruvius claimed, since the distance from the toes to the top of the head equals that from fingertip to fingertip if arms are outstretched.[19]

The sole Roman architectural treatise to survive antiquity, *The Ten Books on Architecture* was hugely influential in the fifteenth century. Vitruvius's treatise

was an eclectic combination of the philosophical and the practical, describing everything from the phases of the moon to how to construct catapults and battering rams. One chapter is entitled "On the Primordial Substance According to the Physicists"; the next is called "Bricks." Such a book was bound to appeal to Leonardo. "Enquire at the stationers about Vitruvius," he wrote in one of his ubiquitous book-hunter notes.[20] He must have acquired a copy soon after the first printed edition appeared in 1486.

One chapter of *The Ten Books on Architecture* is called "On Symmetry: In Temples and the Human Body." Vitruvius seems to have spent a great deal of time measuring people's faces and bodies. He saw in the human body a combination of ratios and proportions, of fractions and modules, of subtle interrelationships between the different parts. For instance, the distance from the hairline to the tip of the chin was the same, he claimed, as the length of the hand from the base of the palm to the tip of the middle finger. This measure equaled a tenth of a person's height, while the distance from the chin to the crown was an eighth. "If we take the height of the face itself," he continued, "the distance from the bottom of the chin to the under side of the nostrils is one third of it; the nose from the under side of the nostrils to a line between the eyebrows is the same."[21]

Because he took nothing on authority, not even on that of Vitruvius, Leonardo began conducting similar experiments of his own. By about 1490 he was systematically measuring the heads, torsos, and limbs of a number of young men, including a pair that he called Trezzo and Caravaggio, after their hometowns in Lombardy. One of these two men was probably the model for *Vitruvian Man*.[22] He was therefore able to come up with an infinite series of refinements and additions to Vitruvius's measurements, declaring, for example, that the space between the mouth and the base of the nose is one seventh of the face, while the distance from the mouth to the tip of the chin is "a fourth part of the face and equal to the width of the mouth." Meanwhile the palm of the hand, he discovered, "goes twice into the length of the foot without the toes," and the distance between the nipples and the top of the head was a quarter of a person's height.[23]

What was the point of all these ratios and proportions? For Vitruvius, all temples should be built according to strict proportions, which he defined as "a correspondence among the measures of the members of an entire work." The best example of proportionality could be found, Vitruvius pointed out, in the human body, because it was "designed by nature."[24] Since

the correspondences among the parts of the human body reflected the order of nature, exact bodily proportions were worth studying as the model for how the various parts of Roman temples could harmonize with each other and reflect this same order and beauty.

Fifteenth-century architects such as Alberti and Francesco di Giorgio were mesmerized by this idea of harmonizing architecture with the proportions of the human body. Not coincidentally, Leonardo's inch-by-inch studies of Trezzo and Caravaggio corresponded closely with his architectural ambitions, such as his design for the domed crossing of Milan's cathedral. He was also interested in using these measurements, together with perspective, to place painting on a firm scientific footing, though his proportional hairsplitting certainly exceeded the demands of normal artistic practice. He believed proportion was to be found everywhere in nature, even speculating that there must be a discoverable proportional relationship between the circumference of a tree's trunk and the length of its branches.[25]

Pacioli, too, concerned himself with proportion, as the full title of his treatise suggests. Besides giving instructions in the conduct of business, the *Summa de arithmetica* had attempted to apply the laws of mathematics and proportion to art and architecture. Pacioli pursued these studies even more intensively in Milan. Soon after his arrival he began composing a book on which he collaborated with Leonardo, who provided the illustrations at the same time as he worked on *The Last Supper*. Pacioli's book was to be called *De divina proportione* (*On Divine Proportion*). There was certainly much in its pages to stimulate Leonardo. Pacioli was interested not merely in measurements such as the distance between the lips and the chin; he concerned himself with nothing less than the proportions of God and the universe.[26]

The collaboration between the two men was evidently a happy one. Pacioli admired Leonardo's artistic genius every bit as much as Leonardo admired the friar's facility with mathematics and geometry. Pacioli called Leonardo "the prince among all human beings," and he later remembered their collaboration on *On Divine Proportion* with much nostalgia, writing of "that happy time when we were together in the most admirable city of Milan."[27] Leonardo had little or no input into the content of the treatise, but he was asked by Pacioli to contribute drawings of sixty polyhedra.

Composed in the course of a year or two following his arrival in Milan, Pacioli's *On Divine Proportion* is yet another of his fat, mind-numbing disquisitions, this time on geometry and proportion rather than accounting. It is composed in poor Italian and brings to mind the comment supposedly made by Samuel Johnson about a manuscript being both good and original: "But the part that is good is not original, and the part that is original is not good." He drew freely on the mathematical thought of Plato, Euclid, and Leonardo da Pisa (known to later centuries as Fibonacci). He also took from his old teacher Piero della Francesca—so liberally, in fact, that he was accused of plagiarizing Piero's *De quinque corporibus regularibus*.

On Divine Proportion concerned itself with one proportion in particular. In Book 6 of *The Elements*, Euclid had demonstrated how to divide a line so the ratio of the shorter section to the longer one equaled that of the longer section to the line's entire length. Euclid called this process dividing a line "in mean and extreme ratio," and the ratio was expressed in an irrational number that begins 1.61803 and continues to infinity. This ratio would manifest itself in a wide number of phenomena, including in the ascending series of numbers described by Leonardo da Pisa (whose work Pacioli knew well) and now famously known as the "Fibonacci sequence": 1, 2, 3, 5, 8, 13, 21, 34, 55, 89, and so forth. In this series, each number is the sum of the previous two; moreover, after the first few in the series, each number divided by the previous one yields a ratio that approximates (but *only* approximates) 1.61803. For example, $21 \div 13 = 1.61538$.

Pacioli christened dividing a line "in mean and extreme ratio" (as it was known for many centuries) with a much more evocative name: he called it "divine proportion." For Pacioli the proportion was divine because of its intimate connection to (and here the Franciscan emerges) the nature of God. The mathematical properties of this ratio—the fact that, for example, $1.618^2 = 2.618$—he regarded as divine rather than coincidental. Among the arguments he advanced to prove his point is that both God and divine proportion are irrational, by which he meant they are both beyond reason and not expressible as the ratio of two integers. Pacioli's number crunching had clearly moved well beyond bookkeeping and progressed into the lofty realms of ontology.

Besides Euclid, Pacioli also borrowed heavily from Plato's *Timaeus*, a work that dealt with such weighty matters as the origin of time, the sun, and the "soul of the world." Pacioli was attracted in particular to the section dealing

with polyhedra. It is difficult to overestimate the importance of these polyhedra for Plato. They were not just geometrical fancies: they formed, he believed, the building blocks of the physical world. In his description of the universe, the four elements (earth, air, fire, and water) are solid bodies expressed by four distinct polyhedra: respectively, the cube, the octahedron (diamond), the tetrahedron (pyramid), and the icosahedron (soccer ball). Plato was extremely vague about his reasoning but stated that the tetrahedron, made from four equilateral triangles, was "the substance of fire" (presumably because of its flame-like shape), while the globular icosahedron made it the polyhedron appropriate for water. Such analogies may seem odd to us, but in some respects they were the ancient Greek equivalents of the ball-and-stick molecular models used in, for example, Watson and Crick's double helix.

In fact, Plato had his own equivalent of a "molecule of life": a fifth polyhedra, the dodecahedron. To the dodecahedron he assigned a particularly vital role. Composed of twelve interlocking pentagons, this figure had the cosmological function of encompassing and structuring all the others: a kind of geometrical Higgs boson. "God used it for the universe," Plato asserted with no undue explanation, "in embellishing it with designs."[28]

Significantly for Pacioli, this bit of cosmic origami could only be constructed by means of divine proportion, which inhered in the relationship between the sides of the pentagons and their diagonals. Moreover, the dodecahedron encompasses the other four bodies—quite literally, because they can fit inside it (sometimes simultaneously, as in the case of the tetrahedron and the cube). The dodecahedron was therefore a perfect metaphor for the all-encompassing quintessence, though for Pacioli it was, of course, more than a metaphor: the dodecahedron partook of the divine itself.* Divine proportion as described by Pacioli was an attempt to offer a Christianized version of Plato's account of the Demiurge creating a dodecahedron-shaped universe. It was, in many respects, a geometer's or an accountant's attempt to prove the existence of God.

Leonardo's task of illustrating these geometric figures was not an easy one. Among the sixty drawings he needed to provide was the rhombicuboctahedron, whose twenty-six sides (involving eighteen squares and eight equilateral triangles) must have involved him in considerable mental funambulism.

* An equivalent claim today might be that—as some have maintained—DNA is "God's handwriting," or that the Higgs boson, if it exists, truly is "God's particle."

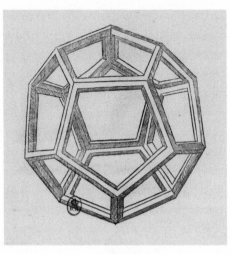

Leonardo's dodecahedron

However, Leonardo clearly relished the job. One of his notebooks has careful drawings of the five basic solids accompanied by a rhyme: "The sweet fruit, so attractive and refined / Have already drawn philosophers to seek / Our origins, to nourish the mind."[29] For the manuscripts he produced drawings of these "sweet fruit," done in ink touched up with watercolor, showing the bodies both in solid form and—in masterpieces of perspective and three-dimensional geometry—in see-through skeletal form.

Pacioli was evidently delighted with Leonardo's results. He later wrote that the artist had created "supreme and very graceful figures," ones that (in the familiar comparison) not even ancient artists such as Apelles, Myron, and Polykleitos could have surpassed.[30]

Leonardo's participation in this project and his friendship and close collaboration with Pacioli raises the question of whether he used divine proportion in *The Last Supper*. After all, Pacioli recommended his treatise to "clear-sighted and inquiring human minds," and he promised that anyone who studied "philosophy, perspective, painting, sculpture, architecture, music and other mathematical disciplines" would find in his work "a very delicate, subtle and admirable teaching and will delight in diverse questions

touching upon a very secret science."[31] Did Leonardo, then, make any use of Pacioli's "secret science"?

Since the middle of the nineteenth century, numerous claims have been advanced about the artistic application of divine proportion, or what has become known variously as the "golden section," the "golden ratio" or—in honor of Phidias, who supposedly employed it in the construction of the Parthenon—the Greek letter phi (ϕ). (In fact, the architect of the Parthenon was not Phidias: he was in charge, rather, of its decorative scheme. Early sources variously credit Iktinos, Kallikrates, and Karpion.)

The golden section is found without question in nature: in pineapples, sunflowers, mollusk shells, and the spiral shape of galaxies such as the Milky Way. Various writers have claimed the golden section can also be found in everything from the Egyptian pyramids to Greek vases and Gregorian chants. But the golden section is a modern obsession. The name was invented only in the nineteenth century. The majority of the claims for art and architecture do not withstand close scrutiny, and a growing literature has comprehensively debunked most of these assertions. The dimensions of the Parthenon, for example, by no means readily support the widespread theory that Phidias (or, rather, Iktinos, Kallikrates, and Karpion) knew or used divine proportion. Theories about the pyramids are difficult to prove because they are based on modern mathematical systems rather than the ones used by the ancient Egyptians.[32]

Pacioli's arrival in Milan served to stimulate even more Leonardo's keen interest in mathematics and geometry. He began filling his notebooks with multiplications and square roots. He praised the "supreme certainty of mathematics."[33] Many hours were spent taking numbers to the power of three or four, dividing and subdividing geometrical figures, and involving himself in the age-old problem of "finding a square equal to a circle."[34] So intense did these preoccupations become that they, rather than some catastrophic mishap or disconsolate realization about the impossibility of his designs, may have been responsible for temporarily curtailing Leonardo's interest in flying machines. Coincidentally or not, Leonardo's ambitions for flight began to languish the moment Pacioli arrived in Milan.

Yet the evidence for Leonardo's interest in or use of divine proportion is scanty indeed. Nowhere in his notebooks did he mention or describe divine proportion: the concept can be found neither in his numerous comments on proportion nor in his even more voluminous notes on mathematics and geometry. Indeed, the complete absence of any reference to divine proportion is one of the surprises of Leonardo's writings. If he believed divine proportion was indeed the key to beautiful design, something that had a universal applicability, why did he not mention it in his lengthy discussion of proportion in his treatise on painting?

Nor can Leonardo's paintings easily be adduced as evidence for experimentation with divine proportion. Geometric shapes can certainly be found in his paintings, as in the case of the equilateral triangle formed by Christ's head and arms in *The Last Supper*. Moreover, rectangles created via the golden section may be imposed on some of the various faces in his paintings. The superimposition is, however, usually arbitrary and unconvincing. For example, a painting sometimes offered as proof is Leonardo's unfinished *St. Jerome Praying in the Wilderness*, painted sometime in the 1480s. According to David Bergamini's *Mathematics*, published in Time-Life's wonderful "Science Library" series, the golden rectangle "fits so neatly around St. Jerome that some experts believe Leonardo purposely painted the figure to conform to these proportions."[35] However, the visual evidence suggests, on the contrary, that the "experts" have purposely arranged the rectangle to conform (albeit imperfectly) to the figure of St. Jerome, whose arm extends well beyond this rectangular confinement and whose head is inconveniently below the upper perimeter. The theory is further troubled by the fact that Leonardo painted *St. Jerome Praying in the Wilderness* a decade before he met Pacioli and learned about divine proportion. The exercise recalls the efforts of the mathematician who, in the course of some doubtlessly pleasing research conducted during the 1940s, claimed to have discovered the golden section in the chest and waist measurements of Hollywood star Veronica Lake.[36]

The reality is that the brilliance and appeal of Leonardo's paintings have little to do with rectangles or measuring sticks and everything to do with astounding powers of observation and unsurpassed understanding of light, movement, and anatomy. *St. Jerome Praying in the Wilderness* takes its power from the profound contrast between the dazed and sinewy old hermit—in whom we see Leonardo's fascination with the structural members of the human body—and the lithe torsion of the lion curled on the ground before

Leonardo's St. Jerome Praying in the Wilderness *with rectangle imposed, exploring the supposed relationship of the painting to the golden section*

him. This beast was no doubt drawn from life, modeled by one of the captive lions in the enclosure behind Florence's Palazzo Vecchio, literally a few yards from his father's house. Leonardo may even have dissected one of these lions at some point: "I have seen in the lion tribe," one of his notes reads, "that the sense of smell is connected with part of the substance of the brain which comes down the nostrils, which form a spacious receptacle for the sense of smell."[37] That kind of curiosity and dedication—a willingness to study the fierce creatures padding around their pens and then to peer inside their sectioned skulls—was the secret of Leonardo's artistic genius, not a dedication to drawing rectangles.

One reason why Leonardo did not use divine proportion in his works (or advocate it in his writings) is that Pacioli himself did not actually promote it as a design template for painters and architects. That is, Pacioli did not champion divine proportion as the key to perfect design: indeed, the thought never seems to have occurred to him. He advocated instead the Vitruvian system: one based not on the irrational mathematical constant 1.61803 but rather on simple ratios (Vitruvius believed *10* to be the "perfect number").[38]

Leonardo trusted empirical study far more than abstract concepts. He was more inclined to believe his own eyes and a set of calipers than one of Plato's pronouncements on the shape or proportions of the universe. Like Niccolò Machiavelli, he was interested in "things as they are in a real truth, rather than as they are imagined."[39] He could have known from his measurements of Trezzo and Caravaggio that one widespread modern notion about the golden section—that if you divide your height by the distance

from your navel to the floor you get 1.61803—was demonstrably incorrect. Indeed, the height versus navel measurements of his *Vitruvian Man* (sometimes held out as bodily evidence of the golden section) yield a ratio of approximately 1.512, a good deal short of this universal ideal—and a perfect example of the sort of fudging required by so many theories about the artistic use of the golden section. Leonardo's more empirical approach to human proportion led him to state ratios in other terms, using round numbers. Typical of his method was his claim that a man's height equals eight times the length of his foot, or nine times the distance between his chin and the top of his forehead.[40] Or, as we have seen in the case of *The Last Supper*, he was interested in the application of tonal intervals to painting and architecture, using ratios such as 1:2, 2:3, and 3:4 to organize the architectural components of the room where Christ and the apostles sit.

Leonardo would have been mesmerized by the various manifestations of the golden section in the natural world: in the phyllotaxis of sunflowers, for example, whereby the florets in the seed head are configured in two opposing spirals, which always happen to be consecutive Fibonacci numbers: 21, 34, 55, 89, or 144 running clockwise versus, respectively, 34, 55, 89, 144, or 233 running counterclockwise. But Leonardo and his contemporaries, including Pacioli, were completely unaware of these manifestations, most of which were not discovered until the first half of the nineteenth century. Only in the first decades of the twentieth century—thanks to the Bauhaus designers as well as American painters such as Robert Henri and George Bellows—did the golden section actually enter the studios of artists and architects.

A few months after Luca Pacioli arrived in Milan, his collaborator and new friend abruptly vanished. In the summer of 1496, after some eighteen months of work at Santa Maria delle Grazie, Leonardo abruptly downed tools and left Milan. On 8 June, one of Lodovico Sforza's secretaries reported that the artist had "caused a decided scandal, after which he left."[41]

The exact details of this scandal are not known. It may have involved a dispute over payment. Or perhaps Il Moro was losing patience with his tardy painter (who was perhaps spending more time on Pacioli's polyhedra and less on the apostles) and urging him to finish. The scandal and the ensuing flight must have served to enhance Leonardo's reputation as a willful

and difficult artist. It also meant that *The Last Supper*, like so many of his other works, was in danger of being abandoned unfinished.

For want of the original contract, we know none of the details about the commissioning, such as how much Leonardo was to be paid for *The Last Supper* or when he was supposed to finish. Reports about payments tend to vary widely. A friar at Santa Maria delle Grazie in the middle of the next century claimed Lodovico paid Leonardo an annual salary of five hundred ducats. This sum would have been substantial considering that the salary of high-ranking government officials was three hundred ducats, but it was hardly likely to keep Leonardo, with his expensive wardrobe and his entourage of servants and apprentices, in the lavish style to which he aspired. Matteo Bandello put Leonardo on a salary of two thousand ducats, which certainly would have kept him in lavish style.[42] Bandello was probably exaggerating and he may not have had access to the facts (he was only ten years old when Leonardo began work). However, it is plausible that Leonardo was paid two thousand ducats for the entire job of painting in the refectory. That was the exact amount paid to Filippino Lippi a few years earlier when he frescoed the Carafa Chapel in Santa Maria sopra Minerva in Rome.[43] A few years later, Michelangelo would receive three thousand ducats for frescoing the vault of the Sistine Chapel, a much larger commission.

Two thousand ducats—if that were indeed his payment for *The Last Supper*—was a substantial amount. It would have been sufficient, for example, for Leonardo to purchase a grand house beside the Arno in Florence.[44] It is tricky to translate two thousand ducats into today's money. However, the ducat was composed of 0.1107 troy ounces (3.443 grams) of gold, which means that Leonardo (if Bandello is correct) received a total of 221.4 ounces of gold. Translated into today's prices, with gold at $1,600 per ounce, Leonardo would have received the equivalent of a little more than $350,000.

Given Leonardo's apparently generous remuneration, one wonders if the artist was unhappy with certain other circumstances. His frustration and indignation may have stemmed from the myriad of smaller tasks assigned to him by Lodovico. Like the monks of San Donato a Scopeto, who got Leonardo to paint a sundial for them while he was working on his *Adoration of the Magi*, Lodovico regarded his resident painter as a journeyman to whom he could prescribe, on a whim, the most menial and uninspiring tasks. If Beatrice required new plumbing for her bathroom, or if her bedchamber needed a new coat of paint, Leonardo was conscripted into service. The

duchess's bedchamber may well have caused the breach, since Leonardo was painting her rooms in the Castello when he stormed off the job.

It is unclear if at this point Leonardo simply left the Castello or whether his fit of high dudgeon compelled him to flee Milan altogether. If he did leave Milan, one possibility is that he went to Brescia, in Venetian territory forty miles east of Milan. His presence in Brescia is undocumented, but it appears that he hoped to secure work painting an altarpiece for the Franciscan church of San Francesco. Thanks to Luca Pacioli, he knew the general of the Franciscan Order, Francesco Nani. Leonardo had sketched Nani's portrait earlier in the year, and he may have gone to Brescia in the hope that the powerful ecclesiastic, whose family came from the city, would help pull strings to secure him the altarpiece commission.[45]

Leonardo's brief description of the proposed altarpiece makes it sound like a fairly traditional work. He planned to feature the Virgin Mary and Brescia's two patron saints, Faustino and Giovita. The Virgin was to be elevated, probably on a throne, and the trio would be surrounded by an ensemble cast of Franciscan worthies, such as St. Francis, St. Bonaventure, St. Clare, and St. Anthony of Padua. The design (no doubt dictated by the Franciscan friars) is eerily reminiscent of the kind of work—such as the altarpiece for the chapel of San Bernardo in the Palazzo della Signoria— that he had left behind, unfinished, in Florence. How he could have summoned much enthusiasm for these figures after the dramatic mural he was in the midst of creating in Milan is difficult to imagine.

Back in Milan, Lodovico's secretary wrote to the archbishop of Milan, requesting that he secure the services of Pietro Perugino—a reliable painter if ever there was one—to finish the work in Beatrice's apartments. No mention was made of what would become of the half-finished mural in Santa Maria delle Grazie.[46]

Lodovico Sforza had more pressing concerns in the summer of 1496 than merely the plight of his mercurial painter. Since the beginning of the year he had been busying himself with yet another risky plot. This time, instead of inviting the French into Italy as protection against the Neapolitans, he invited Maximilian into Italy as protection against the French. As before,

there would be far-reaching consequences for virtually every principality and republic in Italy.

During his invasion of Italy, Charles VIII had signed a treaty with the Florentines promising to return Pisa as soon as he captured Naples. However, restitution had not been forthcoming, partly because the Pisans complained to the French that the Florentines had "treated them very barbarously."[47] Florence was therefore attempting to recover her valuable possession by force. Lodovico, meanwhile, hoped to take advantage of the situation and capture Pisa for himself. The Pisans welcomed his overtures, which came in the form of military and financial assistance for the battle against Florence. The Venetians were also offering aid to Pisa, and Lodovico's fears that the city might fall into the hands of Venice led him to appeal to Maximilian, the husband of his niece Bianca Maria.

Besides helping him secure Pisa, the arrival of Maximilian on Italian soil would have the added benefit of providing a buffer against any future French invasion, another of which seemed likely in 1496. The Neapolitans were steadily recapturing all of their lost territories, and a large French force under Gian Giacomo Trivulzio—the Milanese mercenary captain who had switched sides to serve the king of France—was stationed at Asti, poised to descend into Italy once again. Faced with this threat, Lodovico found himself, according to a chronicler, "in a state of the greatest anxiety."[48]

In July, Lodovico met with Maximilian at a Benedictine abbey on the German frontier. Under the cover of hunting and feasting, they hatched a plan whereby Maximilian would enter Italy on the pretext of going to Rome and receiving the imperial crown from the pope. On his way he would take the opportunity to keep Pisa free from Florentine clutches. Although Maximilian had little wish either to help the Pisans or to antagonize Florence, he was motivated by two important considerations. First of all, he would receive the imperial crown, without which he could not officially call himself the Holy Roman emperor (until this coronation he was, technically speaking, only the emperor elect). Second, and even more compelling, Lodovico promised him large sums of money.

Thus, early in September, Maximilian set off for Italy with eight regiments of infantry. He spent several weeks in the company of Lodovico at Vigevano, banqueting and hunting with leopards. In October he traveled

overland to Genoa, from where he sailed down the coast to Pisa. Here he was received with much rejoicing from the locals. Down came a statue of Charles VIII; up went the imperial eagles. But enthusiasm and adulation were short-lived. The German troops were ill provisioned and ill disciplined, and Pisa was already adequately garrisoned by the Venetians, making Maximilian's troops redundant. He sailed for Livorno, which he promised to conquer for the Pisans, but French ships and foul weather counted against him. His fleet was scattered by a storm, some of his ships were wrecked, and during a skirmish with the French a cannonball whizzed so close that it carried away part of his imperial robe. His appetite for the enterprise rapidly began to diminish. He soon made for the friendlier environs of Pavia, in Lodovico's domains, where yet another round of feasting was planned.

Maximilian's botched expedition did little for Lodovico's reputation. A Venetian chronicler described the duke as "one of the wisest men in the world... All men fear him, because fortune is propitious to him in everything." But he noted that no one liked or trusted Lodovico, and that "some day he will be punished for his bad faith. For he never keeps his promises, and when he says one thing, always does another." Another Venetian likewise deplored his behavior: "His pride and arrogance are beyond description," he fumed.[49]

Lodovico was proving as faithless in his personal dealings as he was in his political machinations. In November an observer from Ferrara wrote home: "The latest news from Milan is that the duke spends his whole time and finds all his pleasure in the company of a girl who is one of his wife's maidens. And his conduct is ill regarded here."[50] The girl was Lucrezia Crivelli, one of Beatrice's ladies-in-waiting, and the conduct was ill regarded by, above all, Beatrice herself. Beatrice had already seen off Lodovico's earlier mistress, Cecilia Gallerani, with whom Il Moro had tactlessly cavorted in the weeks following his marriage. But now, five years later, another rival emerged, plunging Beatrice—who was several months pregnant—into despair. Moreover, Lucrezia received the ultimate mark of affection from Lodovico: her portrait was painted by Leonardo.

Lodovico had once hired Leonardo to paint Cecilia Gallerani. Now he contrived for Leonardo to do a portrait of his latest concubine. A series of Latin epigraphs in Leonardo's notebooks, composed by an unknown poet, state that Leonardo, "the first among painters," executed Lucrezia's portrait. Lucrezia, enthused the poet, was "painted by Leonardo and loved by

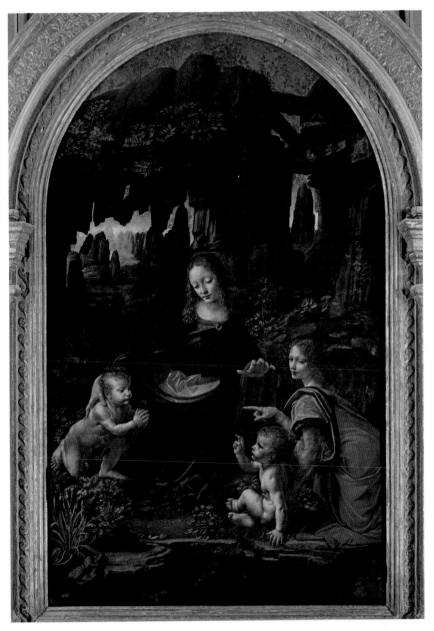

Leonardo da Vinci, *The Virgin of the Rocks* (Louvre version), 1483–c.1485

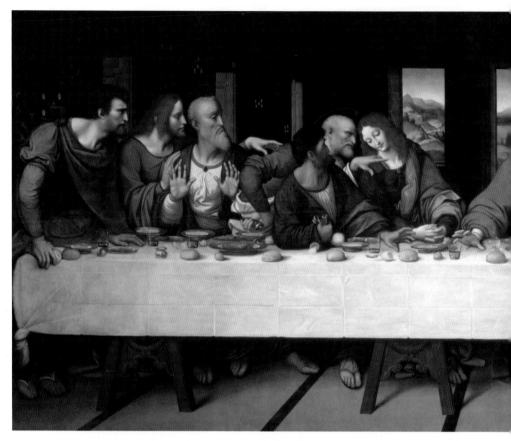

Giovanni Pietro Rizzoli, later known as Giampietrino, copy of Leonardo's *The Last Supper*, c. 1520. This copy of the mural by Leonardo's former apprentice is among the most faithful ever produced.

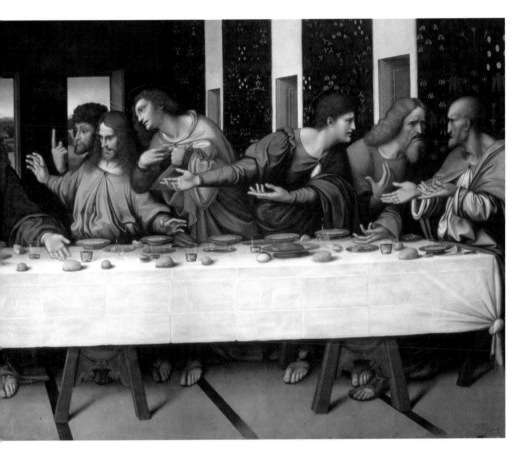

Map of Milan from George Braun and Frans Hogenburg's *Civitates Orbis Terrarum*, showing the Castello Sforzesco at the top

Leonardo da Vinci, detail of Christ in *The Last Supper*

Giovanni Donato da Montorfano, *Crucifixion*, refectory of Santa Maria delle Grazie, 1495

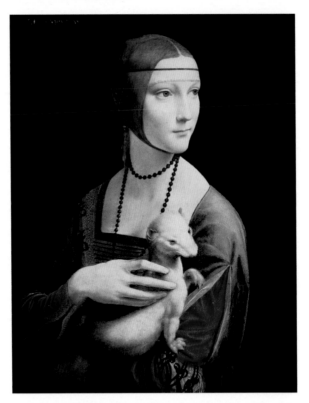

Leonardo da Vinci, *Portrait of Cecilia Gallerani* (*Lady with an Ermine*), c. 1489

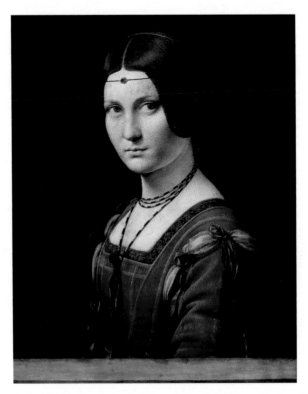

Leonardo da Vinci, *Portrait of a Woman* (*La Belle Ferronière*), c. 1496

Leonardo da Vinci, *Vitruvian Man*, c. 1490

Andy Warhol, *The Last Supper,* 1986

Il Moro."[51] When exactly this portrait was done is unclear. Nor is the identity of the painting completely evident, although the most likely candidate is the work known as *La Belle Ferronière*.[52] This portrait of a doe-eye brunette was done in oils on a panel made from walnut—possibly from the same walnut tree, in fact, from which came the panel used for *Lady with an Ermine*.[53] The identity of the sitter in this portrait is not definitively known, but the Latin epigrams suggest that for want of another portrait that might fit the bill, Lucrezia was the sitter.*

As so often with Leonardo, uncertainty and equivocation reign. *La Belle Ferronière* exemplifies the gaps and disputes surrounding so much of his output. Not everyone agrees the work is by Leonardo: one Leonardo scholar claimed that not so much as a single brushstroke came from the hand of the master.[54] It was not identified as a Leonardo until 1839; later in the nineteenth century it was attributed to his pupil Boltraffio, while in the 1920s a version owned by an American car salesman was put forward as the real Leonardo, with the resulting slander trial exposing the prejudices and drastic limitations of leading art connoisseurs such as Bernard Berenson.[55] There is very little, other than the Latin epigrams, to link the painting to Lucrezia Crivelli.

If *La Belle Ferronière* does represent Lucrezia, this portrait must have been painted while Leonardo worked on *The Last Supper*. Lodovico took Lucrezia as his mistress, at the very latest, in August 1496, in the weeks following his visit to Maximilian: that, at any rate, was when she became pregnant with his child. The liaison continued through the autumn, which may have been when the duke engaged Leonardo to execute her portrait. The date of Leonardo's return from Brescia to Milan is—like so many of his comings and goings—uncertain. However, the altarpiece for San Francesco never materialized, and Leonardo was recorded in Milan in January 1497, back at work in Santa Maria delle Grazie.

* During the eighteenth century the sitter was erroneously believed to be the wife of a Parisian iron merchant named Jean Féron whose wife was the mistress of François I of France, Leonardo's last patron. The painting actually became known as *La Belle Ferronière* not in homage to the royally cuckolded ironmonger but because its subject wears a *ferronière*, a slim headband with a gem on the brow, an accessory fashionable in Milan in the 1490s.

The Beloved Disciple

How did people during the Italian Renaissance, when they looked at a painting of a biblical scene, know who they were looking at? How did they identify the often huge casts of saints and disciples with which frescoes and altarpieces teemed?

Until about 1300, painters often identified the figures in their painting by helpfully inscribing their names underneath—giving them, in effect, name tags. By the time of Giotto, these inscriptions largely disappeared and a tradition was established whereby painters used distinctive attributes to illustrate and individuate saints and biblical characters. Peter is easily recognizable because he is often shown holding a pair of keys ("I will give to you the keys of the kingdom of heaven," Jesus tells him in the Gospel of St. Matthew). Sometimes, in reference to his former occupation, he might be holding a fish. Mary Magdalene is identifiable because she sometimes holds the jar of ointment that she carried to Christ's tomb. The attributes of several apostles foretell their violent and grisly fates: James the Lesser's is the

club used to beat him to death, Simon's the saw that cut him in half, and Thaddeus's the halberd with which pagan magicians slew him in Persia.

Painters of Last Suppers did not bother with these symbols, which would have detracted from the pictorial effect. Even so, a number of the apostles were usually obvious to viewers because of their appearances or actions, especially the gray and grizzled Peter, the youthful John, and, of course, the villainous Judas. But artists were not always concerned to individuate the entire cast of twelve apostles. Lorenzo Ghiberti, in his bronze relief on the door of the Baptistery of San Giovanni, even depicted five of them from the rear, showing nothing but the backs of their heads and thereby making their true identities anybody's guess.

Art historians are confident, however, about the identities of the twelve apostles in Leonardo's *Last Supper*. Their names were established when, in about 1807, an official from the Accademia di Belle Arti di Brera in Milan, Giuseppe Bossi, discovered in the parish church of Ponte Capriasca, near Lake Lugano, a sixteenth-century fresco copy of Leonardo's mural. Even though such inscriptions had virtually disappeared from Italian art, twelve names were carefully painted on a frieze underneath. These identifications, because they were probably made by someone who knew Leonardo and his circle, are now almost universally accepted—albeit, in one case, controversially disputed.

Leonardo faced the same compositional problem as any painter of a Last Supper: how to range thirteen men around a dinner table such that they could interact with each other. A notable feature of his design for *The Last Supper* is how he arranged the twelve apostles in four groups of three, with two of these triads on either side of Christ. The most dramatic and intriguing of these groupings is the one immediately to the right of Christ, featuring—as the copy at Ponte Capriasca tells us—Judas, Peter, and John. Leonardo positioned John leaning away from Christ and toward Peter, who inclines eagerly forward to whisper in John's ear, an action that causes Judas, seated in between, to rear back and to his right.

Anyone familiar with the Gospel of St. John would know exactly the moment depicted. "Amen, amen, I say to you, one of you shall betray me," Jesus announces. "The disciples therefore looked one upon another," John reports, "doubting of whom he spoke. Now there was leaning on Jesus's bosom one of his disciples, whom Jesus loved. Peter therefore beckoned to him and said to him: Who is it of whom he speaks?" (John 13:21–4).

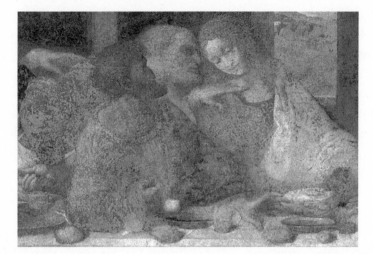

Three apostles (Judas, Peter, John) to the right of Christ in Leonardo's The Last Supper

Jesus is speaking of Judas, of course—but who is it of whom John speaks? The disciple leaning on the bosom of Jesus is not only in a privileged position at the dinner table, in physical contact with Jesus, but he is evidently privy to special knowledge about the betrayal, or at least so Peter believes.

The disciple leaning on Jesus—the one "whom Jesus loved"—is traditionally identified, as we have seen, as John himself. The Greek translators of the Bible had several different words for love at their disposal. Earlier in the Gospel of St. John (11:3) we are told that Jesus loves Lazarus, the brother of Mary and Martha whom he raises from the dead. His love for Lazarus is expressed by the Greek word *philia*, which refers to strong friendship or brotherly love. The Greek translation of the New Testament uses the word *agape*, on the other hand, to describe his feelings for John, connoting a much deeper affection—one that is, however, untouched by the sensual yearnings of *eros*.

All Last Suppers portrayed John as a youthful and slightly feminine figure among his mostly bewhiskered and older companions. Virtually all of them, too, following the Gospel of St. John, showed him asleep on the bosom of Christ. From the twelfth century onward this motif was ubiquitous in Last Suppers, with Giotto in the Scrovegni Chapel in Padua, for example, showing Jesus cradling a sleeping John. All of the great refectory Last Suppers in Florence—by Gaddi, Castagno, and Ghirlandaio—used the motif, with Ghirlandaio featuring it in each of his three versions.

Leonardo's approach to John was unique. Although one of his earliest sketches for the composition shows John asleep beside Christ, he abandoned the pose, undoubtedly because it detracted from the figure of Christ, whom he wished to isolate and emphasize in the middle of the scene. He therefore deviated from well-established pictorial tradition, illustrating a moment in the narrative that comes a second or two later than all others: having roused himself from Christ's breast, John leans gracefully toward Peter, his head tipped to the right, the better to hear his urgent question: "Who is it of whom he speaks?" In the copy at Ponte Capriasca the painter inscribed beneath the feet of this character the confident label: S. IOHANES—that is, St. John.

But is this figure truly meant to represent St. John? Famously, a character in Dan Brown's 2003 novel *The Da Vinci Code* sees someone else depicted: "That's a woman!" exclaims Sophie Neveu after studying a reproduction of the painting and discerning "the hint of a bosom." "That, my dear," another character informs her, "is Mary Magdalene."[1]

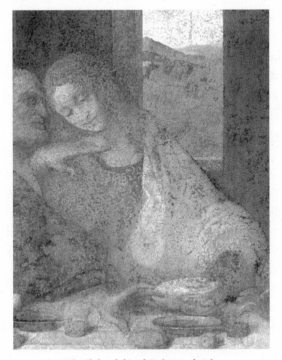

The "beloved disciple": the apostle John

In Brown's novel, Leonardo has omitted one of the apostles, presumably John, and instead painted Mary Magdalene into the mural. The painting therefore offers testimony that she was present at the Last Supper, that she and Jesus were married or in a sexual relationship, that they conceived a child together, that Jesus asked her (and not Peter) to establish his church, and that Leonardo was, by dint of his leadership of an arcane lodge, the Priory of Sion, privy to this explosive train of secrets. The novel's claims made it a worldwide bestseller, spawned both an ABC News documentary and a feature film, and prompted the Vatican to appoint the archbishop of Genoa to refute the novel's "shameful and unfounded errors."[2]

Claims for Mary Magdalene as the lover of Christ date from long before 2003. They were given support by the Gospel of Philip, an anthology of early Christian writings discovered in a cave with other papyrus codices near Nag Hammadi in Egypt in 1945. The codices were written in Coptic as much as two centuries after Christ's death and hidden sometime afterward because as Gnostic texts they were deemed heretical, their interpretations of the Christian faith outside the orthodoxy in the process of being established by the church fathers. The Gospel of Philip makes no pretense of having been written by Philip. Its name merely comes from the fact that Philip is the only apostle mentioned in its pages. He is apparently the source for the text's poignant fable that the wood of the cross on which Jesus was crucified came from a tree planted by his father, Joseph, because he needed wood for his trade as a carpenter.[3]

The Gospel of Philip is a mishmash of biblical quotations, cryptic sayings, and bizarre musings such as the one that some people fear the Resurrection "lest they rise naked." But its author or authors were most concerned with the institution of marriage. References to bridal chambers abound, and the text stipulates that slaves, animals, and "defiled women" should never be admitted into this place of mystery, nor should the bride ever let anyone see her as she "slips out of her bedroom." As the text primly declares, "No one can know when the husband and the wife have intercourse with one another, except the two of them."

In the context of these scattered oddities, Mary Magdalene is mentioned as the "companion" of Christ. "As any Aramaic scholar will tell you," Sophie Neveu learns, "the word *companion*, in those days, literally meant *spouse*."[4] However, the word used in the Gospel of Philip, *koinonos*, is actually Greek

(and the rest of the text is in Coptic, not Aramaic). The word's compass of meanings (companion, partner, associate) does not necessarily imply a sexual relationship, much less marriage. The word *koinonos* is used in the Bible to refer to the business partnership of Peter with his fellow fishermen John and James (Luke 5:10).

Be that as it may, the Gospel of Philip goes on to state that Jesus "loved Mary more than the other disciples and kissed her often on her mouth"—or at least the word "mouth" is assumed by scholars and translators, but at this point (as elsewhere in the codex) there is, tantalizingly, a hole in the papyrus. The text reports that other disciples grew jealous of this intimacy, asking, "Why do you love her more than all of us?" Christ's answer stresses her greater spiritual insight: "Why do I not love you like her? When a blind man and one who sees are both together in darkness, they are no different from one another. When the light comes, then he who sees will see the light, and he who is blind will remain in darkness."

The Gospel of Philip offers no more information on the dealings between Jesus and Mary Magdalene. However, Mary Magdalene was not the only recipient of a kiss from Jesus in the Gnostic Gospels or the only follower for whom greater spiritual insight was claimed. One of the other papyrus codices found at Nag Hammadi, known as The (Second) Apocalypse of James, describes how Jesus kissed his brother James as a prelude to offering him enlightenment. "And he kissed my mouth," the text reads. "He took hold of me, saying, 'My beloved! Behold, I shall reveal to you those things that neither the heavens nor their archons have known.'" This codex is supposedly a transcription of James's preaching in Jerusalem, and one of his most insistent messages was his own privileged position among the disciples. "I am he who received revelation from the Pleroma of Imperishability," he boasts. "I am he who was first summoned by him who is great, and who obeyed the Lord." A few lines later he further stresses his unparalleled prominence: "Now again am I rich in knowledge and I have a unique understanding . . . That which was revealed to me was hidden from everyone." So in this version, James—in the midst of much apostolic jockeying for position—becomes the truest follower of Christ.

Leonardo was of course unaware of these Gnostic texts. What he could have known of Mary Magdalene came from the few times she is mentioned in the Bible. Both Matthew (27:55–61) and Mark (15:40–47) state that she

was present at the Crucifixion and burial, and all four Gospels describe (with some variation) the incident when she carried the ointment to Christ's tomb on Easter morning and witnessed the empty tomb.

Leonardo must also have known something of Mary Magdalene from the detailed treatment she receives in *The Golden Legend*, a work that offered a more interesting and significant role to her than merely the recipient of Christ's kisses. *The Golden Legend* was a collection of saints' lives compiled in the thirteenth century by the Dominican archbishop of Genoa. Hugely popular among both the clergy and the laity, it was second only to the Bible in terms of its readership. It describes a Mary Magdalene who enjoys a very close relationship with Christ and plays an important part in his apostolic mission. The book's author, Jacobus de Voragine, followed the example of Pope Gregory the Great (540–604) in creating a compelling character by combining the Mary Magdalene described (with extreme brevity) in the Bible with a number of other women in the New Testament, some of them named Mary (such as Mary of Bethany, the sister of Lazarus) and others anonymous, including the woman who anoints Jesus with ointment and wipes his feet with her hair. He also adds into the mix Mary of Egypt, a repentant prostitute from Alexandria who lived as a hermit in the desert, covered only by her hair. Mary of Egypt was a figure from a much later date, having died in about 421—but Voragine blithely assimilates her into his composite character of Mary Magdalene.

Voragine begins his tale by giving Mary Magdalene an impressive (and obviously false) pedigree: she came from a wealthy and noble family, he says, with a castle near Nazareth named Magdalo. As a young woman she gave herself over to sensual delights, for which Jesus forgave her, showing her "many marks of love," such as having her act as his housekeeper when he was on the road. He counted her "among his closest familiars," and took her side when her sister, Martha, denounced her as lazy or when Judas called her wasteful. The attachment was indeed a sentimental one: "Seeing her weep he could not contain his tears."[5]

According to Voragine's account, Mary's reputation increased after the death of Christ. She was entrusted by Peter to a man named Maximin (a figure not mentioned in the Bible: Voragine confuses a fourth-century bishop of Trier with Maximinus, one of the seventy apostles mentioned in Luke 10:1). The pair of them, along with her sister, Martha, and brother, Lazarus, were persecuted by villains who tried to kill them by the cruel and unusual

expedient of putting them out to sea on a rudderless ship. The ship miraculously fetched up in Marseilles, where Mary won the locals away from idolatry, becoming a miracle worker and gathering disciples about her. At the height of her powers she retired to live in an empty wilderness, all alone except for attending angels who each day carried her up to heaven to eat manna and listen to celestial music. Following thirty years of this idyllic regime, she died and was interred in a church in Aix-en-Provence, from which, in the time of Charlemagne, her bones were taken to the abbey of Vézelay. Here she continued to work miracles, raising a knight from the dead, letting a blind man see, and helping a duke of Burgundy conceive an heir.

Thanks to these relics, Vézelay became one of the most important pilgrimage destinations in France, and a new abbey needed to be constructed to accommodate the hordes of pilgrims. However, toward the end of the thirteenth century the Dominicans at the church of Saint-Maximin in Aix claimed that they, not the Benedictines in Vézelay, possessed her true relics. Their claim was based on the opening of an ancient sarcophagus in the church in 1279, roughly two decades after Voragine popularized Mary Magdalene in *The Golden Legend*. The authorities confirmed the relics were indeed hers, with the Dominican inquisitor Bernard Gui recounting in his chronicle how a marvelous odor issued from her tomb, "as if an apothecary shop of sweet spices had been opened," and how a tender green shoot—what was later described as a palm frond—was sprouting on her tongue.[6]

The Dominicans henceforth became the guardians of Mary Magdalene's relics. She was one of their most important saints, in part because she supposedly spread Christ's message in southern France, where Dominic evangelized in the early years of the thirteenth century. In fact, it was on her feast day in 1206 that Dominic received a vision of a ball of fire above a shrine to Mary Magdalene on a hill outside the village of Prouille. Taking this vision as a sign from God, he opened the first Dominican convent on the site a few months later, appealing for the patronage of Mary Magdalene. She was declared the patroness of the Dominican Order itself in 1297, and her feast day was observed with such zeal that anyone failing to observe it properly risked a flogging.[7]

Given such veneration, the Dominicans of Santa Maria delle Grazie would not have regarded the appearance in a Last Supper of Mary Magdalene—if Leonardo were to put her there—as unusual or heretical. There was even a precedent for including Mary Magdalene among the company at the Last

Supper. Fra Angelico placed her prominently in a Last Supper fresco at the Dominican convent of San Marco in Florence, showing her kneeling and haloed in the room with the twelve apostles. The sight of Mary Magdalene among the apostles did not cause disquiet or disturbance given her supposed apostolic career in France and the title by which she was known in the Middle Ages—*apostolorum apostola*, apostle of the apostles—a name given to her because, as the Gospels made clear, she was the first witness of the Resurrection and the one whom Christ asked to spread the news.[8]

Leonardo would have seen numerous images of Mary Magdalene during his youth in Florence. Most striking was Donatello's wooden statue in the baptistery, a harrowing portrait that shows her with a gaunt face, sunken eyes, a protruding sternum, and long, matted hair covering her emaciated body. Donatello was basing his depiction on a life of Mary Magdalene composed by a Dominican friar in the middle of the fourteenth century. Emphasizing her extreme penitence, this biography described how she physically abused herself after giving up prostitution, clawing her face and legs until they bled, tearing out clumps of hair, and striking her face with her fists and her breasts with a stone. At the end of this violent self-laceration she cried, "Take the reward, O my body, of the vain pleasures thou has frequented."[9]

Donatello's version was extreme, but the dominant image of Mary Magdalene in the fifteenth century was as a penitent.[10] She was the patron saint

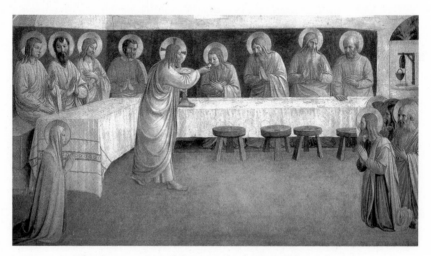

The Communion of the Apostles *by Fra Angelico, with Mary*
Magdalene kneeling in the lower left

of prostitutes, and her image often adorned the charitable institutions in Florence and elsewhere that gave refuge to reformed prostitutes. She was also, as a completely rehabilitated sinner, an image for all sinners to contemplate, not just reformed prostitutes—an example of how even the most degraded could recover purity of heart and find salvation. Such was her rehabilitation that she was regarded by the church (perhaps unexpectedly given her career as a prostitute) as one of the virgin saints. The Dominican theologian Thomas Aquinas explained this transformation: "A person who has lost virginity by sin recovers by repenting, not the matter of virginity but the purpose of virginity." A Luca Signorelli fresco in the cathedral in Orvieto, *Retinue of Chaste Virgins*—a project on which Dominican friars served as theological advisers—duly depicted her as the leader of the virgin saints. A far cry from Donatello's haggard penitent, she has golden hair and a rose-colored gown.[11]

By the 1490s, then, Mary Magdalene had a rich history and a wide range of meanings: prostitute, close companion of Christ, "apostle of the apostles," patron saint of the Dominicans, miracle worker, virgin saint, and, most of all, reformed sinner—an example of how fallen humanity could redeem itself, and how even the most lowly and despised could be called by Christ to an apostolic mission. She was prolifically represented in frescoes and altarpieces. There could be nothing controversial or theologically untoward about her appearance in a painting showing Christ and his apostles.

That much said, did Leonardo in fact omit John from his *Last Supper* and substitute Mary Magdalene in his place? Does the figure traditionally identified as John betray, as Sophie Neveu exclaims, the "hint of a bosom" and—perhaps—other female features that require us to identify her as a woman, not a man?

One reason for the supposed cameo by Mary Magdalene was removed, under oath, during a corruption trial in a French court, where Leonardo's role as grandmaster of the shadowy "Priory of Sion" was revealed as a crude hoax. The Priory of Sion was supposedly a secret society founded in Jerusalem in 1099 to safeguard documents proving that Mary Magdalene gave birth to Christ's baby. The descendants of Christ went on to found the Merovingian dynasty of Frankish kings, who ruled most of what is now

France (and large chunks of Germany) between the fifth and eighth centuries. In fact, the Priory of Sion was invented in the 1950s by Pierre Plantard, an anti-Semite, hoaxer, and fantasist who believed himself to be the true king of France and the latest in a long line of descendants of Christ and Mary Magdalene. Leonardo got dragged into the tale because his name—along with those of Sir Isaac Newton, Victor Hugo, and a corrupt French businessman named Roger-Patrice Pelat—was inscribed on a list of "grandmasters" that Plantard composed and then stashed in the Bibliothèque nationale. In 1993, Plantard admitted his forgery in French court before an unamused judge.[12]

If Leonardo is not the custodian of insider knowledge about Mary Magdalene's secret nuptials, Christ's Gallic descendants, or Pierre Plantard's right to the French throne, what reason might he have had to show her in *The Last Supper*? Or, if indeed he depicted her, why disguise her? He could, like Fra Angelico, simply have shown her—the apostle of the apostles—among the others. If the Dominicans at San Marco in Florence did not object to her appearance in Fra Angelico's depiction, why should the Dominicans at Santa Maria delle Grazie protest, especially given their veneration of her?

A clue to the identity of the mysterious figure beside St. Peter is undoubtedly his or her gender. In *The Da Vinci Code*, she is unambiguously a woman. "Leonardo was skilled at painting the difference between the sexes," a character explains to Sophie.[13] On the contrary: Leonardo was skilled at blurring the differences between the sexes. He was fond of producing mysteriously androgynous figures: not only the beautiful adolescent (probably based on Salaì) who appears almost obsessively in his sketches, but also figures such as Uriel, the angel kneeling on the right in his *Virgin of the Rocks*. For this painting Leonardo drew on a fourteenth-century biography of John the Baptist by Domenico Cavalca that described how as a child John was living under the protection of the angel Uriel when he met the Christ Child in the wilderness. Leonardo's Uriel is a gloriously enigmatic creature who defies easy gender categorization. Judging from the beautiful silverpoint drawing of Uriel's head, Leonardo's model was almost certainly female. In the two versions of *The Virgin of the Rocks* he heightened and emphasized the angel's feminine qualities with golden curls and delicate features. The end result is head-scratchingly ambiguous: a young woman or androgynously beautiful adolescent male? Leonardo was deliberately coy about "the difference between the sexes."

Equally ambiguous is the figure in one of his last paintings, *St. John the Bap-*

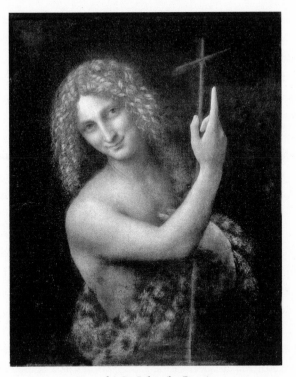

Leonardo's St. John the Baptist

tist. The subtle shading of the Baptist's features gives soft tones to his smooth, feminized face, with its wide, come-hither eyes and the sphinxlike smile. Many viewers have been disturbed by this remarkable-looking figure. "Is it even a man?" asked Hippolyte Taine. "It is a woman, the body of a woman, or the body of a beautiful ambiguous adolescent."[14] Perhaps most alarmed by this she-male was Bernard Berenson. The great connoisseur could not understand "why this fleshy female should pretend to be the virile sun-dried Baptist . . . And why did it smirk and point up and touch its breasts?"[15]

The model for this mysteriously leering *séducteur* may have been Salai, then in his thirties and still, apparently, possessed of powers of both attraction and repulsion. Salai has been advanced as the model for another of Leonardo's bewitching portraits: the art investigator Silvano Vinceti claims he was the model for the *Mona Lisa.* Vinceti, the man who discovered Caravaggio's remains in 2010, based his theory on supposed similarities between the faces of the Baptist and the subject of the *Mona Lisa,* noting that Leonardo often used Salai as a model, and that he "certainly inserted" some of

Salai's characteristics into Lisa's features.[16] Vinceti's theory is seriously undermined by a lack of visual evidence: we do not actually know exactly what Salai looked like. There are no certain sketches of him, merely drawings of a ringleted youth that it is reasonably assumed were modeled by the young man. However, it should be noted that ringleted youths appear in Leonardo's sketches *before* Salai's arrival in his studio.

Salai is an unlikely model for the *Mona Lisa*, but the androgynous qualities of the sitter have been noted by others, such as the French artist Marcel Duchamp, who in 1919 added a goatee and mustache to a reproduction of the painting to create his work *L.H.O.O.Q.*, turning Mona Lisa into that hermaphroditic cliché of the fairground freak show, a bearded lady.* Yet another male model has even been claimed for the *Mona Lisa*—Leonardo himself. In 1987 the American artist Lillian Schwartz used a computer program to align the face in the *Mona Lisa* with the supposed self-portrait of Leonardo in the Biblioteca Reale in Turin. She discovered that their eyes, eyebrows, nose, and chin matched so closely that the mirroring could not be coincidental—meaning the *Mona Lisa* was really Leonardo's self-portrait in drag. She pointed to the painting's apparently hermaphroditic quality by calling her resulting image *Mona/Leo*. Her theory is undercut by the fact that the sketch in Turin is not Leonardo's self-portrait, but if the two faces do indeed mirror one another, then the *Mona Lisa* may well have been based at least in part on a male model.[17]

Another of Leonardo's ambiguously gendered figures is the erotic drawing known as *Angelo Incarnato*, or the *Angel Made Flesh*, which appears to be Leonardo's obscene caricature of his own smiling androgyne in *St. John the Baptist*. To the feminine features of the latter painting (the soft features and corkscrew hair) the sketch adds not merely the "hint of a bosom" but a round pubescent breast with a large nipple. However, Leonardo's angel also proudly sports a large erection. Leonardo's most recent biographer describes the sketch as "a kind of specialist transsexual pornography" in which an angel is given the features of "an unsavoury-looking catamite fished up from the lower reaches of the Roman flesh-market."[18]

According to Carlo Pedretti, Leonardo was "playfully intrigued first and then dangerously fascinated by the idea of having one sex merge into the

* The title of Duchamp's work is a pun. The letters L.H.O.O.Q., spoken aloud in French, sound like *"Elle a chaud au cul,"* which translates as "She has a hot ass."

other."[19] Leonardo was not alone: he came out of an artistic tradition that relished this kind of gender-bending. Florentine art over the previous generations had produced numerous images of beautiful young boys, often androgynous and lithely sensual. Most notable was Donatello's bronze *David*, commissioned by Cosimo de' Medici for the courtyard of his Florentine palazzo. The statue's combination of masculine and feminine elements may have been intended to evoke the mythical figure of the hermaphrodite, celebrated in obscene verse by Antonio Beccadelli in *The Hermaphrodite* around the time Donatello cast his sculpture. Also around the same time, an ancient Roman statue uncovered in Florence, *Sleeping Hermaphrodite*, showing a beautiful young creature with female breasts and male genitalia, was much admired.[20] In the fifteenth century the hermaphrodite did not have negative connotations: its androgyny was understood to be a sign of the unity and perfection of the self. A member of Cosimo de' Medici's circle, the scholar Marsilio Ficino, wrote in his commentary of Plato's *Symposium* that the androgyne reconciled the masculine virtue of courage with the feminine one of temperance. The hermaphrodite was, in this view, the perfect being: someone whole and complete. Leonardo's last patron, King François I of France, therefore did not object when the painter Niccolò da Modena represented him as an androgyne: he was shown to combine the warrior qualities of the male with the productive and creative powers of a woman.[21]

Leonardo was less interested in the philosophical underpinnings of the androgyne than he was in its erotic charge. He was interested in faces of every type, but his ideal of physical beauty was a young man, an adolescent or even a prepubescent boy, with curly hair and feminine features—someone encompassing both childhood and adulthood, and masculinity and femininity. Salai best represented this style of beauty for him, and Leonardo no doubt tolerated the boy's errant behavior for the sake of his angelic face and mass of ringlets.

It would have been natural for Leonardo to consider Salai as a model for *The Last Supper*: not for one of the older apostles, obviously, since Salai was still an adolescent when Leonardo began work, but rather for one of the younger ones. He may have been the model for St. Philip, the apostle in the orange-colored robe who, standing three figures to Christ's left, seems to be protesting his innocence. The model for Philip, sketched by Leonardo in a study done in black chalk, was thought for many years to be a young woman, not only because of the delicate features but also because the model

seemed to be wearing a ribbon or hair band. However, the "hair band" proved on further investigation to be nothing more than a crease in the paper, and it is equally possible that the model was actually a young man or an adolescent. However, the gender of the model was complicated even more when a drawing was discovered beneath the paint of one of Leonardo's other works, the London version of *The Virgin of the Rocks*. The sketch is of the Virgin Mary, and her features exactly match those of Philip in *The Last Supper*, indicating that Leonardo used the same drawing—and the same model— for both Mary and the apostle. The gender of the model remains an open question.[22]

The black chalk drawing of Philip bears undeniable similarities to a Salai-type sketch dating from about 1495: Leonardo gave large eyes and a Greek nose to both of them, and the pair, crucially, seem to be the same age. Leonardo made Philip look somewhat older in the finished painting but nonetheless emphasized his youth by depicting him, along with John and Matthew, as one of the three beardless apostles. Salai-like features can also be read into those of Matthew, another of the younger-looking apostles, and one whose mop of curls has been sadly obscured by paint loss. In any case, the matching Greek noses, the downturn of the mouths, and the slightly bulbous chins—all suggestive of the "Salai-type profile"—indicate that Leonardo used the same model for both Philip and Matthew.

No sketch or study has ever been found for the figure traditionally iden-

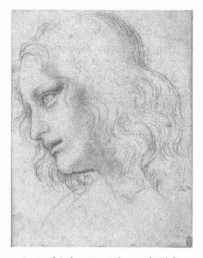

Leonardo's drawing of the apostle Philip

The apostle Matthew

tified as John, and the paint loss in the finished work (only one tenth of John's original flesh tones have survived) has left only a shadow of what the true features would have been.[23] He appears even more youthful even than Philip or Matthew. It is more difficult to read Salai's features into John since, unlike the two others, he is not shown in profile (which is how Leonardo usually chose to draw the ringleted adolescent for which Salai was an exemplar). But he is dreamy and demure, another of Leonardo's angel-faced androgynes. If there is no hint of a bosom, there is, however, the hint of a sphinxlike smile: the same riddling smile seen on the lips of Leonardo's other hypnotic androgynes such as Uriel and John the Baptist.

A figure in a Leonardo painting with feminine features does not therefore automatically, easily, or unambiguously qualify as a woman. In fact, the figure in *The Last Supper* is not a woman: only the most partisan reading can place Mary Magdalene in the scene. Viewers in the fifteenth and sixteenth centuries would have read the painting quite differently.

As we have seen, a well-established tradition gave John, the beloved disciple, a feminized appearance and sat him beside Christ—or often placed him asleep on Christ's breast—at the Last Supper. He was traditionally understood to be the youngest of the apostles, and painters made much of

his youthfulness. The earliest known image of him, in the St. Tecla cata-
comb in Rome, dating from the late fourth century, shows him as slim and
beardless, little more than a boy. Painters of the Last Supper invariably de-
picted him as a handsome, beardless, and often effeminate youth with long
hair. Leonardo preserves this feminine appearance but otherwise his depic-
tion departs from the tradition: John sits next to Jesus, on his right side, but
leans toward St. Peter, who beckons him and anxiously asks his question.
There was a clear compositional reason for this change: Leonardo wanted
to isolate Jesus in the middle of the scene, a pose that the figure of John asleep
on his breast would have weakened.

None of the three synoptic Gospels mentions the special relationship be-
tween Jesus and John, and the Bible itself provides only a few details of John's
life and character. John is not even mentioned in his own Gospel beyond
several cryptic references to the disciple whom Jesus loved most. From the
synoptics it can be determined that he was the brother of James the Greater
and the son of a fisherman named Zebedee. Called by Christ as they were
mending their father's nets, John and James left their boat to follow him.

Some of the gaps in John's life story were eagerly but unreliably filled by
various legends composed and transmitted after his death. These accounts
underscored and expanded his role as the disciple whom Christ loved. The
Apocryphal Acts of John, in particular, stressed the closeness of their rela-
tionship. Written in the third or fourth century to supplement the skimpy
details given in the Bible about the lives (and also the deaths) of John, An-
drew, Paul, Peter, and Thomas, the Apocryphal Acts were lively and popular
accounts that featured talking animals, flying magicians, and melodramatic
episodes of self-castration and necrophilia. In them, the apostles performed
exciting feats such as reviving a dead fish and baptizing a lion, and the Acts
of John included the charming story of how John, while bedding down at
an inn, successfully ordered the bedbugs to leave him alone so he could get a
good night's sleep.

In the fifth century, Pope Leo the Great condemned the Apocryphal
Acts as "a hotbed of manifold perversity" and ordered them to be burned.[24]
Such was their enduring appeal, however, that they were still being copied
in the fourteenth century, and artists often turned to them for inspiration,
as for example when Giotto painted the raising of Drusiana by St. John or
Filippino Lippi the upside-down crucifixion of St. Peter.

The Acts of John provide much information about John's close relation-

ship with Jesus. John is depicted as someone whom Jesus must rescue from marriage and a love of women (making him a salutary example for young men entering the priesthood). The text includes a long speech in which John describes how Jesus made sure that he, John, was "untouched by union with a woman." When he wished to marry in his youth, Jesus appeared to him and declared, "John, I need thee." John remained determined, however, and so with the wedding fast approaching Jesus struck him down with a "bodily sickness" that prevented the union. On another occasion when John was preparing for his nuptials, Jesus told him: "John, if thou wert not mine, I should have allowed thee to marry," whereupon he blinded him. When John finally regained his sight, Jesus disclosed to him "the repugnance of even looking closely at a woman." The apostle was thereby saved from "the foul madness that is in the flesh."[25]

The tradition of John as the beloved disciple later caused suspicious comment, particularly in England. The Elizabethan playwright Christopher Marlowe was accused of calling John a catamite, a "bedfellow to Christ" who "leaned alwaies in his bosome," and who was used "as the sinners of Sodoma." A few decades later, in 1617, King James I cited the relationship as a justification for his love of George Villiers, the Duke of Buckingham, when he told the Privy Council: "Christ had His John and I have my George."[26] In 1967, Hugh Montefiore, later bishop of Birmingham, read a paper at the annual conference of modern churchmen at Oxford speculating that Jesus was a homosexual, citing as evidence his relationship with John and the other apostles. Other theologians have recently developed the idea further, with one of them outlining the "possibly homosexual behaviour" of Jesus in his relations with John.[27]

The master-disciple relationship has a long history in the Mediterranean world. The intense connection between an older teacher and his younger pupil was celebrated by the ancient Greeks, for whom young men were initiated into society through what has been called "educational homosexuality." Such attachments were equally well-known to Renaissance Italy, especially in Florence, where in 1469 Marsilio Ficino, the translator of Plato, celebrated what he called "Socratic Love": boys who were "nearly adults" should be instructed in the ways of society, he argued, through "personal and pleasing intimacy" with older men.[28] Such intimacy no doubt sometimes existed in the workshop between masters and their apprentices. "Botticelli keeps a boy," snarled a denunciation of the painter and

one of his young helpers.[29] A similar intimacy existed between Leonardo and Salai (and before that, possibly, between Verrocchio and Leonardo).

Jesus cradling John on his bosom was therefore an evocative image in fifteenth-century Italy. But this particular master-disciple relationship was understood to exist on a higher plane. As we have seen, rather than *philia* or *eros*, the Greek translation of the Hebrew scriptures characterizes Jesus's love for John with the noun *agape*, which elsewhere describes God's redeeming love for the world. Many religious texts therefore emphasized the spiritual rather than earthly or carnal nature of the relationship. A case in point is the popular medieval text, *Meditations on the Life of Christ*, composed in about 1300 by an anonymous author, a Franciscan friar known to posterity as the Pseudo-Bonaventure. Here John is identified as the bridegroom at the Marriage Feast at Cana, the episode (described in John 2:1–11) in which Jesus performed the first of his miracles, turning water into wine. The Pseudo-Bonaventure elaborated the story of the wedding with a detail not mentioned in John's Gospel: "When the feast was over the Lord Jesus called John aside and said, 'Leave this wife of yours and follow me for I shall lead you to a higher wedding.' And he followed him."[30]

This "higher wedding" is the whole point of the close relationship between Christ and John: a union of the soul with God in a kind of "mystic marriage." The pair of them became, in fact, a symbol of religious mysticism, their higher wedding illustrated through numerous depictions (in sculpture as well as painting) of John leaning on Christ's bosom and sometimes holding his hand. There was no nudging and winking for the fourteenth-century Dominican nun who wrote, "When I remembered how St. John rested on the sweet heart of my Lord Jesus Christ I was moved by such a sweet grace that I could not express it in words."[31] Many writers stressed that John was not merely leaning physically on Jesus. St. Augustine claimed that John took divine inspiration for his ministry and his Gospel from this posture because "he drank . . . from the Lord's Breast."[32] Likewise the hymn composed at the turn of the tenth century by a monk named Notker Balbulus, who succinctly summed up John's career: "You rise to renounce the breast of marriage, follow the Messiah, and from his breast drink of the sacred streams."[33]

These descriptions of John drinking from the Lord's breast were developed in the Middle Ages into the cult of the Sacred Heart, which regarded Jesus's heart as the symbol of his love for humanity and a source from which devotees could imbibe grace and wisdom. Its most famous expression

is found in *The Herald of Divine Love* by the Benedictine nun Gertrude of Helfta. Gertrude's work describes a vision she received during Holy Week in 1289, when she rested her head on Jesus's left arm, near the wound in his side, and heard the "loving pulsation" of his heart. The Sacred Heart was represented in art by the image of a beardless and youthful St. John leaning on Jesus's breast. The pair was sometimes shown holding hands like a bride and bridegroom: an image of contented mystical matrimony.[34]

Painters of Last Supper scenes during the Renaissance had the cult of the Sacred Heart in mind when they showed Jesus and John seated intimately together at the table. Many portrayed John sitting to Christ's left, with his head over Christ's heart. Equally, the cult of the Sacred Heart could have been influenced by images of the Last Supper, since the earliest known work of art to feature John leaning on Jesus's bosom at the Last Supper (on the bronze door of the basilica of San Zeno in Verona) predated Gertrude by some two centuries.

The marriage hinted at in *The Last Supper* is therefore not a secret one between Jesus and Mary Magdalene but rather the much-celebrated mystical union between Jesus and the beloved disciple. As we have seen, one of Leonardo's sketches experimented with the idea of placing John asleep on Christ's breast (in the same way that it experimented with—and finally abandoned—the idea of placing Judas on the opposite side of the table). His description of how to paint a Last Supper makes no mention of this tableau, offering instead a scenario much closer to what he actually painted: "Another speaks into his neighbour's ear and he, as he listens to him, turns towards him to lend an ear." Ever concerned with action and movement, Leonardo chose to depict the scene that occurred a second or two later than that portrayed by all the other representations: not the still vignette that finds John asleep on the bosom of Christ, but rather John awake—albeit barely—and in the act of listening to Peter's importunate question, "Who is it of whom he speaks?"

CHAPTER 13

Food and Drink

L eonardo was, famously, a vegetarian. In 1516 an Italian traveler to India
wrote home to Giuliano de' Medici, the son of Lorenzo the Magnifi-
cent, that the Indians were a "gentle people . . . who do not feed on anything
that has blood, nor will they allow anyone to hunt living things, like our
Leonardo da Vinci."[1] Leonardo's shopping lists attest to an apparently veg-
etarian diet: kidney beans, white and red maize, millet, buckwheat, peas,
grapes, mushrooms, fruit, and bran. "Have some ears of corn of large size
sent from Florence," reads a note written around the time he painted *The
Last Supper*. Corn was a completely new food in Italy, having been introduced
to Europe from the Americas only a few years previously. Leonardo had
evidently developed a taste for this exotic new import.[2]

When precisely Leonardo became a vegetarian is unknown. Meat does
turn up on several of his lists: one of them, from 1504, records the purchase
of "good beef."[3] However, he was probably supplying it to his assistants and

apprentices rather than to himself. Certain writings from his years in Milan in the 1490s clearly demonstrate that he regarded eating flesh with revulsion. "Oh! how foul a thing, that we should see the tongue of one animal in the guts of another," he wrote of the sausage. He was disturbed by the paradox of life sustaining itself on the death of something else. "Our life is made by the death of others," he wrote in his notes on physiology. "In dead matter insensible life remains, which, reunited to the stomachs of living beings, resumes life, both sensual and intellectual." The image of dead animals coming back to life in our bellies is enough to give second thoughts, surely, to even the most enthusiastic of carnivores.[4]

Leonardo's writings from this period also reveal his outrage at the mistreatment of animals. He offered a horrified and gruesome litany of animals caught in traps, eaten by their owners, or treated with "blows, and goadings, and curses, and great abuse."[5] In this context we can believe the famous story told by Vasari of how Leonardo used to buy caged birds only to release them into the air, "giving them back their lost freedom."[6] Leonardo was, in this respect, different from so many other Italians. Blood sports were popular pastimes at all Italian courts, including Lodovico's, with courtiers and visiting dignitaries regularly descending on the duke's country home at Vigevano to slaughter stags, boars, and wolves. Even Beatrice was a dedicated participant, "always either riding or hunting," as Lodovico boasted in a letter to his sister-in-law.[7]

Leonardo's assistant Tommaso Masini—the eccentric dabbler known as Zoroastro—was also a vegetarian: a later source claimed that he wore linen because he could not bear to wear dead animals, and that he "would not for anything kill a flea."[8] Other vegetarians in Italy at this time were members of the mendicant orders. Luca Pacioli was probably a vegetarian because the Franciscans, following the example of St. Francis, abstained from meat. St. Francis himself offered a precedent for Leonardo's love of the animal kingdom: he was said to have freed animals from traps, preached a sermon to the birds, and tamed the man-eating wolf of Gubbio. St. Dominic likewise abstained from meat, and the Dominican Constitutions urged friars to forego flesh except in the case of serious illness.[9]

That Leonardo took any inspiration for his vegetarianism from the religious orders seems unlikely. The Dominicans avoided meat not because they objected to the cruelty inflicted on animals, but because eating meat

was a pleasure of the flesh that needed to be denied lest it expose a friar to other dangers and temptations: Aquinas, as we have seen, believed meat stimulated sexual appetites and produced a surplus of "seminal matter." Nonetheless, vegetarianism was one of the few things that Leonardo and the friars of Santa Maria delle Grazie shared in common.

Given that he was painting a dinner scene, Leonardo probably paid attention to how the friars ate their meal in the refectory—to their food and the other accoutrements of their table. After all, Last Supper scenes painted in refectories were meant to reflect the communal meal taken by nuns or friars, allowing them to identify with one of the most important episodes in the Passion. Like so many other artists, Leonardo accommodated certain features of his painting to its setting. As Goethe noted, "Christ was to celebrate his Last Supper among the Dominicans at Milan." Visiting Santa Maria delle Grazie at the end of the eighteenth century, the German poet believed that the original configuration of tables was still evident. The prior's table stood opposite the entrance, raised a step above the ground, while the friars' tables ran lengthwise down either side of the room. He conjectured that Leonardo took these tables as the model for the one in his painting. There is no doubt, he wrote, "that the tablecloth, with its pleated folds, its stripes and figures, and even the knots at the corners, was borrowed from the laundry of the convent. Dishes, plates, cups, and other utensils were probably likewise copied from those which the monks made use of."[10]

Goethe's instinct was probably right. The knots in the corner of the tablecloth are a nice touch, and it is easy to imagine the tablecloth in the mural reflecting those spread on the refectory tables. In earlier centuries, Leonardo's depiction of the tablecloth, food, and utensils excited much comment and admiration. A French priest visiting Santa Maria delle Grazie in 1515 described Leonardo's painting as "a thing of extraordinary excellence," and what he singled out for special praise was the table setting: "because as one sees the bread on the table one would say that it is actual bread, not simulated. The same can be said of the wine, the glasses, the vessels, the table and tablecloth."[11] Vasari, too, reserved high praise for the tablecloth, noting that its texture "is counterfeited so cunningly that the linen itself could not look more realistic."[12] Four hundred years later, the pleasures of Leonardo's table were what attracted Andy Warhol to the painting. The artist who made his name with soup cans and Coke bottles claimed that he "felt comfortable

with the subject of food" and, excited about the opportunity to "update Leonardo's dining scene," went on to produce forty paintings and silk screens of *The Last Supper*.[13]

Warhol died in 1987, a dozen years before the most recent conservation of this "dining scene" was completed. This cleaning of the painting has allowed us to appreciate, as previous generations could not, these still-life details. Prominent in the lifelike tableware is the cruet of water that sits before James the Greater: Leonardo captured not only the transparency of the glass (through which we see the plate behind it) but also the reflection of light on its bulbous surface: a truly virtuoso performance.

If Leonardo took his models for the tablecloth and utensils from the convent, other details in the painting created a sharp contrast with the humble and spartan refectory. The walls of the room in which Christ and the apostles take their meal are hung with eight tapestries, four on each lateral wall. These tapestries have a floral design similar to the *millefleurs* (thousand flowers) pattern of fifteenth-century Flemish tapestries (with the finicky details no doubt left to Leonardo's apprentices). The appearance of these tapestries introduces a contemporary courtly note into the scene, and one alien to the experience of the friars at Santa Maria delle Grazie, whose walls would have been bare of such ornate decor. Flemish tapestries were popular and prestigious decorations at Italian courts. Their beauty and expense made them conspicuous markers of wealth and magnificence. The wedding feast for Lodovico Sforza's brother Galeazzo Maria saw the main piazza in Pavia draped with sumptuous tapestries. Without this opulent display, a courtier explained to the groom's mother, "we would be put to great shame."[14]

In Milan, many rooms in the Castello Sforzesco were hung with tapestries. Lodovico's father, Francesco, had brought four master weavers from Flanders to Milan, and before his death in 1466 another five had arrived to assist them. In Lodovico's day, the tapestries in the Castello were valued at more than 150,000 ducats.[15] None of the tapestries woven for the Castello survives, but Leonardo may well have taken from them the pattern for the tapestries in *The Last Supper*, thereby deliberately suggesting a link between his mural and the grandeur of the Sforza court.[16]

One indication of the value and importance of tapestries comes from a few decades later. For his marriage in 1514, the future King François I of France was given the gift of a Flemish tapestry that in 1533 he ceremoniously

presented to Pope Clement VII. The scene depicted on this tapestry was Leonardo's *Last Supper.*

Painters of Last Suppers had only a few indications from the Gospels about the food and drink served to Jesus and the apostles. These clues are sometimes ambiguous and conflicting. Matthew gave a very compressed account of the Last Supper. He stated that it was the Passover feast, from which we can assume (though he did not say) that a lamb and unleavened bread were served. Mark and Luke likewise indicated that the Last Supper took place at Passover, and so when the apostles "made ready the pasch" (Luke 22:13) their preparations would have involved a lamb and unleavened bread. Like Matthew, both added the scene in which Christ shares bread and wine with the apostles.

John's account is, typically, rather different. He clearly stated that the Last Supper took place several days before the Passover feast, so lamb was presumably not on the menu. The only food he mentioned is the bread that Jesus dips and then offers to Judas. John did not describe the institution of the Eucharist and so there is no reference to a chalice of wine.

What was an artist to make of these various descriptions? The Gospels were certainly rich in drama, with the startling announcement of the traitor in the midst of the apostles and the description (in Matthew, Mark, and Luke) of the institution of the Eucharist. But props were lacking for the painter, who needed to use his imagination to furnish the table with food and drink.

Most painters depicted the Last Supper as a simple and spartan meal. These portrayals accorded with the scanty details given in the Gospels. They also mirrored the meager dinners served in refectories, especially during the frequent fasts, when friars and nuns were given only bread and water. They indicated, furthermore, how painters in the Middle Ages and Renaissance took very little interest in gastronomic details. In the fifteenth century and earlier, food was a perfunctory addition to dinner scenes rather than a celebration of conspicuous culinary consumption or a demonstration of the painter's virtuoso abilities, as it would become in the seventeenth century when Dutch artists created sumptuous still lifes of tables adorned with exotic food. For instance, in the early 1460s the Florentine painters Filippo

Lippi and Benozzo Gozzoli each painted a scene showing the Feast of Herod. The subject matter might have seemed like an opportunity for the painters to show a table groaning with exotic fare. By the standards of later centuries, however, they produced incredibly paltry spreads: a few tiny wineglasses and miniscule serving dishes. But these painters were uninterested in showcasing their skills through detailed and scrupulously realistic depictions of slabs of meat or bunches of fruit.

Painters of Last Suppers had been equally restrained, often showing only bread and wine or, at most, a small lamb on a platter. Leonardo, however, depicted a meal that in both style and subject was very different from all his predecessors. Besides the bread rolls, tableware, and half-full glasses of red wine, he showed three large serving platters. Although the one in the center, in front of Christ, stands empty except for a section of fruit on its edge (perhaps a pomegranate), the other two are generously heaped with food. The one in front of Andrew is piled, interestingly enough, with eight or nine fish. The depiction of fish is unusual in a Last Supper, though the oldest-known version, the fifth-century mosaic in the basilica of Sant'Apollinare Nuovo in Ravenna, shows two enormous fish on the table. Although the Gospels say nothing about fish at the Last Supper, the image is appropriate given that a number of the apostles were fishermen and the fish was a symbol of Christ: in Greek the first letter of the words *Jesus Christos Theou Uios Soter* (Jesus Christ, Son of God, Savior) form *ichthus* (iota, chi, theta, upsilon, sigma)—which happens to be Greek for fish.

The other platter, sitting in front of Matthew, is even more interesting. Paint loss means its contents are virtually illegible, and presumably they have been obscured for many centuries because no one seems to have commented on what is a unique—and remarkable—contribution to a Last Supper. Luckily, thanks to the recent restoration of the mural we can see from several small serving dishes (including the one beneath Christ's right arm) exactly what Leonardo imagined Jesus and the apostles to be eating: chunks of eel garnished with slices of orange.[17]

Eels were certainly an interesting choice. Leonardo has provided the apostles with a vegetarian—or at least a pescetarian—meal. He may have been alluding to the meals served in Santa Maria delle Grazie, since eels could be caught in the rivers around Milan. However, eels were a delicacy associated more with courtly banquets than refectory suppers. The Greek poet Archestratus, author of the world's earliest cookbook, declared eels

Detail of slices of eel and orange

"superior to all other fishes," and for centuries they were prominent on royal bills of fare.[18] Eels featured conspicuously in the festivities when Lodovico Sforza's father-in-law, Ercole d'Este, married Eleanor of Aragon in 1473. In a letter to a friend, Eleanor described how during the entertainments five plates of eels were served "wrapped in crust." This course was followed by an intermezzo during which actors playing Perseus and Andromeda recited lines of poetry. Then the next course arrived: "Five plates of roasted eels with yellow sauce." A second intermezzo was performed, this time with the goddess Ceres appearing on a chariot drawn by two eels.[19]

Because of their ubiquity at feasts of this sort, eels came to be associated with luxury and overindulgence. Eels certainly seemed to bring out the gluttony in diners. In 1491, Galeazzo Sanseverino described in a letter how he and Beatrice, Lodovico's young wife, caught eels in the river north of Milan and, after retiring to one of Lodovico's nearby villas, "proceeded to dine off them until we could eat no more."[20] This sort of overindulgence sometimes had fatal effects. Surfeits of eels were blamed for the deaths of both King Henry I of England in 1135 and, 150 years later, Pope Martin IV, who liked his eels marinated in Vernaccia wine. His gluttony won him a place, according to Dante, among the sinners in purgatory.

Leonardo probably enjoyed eels at Lodovico's table in the Castello. The kitchen in the Castello may even have prepared them, as he showed, with orange slices. However, a recipe for eels and oranges is found in a story by a

fifteenth-century writer named Gentile Sermini, whose tales were collected together in about 1424. The recipe involves skinning the eel, boiling it in water, chopping it into chunks, and then roasting the chunks on a skewer before marinating them in the juice of six pomegranates and twenty oranges. Coincidentally or not, Leonardo appears to have included pomegranates on the table.[21]

Sermini came from Siena, and he may have been describing a recipe well-known to Tuscans like Leonardo. But Leonardo, with his fondness for funny stories such as those by Poggio Bracciolini, may actually have known Sermini's tale. No doubt it would have appealed to him. Like many Italian storytellers of the fifteenth century, Sermini had a strong anticlerical bias, and in his story the eel is a symbol of greedy self-indulgence. His tale involves a priest who cannot wait to finish his sermon so he can return home to eat a fat and juicy eel given to him by a dirt-poor parishioner and prepared by his cook using the special orange-and-pomegranate recipe. His gluttony outrages another parishioner, Lodovico, who, in the middle of a tirade against the priest, grabs his breviary: "It was full of recipes for every possible dish," Lodovico finds to his disgust, "every possible treat: how to cook them, what sauces to accompany them with, what time of year to prepare them."[22]

Sermini's story is a satire on ecclesiastical corruption in general and epicurean priests in particular. Leonardo voiced strong anticlerical sentiments of his own, finding the religious orders hypocritical insofar as they made themselves "acceptable to God" by—in his opinion—enjoying great wealth and living in "splendid buildings." His depiction of a dinner of eels, a food associated with gluttony, could have been a mischievous commentary on what he regarded as priestly corruption. On the other hand, Leonardo clearly placed a plate of half-eaten eels in front of Christ, and it is unlikely in the extreme that he intended any sort of blasphemy. Since he used Milanese courtiers for his models, and since the painting was meant to be, among other things, a glorification of Lodovico's regime, he may simply have wished to show the scrumptious food enjoyed at the duke's table.

Another possibility is that Leonardo was perpetrating a joke on the friars of Santa Maria delle Grazie. The French priest who saw the mural in 1515 commented on the astonishingly lifelike appearance of the food, and although he did not mention the eels, there can be no doubt that Leonardo painted them with the same attention to detail as everything else on the

table: following the restoration, we can see the fat chunks with their juicy white flesh over which the apostles will drizzle the slices of orange. The oranges have been painted with such detail that the pith is visible. Given the traditional ambivalence of Italian artists toward gastronomic details, there was no precedent in the 1490s for the sight of food so scrupulously and scrumptiously depicted, especially by someone with Leonardo's prodigious talents. Whatever his intentions might have been, Leonardo succeeded in painting a famously mouthwatering delicacy for a group of friars who for much of the year fasted on bread and water, and who at all other times were obliged to observe strict culinary frugality.

Virtually all paintings of the Last Supper showed bread and wine on the table. Occasionally a chalice of wine would be depicted in front of Christ, as for example by Cosimo Rosselli in his fresco on the wall of the Sistine Chapel. More often the painters simply showed several beakers of wine distributed across the table, with half-filled glasses in front of each apostle. The painter of the Last Supper fresco in the church of San Andrea a Cercina, a few miles north of Florence, was particularly generous: he made no fewer than thirteen beakers of wine available to the apostles, including choices of both red and white.

There was, of course, a scriptural justification for showing bread and wine: they were necessary for the sacrament described in the synoptic Gospels. But in showing bread and wine on the table, painters were duplicating conditions not only in refectories but on Italian dinner tables in general. Bread and wine were the two staples of the Italian diet in the fifteenth century: the provisions on which the most household money was spent. Bread accounted for 40 percent of a family's total food bill and 60 percent of its total caloric intake, which explained why the harvest was literally a matter of life and death, and why biblical verses such as "Give us this day our daily bread" or "I am the bread of life" resonated so powerfully with people in the Middle Ages and Renaissance. The Dominicans lived by begging, quite literally, for their bread, and the difficulty of obtaining enough bread to eat was a regular refrain in early Dominican literature.[23]

Along with bread, wine was regularly (and copiously) served with meals, both in the refectory and in the family home, in part because its alcoholic

content meant that, unlike water, it was free from bacteria and other pathogens. The average Florentine household went through seven barrels (or more than 2,800 liters) of wine per year, and the annual per capita consumption of wine across the whole of Italy during the Renaissance is estimated to have been between 200 and 415 liters (compared to a paltry 60 liters in present-day Italy).[24] Leonardo was certainly careful to keep his own house well stocked with wine: his shopping lists record frequent purchases. One of his notes observed that a particular wine cost one *soldo* a bottle, and at that rate his household, over the course of three days in 1504, must have downed at least twenty-four bottles. Wine was even on the menu at breakfast chez Leonardo since a note from 1495 proclaimed, "On Tuesday I bought wine for morning."[25]

The clergy drank as abundantly as the rest of the population. The Dominicans, in particular, were well-known for their love of wine. St. Dominic took his wine "austerely diluted," but his follower and successor, Jordan of Saxony, was more enthusiastic, noting that "wine brings delight and puts a man at his ease." Soon Dominicans began acquiring a reputation for enjoying too much of this delight. One master of the order complained that in the refectories—where silence was supposed to reign—the friars discussed the merits of their wines through "almost an entire meal," saying, "This one is like that and the other like that, and so on."[26] These oenophiles could at least console themselves that Aquinas declined to classify sobriety as a virtue and proclaimed "sober drinking" to be good for both body and soul.[27]

Leonardo placed at least twelve glasses of wine on the table in *The Last Supper*, all of them at varying levels (the one sitting in front of Bartholomew is nearly drained: another reason, perhaps, to see the famously high-living Bramante as his model). Like most painters he gave Jesus and the apostles red wine, the better to allude to the blood of Christ. He also showed numerous rolls of bread distributed across the table. No cutlery appears except for several bread knives and the dangerous-looking knife in Peter's hand, more weapon than utensil. The lack of cutlery is in keeping with the dining habits of the day. Leonardo's own inventory of his kitchen listed such items as a cauldron, a frying pan, a soup ladle, a jug, glasses and flasks, saltcellars, and a single knife, but no other cutlery.[28] The fork was not yet widely in use, though by the Middle Ages the Italians had invented a single-pronged fork for eating lasagna. People therefore ate with their fingers, often from communal plates. A poem on etiquette composed by a Milanese

friar reminded them: "The man who is eating must not be cleaning / By scraping with his fingers at any foul part."[29]

In front of Christ there is, besides the half-finished plate of eels, a glass of wine, a roll of bread, and a pomegranate (or perhaps an apple). While Leonardo was interested, like no one before him, in the meticulously realistic depiction of natural objects, he was not above using natural objects symbolically. One of his Madonna and Child paintings, known as the *Benois Madonna*, shows the infant Christ holding some kind of cruciferous plant, an obvious symbol of the Passion. Another, *Madonna of the Yarnwinder*, shows the Christ Child holding his mother's cross-shaped distaff: another allusion to the Passion. *The Virgin of the Rocks*, meanwhile, is rich in botanical symbols, with Mary's grace and purity emphasized by flowers such as violets and lilies, and Christ's Passion foreshadowed by the palm tree and (in the left foreground of the Paris version) the anemone, the red of whose flowers was said to have come from Christ's dripping blood. Symbolic elements have even been read into the *Mona Lisa*. Despite the portrait's apparent naturalism, a scholar has convincingly argued that it represents the triumph of Virtue over Time.[30]

Leonardo used some of the food on the table in *The Last Supper* in a similarly symbolic fashion. The bread and wine allude, obviously, to the body and blood of Christ. The apple (if it is indeed an apple) would indicate that Christ is the "new Adam." If the fruit is a pomegranate, the iconography is equally appropriate. Pomegranates made frequent appearances in Italian art: in Botticelli's 1487 *Madonna of the Pomegranate*, the Christ Child holds a pomegranate that is split open and oozing seeds. The numerous red seeds symbolize not only the blood of Christ but also the many people who come together under the unity of the church.

Leonardo shows Christ's hands on the table, near his servings of bread and wine. He appears to be simultaneously indicating with his left hand and reaching for something with his right. This double gesture seems simple and natural, but how are we to interpret it? More to the point, how would the Dominicans have interpreted it? Is Christ about to dip his hand in the dish with Judas, thereby identifying him as the traitor? Or is he reaching for the bread and wine to institute the Eucharist?

Matthew described the institution of the Eucharist: "And whilst they were at supper, Jesus took bread and blessed and broke and gave to his disciples and said: Take and eat. This is my body. And taking the chalice, he

gave thanks and gave to them, saying: Drink all of this. For this is my blood of the new testament, which shall be shed for many unto remission of sins" (Matthew 26:26–8). Mark gave almost the same description, but Luke reversed the order: the wine is taken first, then the bread. The synoptic Gospels also disagree about the exact point in the meal when the institution of the Eucharist takes place. In Matthew and Mark, Christ's announcement of the impending betrayal precedes the sharing of the body and blood of Christ; for Luke, the sacrament comes first, or perhaps—in a moment of high drama—Jesus actually institutes the Eucharist at the same time as he announces the betrayal: "But yet behold," says Jesus as he shares out the wine from the chalice, "the hand of him that betrays me is with me on the table." The statement that he is about to die for his companions is immediately followed, in other words, by the startling declaration that a traitor sits among them.

A painter of a Last Supper needed to decide how to juggle these varying accounts. Some followed the versions describing Christ sharing the bread and wine in order to show a Last Supper subgenre known as the *Communion of the Apostles*. The best example is probably the one by Fra Angelico at San Marco: the table has been cleared and Jesus is on his feet, chalice in hand, offering bread to John while the other apostles sit more or less imperturbably in their places or else kneel on the floor (with Mary Magdalene among them), awaiting their turn to take Communion.

Tellingly, Fra Angelico's scene was painted not in a refectory but in a monk's cell. Such scenes, with their obvious sacramental associations, were far more common in chapels than in refectories. Painters of Last Suppers in refectories often followed the Gospel of St. John, which, as we have seen, makes no mention of the institution of the Eucharist. Therefore they emphasized the literal food and wine rather than the body and blood of Christ—so much so that no holy chalice appears in a refectory version of a Last Supper before the seventeenth century.[31] Hence the famous "lack" of a chalice in Leonardo's *Last Supper* ("There was no chalice in the painting," declares *The Da Vinci Code*. "No Holy Grail").[32]

Rather than the apostles taking Communion, painters of refectory Last Suppers might show John asleep on Christ's bosom or, less often, Jesus offering a sop of bread to Judas. This latter gesture fixes the narrative at a very specific point: the revelation of Judas as the traitor. This way of proceeding was more common in earlier centuries, especially in illuminated manuscripts.

It was likewise popular among Sienese painters in the fourteenth century, with Duccio, Pietro Lorenzetti, and Barna da Siena all showing how Christ identified the guilty party by handing a sop of bread to Judas. Yet by the fifteenth century the exact moment in the narrative became more ambiguous and less dramatic as painters such as Castagno and Ghirlandaio dispensed with the motifs of both the dipped bread and the sharing of bread and wine. They merely showed the company assembled at the table for dinner, with John resting on Christ's breast and Judas seated on the opposite side of the table.

Leonardo was adamant that a figure's actions and expressions needed to convey a clear and specific meaning to the spectator: "A picture or representation of human figures," he wrote in his treatise on painting, "ought to be done in such a way as that the spectator may easily recognise, by means of their attitudes, the purpose in their minds."[33] What, then, is the purpose of Christ's mind?

Many earlier viewers of the painting were in little doubt about which particular moment Leonardo depicted. One of the first copies of Leonardo's *Last Supper* ever made, an engraving done about 1500 and attributed to the Milanese artist Giovanni Pietro da Birago, tried to remove any confusion. The engraving boldly added to Leonardo's scene a caption—a kind of early speech bubble—that reads, *"Amen dico vobis, quia unus vestrum me traditurus est."* That is, "Amen I say to you that one of you is about to betray me" (Matthew 26:21).[34]

For Giovanni and many who followed, the subject of the painting was Jesus's announcement of the betrayal and the subsequent agitation among the apostles. Goethe gave his considerable authority to this interpretation, noting that "the whole company is thrown into consternation" by Jesus's words: "There is one among you that betrays me."[35] Goethe, whose essay appeared in 1817, was influenced by a book on *The Last Supper* published seven years earlier by Giuseppe Bossi, who restored the painting after it was badly damaged in a flood. For Bossi, the painting was all about human emotion: Leonardo "wished to engage the spirits of all men capable of feeling, men of all times and of every creed." Bossi was eager to discount the possibility of any religious dimension to the painting. In *The Last Supper*, he insisted, Leo-

nardo sacrificed nothing to "private opinions or religious ceremonies, which are neither as eternal nor as universal as human feelings." The universal human feelings in question were, according to Bossi, "friendship and the horror of treason."[36] Leonardo becomes, in this reading, a Shakespeare of the paintbrush, raising ethical questions and capturing universal emotions in a scene of tense drama that has little, if anything, to do with a religious ceremony.

Readings that emphasized the painting's secular qualities at the expense of the religious prevailed for many years, particularly in the classrooms of American colleges and universities. A textbook published in the United States in 1935 confidently reassured students that "this celebrated religious painting is not fundamentally religious in character. It represents the psychological observations of the profoundest scientist of his century."[37] In other words, Leonardo was ignoring the religious hocus-pocus of the Gospels and simply using their narrative to offer a scientific and psychological exploration of human behavior that might have done credit to Freud or a good novelist. A generation later, in 1969, the scholar Frederick Hartt published a survey of Italian art in which he likewise argued that Leonardo was "not in the least concerned with the institution of the Eucharist . . . but with a single aspect of the narrative—the speculation regarding the identity of the betrayer."[38]

The appeal of these sorts of readings is obvious. For one thing, the puzzled reactions to Christ's announcement are (unlike the institution of the Eucharist) described in all four Gospels. Also, not only do these readings commonsensically explain the twisting bodies, protesting gestures, and surprised expressions in *The Last Supper*; they also allow the painting to take as its subject one of the most suspenseful and dramatic passages in the entire Bible. Further, these readings fit with our impression of how the Italian Renaissance witnessed painters and sculptors depicting human emotion rather than religious symbolism. There is also the added benefit—especially attractive for a lapsed Protestant like Goethe, who did not consider himself a Christian, let alone a Catholic, or for twentieth-century American educators who needed to keep religion off the curriculum—of doing away with the sacramental component and burnishing the image of Leonardo as "the profoundest scientist of his century."[39]

This consensus eventually began to break down, mainly due to the scholarly exertions of the American art historian Leo Steinberg. In 1973, Steinberg

wrote a 113-page article in *Art Quarterly* advancing erudite and dizzyingly intricate arguments for recognizing the sacramental component.[40] Meanwhile other art historians had also begun looking more closely at Christ's hands, at the bread and wine on the table, and perhaps even at their Bibles, and then reevaluating the action of the painting. The bestselling university textbook on any subject in the last decades of the twentieth century was H. W. Janson's *A History of Art: A Survey of the Major Visual Arts from the Dawn of History to the Present Day.* The Russian-born Janson made room for the Eucharist by acknowledging that Leonardo was doing more than simply showing one particular moment in a psychological drama, and by viewing Christ's hand gestures as an indication of "his main act at the Last Supper, the institution of the Eucharist."[41] Likewise another widely used textbook found in Leonardo's painting a "brilliant conjunction" of the dramatic "one of you shall betray me" and the liturgical ceremony of the Eucharist.[42] By 1983 an art historian and Leonardo expert could write that most authorities on the subject agreed that *The Last Supper* was "an amalgam of two consecutive situations"—that is, the announcement of the betrayal and the institution of the Eucharist.[43]

A number of different things, then, are happening in the work, whose complexity of detail earlier viewers overlooked in their haste to purge the work of religious content. Through both dramatic gestures and subtle feints and allusions Leonardo captured the interweaving of successive events as they unfolded in the chamber in Jerusalem (and in the varying versions given in the Gospels). The announcement of the betrayal is only the most obvious. Jesus has evidently spoken ("Amen I say to you that one of you is about to betray me") but has now fallen silent. The other apostles react with astonished puzzlement. Leonardo gave the full range of responses provided in the Gospels' accounts: he showed them asking, "Is it I, Lord?" (as in Matthew and Mark), inquiring "among themselves" (Luke), and looking "upon one another, doubting of whom he spoke" (John). He included, as we have seen, the incident from the Gospel of St. John where Peter beckons John, who, rousing himself from Jesus's bosom, leans to his right to hear the question: "Who is it of whom he speaks?"

Leonardo's notes reveal his undeniable fascination with the dynamics of

how people speak, listen, ask questions, or convey emotions with their faces, hands, and bodies. Even so, there is more to the painting than merely the revelation of betrayal and the subsequent responses. Crucially, Jesus is performing other actions besides announcing the presence of the traitor. Leonardo clearly regarded the hands of Christ to be essential to his composition. These hands were so fundamental that Alessandro Carissimi da Parma—a man with, presumably, elegant and expressive hands—was conscripted as a model: evidently not just any pair of hands would do. Christ's hands are also quite literally central to the composition, since they help form the equilateral triangle at the center of the painting. To ignore these hands is therefore to miss an important aspect of the mural.

With his right hand Jesus reaches toward the same dish to which Judas, two seats away, is likewise reaching. As they approach the dish, their two hands, skillfully foreshortened and almost mirror images of one another, suggest the line from Matthew: "He that dips his hand with me in the dish, he shall betray me." Yet the dish, and Judas's guilty hand, are not the only objects that Jesus's hand approaches: he is reaching, simultaneously, for the wineglass in front of him. Indeed, two joints of his pinkie and the ball of his third fingers are seen, in yet another bedazzling show of painterly skill, only through the transparency of the wineglass. This display must originally have been so conspicuous and arresting that only the paint loss could have caused earlier viewers to miss the fact that Jesus is about to share the wine with the apostles.

The left hand of Jesus is likewise in motion, indicating—with much subtlety and restraint in the midst of so much frantic gesticulation—the bread that sits within easy reach. More than that: Jesus is looking directly at the bread, which, despite the commotion that surrounds him, is the sole object of his gaze. Leonardo was extraordinarily astute in his understanding of visual perception, and through single-point perspective he carefully controlled how the viewer experiences his painting. The perspective draws our attention to the face of Christ at the center of the composition, and Christ's face, through his down-turned gaze, directs our focus along the diagonal of his left arm to his hand and, therefore, the bread. If Goethe and so many others once missed or ignored this graceful but obvious gesture, to the Dominicans of Santa Maria delle Grazie it would have been overt and unmistakable: the friars would have known they were seeing Christ about to administer the holy bread to his apostles.

It would have been unusual to say the least for a painter to cover a wall

in a Dominican convent with a work that was "not fundamentally religious in character." While Franciscan art, such as Giotto's at Assisi, excelled at offering inspiring narratives from biblical and church history, Dominican art was often meant to reinforce doctrinal issues. One such issue in which the Dominicans, as the church's spiritual enforcers, took an acute interest was transubstantiation. This doctrine was established in 1215 in the opening creed of the Fourth Lateran Council, which stated that the body and blood of Christ "are truly contained in the sacrament of the altar under the forms of bread and wine." Given its philosophical justification later in the century by Aquinas, a Dominican, the sacrament was celebrated after 1264 in the Feast of Corpus Christi. By the end of the thirteenth century, the Eucharist was the church's most important sacrament. The entire philosophy of the church depended on the miracle of a wafer turning into flesh and wine into blood.[44]

In our secular age, with altarpieces removed from their original locations in chapels and hung on the walls of public museums, paintings can easily be seen for their artistic qualities alone. Italians during the fifteenth century certainly appreciated and celebrated these aesthetic values, but works of art also had another dimension for them. Paintings were invested with holiness because venerating an image of Christ or the Virgin was, according to the Council of Nicaea, tantamount to venerating Christ or the Virgin themselves, who could then intercede on behalf of the praying community. Giotto's monumental altarpiece, the *Ognissanti Madonna*, is nowadays celebrated—quite rightly—as a landmark in the history of art because of its convincing illusion of depth and its realistic-looking treatment of facial features and bodily form. However, it was originally painted in the first decade of the fourteenth century not for purely formal and aesthetic reasons, but rather, primarily, to invite the intercession of the Virgin on behalf of the local religious community of Umiliati monks. Likewise, Leonardo's *Last Supper* was created not for the art historians and tour groups of a later, secular age, but for a band of Dominican friars who ritually commemorated Christ's sacrifice through the celebration of the Eucharist.

How Leonardo's contemporaries and immediate successors viewed his works for something more than their aesthetic qualities can be seen in the case of his *Virgin of the Rocks*. The altarpiece was believed to possess, like many religious paintings, special powers of intercession. During an outbreak of plague in 1576 the local people turned to Leonardo's altarpiece (then in-

stalled in San Francesco Grande) to save them, dedicating special Masses of devotion to the image. The qualities they believed would save them were not those we appreciate today—the dramatic scenery and the sensitive handling of light and shade—but rather the fact that Leonardo had depicted the Virgin Mary.[45]

There is another example. In 1501, the brutal warlord Cesare Borgia was threatening to invade Florence. At the same time, a Leonardo cartoon featuring the Virgin and her mother, St. Anne, was unveiled in Florence, causing a sensation. When it was exhibited, according to Vasari, "a crowd of men and women, young and old, . . . flocked there, as if they were attending a great festival, to gaze in amazement at the marvels he had created."[46] The temptation is to compare these huge crowds to those who swarm up the steps of today's museums to gaze in amazement at blockbuster Leonardo exhibitions. Yet Frederick Hartt has pointed out that in Florence these crowds may well have been drawn to the cartoon less for reasons of artistic appreciation than because St. Anne was considered to be the special protectress of the city. These enthusiasts, Hartt writes, could have been "less a testament to Leonardo's genius than an invocation to this mighty guardian against the menace of a new and pitiless master."[47] Religion, not art, was the major attraction. St. Anne and the Virgin were the draw, not Leonardo.

One other reason makes it inconceivable that Leonardo should not have included a sacramental or religious aspect to his *Last Supper*. Lodovico Sforza intended to turn Santa Maria delle Grazie into a shrine for himself and his family. By 1497, his plans for a Sforza mausoleum had suddenly assumed a tragic urgency.

The failure of Maximilian's Italian expedition in the autumn of 1496 was the first of Lodovico's misfortunes, the earliest indication that Il Moro no longer held the fate of the world in his hands. The second blow fell even before Maximilian left Italian soil. The emperor was on his way to Pavia, where the delights of Lodovico's banqueting table awaited him, when news reached him that there had been a death in Il Moro's family, and that more sober observations were in order.

Besides his two sons from Beatrice, Lodovico was the father of at least two illegitimate children. At the end of 1496 his latest mistress, Lucrezia

Crivelli, was pregnant, while two earlier concubines—Bernardina de Corradis and Cecilia Gallerani—had each given him a child. Cecilia's son, born in 1491, was grandly christened Cesare Sforza Visconti and celebrated in sonnets by Lodovico's court poets. He lived with his mother, who had gracefully retired to one of Milan's grandest homes, the Palazzo del Verme. Bernardina's child, a girl named Bianca, born about 1482, received even greater marks of affection. Legitimized by her father, she became great friends with Beatrice and was betrothed at a young age to the dashing Galeazzo Sanseverino. She even had her portrait done by Leonardo, a chalk sketch on vellum produced on the occasion of her marriage.[48] She and Galeazzo were married in the summer of 1496, but the following November, aged only thirteen or fourteen, she died at Vigevano, probably from complications of a pregnancy.

Bianca was buried in the church of Santa Maria delle Grazie, her death plunging Lodovico's court into mourning. Now heavy with child, Beatrice made frequent visits to the Dominican church to pray at the tomb of her beloved young companion. After one such visit, on 2 January 1497, she returned to the Castello and was taken ill. Delivered that evening of a stillborn child, a boy, she died shortly after midnight. Her death was attended by suitably frightening omens: the sky above the Castello blazed with flames and the walls of her enclosed garden toppled to the ground. "And from that time," wrote a Venetian chronicler, "the duke began to be sore troubled, and to suffer great woes, having up to that time lived very happily." Or as another witness put it, the death of the duchess meant that "everything went into ruins, and the Court was changed from a happy paradise into a gloomy hell."[49]

Beatrice's body was taken from the Castello by pallbearers who included ambassadors from both Maximilian and the king of Spain. "We bore her to Santa Maria delle Grazie," the ambassador from Ferrara wrote to Beatrice's father, "attended by an innumerable company of monks and nuns and priests." In the streets, he reported, there was "the greatest lamentation that was ever seen."[50] At Santa Maria delle Grazie her body was carried up the steps of the high altar, under Bramante's dome, where she was laid on a bier draped with a golden cloth bearing the arms of the House of Sforza. She was interred next to Bianca, while Cristoforo Solari was commissioned to carve her tomb from Carrara marble.

The beautification of Santa Maria delle Grazie henceforth became an

even higher priority for Lodovico. New altars were dedicated in honor of St. Louis and St. Beatrice, the patron saints of Lodovico and his late duchess. Solari was also engaged to carve reliefs for the high altar, and the grieving Lodovico lavished gifts on the Dominican convent: chalices, a jewel-encrusted crucifix, several candelabra, an embroidered altar cloth, illuminated choir books with jeweled bindings, and even a new organ. He planned to convene a team of architectural experts to design a facade for the church. And Lodovico suddenly became anxious for Leonardo, working only a few yards away from Beatrice's last resting-place, to complete his painting in the refectory.

The Language of the Hands

There is no reason to doubt that Beatrice's death caused the "greatest lamentation" in Milan. The Italians were notably demonstrative in their grief. The death of a loved one might cause bereaved friends and relatives to wail in the streets, tear apart their clothing, beat their breasts, and tear out their hair by the roots. Such intemperate displays were not limited to women: men, too, gathered in public to weep openly and chant elegies together. These spectacles eventually became so extreme that in the Middle Ages a number of cities introduced legislation to prohibit such violent histrionics. Spies were sent to funerals and the grief stricken could face heavy fines and sometimes beatings. But the authorities were fighting a losing battle. Emotional outbursts were, it seems, part of the culture. Long after the legislation was enacted, Petrarch was still complaining about the "loud and indecent wailing" of people grieving in the streets.[1]

Italians were equally demonstrative in their other emotions, and Goethe believed this habit of impassioned expression was a boon for Leonardo

when he came to paint *The Last Supper*. "In this nation," he wrote, "the whole body is animated, every member, every limb participates in any expression of feeling, of passion, and even of thought." Furthermore, the Italians had a "national peculiarity" to use distinctive hand gestures and body language when they spoke: a resource that was, he believed, obvious to an Italian like Leonardo when he came to paint *The Last Supper*.[2]

Leonardo was fascinated, as no one before him, by the expressive possibilities of the human hand. Among the studies for his unfinished *Adoration of the Magi* are two sheets of paper covered with drawings of hands in various poses sketched from every conceivable angle. The hands in question are probably those of a musician, perhaps one of Leonardo's friends such as Atalante Migliorotti (to whom he supposedly gave music lessons): a left hand, at any rate, is poised gracefully on the neck of what looks to be a musical instrument. Likewise, one of Leonardo's notebooks features a drawing of a woman playing a lute, her left hand adeptly positioned on the fingerboard.[3] Watching his own hands or those of his students holding the long bow of a *lira da braccio*, or dancing along the instrument's fingerboard, may have awakened him to the hand's possibilities for beauty and expression.

Leonardo's sketches of hands in various poses

Other pairs of hands also fascinated Leonardo. When he first arrived in Milan, he must have met Cristoforo de' Predis, the father of the brothers Ambrogio and Evangelista. Cristoforo was a successful artist in his own right, a talented miniaturist who had illustrated books for Galeazzo Maria Sforza. He was also a deaf-mute. Leonardo, with his typically insatiable curiosity, observed how deaf-mutes like Cristoforo were able to communicate by using both facial expressions and "the movements of their hands." He urged young painters to study "the motions of the dumb" in order to understand how best to convey thoughts or emotions. He observed how deaf people could understand what was said to them through their ability to interpret the hand gestures of a speaker: "Thus it is with a deaf and dumb person who, when he sees two men in conversation—although he is deprived of hearing—can nevertheless understand, from the attitudes and gestures of the speakers, the nature of their discussion." For Leonardo, a person looking at a painting (which he calls "dumb poetry") was like a deaf person studying an animated conversation: he could understand what was happening through the language of gesture.[4] Paintings were a sort of dumb show, in other words, whereby the figures were to signal "the purpose in their minds" through their body language and hand gestures.

Hand gestures and facial expressions abound in Leonardo's paintings, but nowhere more so than in *The Last Supper.* A wide array of gestures and actions suggest the apostles' shocked, puzzled, angry, or sorrowful reactions to Christ's announcement. The painting is a brouhaha of pointing and gesticulation. "What a pack of vehement, gesticulating, noisy foreigners they are," Bernard Berenson once complained.[5] Philip's hands touch his breast, James the Greater's are thrown wide, while John's are demurely clasped together. James the Lesser touches Peter's shoulder, and Peter in turn touches the shoulder of John with one hand, while in the other he clutches a knife. Andrew, Matthew, and Simon all open or extend their hands in gestures that can be interpreted as—well, what exactly?

Several of the apostles perform gestures whose significance is far from apparent. Some are downright puzzling and ambiguous. What, for example, are we to make of the hand gestures of Thaddeus, the apostle second from the right? His right hand cups the air, thumb extended, perhaps pointing at someone in an accusative jerk, while his left hand rests somewhat awkwardly on the table. Over the years, various commentators have tried to explain Thaddeus's gesture. One claimed the thumb points to Christ as he vows

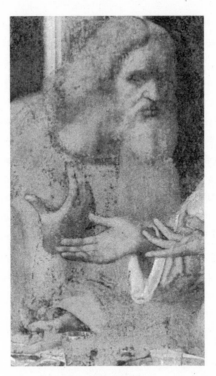

The apostle Thaddeus

that he, Thaddeus, is not the guilty party. Another maintained that Thaddeus is telling Simon (on his left) to trust the report of Matthew (on his right), whom he indicates with his thumb. Yet another viewer of the painting believed Thaddeus was "pointing his thumb surreptitiously at Judas," thereby identifying him as the culprit.

One thumb, three different targets—and each reading imputes a different purpose. Goethe, meanwhile, did not believe Thaddeus was pointing at anyone. Instead, he is about to strike the back of his right hand into the palm of his left, a distinctive gesture whose meaning, Goethe says, is clear: "Did I not tell you so! Did I not always suspect it!"[6] So Thaddeus, in these interpretations, is doing everything from protesting his innocence to saying, "I told you so!"

As Goethe noted, by using hand gestures Leonardo was capitalizing on what we have come to think of as a national trait. The great German poet, fluent in Italian and steeped in the culture, claimed the Italians had at their disposal an entire repertoire of hand gestures. By a "varied position and

motion of the hands" they could signify such things as: "What do I care!" or "This is a rogue!" or "Attend to this, ye that hear me!"[7] Undoubtedly Italians use hand gestures and body language more creatively and prolifically than other European cultures. In 1832 a priest and curator from Naples named Andrea de Jorio published *La Mimica degli antichi investigata nel gestire napoletano* (*Gestural Expression of the Ancients in the Light of Neapolitan Gesturing*). De Jorio wished to see how the expressive gestures of a living population—namely, his fellow Neapolitans—might help explain the gestures and postures seen in ancient statues, vases, and frescoes such as those found near Naples at Herculaneum and Pompeii. He believed a "perfect resemblance" existed between the gesturing of his fellow Neapolitans and that of their distant ancestors buried under Vesuvius's pyroclastic flow.[8]

What de Jorio produced was an illustrated catalog of gestures and expressions that documents the wide repertoire used by Neapolitans (and by Italians more generally) not only in the nineteenth century but—as he suspected—back and forth across the centuries. Some are still practiced to-

A page from Andrea de Jorio's treatise on hand gestures

day, such as the *mano cornuto*, or "horn hand," in which the middle and ring fingers are held down with the index finger and pinkie extended. Or the beseeching gesture where the palm is turned upward and fingers and thumb are extended and joined in a point—which means, de Jorio explained, "What are you talking about?" He also described the familiar gesture he called *negativa*: the outside tips of the fingers are held upright under the chin and then pushed violently forward, indicating that the subject "wishes to distance his head from whatever is offered to him or proposed that does not please him." Other gestures are familiar not only today but also from examples in the Middle Ages and Renaissance. The obscene *mano in fica* or "fig hand"— thumb protruding between the middle and index finger of a fist—appears both in Dante's *Inferno* and on the vault of the Sistine Chapel, where one of Michelangelo's irreverent putti performs it.[9]

Yet de Jorio makes sober reading for anyone hoping to decipher the purpose in the minds of the apostles in Leonardo's *Last Supper*. The hand gestures of Italians are not, apparently, as clear-cut as Goethe believed. De Jorio discovered that knowing the purpose of someone's mind through hand gestures was no easy business. A single gesture could have many different significations. Even the *mano in fica* turned out to have three different interpretations: it could mean the subject was warding off evil, or dishing out an insult, or making "a kind of offensive or impertinent invitation." Thirteen different gestures meant "no," while the *mano cornuto* possessed, by de Jorio's reckoning, no fewer than fifteen different meanings: everything from defending someone against an evil spell to threatening to gouge out their eyes. Someone sitting with their fingers interlaced was either feeling sad or else trying to cast a spell on a woman giving birth.* Even a simple gesture such as raising the hands in the air had numerous potential meanings: acclamation, ridicule, a request, a dismissal, an entreaty, a surprise.

There are, wrote de Jorio, "various small modifications in the gesture that determine its particular meaning in each case."[10] The meaning of a particular action of the hand was understood only in terms of the positioning of the entire body, the facial expression, and the direction of the glance. Gesture, stressed de Jorio, always needed context, including that of the conversation

* The latter association undoubtedly comes from Ovid's *Metamorphosis*, in which Jupiter's wife, Juno, dispatches the goddess of childbirth, Lucina, to hinder the birth of Jupiter's child by Alcmena, and Lucina (disguised as an old hag) sits with her fingers interlaced like a trellis.

itself. Even the slightest change in the orientation of a hand could radically change the meaning of a particular gesture.

The context for the gestures in *The Last Supper* is, of course, a religious one, because the mural illustrates a story from the Gospels, and because its initial audience was a group of Dominican friars. These friars were the ones to whom, above all, the actions of the apostles needed to speak.

Bodily movement was vital to the vocation of the Dominicans. They were preachers, and as public speakers who addressed the masses in city squares they understood, as few others did, the value of gesture and movement. Numerous books on rhetoric and the art of preaching instructed them in how to use gesture to enhance their sermons. The most famous and influential of them, Quintilian's *Institutio oratoria*, instructed speakers to use "the language of the hands" to communicate their thoughts, emotions, and intentions.[11] When Leonardo praised "good orators" as an example for young painters to study because they "accompany their words with gestures of their hands and arms," he was probably telling his students to watch—among other things—the sermons of Dominican friars.[12] Although Leonardo likely never saw him speak, the most electrifying orator of the fifteenth century was a Dominican, Girolamo Savonarola, who expressed himself with "lively and almost violent gesticulations."[13]

Gesture also had a more private significance for the Dominicans, serving them in the cloister as well as in the piazza. Because monks and friars were obliged to observe silence for many hours of the day, including in the refectory, a language of gesture was developed (initially by the Benedictines and Cistercians) to help them communicate. Among the several hundred signs were ones for affirmation ("lift your arm gently . . . so that the back of the hand faces the beholder"), demonstration ("a thing one has seen may be noted by opening the palm of the hand in its direction"), and grief ("pressing the breast of the palm with the hand"). Individual gestures were even developed in some monasteries to refer to bread, fish, and vegetables.[14] Like deaf-mutes, therefore, the Dominicans would have been adept at miming their intentions and emotions, a spectacle Leonardo surely must have witnessed during his time at Santa Maria delle Grazie.

The Dominicans used ritualized movements to communicate with saints and martyrs as well as with their fellow friars. An illustrated Dominican prayer manual, *De modo orandi*, taught novices how to use physical gestures to improve their prayers and meditations. The treatise maintained that spe-

cific bodily postures, based on those used by St. Dominic, could be used to induce certain psychological states. All of Dominic's gestures were carefully described and examined: "Sometimes he would hold his hands out, open before his breast, like an open book . . . At other times, he joined his hands and held them tightly fastened together in front of his eyes, hunching himself up." Humility he achieved with a bow, ecstasy by standing with his hands joined together and raised over his head, and penitence through self-flagellation. Many of these postures found their way into paintings.[15] The Dominicans of Santa Maria delle Grazie were an audience highly literate in the language of gesture. What, then, might they have made of Leonardo's gesticulating apostles?

One of the simplest hand gestures in Leonardo's *Last Supper* is performed by John, who clasps his hands on the table, fingers interlaced. As de Jorio pointed out, this gesture, which he called *mani in pettine* ("comb hands"), can be used to indicate sorrow. Leonardo himself noted that the gesture could be used by painters to indicate sorrow and weeping: "As to types of weeping," he wrote, "one shows despair, another is moderate; some are tearful, some shout, some weep their face to heaven with their hands held low, their fingers intertwined."[16]

Leonardo's study for the hands of the apostle John

John was often shown by painters in postures of grief, standing or kneeling at the foot of the cross with his hands clasped together. For example, Masaccio depicted him performing exactly these gestures in his *Holy Trinity* in the Dominican basilica of Santa Maria Novella, a work certainly known to Leonardo (and probably to many of the Dominicans in Santa Maria delle Grazie). According to the Gospel of St. John, the beloved disciple was one of the few who, with Mary and Mary Magdalene, "stood by the cross of Jesus" (19:25) in his time of dying. Scenes of the Crucifixion therefore showed John in a posture of mourning, usually with his hands clasped and fingers intertwined in the *mani in pettine*. That, in fact, is exactly how Giovanni da Montorfano depicted him on the opposite wall of the refectory in Santa Maria delle Grazie: a blond, beardless figure who stands beside the cross with his brow knit and his fingers interlaced. His head is tipped to his left, making him a kind of mirror image of Leonardo's John on the opposing wall. Anyone in doubt about the figure sitting beside Christ in Leonardo's painting need only to turn around to see his double in Montorfano's *Crucifixion*.

A number of the other gestures in Leonardo's mural likewise allude to forthcoming episodes in the Passion. Perhaps the most obvious is the one performed by Peter, whose right arm is held akimbo in the posture de Jorio calls the *mano in fianco*—a gesture of indignation.[17] In his hand Peter holds a knife, a weapon whose pointed blade is a good eight inches long. Ghirlandaio showed Peter with a similar knife in his *Last Supper* in the church of Ognissanti, finished in 1480 while Leonardo was still in Florence. In both cases the knife foretells the event that occurred later that same evening when Peter, defending Jesus from "a great multitude with swords and clubs," sliced off the ear of Malchus, the servant of the high priest (Matthew 26:47). In placing the knife in Peter's hand, Leonardo revealed his familiarity not only with the Gospels—all four of which tell the story of the severed ear—but also with Ghirlandaio's painting.

Peter's knife points, quite literally, to something else: its tip is aimed at Bartholomew, the apostle who stands at the left end of the table.[18] As we have seen, saints were often identified by the symbols of their martyrdom. Montorfano, for example, gave clues to help identify the various saints in his fresco: St. Peter of Verona (who was murdered by Cathars) has a bloody sword buried in his skull, while St. Catherine of Siena (who took out her "stony" heart and exchanged it for Christ's loving one) is identifiable by the

disembodied heart she holds in her right hand. Bartholomew's attribute was the knife with which he was flayed alive by Armenian barbarians (a martyrdom that explains why he is the patron saint of both Armenia and skinners). Michelangelo would later depict Bartholomew on the altar wall of the Sistine Chapel clutching both a knife and his own flayed skin. Leonardo, by showing the knife, foretold not only Bartholomew's gruesome death but also the agonies and tribulations that awaited the apostles (many of whom would be martyred) as they witnessed to Christ "in Jerusalem, and in all Judea, and Samaria, and even to the uttermost part of the earth" (Acts 1:8).

Another hand gesture that anticipates future events is the one performed by Thomas, who, as he leaves his place at the table and appears from behind James the Greater, points his right index finger into the air. In Leonardo's art a pointing finger is often, like the smile, an enigmatic gesture. Uriel in *The Virgin of the Rocks* (Louvre version) and the mysterious creature in his *John the Baptist* both point with their index fingers. Uriel directs our gaze to the infant John the Baptist, while in the latter painting the Baptist points upward, presumably an allusion to his recognition of the Messiah foretold in prophecy.

Thomas's finger in *The Last Supper*, likewise pointing upward, is more clear-cut, because if any man in history is defined by his finger, it is surely Thomas. Informed by the other apostles that they had seen the risen Christ, Thomas demanded empirical proof. "Except I shall see in his hands the print of the nails," he informed them, "and put my finger into the place of the nails, and put my hand into his side, I will not believe." Eight days later, Christ entered the same room as Thomas and closed the door behind him. "Put in your finger hither," he instructed him (John 20:25, 27). Such was the importance of Thomas's finger that in the fourth century its relic was brought from Jerusalem by St. Helena and placed in the basilica of Santa Croce in Gerusalemme in Rome.

Leonardo knew very well the story of Thomas's doubt and his probing finger. For the entirety of the time that he studied and worked with Verrocchio, the master was designing and casting the life-size bronze sculpture group *The Incredulity of Saint Thomas* for a niche in the exterior wall of Orsanmichele in Florence. Around the time Leonardo entered his workshop, Verrocchio received the commission from the Università della Mercanzia, the commercial tribunal that presided over all of the Florentine guilds. Leonardo's father, Ser Piero, who rented rooms from the Mercanzia

The apostle Thomas

and served as their notary, may even have negotiated the contract. The Mercanzia's motto—"No judgment should be given until truth is tangibly manifest"—meant that Thomas, the apostle who wanted truth to manifest itself, seemed the saint most appropriate to represent the inquisitorial members of the tribunal, and indeed Tuscan town halls often used Thomas as a symbol of justice.[19] Verrocchio's entire sculpture is about a hand gesture, and he showed Thomas, encouraged by Christ, about to probe the wound with his finger.

If Thomas was an appropriate saint for the Mercanzia, he was likewise, as someone who demanded ocular and tactile proof, and who "anatomized" the resurrected Christ with his finger, an apt saint for Leonardo, who accepted nothing on faith, who needed to probe and feel and see for himself. For Leonardo as for Thomas, seeing was believing. "All our knowledge has its foundation in our sensations," he declared in one manuscript. In another: "All science will be vain and full of errors which is not born of experience, mother of all certainty. True sciences are those which experience has caused to enter through the senses."[20]

"Every painter paints himself": if Leonardo used his own features in *The Last Supper*, as Gasparo Visconti claimed, then Thomas, in terms of personal identification, would have been the most attractive candidate. Visconti claimed that Leonardo represented not only his own features but also his own "actions and ways"—that is, his gestures and expressions. The point-

ing finger was such a well-known Leonardo trademark by 1511 that Raphael included it in the supposed portrait of the painter as Plato in *The School of Athens* (which features Bramante as Euclid and Michelangelo as Heraclitus). This Vatican fresco shows a bearded and balding Plato replicating the gesture of Leonardo's Thomas by pointing skyward with his index finger. Raphael was certainly playful with his portraits and allusions. His fresco gently mocked the gloomy, truculent Michelangelo by means of the figure of Heraclitus—a famously cantankerous philosopher—while at the same time paying tribute to his talents by imitating his powerful new style. In similar fashion he may have been self-consciously duplicating both Leonardo's style (the total conception of *The School of Athens*, according to Janson, "suggests the spirit of Leonardo's *Last Supper*") and one of the signature gestures of his art.[21]

The difficulty of ascribing Leonardo's features to Thomas is that no drawing exists that would allow us to see the original conception, which often differed (as the example of Bartholomew shows) from the end result on the wall of the refectory. Also, while Thomas is far from ugly, revealing large eyes and a fine Greek nose, he is hardly the paragon of beauty rhapsodized by later writers—though neither, it must be said, is the solemn old codger in *The School of Athens*. Thomas is one of Leonardo's nutcracker men, arguably toothless, complete with a down-turned mouth, beetling lower lip and protuberant jaw. However, the paint loss in the mural makes it difficult to determine the finer details of his original appearance. Earlier restorers of the painting were guilty of coarsening and exaggerating the features of several of the apostles, and recent conservation of the mural found that one of

The apostle James the Lesser, reversed, opposed to Francesco Melzi's portrait of Leonardo

them altered the contours of Thomas's mouth, giving it a downward turn.[22] By contrast, some of the earliest copies of the mural, such as a copperplate engraving done in about 1500 or the version done in oil by Leonardo's student Giampietrino, reveal a version of Thomas whose mouth and jaw are far less grotesque.

Thomas appears to have been modeled by the same person Leonardo used for James the Lesser, the apostle second from left, beside Bartholomew. James's features, likewise in profile, are less caricatured and therefore perhaps allow us to appreciate Leonardo's appearance in the mid-1490s. Difficult as it is to compare the James of the ravaged mural with the beautiful and highly detailed red chalk profile portrait, apparently of Leonardo, the two subjects do bear certain similarities: both have Greek noses and long hair worn parted in the middle. Also, both wear beards, and the beards in *The Last Supper* may help explain Visconti's claim about Leonardo's self-portraiture. He would have detected the painter's lineaments in both Thomas and James the Lesser even more readily if Leonardo wore a beard in the 1490s: a rare sight, as we have seen, on the chins of fifteenth-century Italians.[23]

This kind of Leonardo spotting must stay stuck, for lack of further evidence, in the realm of speculation. What is more certain is that the friars of Santa Maria delle Grazie, looking at the gesticulating apostles, would have seen revealed in their gestures, not merely human emotions realistically and eloquently portrayed, but also clear and unmistakable allusions to the Christian story.

Painters were always careful to identify the traitor at the Last Supper. Often Judas reaches for the bread offered by Christ or else, in an unholy communion, opens his mouth to receive the sop. Sometimes he sits on the opposite side of the table from Christ and the other apostles, while in other paintings he is the lone apostle without a halo. Cosimo Rosselli's *Last Supper* in the Sistine Chapel shows him with a dark halo and, lest there be any lingering doubts about his identity, a winged demon perched on his shoulder. Some versions show Judas with a fish or other item of food concealed behind his back. In the Middle Ages, especially in Passion plays, his thieving was em-

phasized along with his treachery. "Abjured traitor, thief, money-grubber, faithless man filled with rancour," fumes a French play of 1486.[24]

Leonardo was more subtle than most painters, but his Judas is still unmistakable. Like many other artists, he showed him reaching for the same dish as Christ. However, Leonardo departed from every other painter who included this motif by depicting Judas reaching with his left hand, not his right. Leonardo's Judas is, like Leonardo himself, a *mancinò*. The only other Judas who reaches with his left hand is found in a stained-glass window in Chartres cathedral, though viewed from the other side, this Judas is, naturally, right-handed.

Leonardo, of all people, would have known how left-handedness was regarded with fear and suspicion. The well-known connection between "left-handed" and "sinister" is usually explained with reference to the Roman auguries: a bird or other sign appearing to the left of the priest—on the "sinister" (left) side as opposed to the "dexter" (right)—supposedly foretold unfavorable events. Left-handedness certainly came to be synonymous with bad luck and even evil. In Christianity, the right side of the body was viewed as morally superior and supposedly protected by God. According to St. Augustine, the left hand represented the temporal, the mortal, and the bodily, as opposed to the right, which stood for "God, eternity, the years of God which fail not."[25] For centuries the preference for the right hand over the left governed how people fished, ploughed fields, twisted rope, and ate their meals. The Greeks and Romans, for example, always reclined on the left side, propped on the left elbow, leaving the right hand free for the business of eating and drinking. Plutarch noted that parents taught children to eat right-handed from a young age, and "if they do put forth the left hand, at once we correct them."[26] The prejudice against the left hand persisted during the Renaissance, with parents freeing a child's right hand from its swaddling clothes to ensure right-handedness at the dinner table as well as at the writing desk.

Painters were acutely conscious of the implications of left versus right. In profile portraits, the lady always faced to the left, which meant she was in the position known as the "heraldic sinister" because she was on God's left hand, while her husband, hierarchically superior, faced to the right.[27] Crucifixion scenes always showed Christ with his head inclined to the right, the side of salvation and eternity. Giovanni da Montorfano followed the usual

pattern: his fresco in Santa Maria delle Grazie shows Christ's head turned to the right, toward the Good Thief (above whom rises an angel) and away from the Bad Thief (above whom perches a demon) to his left. Among the few left-handers to appear in paintings are witches: artists like Albrecht Dürer and Parmigianino deliberately portrayed them as left-handed.[28]

Leonardo's invention of Judas as a *mancino* therefore cleverly exploits this cluster of negative cultural associations. The sight of someone eating with his left hand would have been highly unusual, the anomaly all the more obvious in a refectory setting. It comes as an unexpected surprise, however, that Leonardo, one of history's most famous left-handers, should have pressed this antisouthpaw bias into service, though possibly he, more than other artists, was attuned to these negative connotations.

Judas is doing something else besides reaching for food with his left hand: he rears forward and twists sideways and, in doing so, tips over the saltcellar and spills its contents. This gesture—another of Leonardo's inspired inventions—was anticipated in his earlier description of how to show a group of men dining at a table. One part closely matches (albeit with some modifications) the Peter-Judas-John grouping: "Another speaks into his neighbour's ear and he, as he listens to him, turns towards him to lend an ear, while he holds a knife in one hand, and in the other the loaf half cut through by the knife. Another who has turned, holding a knife in his hand, upsets with his hand a glass on the table." Leonardo chose, in the end, to show an overturned saltcellar rather than a glass.

This saltcellar, unfortunately, is no longer visible: every trace of it has been lost due to the mural's deterioration. It can clearly be seen in many early copies, such as Giampietrino's and the one at Ponte Capriasca, and there is no question that Leonardo's mural included a saltcellar. He was not the first artist to put a saltcellar on the table at the Last Supper: they feature in at least two other versions painted in northern Italy in the second half of the fifteenth century.[29] However, he invented the motif of the spilled salt—and in doing so this least superstitious of men became responsible, ironically, for a famous and widespread superstition.

Spilling salt is usually taken as a sign of ill omen. Once again the Roman priests who took the auguries are to blame. Spilling salt was one of a series

of events of calamitous significance that the priests called *dirae* (others included sneezing, spilling wine, hearing certain portentous words or sounds, or seeing apparitions). Saltcellars were symbols of families for the ancient Romans, with Horace praising the "ancestral salt-box" gleaming on the table as an image of stability and domestic bliss. In the Middle Ages and Renaissance the saltcellars of royal families became ornate affairs proclaiming the wealth and status of their owners, and in England a dinner guest sitting "above the salt" occupied a privileged place at the table between the saltcellar and the host. Saltcellars in France were bejeweled and often shaped like ships, and it is easy to imagine that upsetting one of these royal saltcellars—which symbolized the "ship of state"—could be taken as ominous.[30]

How much Leonardo knew of these superstitions, or how widespread they were in fifteenth-century Italy, is debatable. What he could have known about, however, is the religious significance of salt. Salt is mentioned many times in both the Old and New Testaments, most famously in Jesus's metaphor to describe the apostles: "You are the salt of the earth," he tells them (Matthew 5:13). In the Old Testament, salt was used to seal agreements between God and man, such as the "covenant of salt" by which God gave the kingdom of Israel to David and his descendants (2 Chronicles 13:5). This phrase probably originated because salt, as a preservative, readily symbolized something that endured. Also, salt was necessary to make offerings to God: "Whatsoever sacrifice you offer," stipulates the Book of Leviticus, "you shall season it with salt" (2:13). Salt was believed by the ancient Hebrews to have healing or talismanic powers. The prophet Elisha purified Jericho's toxic water supply by casting salt into its springs (2 Kings 2:19–24), and newborn children were rubbed with salt (Ezekiel 16:4).

This latter practice—which links salt with the preservation of health—survived in Florence: a small supply of salt left with a child dropped anonymously at the Ospedale degli Innocenti, the foundling hospital, meant the infant was unbaptized.[31] Besides preserving health, the salt was probably also meant to protect the infant from evil spirits. Consecrated salt, sprinkled like holy water, was used against witches and demons, and in some countries it was thrown on gypsies.[32]

Although Leonardo may have been aware of these associations, he need not have turned to his Bible or folk superstitions to appreciate the importance of salt. The nature of salt fascinated him: its origins and composition,

and the fact that, as he wrote, it "is in all created things." His manuscripts include a series of notes refuting Pliny the Elder's argument about why the sea is salty. His discussion veers off in an interesting direction when he begins considering the necessity of salt (which he views as essential to life) to the human diet. Leonardo observed that humans have "eternally been and would always be consumers of salt." But how long, he wondered, will supplies last? Was the world's supply of salt finite, in which case humans would die out when they use it all up? Or was it renewable and self-replenishing? He decided on the latter because salt recycles itself through our bodies, "either in the urine or the sweat or other excretions where it is found again," thereby ensuring an undiminishing supply (even if we would eventually need to source it from "places where there is urine"). The interesting thing about these comments is the quasi-religious language Leonardo employed to describe salt: he pondered whether it "dies and is born again like the men who devour it" or whether it is "everlasting," concluding that it must be everlasting because not even fire can destroy it.

Salt therefore had a range of possible meanings for Leonardo and the first spectators of *The Last Supper*, the Dominican friars: essential to human life and an image of endless renewal, while symbolizing not only the apostles' and man's covenant with God but also good health and good luck. The spillage of salt at such a crucial moment—the announcement of the traitor—was at best a bad omen and at worst a kind of desecration.

Spilling salt is, of course, still regarded as a dire omen by people in modern nations: a recent study found that 50 percent of people in England admit to throwing salt over their shoulders to ward off bad luck if the saltshaker overturns.[33] Ironically for Leonardo, the man who did more than anyone to popularize this superstition, we counter the ill omen by throwing a pinch of salt over our left shoulder—because the devil, naturally, appears on our left.

Judas is performing yet another gesture in *The Last Supper*: Leonardo shows him clutching his purse of ill-gotten gains. This action is in keeping with the Gospels, which describe Judas as the keeper of the communal purse and, of course, as the traitor who betrays Jesus for (according to the Gospel of St. Matthew) thirty pieces of silver. Yet the sight of Judas clutching a purse is much rarer than we might expect in Last Suppers: Perugino, in a

fresco done a few years earlier in Florence, is one of the few other artists to feature the motif. Later, in 1512, the Tuscan painter Luca Signorelli would paint a version showing Judas, in a brazen act of theft, furtively slipping the Eucharist into his money bag.

Judas clutching a money bag was an evocative image in a Last Supper. A money bag was a common attribute of Jews in European art, bringing together Judas's betrayal of Jesus with Christian denunciations of avarice and contemporary social tensions about the sin of usury. Psalters and illustrated Bibles frequently featured such images as Jews with money bags around their necks happily greeting the devil or languishing miserably in hell.[34]

Leonardo is far subtler than Signorelli or the illustrated Bibles, but by giving Judas a money bag he links the story of Judas's betrayal of Christ to the wider history of the Jews. Judas and the Jews had become virtual synonyms thanks in part to etymological "proof" offered by the church fathers: "The Jews take their name," declared St. Jerome, "not from that Judah, who was a holy man, but from the betrayer."[35] St. Ambrose, a fourth-century bishop of Milan, saw a link between Judas, the Jews, usurers, and ultimately the devil, who "himself should be compared to a usurer, who destroys the things of the soul."[36] Christians practiced moneylending, of course: the Medici and other Florentine families built up their immense fortunes by lending out money at interest. But usury became so identified with Jewry that the charging of interest was known as "judaizing."[37] The so-called crime of usury was one of the reasons why the Jews were expelled from England in 1290 and from France in 1306.

The papacy was more tolerant of usurers than secular monarchies, but that did not stop various preachers from railing against the sin. "God has commended that a person should not lend in usury," proclaimed the Franciscan firebrand Bernardino da Siena, who died in 1444. "It is theft, it is done against the command of God, and thus you must object to usury and to any person who practices usury."[38] Bernardino called for marking Jews with a distinguishing sign. Periodically Jews in Italy were forced to wear a yellow badge, the *segno del O*. A law passed in Florence in 1463 fined any Jew failing to display this badge the substantial sum of twenty-five lire. In 1452, a similar law was effected in Milan, where it was one of the prices Jews paid for the right to live in the city, build synagogues, and celebrate their feasts. This yellow circle appears to have been intended to represent a coin, thereby stigmatizing all Jews as accomplices of Judas.[39]

The language of officialdom was often severe in dealing with Jews. In 1406, Jewish moneylenders had their rights revoked in Florence with a decree proposing that "Jews or Hebrews are enemies of the cross, of our Lord Jesus Christ, and of all Christians."[40] Several decades later, in 1442, the Council of Florence made clear the church's attitude toward the Jews, classifying them along with "heretics and schismatics" as people who "cannot share in eternal life and will go into the everlasting fire which was prepared for the devil and his angels."[41] However, little of this theological abomination of Jews actually seems to have made its way into everyday life in fifteenth-century Italy. Vasari did tell the story of an ironworker in Florence, a contemporary of Leonardo known as Il Caparra, who refused to work for Jews, and who "was wont, indeed, to say that their money was putrid and stinking." However, Vasari stressed that Caparra was a hotheaded eccentric, "whimsical in brain," and his bigotry seems to have been a minority view.[42] Jewish-Christian relations in Milan, for instance, were mostly cordial, with a good deal of mutual toleration and shared camaraderie. Jews and Christians frequently ate meals together and participated in one another's feasts. Jews taught Christian noblewomen music and dance, while Christians served as midwives and even wet nurses to Jewish families.[43] Galeazzo Maria Sforza, monstrous in so many other respects, treated the Jews with admirable restraint, releasing them in 1466 from the obligation of wearing the *segno del O* and then in 1475 forbidding the clergy from attacking Jews in their sermons.

Leonardo presumably took the same liberal attitude toward the Jews as most of his contemporaries in Milan. He would have known Jews from, among other places, the court of Lodovico Sforza, who was interested in fostering Hebrew studies. In 1490 he appointed the scholar Benedetto Ispano to a newly established chair of Hebrew studies. Another Jewish scholar, Salomone Ebreo, was invited by Lodovico to live in the Castello while he translated Hebrew manuscripts into Latin.[44]

One Leonardo expert has argued that the Judas of *The Last Supper* is "clearly Semitic in type."[45] Arguably, a number of the apostles look Semitic. A nineteenth-century ethnographer named William Edwards even used the faces in Leonardo's *Last Supper* to argue for the purity and continuity across the centuries of the Jewish "national countenance": the faces of nineteenth-century Jews, he believed, appeared "feature for feature" in Leonardo's painting.[46] Edwards was under the illusion that Leonardo's models were

Leonardo's red chalk study of Judas

Jewish, whereas it is not certain that even the model for Judas was Jewish. One of the few clues to his identity is the story told by Giovanni Battista Giraldi, who claimed that Leonardo went to the outskirts of Milan, to a neighborhood known as the Borghetto, to sketch the physiognomies of vile and depraved characters (no mention is made of Jews). The Borghetto ("little borough") should not be confused with a Jewish ghetto such as that established in Venice some decades earlier. It was a cluster of small houses in the northeast corner of Milan, outside the city walls. Going to this poor area, roughly a mile as the crow files from the Corte dell'Arengo, by no means guaranteed Leonardo a Jewish model. Indeed, if we believe Giraldi, Leonardo considered a gentile for his model: harassed to finish the work by Vincenzo Bandello, the prior of Santa Maria delle Grazie, Leonardo threatened to immortalize the irritating prior as Judas.

Giraldi is theoretically a good source, since he got information from his father, who knew Leonardo and watched him at work on the scaffold. At the same time, Giraldi was a storyteller (one of his collections, published in 1565, provided Shakespeare with the plots for both *Measure for Measure* and *Othello*). We therefore cannot discount that he was exaggerating Leonardo's words and actions for the sake of a good story. His observation is found, after all, in a work called "A Discourse on the Manner of Composing Romance and Comedy." However, his story (which Vasari repeated) may not have been completely wide of the mark. Leonardo appears to have used one

of the friars, at any rate, as his model for Judas: a red chalk study for Judas's head clearly shows him with the clerical tonsure—that is, the shaven crown—worn by the Dominicans. Thus, Leonardo had no need to frequent the slums of Milan to find a model: he may simply have cast his eye around Santa Maria delle Grazie.

Very little of the original paint remains on the face of Leonardo's Judas. Only from the red chalk drawing do we get a sense of his earliest conception. On the evidence of this study, the model for Judas is not really "Semitic in type" beyond having an aquiline nose—if an aquiline nose can truly be viewed as an exclusively Semitic trademark. Judas's proboscis is certainly not the exaggerated hook often used by artists to stereotype and caricature Jews. Furthermore, Leonardo sketched dozens of faces with aquiline noses, noting that it was one of the ten different shapes noses came in. Aquiline noses were not regarded as grotesque during the Italian Renaissance: named after the beak of the eagle (*aquila*), they were seen by some as markers of nobility.[47] Several of the other apostles have identical Roman noses, most notably Simon, shown in profile on the far right. Simon was, in fact, almost certainly modeled by the same person as Judas: their noses and mouths (down-turned and sunken) are virtually identical. Intriguingly, an engraving of Vincenzo Bandello shows the prior to have, besides the clerical tonsure, a pronounced aquiline nose.[48]

In any case, Leonardo's Judas is no crude caricature of a Jew. His supposedly villainous face is partly the creation of successive restorers who reworked his features, and partly that of copyists determined to give the traitor an appropriately evil look. Goethe noted that Leonardo's Judas was "by no means ugly" but that some copyists—such as Andrea Vespino, who made a full-size version between 1612 and 1616—had transformed him into a "monster" whose features and expression testified to a "malicious love of evil."[49] These transformations were not necessarily aimed at making Judas look more Semitic. However, the increasing vilification of Judas would have been in keeping with the Italian tradition of Last Suppers. Judas was often represented as the only non-Christian at the table, a stand-in for Jews in general, the people who tortured and murdered Jesus. A good example is a *Communion of the Apostles* painted for the Confraternity of the Corpus Domini in Urbino by Joos van Ghent in 1474. The altarpiece shows Judas clutching a money bag and wearing a Jewish prayer shawl. In keeping with a northern

European tradition (van Ghent was Flemish) Judas has red hair, because redheads were viewed, like left-handers, as dangerous and untrustworthy.[50]

Many have noted that in Leonardo's *Last Supper* Judas is the only apostle whose face is in shadow. Leonardo did indeed contrast Judas's face, darkened by shade and turned partially away from the viewer, with the radiant features of Christ haloed by the window. But Judas was also downgraded in another way. Leonardo dressed him in a costume consisting of a violet undergarment and blue mantle (whose sleeve, as the light catches it, turns green). Leonardo used a good deal of ultramarine in his fresco, most conspicuously in Christ's mantle, where it is applied most thickly and freely, but also in the costumes of Bartholomew, Peter, Matthew, and Philip. Judas is one of these figures in blue but, unlike Christ and the other apostles, he did not warrant ultramarine, the expensive pigment that artists reserved, as we have seen, for the most revered parts of a painting. Instead, Judas's costume was painted with azurite, a pigment thirty times less expensive.[51]

Finally, one story about Leonardo's Judas may be safely discounted. To borrow the phrase of Lorenzo Valla, it is "knavishly forged." It seems to have been spread through America in the first decades of the twentieth century by a Presbyterian evangelist from Indiana named J. Wilbur Chapman. Chapman probably took it from what appears to be the first of its many appearances in print, Harry Cassell Davis's *Commencement Parts*, an 1898 compendium of "valedictories, salutatories, orations, essays, class poems, ivy orations, toasts; also original speeches and addresses for the national holidays and other occasions."

The anecdote involves Leonardo and a youngster named Pietro Bandinelli. The name is impressively plausible but appears absolutely nowhere in any documents on Leonardo. Identified variously as a chorus boy and a seminarian, Pietro was supposedly selected by Leonardo to model the head of Christ. Leonardo then went looking for a model for Judas. He had no luck until, in a eureka moment many years later, he found a beggar in whose vicious features he saw the perfect fit. This ugly old indigent, it transpired, was none other than Pietro Bandinelli, his Christlike features corrupted by—and here comes the moral of the story—years of sinful living.

The story is typical of the crackpottery that follows Leonardo. It is riddled with numerous errors, such as the length of time it assumes that Leonardo took to paint the mural and the fact that not even several lifetimes of the most unbridled debauchery could turn the features of Jesus into those of Judas. Occasionally the story is even set in Rome, not Milan, and *The Last Supper* is said to have been painted on canvas, not a wall. But such stories seldom founder on the rocks of hard fact, and in the past decade it has been related uncritically in at least eight different books. The legend of Pietro Bandinelli sails determinedly on, as difficult to sink as the equally fictitious stories about golden rectangles or the mysterious substitution of Mary Magdalene for St. John.[52]

CHAPTER 15

"No One Loves the Duke"

B y the summer of 1497, Leonardo had been at work on *The Last Supper*, off
and on, for several years. At times he was no doubt guilty of neglecting
his duties in Santa Maria delle Grazie in favor of many other projects and
pursuits. His mathematical studies obsessed him, and he was still hard at
work on his illustrations for Luca Pacioli's *Divine Proportion*. Someone who
lived in Milan during these years later observed that whenever Leonardo
"should have attended to his painting ... he devoted himself completely to
geometry, architecture and anatomy."[1]

With Giovanni da Montorfano having completed his *Crucifixion* on the
opposite wall of the refectory at least eighteen months earlier, Lodovico
Sforza was anxious to see Leonardo finish his own wall. At the end of June
he instructed his secretary "to urge Leonardo the Florentine to finish the
work already begun in the refectory of the Grazie." Lodovico wanted Leo-
nardo to complete *The Last Supper* because he had another task for him:
Leonardo was to "attend to the other side of the refectory."[2]

Montorfano had either left several blank patches of wall in his fresco or else Lodovico was planning for the removal and replastering of several sections of the foreground to make room for a late addition: portraits of Lodovico, his late duchess, and their two children. This time, having learned his lesson with *The Last Supper*, the duke was taking no chances with his capricious painter. He referred to a contract for the portraits that Leonardo evidently had yet to sign. The secretary was told to make Leonardo "sign the contract with his own hand and oblige him to finish within an agreed time."[3]

Altarpieces and frescoes often included portraits of the people who commissioned them, anachronistically showing families in modern dress kneeling at the foot of the cross or even, as in Joos van Ghent's *Communion of the Apostles*, mixing with Christ and the apostles at the Last Supper. In Montorfano's fresco, Lodovico was to be shown in profile on the left side of the scene, kneeling beneath the figure of the Dominican martyr St. Peter of Verona, his son Massimiliano at his side. Beatrice and son number two, Francesco, were to be on the right, beneath St. Catherine of Siena. Because of Beatrice's death at the start of the year, there would be a great poignancy to her portrait, which Lodovico was understandably anxious to see completed.

These likenesses were to be one of a number of ways in which Lodovico commemorated his late wife, whom he clearly adored despite his various mistresses. He planned to open a new gate in the city walls and christen it the Porta Beatrice, while her portrait on a medallion would adorn the doors of Santa Maria delle Grazie. Inside the church, the commemoration continued, with Cristofo Solari carving a marble effigy for her tomb that would show her reposing peacefully on her back, arms folded and eyes closed, dressed in the clothing she wore to mark the birth of her eldest son. Draped over her hands would be—poignantly—the pelt of a marten, a creature believed to offer protection to women in childbirth.

Just as Beatrice had spent many hours each day at the sepulcher of Bianca, so, too, Lodovico, wrapped in a black cloak, now spent many hours mourning his wife in Santa Maria delle Grazie. "He goes every day to visit the church where his wife is buried," wrote a young Venetian politician, "and never leaves this undone, and much of his time is spent with the friars of the convent." In fact, he attended two or three masses each day. "He is very religious," the young Venetian continued, "recites offices daily, observes fasts, and lives chastely and devoutly. His rooms are still hung with

black, and he takes all his meals standing."[4] Two weeks after her death, as a kind of penance, he shaved his head.

How much progress Leonardo had made on *The Last Supper* by the summer of 1497 is impossible to know. Presumably it was nearing completion, though Lodovico's urgent note to his secretary ordering Leonardo to "finish the work already begun" may imply that work was proceeding only fitfully, with no clear end in sight. Leonardo had, however, recommenced painting in 1497 following his "scandal" the previous year. That January, Matteo Bandello, the prior's nephew, witnessed Leonardo working erratically on the scaffold, sometimes painting furiously from dawn to dusk without stopping for food or drink, at other times studying the mural for hours on end without touching his brushes.

Bandello gave further insights into Leonardo's work at this time. He claimed that people used to gather in the refectory to watch Leonardo and offer opinions regarding his work—overtures that the painter welcomed. Bandello failed to identify these visitors beyond noting that one of them, early in 1497, was a Frenchman, Raymond Peraudi, the bishop of Gurk, who was staying at Santa Maria delle Grazie during a visit to Milan. Apparently the bishop was not impressed by what he saw. He believed that, on a salary of two thousand ducats, Leonardo was overpaid. Peraudi may have been aggrieved because his own annual income was a mere three thousand ducats. No doubt he regarded himself, as a bishop and a cardinal, infinitely more worthy than someone whose job it was to decorate a refectory.[5]

Bandello also claimed that one reason why Leonardo sometimes failed to arrive at the refectory was because he was still working on his "stupendous horse of clay" in the Corte dell'Arengo. Bandello may have recalled the facts incorrectly, because his account was composed many decades later. Yet it may well be the case that, more than two years on, Leonardo was unwilling to abandon this magnificent project and therefore, still dreaming of seeing the work take shape in bronze, gamely continued modeling his horse even as he worked on *The Last Supper*. Certainly the project was never far from his thoughts, and his papers reveal that in the years between 1495 and 1497 he was still making notes on how to cast the giant horse. He could have had no encouragement, and no money, from Lodovico.[6]

Leonardo was distracted by other projects, too, in 1497. He finally had an architectural commission: the remodeling of a villa owned by Mariolo de' Guiscardi near the Porta Vercellina, a stone's throw from Santa Maria

delle Grazie. Little is known about Mariolo beyond the fact that he was Lodovico's chamberlain and that he owned a stable of horses, one of which Leonardo had considered as one of the models for his equestrian monument. Mariolo's villa stood outside the city gate in a district recently transformed into a suburb for wealthy Milanese courtiers. Galeazzo Sanseverino, with his own stable of horses, was one of Mariolo's neighbors.

Leonardo was given precise specifications for the villa, which was to be comfortable but not palatial. It was to feature a drawing-room forty-six feet in length and four bedrooms, including ones, Mariolo stipulated, "for my wife and her ladies." There would also be a courtyard, a guard room, and a thirty-eight-foot-long dining hall for the servants. Leonardo applied himself to the task with enthusiasm, making many notes, drawings, and calculations. He seems to have thought of everything: kitchen, larder, scullery, a hen coop, stables for sixteen horses, and even places to store wood and keep manure. Comfort and convenience were paramount. "The servants' hall beyond the kitchen," Leonardo noted on his plan, "so that the master does not hear their noise."[7]

As work began on the villa, Leonardo also had other, less welcome distractions. Salai, though now an adolescent, was still proving a trial despite—or because of—Leonardo's continued indulgence of him. In April 1497 Leonardo treated the young man to an expensive cloak made from silver-colored cloth trimmed with green velvet and decorated with loops. The garment cost twenty-six lire, the equivalent of a week's wages for a construction worker. Unwisely, he gave Salai the money to pay for the cloak. "Salai stole the money," Leonardo recorded in weary resignation.[8]

Raymond Peraudi, whose bishopric was in present-day Austria, was visiting Milan to further the good relations between Lodovico and Maximilian. Following his failed expedition to Pisa, the emperor had bidden farewell to Lodovico in the last weeks of 1496, leaving Italy (as a Venetian noted) "in still greater confusion than he found her."[9] The year 1497 witnessed continued upheaval and unrest. In Naples, Ferdinand II had died at twenty-seven, leaving conditions in his kingdom "more disturbed than they had ever been."[10] In Florence, Girolamo Savonarola held the first of his "bonfires of the vanities." A ninety-foot-high pyramid was built from perfume bottles,

wigs, hats, masks, dolls, chessmen, playing cards, musical instruments, books, manuscripts, paintings, and statues. After an effigy of Satan was placed on top, the glittering heap was sprinkled with gunpowder and set alight. "With the greatest happiness they burned everything," recorded one witness. Afterward, a song was sung declaring Christ the king of Florence.[11]

Three months later, in May, Savonarola was excommunicated by Pope Alexander VI for having "disseminated pernicious doctrines to the scandal and great grief of simple souls."[12] Then, in June, the pope's son, Juan Borgia, the duke of Gandía, was murdered in Rome, his throat cut by an unknown assailant and his body tossed into the Tiber. The pope regarded his son's mysterious death as a punishment from God, but he believed a hand besides the Lord's had also been involved: that of Lodovico Sforza's brother, Cardinal Ascanio. Juan's restless ghost would soon be seen stalking Rome, and in October lightning struck the Castel Sant'Angelo, causing an explosion that showered the city with chunks of marble. "The reign of Pope Alexander," wrote a Venetian chronicler, "is full of startling and portentous events." The pope had his own theory about what was causing all of these problems. "May God forgive him who invited the French into Italy," he told a Florentine envoy, "for all our troubles have arisen from that."[13]

A Venetian jealously scrutinizing Lodovico Sforza's fortunes at the end of 1496 had reached a hopeful conclusion: "I believe that he will not continue long in prosperity, for God is just, and will punish him because he is a traitor and never keeps faith with any one."[14] Lodovico's chickens did indeed seem to be coming home to roost. The deaths of his wife and daughter had been terrible blows. Also, his enormous outlays of revenue—the dowry paid to Maximilian, the funds sent to Pisa, the money for the building of churches and the beautification of Milan and Vigevano, not to mention the endless rounds of banquets and other extravagances—forced him to impose higher and higher taxes on his people. A tax called the *inquinto* was levied, adding a further 20 percent on the existing taxes on such necessities as meat, wine, and bread. Before the end of the year, riots broke out in Cremona, Lodi, and Pavia. "In the whole Milanese there is trouble and discontent," wrote a Venetian. "No one loves the duke."[15]

Danger also lay beyond Lodovico's borders. The French were poised to descend into Italy, with Charles VIII, as one of his ambassadors observed, harboring "great hopes of revenging himself on the duke of Milan."[16] The instrument of the duke's destruction would be, it seemed, Louis of Orléans,

who in 1496 had massed thousands of troops at Asti in preparation for an invasion of Lombardy to press his claim to the dukedom of Milan. Other powers besides the French had turned on Lodovico. Louis gathered support for his invasion from Florence, from Bologna, from the duke of Mantua, and even—such was the brutal nature of Italian politics—from Lodovico's own father-in-law, Ercole d'Este, the duke of Ferrara. The Venetians, too, were ready to join the French cause against Lodovico as punishment for his treachery.

Yet the invasion failed to happen in 1496 or 1497. Despite the urgings of his Italian allies, Louis hesitated on the brink. Perhaps wisely, he was biding his time. Since the death of the dauphin at the end of 1495, he was now heir to the French throne, and Charles, dissolute and frivolous as ever, was not in the best of health. Despite his losses in Naples—all of the lands he had conquered in 1495 had been reconquered—the French king made no urgent moves to reclaim his erstwhile possessions. He reflected on the "many great errors" he had committed during his Italian campaign and casually mooted a second one, resolving to do better next time around.[17] However, most of his time was spent entertaining himself with jousts and tournaments. He also paid long visits to Tours, supposedly to worship at the tomb of St. Martin but in reality, cynical observers remarked, to worship a lady in the queen's entourage.

Early in the afternoon of 7 April 1498, Palm Sunday, King Charles took his queen by the hand and led her to a part of his castle at Amboise she had never seen before, the Galerie d'Haquelebac. Here the pair planned to watch a game of tennis, or *jeu de paume*, contested in a ditch below the gallery. Tennis had already caused the death of one of the king's distant ancestors, Louis X, who in 1316 expired at the age of twenty-six after his vigorous game of tennis in sweltering heat was followed by too copious a draft of chilled wine in a cool grotto. In Charles's case, the contributing factor was not wine but architecture. Since his return from Italy, and inspired by its architectural wonders, he had begun refurbishing his castle at Amboise, turning it into, an admiring courtier noted, "the most august and magnificent building that any prince had undertaken for one hundred years before."[18]

Alas, the king's architects had not yet started work on the Galerie d'Haquelebac, which was the "nastiest place about the castle."[19] Ironically for such a small man, Charles banged his head on one of the ceiling beams as he made his way into the grubby gallery. He nonetheless watched some of

the match and talked freely with the assembled company before suddenly collapsing and losing consciousness. Placed on a crude bed in the gallery, he died nine hours later, at the age of twenty-seven. One of his courtiers deplored such an unbefitting end: "And thus died that great and powerful monarch in a sordid and filthy place."[20]

Louis of Orléans was crowned king of France at Rheims on 28 May 1498. Now known as Louis XII, he immediately assumed the other title he believed to be his right: duke of Milan.

<center>❦</center>

Lodovico Sforza's promptings had served to concentrate Leonardo's mind. Two weeks before the death of Charles VIII, the duke was informed in a letter from his chancellor that work in the refectory of Santa Maria delle Grazie was progressing "with no time lost."[21] He was probably referring to the portraits of himself, his wife, and children inserted into Montorfano's *Crucifixion*, because by the spring of 1498 Leonardo had finished *The Last Supper*. There is no definitive evidence to prove when precisely he finally put down his brushes and removed his scaffolding. However, it must have been between June 1497, when Lodovico wrote his impatient letter, and the following February. On 9 February 1498, Luca Pacioli composed and dated his dedication of *On Divine Proportion*, three illuminated manuscripts of which would be completed later in the year. Pacioli's dedication implies that Leonardo's painting in Santa Maria delle Grazie was finished. It also praises the mural as "a matter more divine than human:" a satisfying first review if ever there was one.[22]

Leonardo may actually have completed the mural as early as the summer of 1497. That August, at any rate, he received a generous gift from Lodovico: a plot of land with a vineyard outside the Porta Vercellina. The land was probably given to him in partial payment, or even as a bonus, for his work in the refectory. It was only a short distance—a matter of a few yards, in fact—southeast of Santa Maria delle Grazie, running south of the present-day Corso Magenta. The gift, which made him the neighbor of the friars in Santa Maria delle Grazie, points more definitively than anything else to the end of his labors on *The Last Supper*. The fact that Lodovico gave his painter land rather than money says something about the state of the ducal coffers by 1497. Yet it also reflects Lodovico's gratitude to Leonardo: a bonus paid for a job well done.[23]

The land, which once belonged to a monastery, was approximately 220 yards long by 55 yards wide. Nearby were the circular ruins of an ancient Temple of Mars, a Roman theater that had long ago been turned into a church, and the porphyry tomb of the Roman emperor Valentinian II. Leonardo prized his new possession, minutely measuring its dimensions and calculating its value. He came up with the figure of 1,931 and one quarter ducats, which means that if he also received the two thousand ducats mentioned by Bandello, his total remuneration was the equivalent today of about $700,000.

Although a small house stood on the property, Leonardo probably dreamed of raising a more impressive dwelling for himself on the site. The land was in a desirable location, close to the properties of prominent members of the Sforza court such as Galeazzo Sanseverino and Mariolo de' Guiscardi. Leonardo was at last a man of property, and he would keep this status symbol, this little patch of land at the heart of Milan's political elite, for the rest of his life. His will described it as "his garden which is outside the walls of Milan," and it would be divided between Salai (who eventually built himself a house on the property) and another faithful servant. Leonardo clearly regarded it as one of the most precious possessions he had to bestow.[24]

What Lodovico Sforza made of *The Last Supper* is not recorded. But with the scaffold removed he—as well as the long-suffering Vincenzo Bandello and his band of friars—could at last see Leonardo's creation without obstruction.

One of the first things they must have noticed, as they entered the refectory through the small door to the right of the mural, was how Leonardo's use of color, light, and perspective brought the scene magically to life. One visitor, coming through this door a few years later, noted how his attention was "focused on the particular loaf of bread in line with the left hand of Christ, open in a gesture of offering directed to the entrance door."[25] Christ extending his hand in welcome (and indicating the holy bread) would have been everyone's first glimpse of the mural as they stepped into the room. Not only did this gesture emphasize the sacramental aspect of the painting; it also cleverly drew the spectators into the painted illusion.

The illusion of the presence of Christ and the apostles in the refectory would have continued as the friars sat at their tables to eat. Goethe imag-

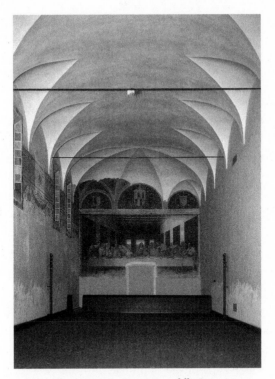

The refectory at Santa Maria delle Grazie

ined the scene: "It must, at the hour of the meal, have been an interesting sight to view the tables of the Prior and Christ thus facing each other, as two counterparts, and the monks at their board enclosed between them."[26] The illusion would have been strengthened if, as Goethe suspected, Leonardo's tablecloth, with its sharp pleats and its intricate blue pattern, were copied from one in the convent's linen cupboard. Moreover, the friars would all have been seated, like the apostles, on one side of their long refectory tables.

Something else that would have struck visitors to the refectory was the brightness of the mural, a dazzling display of color made possible because Leonardo abandoned fresco in favor of his "oil tempera" technique. The apostles' robes were combinations of red, green, yellow, and ultramarine made all the brighter by the carefully controlled interplay of contrasts. As we have seen, Leonardo knew that a color's intensity increased if it was placed next to its complementary. Hence the green of Bartholomew's mantle was opposed to the deep red of James the Lesser, the blue robe of Matthew to

the yellow splash of Thaddeus, and the orange of Philip's overmantle against the blue of his sleeves. Moreover, the colors of the men's robes were carefully syncopated along the line of the table to create a pattern of alternating hues that lead the eye through a hubbub of pushing and pulling darks and lights, adding to the gesticulations of the apostles.

One of the more sensational coloristic effects involved the clothing of Judas. Leonardo was fascinated by what light and shade could do to color. He wrote that shade affected tone and that a color's "true" character" was revealed by its exposure to light.[27] In the damaged mural, Judas's garment appears to be two-tone: his right arm in blue and his left in green. However, the true effect is best appreciated today in the faithful copy done in about 1520 by Leonardo's student Giampietrino (who probably worked beside Leonardo on the scaffold). Giampietrino reveals that Judas's mantle is blue in shadow and green where—as he reaches for the bread with his left hand—the light from the window catches and illuminates the material. The same thing happens with Christ's left hand as it gestures toward the bread. Once again, paint loss now obscures the effect in the original, but Giampietrino shows how Christ's upper arm and left shoulder are darkened while his palm and forearm, as he extends them, are illuminated—thus emphasizing his words ("This is my body") and explaining why the visitor felt the hand was reaching out from the mural and welcoming him into the refectory.

This subtle but ingenious play of light is one of the most tragic casualties of the mural's deterioration. Giampietrino's copy shows that Leonardo made his painted scene look like part of the refectory by having the fall of light in the painting—coming from an unseen source at the left—correspond to the actual windows opposite the entrance. This interplay of light and shade even extended to the floor, where the legs of the table (as Giampietrino shows) cast their oblique shadows from left to right. The illusion is further enhanced by the fact that the three deeply embrasured windows in the background of the painting make the north wall of the refectory look like it has been pierced. The view through these windows, a luminous expanse of distant hills, mirrors the Italian countryside, while the church glimpsed beyond the head of Christ faithfully reflects, with its square bell tower with the steeply pitched roof, the Lombard architecture in the countryside around Milan.

But this illusionism had its limits. There were a number of disjunctions between the painting and the actual scene in the refectory. For one thing,

the figures in Leonardo's mural are larger than life-size, exceeding by a half the size of the friars, with Christ the largest of all. For another, they were not on the same level: Leonardo's mural begins some eight feet above the ground, which means Christ and the apostles were elevated well above the heads of the seated friars.

Leonardo included other subtle visual feints. Although he was a master of perspective, he declined to do what might have been expected of him: that is, to make the painted architectural space of his mural look, from the floor, like a smooth continuation of the real architectural space of the refectory. Painters were becoming adept at offering viewers convincing three-dimensional illusions in which the painted architecture of a fresco looked like an extension of the actual room or vault. One of the best examples of this kind of hocus-focus was the choir at the church of Santa Maria presso San Satiro in Milan, built by Bramante in the 1480s to house a miracle-working image of the Virgin. A main road behind the church meant there was not enough room to build a full choir, so Bramante frescoed the (flat) back wall to give the appearance of a barrel-vaulted choir with a coffered ceiling—one of the first and most astonishing instances of trompe l'oeil in the history of art.

This technique of mixing reality and illusion would be exploited to great effect over the next two centuries. Artists often offered an ideal spot from which to view their painted illusions. The full effect of one famous example, Andrea Pozzo's imaginary architecture on the ceiling of the church of Sant'Ignazio in Rome, with its putti, angels, and cloud-borne saints, is best appreciated from the middle of the nave, from a spot helpfully marked by a disk of yellow marble.

The friars on the floor of the refectory of Santa Maria delle Grazie were given no such ideal viewing point.[28] The relation between the painting and the actual space of the refectory is ambiguous, with the lateral walls of the refectory failing to extend (as might be expected) into the tapestry-hung walls of Leonardo's mural. If one stands to the left or right of center, one of the side walls in the refectory appears more or less continuous with those in the painting—but the link between refectory and painting on the other side is then thrown out of kilter. Scholars have only recently discovered that the ideal viewing point (the point at which the perspective is corrected and the illusion perfect) is some thirty feet away from the painted wall and roughly fifteen feet in the air, a spot impossible for the friars to occupy.

Leonardo wrote at some length about how to control and maximize a spectator's view of a work of art. The problem with single-point perspective, he realized, was that while it made the painting appear to good effect from one single spot in a room, a change of viewpoint distorted the effect. "As the plane on which you paint is to be seen by several persons," he wrote, "you would need several points of sight, which would make it look discordant and wrong." What looked good for one friar, in other words, would appear distorted to another seated a few yards away. To compensate for this problem, Leonardo advised painters to have their ideal viewpoint at a far remove from the wall, "at a distance of at least 10 times the size of the objects." Elsewhere he advised a remove of twenty times the height and width of the objects, a distance that would avoid "every false relation and disagreement of proportion" and "satisfy any spectator placed anywhere opposite to the picture."[29]

Leonardo did not quite practice in Santa Maria delle Grazie what he preached in his treatise. Rather than situating the ideal viewing point at a great distance from the wall, he elevated it to an impossible height and then concealed the inconsistencies with some painterly sleight of hand. The perspective, therefore, does not look perfect from any one position on the floor, but nor, thanks to his optical trickery, does it appear especially distorted from any other.

Martin Kemp has shown that the painting's apparent realism masks what he calls "a series of visual paradoxes."[30] For example, the tapestries on the walls are not uniform in size, since they widen as they get closer to the rear of the chamber. Nor are they in perspective: the flowers are painted flat on the wall rather than being foreshortened along the diagonal. The coffered ceiling in the painting does not meet the horizontal cornice at a ninety-degree angle; instead, it tilts more steeply upward, seeming to continue to the level of the central lunette. Likewise, the space of the table is not clearly defined. It looks too wide for the room, yet at the same time it is too small for the number of figures grouped about it: there are no visible seats from which Peter and Thomas have scrambled. Finally, as we have seen, Leonardo used hieratic rather than linear perspective to make Christ significantly larger than the other apostles. He is a giant compared to John, who sits next to him, and as tall as Bartholomew and Philip, even though he is seated and they are standing.

The end result is not quite an Escher-like visual paradox, but for those

who look closely enough there is much hocus-focus, albeit so cleverly concealed that most people fail to notice.

<p style="text-align:center">❋</p>

Lodovico Sforza was not yet finished with Leonardo. There was still time, as Il Moro's enemies gathered their strength, for a few final projects. In the spring of 1498 Leonardo was sent to inspect the ruined defenses in the harbor at Genoa, an ancient French possession ruled for the past two decades by Milan. The mole had been damaged by a storm the previous month, and the duke was anxious to have it repaired before the French—who had tried to retake Genoa a year earlier—attacked from the sea. Around this time Leonardo also investigated how to breach walls by hurling missiles at them.[31] No doubt his dreams of designing cannons, catapults, and giant crossbows, dormant these past few years, quickly revived as the swords began rattling on Milanese borders.

If Leonardo hoped his talent and ingenuity were to be used for the defense of the realm, he must have been, as always, sorely disappointed: soon he was back at work on interior decorations. Besides painting the portraits of Lodovico and his late wife into Montorfano's *Crucifixion*, he was completing the decoration of a room in the Castello known as the Sala delle Asse (Room of the Wooden Boards). He was also preparing to resume his work—apparently begun at the end of 1495—in the Saletta Negra (Little Black Room), one of the private rooms in the Ponticella, the covered bridge spanning the moat.

Nothing has survived of Leonardo's work in the Saletta Negra, but its name suggests that somber decorations were in order. A visitor to Milan a year earlier, following the duchess's death, remarked that Lodovico had hung the walls of the Castello in black, and the rituals of mourning evidently extended to the Ponticella, the suite of rooms to which Lodovico retreated with Beatrice, in their private moments of leisure, to escape the demands of court.

Leonardo's other decoration for the duke, in the Sala delle Asse, a room in the Castello's northeast tower, was more exuberant but also, inevitably, extremely poignant. Here Leonardo and his helpers created a beautiful painted forest. Sixteen trees (probably meant to represent mulberries) spread their branches in complex intertwining patterns across the walls, over the

windows and doors, and onto the lush canopy of the vault. Tablets on the vault commemorate various of Lodovico's recent triumphs, such as his investiture as duke of Milan, the politically advantageous marriage of his niece Bianca, and his trip to Germany with Beatrice to cement his alliance with Maximilian. Woven into the design and running throughout the entire decoration is a continuous golden rope.

These beautiful decorations, especially the golden rope, would have been redolent of the late duchess. Beatrice made knot patterns popular on Milanese clothing in the 1490s, as exemplified in Leonardo's portrait *La Bella Principessa*. They were referred to as *fantasie dei vinci*, a reference to the *dolci vinci*—the sweet bonds of love—mentioned in Canto XIV of Dante's *Paradiso*. The golden rope twisting its way through the mulberry trees was probably an allusion to the bonds of love in which Beatrice held Lodovico.[32]

Leonardo need not have painted the Sala delle Asse by himself: large parts would have been given to his assistants. But the ingenious design was unquestionably all his own. He, like Beatrice, loved knots, and *vinci* is even Italian for knots. They had the same aesthetic appeal for Leonardo as curly hair and Platonic solids. When he inventoried his drawings and other works soon after he arrived in Milan he included on the list "many designs for knots" and "a head of a girl with her hair gathered in a knot."[33] His portrait of Cecilia Gallerani, *Lady with an Ermine*, shows the sitter wearing a gown with knots on the neckline, and the subject of *La Belle Ferronière* has knot patterns on her sleeves and in her hair. It may be that the Milanese vogue for knot patterns in clothing and hair in the 1490s owed something to Leonardo's own tastes and designs. One of his notes, alluding to his work as a dress and costume designer, describes how to make "a beautiful dress" cut from thin cloth and stenciled with "a pattern of knots."[34]

Lodovico may have had one more project in mind for Leonardo. In 1497, as we have seen, he wanted the painter to "attend to the other wall of the refectory." This reference is usually taken to mean that Leonardo was to paint the portraits of Milan's first family into Montorfano's *Crucifixion*. This commission was indeed carried out, possibly by Leonardo in 1497 or 1498. However, the portraits have survived in such a poor condition (all of the paint has flaked off) that determining the extent of Leonardo's involvement is impossible. One Leonardo scholar has put forward another intriguing theory: he suggests that Lodovico may have wished Leonardo to remove Montorfano's fresco—which paled in comparison to *The Last Supper*—and

paint an entirely new mural on the south wall of the refectory.[35] It is a scenario that, if true, makes what was to follow even more tragic.

The end for Lodovico came swiftly and mercilessly. Early in 1499 the French and the Venetians signed the Treaty of Blois, which provided for them to split the duchy between them once they ousted Lodovico from power. The Venetians immediately stationed twelve thousand soldiers on Milan's eastern frontier.

These two hostile powers invited the pope to join their anti-Sforza league. Alexander initially rebuffed their advances, urging Louis XII not to attack Milan. However, Alexander and Louis soon saw eye to eye over a pair of marriages. Louis wanted the pope to allow him to divorce his wife, Jeanne, a pious woman whose mouthwatering dowry had once persuaded him to overlook her cruel bodily deformities ("I did not believe she was so ugly!" exclaimed Jeanne's own father, King Louis XI, after seeing her for the first time when she was eleven).[36] He now wished to replace her with his niece, Charles VIII's widow, Anne of Brittany, who would give him the duchy of Brittany (and also, he hoped, an heir: his marriage to Jeanne had been childless).

The pope, meanwhile, was hoping to arrange a politically advantageous marriage for his son Cesare. The prospect of marrying Cesare to a French princess (Louis was offering a choice of two) and thereby getting him a dukedom changed his way of thinking about both the king's divorce and the contest between France and Milan. "The Pope is quite French since the Most Christian King has offered a duchy to his son," Ascanio Sforza glumly reported to his brother.[37] Ascanio protested to the pope that Cesare's voyage to France would mark the ruin of Italy; the pope reminded him that Il Moro had been the one who invited the French into Italy in the first place. Ascanio soon found it prudent to slip out of Rome and return to Milan. Lodovico, meanwhile, composed his will, stating that he wished to be entombed next to Beatrice in Santa Maria delle Grazie.

Lodovico had few friends left in Italy. Even many of his own people, burdened with heavy taxes, secretly supported a French invasion: a chronicler reported that "the greater part of the Milanese desired the coming of the King."[38] Lodovico could count on little help from Maximilian. Already

busy fighting the Swiss, the emperor had little wish to venture back onto Italian soil, the scene of his earlier disgrace. Never one to scruple about inviting dangerous enemies into Italy in order to save his skin, Lodovico turned for help to the Ottoman sultan, Bayezid II. In July, despite his depleted coffers, he was rumored to have sent two hundred thousand ducats to the "Gran Turco" for his assistance in fighting the Venetians. "The Turk will reach Venice," one diplomatic report quoted him saying, "as soon as the French do Milan."[39]

The Turks did indeed begin raiding Venetian territory in the summer of 1499, burning villages and taking thousands of prisoners; at one point they came within twenty miles of Venice's lagoon. But even the Gran Turco's intervention came too late for Lodovico. At the beginning of August a French army of some thirty thousand men, commanded by Trivulzio, mustered at Asti. On the thirteenth they attacked, taking fortress after fortress, and (in a brutal reprisal of the "terror of Mordano") massacring the garrison at Annone. On the other side of the duchy, a Venetian army crossed the eastern frontier singing, *"Ora il Moro fa la danza!"* (Now the Moor will do a dance!). Panic and disorder broke out in Milan. The homes of Sforza loyalists were attacked. Galeazzo Sanseverino's palazzo and stables were sacked, and Lodovico's treasurer was beaten to death in the street by a mob. A Milanese chronicler described the destruction of another nearby home, "recently built and not yet completed": that of Il Moro's chamberlain Mariolo de' Guiscardi.[40] Leonardo's sole architecture commission, it seems, went up in smoke even before it was completed.

The combination of mob violence and French steel were too much for Lodovico. On the second of September, ill with gout and asthma, he fled the city with Sanseverino and an armed escort, riding north for a refuge in Germany. First, however, he mounted his black charger and, donning a black cape, went to Santa Maria delle Grazie to kneel at the tomb of his wife.

A Venetian diarist was awed by the duke's sudden downfall. "Only think, reader," he wrote, "what grief and shame so great and glorious a lord, who had been held to be the wisest of monarchs and ablest of rulers, must have felt at losing so splendid a state in these few days, without a single stroke of the sword."[41]

Leonardo, like the Venetian diarist, was chastened by Lodovico's downfall. He was also angry. His observation, scrawled on the back cover of one of his notebooks, reads bitterly: "The Duke has lost the state, property and liberty, and none of his enterprises was carried out by him."[42] The judgment is a harsh one, but Leonardo's bitterness is understandable. He may have witnessed the destruction of the villa he was building for Mariolo de' Guiscardi, while an even more precious enterprise—the equestrian monument—also came to final ruin with the invasion of the French.

Leonardo seems to have spent the weeks before the fall of Il Moro in his usual way, avidly pursuing his own studies in the Corte dell'Arengo. "On the 1st of August 1499," reads one of his notes, "I wrote here of motion and of weight."[43] He also seems to have resumed or continued work on the equestrian monument, since another note from this period suggests that his experiments on how to cast the gigantic bronze statue were ongoing. Next to the drawing of the statue of a man in a casting mold (presumably Francesco Sforza) he wrote, "After you have finished it and let it dry, set it in a case."[44] Leonardo may have been planning to turn part of his new property beside Santa Maria delle Grazie into a foundry where he would cast the statue and its rider. It seems likely that at some point in 1498 or 1499 he transported the giant clay model from the Corte dell'Arengo to this vineyard, a distance, as the crow flies, of almost exactly a mile.

The model for the clay horse was probably sitting in the vineyard when, on 9 September, a week after Lodovico's flight from Milan, a vanguard of French troops entered the city through the Porta Vercellina, the gate nearest Santa Maria delle Grazie. Many years later, in 1554, a Knight Hospitaller named Sabba da Castiglione described the ensuing events. Castiglione was born in Milan about 1480 and was probably in the city to witness the invasion. More than fifty years later, he could not speak of what happened without "grief and indignation." The equestrian model was "shamefully ruined," he lamented, when Gascon crossbowmen used it for target practice.[45] Although Castiglione did not identify the location of the model at the time of the incident, the horse would have been especially vulnerable to the archers if it sat in the vineyard outside the Porta Vercellina.

Leonardo likewise had reason to fear for his work in Santa Maria delle Grazie. One reason why the equestrian monument provided such an irresistible target to the crossbowmen was that it was, of course, a symbol of the Sforza regime. Lodovico had wanted *The Last Supper*, like the bronze horse,

to celebrate the Sforza name. Its family crests and the portraits of prominent courtiers gave it unmistakable and perilous associations with the ousted duke. There was also the danger, as ever with the French, of casual despoliation. Their occupations of Florence in 1494 and Naples in 1495 had witnessed widespread looting. Five years later, the plundering resumed. From Pavia, twenty-seven portraits of members of the Visconti and Sforza families were stolen. In Milan, gems and marbles were looted from the Castello, and Trivulzio helped himself to Lodovico's tapestries. The homes of Lodovico's supporters in the quarter outside the Porta Vercellina—Leonardo's new neighbors—were occupied by the French. The invaders also took control of the Castello, which Lodovico's castellan treacherously surrendered in exchange for money. "In the Castello there is nothing but foulness and dirt, such as Signor Lodovico would not have allowed for the whole world!" complained a Venetian witness to the occupation. "The French captains spit upon the floor of the rooms, and the soldiers outrage women in the streets."[46] In the Sala delle Asse, one of the four tablets celebrating Lodovico's achievements was defaced so thoroughly it is impossible to know what it once said.

Leonardo's *Last Supper*, following the arrival in Milan of Louis XII, barely survived this depredation. The king's triumphal entrance to the city, wearing ducal robes, took place on 6 October. Accompanying Louis was Cesare Borgia, who wore a purple suit and paraded beneath an ermine-lined canopy held aloft by eight Milanese noblemen. Much pageantry ensued as a triumphal chariot showing Victory supported by Fortitude, Penance, and Renown passed beneath a triumphal arch surmounted by an equestrian statue of the French king. Coins were distributed bearing the legend "Louis, King of France and Duke of Milan."

On the following day, the new duke of Milan was taken to Santa Maria delle Grazie to gaze upon the mural ordered by his predecessor. Evidently the painting's fame had preceded it. Louis generally had scant interest in paintings unless they depicted him, preferably on horseback. He was, however, suitably impressed by Leonardo's handiwork. He even hoped to pay it the ultimate French compliment: he wanted to loot it. According to Paolo Giovio, the king "coveted it so much that he inquired anxiously from those standing around him whether it could be detached from the wall and transported forthwith to France." He desisted in this endeavor only when informed that the removal of the painting "would have destroyed the famous refectory."[47]

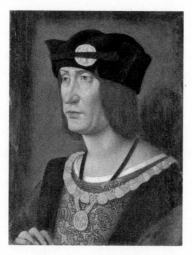

King Louis XII of France

Vasari expanded the story, claiming the king went so far as to engage architects to make cross-stays of wood and iron so the painting could be taken to France. Louis proceeded, he claimed, "without any regard for expense, so great was his desire to have it."[48] The king's failure to expropriate Leonardo's work marked a rare victory for the Milanese.

Lodovico Sforza's flight from Milan deprived Leonardo of his patron of the previous sixteen years. His harsh assessment of the duke, that "none of his enterprises was carried out," reveals his frustration at what he regarded as wasted opportunities, not least those that concerned himself. Yet if Il Moro arguably undervalued and underused his painter and engineer, primarily employing him as a theatrical impresario, interior decorator, and general handyman, he had at least offered Leonardo creative latitude and financial security. For the better part of two decades, Leonardo had been allowed to pursue his intellectually itinerant trail through aeronautics, anatomy, architecture, mathematics, and mechanics.

With Lodovico ousted, Leonardo suddenly needed to find a new patron. He was quite prepared to offer his services to the enemy, remaining in Milan despite the disorder. No document records that he was present when Louis XII visited Santa Maria delle Grazie, but presumably the king would

have wished to meet the artist whose work he so admired. Leonardo, for his part, may have wished to follow in the footsteps of the sculptor Guido Mazzoni, whose work in Naples so impressed Charles VIII in 1495 that he was invited to take up a well-paid job at the French court.

Leonardo did find at least one patron. At some point his services were secured by the powerful secretary to Louis XII, Florimond Robertet, whose Italian-style château in the Loire Valley would soon host one of the great private art collections of the sixteenth century, including a (now-lost) bronze *David* by Michelangelo. Robertet commissioned Leonardo to paint what became the *Madonna of the Yarnwinder,* a small Madonna and Child painting that showed (as a witness who saw the work later recorded) "a Madonna sitting as if she wished to wind yarns onto a distaff" while the Christ Child, feet in a basket of yarn, holds the cross-shaped object, "not willing to yield it to his mother, who appears to want to take it from him."[49]

Apart from Robertet, Leonardo made another contact in Louis XII's entourage: "Get from Gian de Paris the method of painting in tempera," reads one of his notes.[50] Gian de Paris was the court painter and royal *valet de chambre* Jean Perréal—Leonardo's opposite number, so to speak, at the French court. Leonardo probably first met him in 1494 when Perréal accompanied Charles VIII to Milan. The pair shared an interest in, among other things, astronomy. "The measurement of the sun, promised me by Maestro Giovanni, the Frenchman," reads another of Leonardo's notes.[51] In 1499, Perréal returned to Milan in the entourage of Louis XII. As *peintre du roi,* he was probably the man responsible for overseeing the decorations and festivities surrounding Louis's triumphant entrance into the city. He may also have been the one who guided the king's footsteps to Santa Maria delle Grazie.

Leonardo hoped for yet another contact among the invaders. Toward the end of 1499 he began planning his departure from Milan: a permanent move, it appears. "Sell what you cannot take with you," he wrote in a memorandum composed on a page that included an architectural drawing done a decade earlier.[52] The memo listed the possessions he planned to take: bed linen, shoes, handkerchiefs and towels, a book on perspective, another on geometry, four pairs of hose and a jerkin, even some seeds, all packed into "two covered boxes to be carried on mules." A third box would be taken by the muleteer for safekeeping to Vinci, where an uncle still lived.

In this memo, for one of the few times in his life, Leonardo wrote in code. His memo begins cryptically: "Find Ingil and tell him that you wait for him

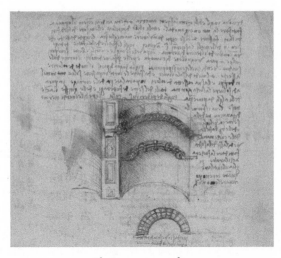

The Ligny memorandum

at Amor and will go with him to Ilopan." The code is disappointingly easy to crack, since Leonardo simply reversed the order of the letters: Amor is Roma and Ilopan is Napoli. Evidently Leonardo planned to go to Rome and from there—once he met "Ingil"—proceed to Naples. A curious aspect of Leonardo's attempted encryption is that because the memo is written in mirror script, the reversed words are actually more legible than the rest of the page, making for woefully ineffective information security.

"Ingil" was Louis de Luxembourg, among whose numerous titles was Count of Ligny. He was Louis XII's lord high chamberlain and, as the governor of Picardy and castellan of Lille, one of his top military advisers. Leonardo probably met him during the first invasion in 1494, when Ligny was made the governor of Siena. Five years on, Leonardo hoped to find employment in Ligny's service. The French still had designs on Naples, and the key to capturing the south of Italy was holding the fortresses in Tuscany and the Papal States. Leonardo's memo ends with a reminder to "learn levelling and how much soil a man can dig out in a day," which suggests that he intended to immerse himself in the construction of earthworks and other fortifications, thereby fulfilling his dream of working as a military engineer.

In the end, Leonardo did not find a patron in Ligny, who soon quit Milan and returned to France. Apart from Robertet, the French seem to have kept their distance from Leonardo, probably viewing him as an untrustworthy Sforza loyalist. One of his best friends was a Sforza die-hard, the

architect Giacomo Andrea da Ferrara, the man at whose dinner table the ten-year-old Salai had once behaved so rambunctiously. Giacomo Andrea was such a close friend of Leonardo that Pacioli, in his introduction to *On Divine Proportion*, called him Leonardo's brother. In December 1499, Giacomo Andrea went to Innsbruck to help Lodovico plot his return to power. The French response, when he returned to Milan, was to hang, draw, and quarter him.

Leonardo's enthusiasm for serving these new political masters no doubt waned as rapidly as everyone else's. At first Louis had won over Milanese hearts by cutting taxes, but French behavior soon became cruel and obnoxious. Many courtiers had already fled the city. Donato Bramante made his way to Rome, where he quickly occupied himself by measuring ancient ruins and painting the pope's coat of arms on the basilica of San Giovanni in Laterano. Luca Pacioli, too, was making preparations for his departure.

Milan had few attractions or possibilities left for Leonardo. Before the end of December he finished clearing out of the Castello dell'Arengo, packing or selling his possessions. He must have made one last trip to Santa Maria delle Grazie: his list of things to do before he left Milan included an instruction to "take the braziers from the Grazie."

Then, as the century slipped away, he took to the frozen roads with his mules and his boxes.

Epilogue: Tell Me If I Ever
Did a Thing

Over the following years, a familiar litany followed Leonardo: desultory progress, unhappy patrons, elaborate schemes that—however ingenious—finally came to nothing.

Mantua, one hundred miles to the southeast, was Leonardo's first stop after Milan. Isabella d'Este, the marchioness, sister of Beatrice, desired her portrait. Isabella was an indomitable personality: a "woman with her own opinion," according to her husband, who "always wanted to do things her own way."[1] A combination of Leonardo and Isabella did not bode well. Within weeks he departed for Venice, leaving behind a chalk sketch and vague promises to complete the portrait.

In Venice, military matters. In the early spring of 1500, Leonardo offered to the Senate his skills in engineering, proposing among other things a sluice gate on the River Isonzo that would flood the valley and drown the invading Ottomans.[2] Even grievous territorial losses to the Turks did not tempt the Venetians to accept.

Leonardo's stay in Venice must have had its poignant moments: the sight of Verrocchio's equestrian monument would have been a forceful reminder of his own lost opportunity with the bronze horse. In the early months of 1500, however, his hopes for his horse may briefly have revived. Lodovico Sforza made a victorious return to Milan in the first week of February, having reconquered large parts of the duchy with the help of Swiss and German troops. He was greeted by the Milanese people—for whom the French rule had become tyrannical and loathsome—by enthusiastic cries of "Moro! Moro!" But any plans Leonardo might have made for a return to Milan and a resumption of his old life were dashed two months later as the French army reasserted itself. Abandoned by his own army and trying to escape in the disguise of a Swiss soldier, Lodovico was captured at Novara on the tenth of April. In a scene of treachery replete with biblical resonance, he was pointed out to the enemy by one of his own Swiss mercenaries, who had taken money from the French in return for betraying him. The Judas, identified as one Hans Turmann, was promptly executed by the Swiss for his treason.[3]

Within a week of Lodovico's capture, Leonardo, for want of other opportunities, returned to Florence. He was now forty-eight years old. His father was still alive, living in the Via Ghibellina with wife number four and his eleven children, the youngest of whom, Giovanni, was a two-year-old. Leonardo took a set of rooms in the monastery of Santissima Annunziata, where his father—ever the puller of strings—seems to have arranged for him to paint an altarpiece for his clients, the Servite friars. Old habits died hard. "He kept them waiting a long time without starting anything," Vasari later recounted.[4] An explanation for this leisurely progress is accounted for by an agent sent by Isabella d'Este to check Leonardo's progress on her portrait. The agent ominously reported that Leonardo was distracted by his mathematical studies. The artist's habits, he informed Isabella, were "variable and indeterminate," and he seemed to live from one day to the next. Moreover, Leonardo "could not bear his paintbrush."[5] The friars of the Annunziata, like Isabella, would never receive a painting from Leonardo.

In 1502 came the opportunity to work as a military engineer. Leonardo entered the pay of Cesare Borgia, but the warlord's savagery left him shocked and disillusioned. War, he decided, was "the most brutal kind of madness."[6]

He then applied to the Ottoman sultan, offering to construct a bridge across the Golden Horn. But the Gran Turco showed no interest. Another engineering scheme—an ambitious plan to divert the course of the Arno by means of a canal—was given the go-ahead by the city fathers in Florence, with Niccolò Machiavelli an enthusiastic proponent. But the plan quickly and disastrously miscarried.[7]

Weary of painting Leonardo may have been, but other commissions came his way—and met with predictable fates. In 1503 he began a portrait of Lisa, the young wife of a well-to-do cloth merchant named Francesco del Giocondo. True to form, he proceeded in no great haste. "He worked on this painting for four years," Vasari reported, "and then left it still unfinished."[8] The portrait, though eventually completed, would never be delivered to Francesco del Giocondo.

No angry complaints survive from either Francesco or his wife, but another patron—the government of Florence—voiced anger and irritation at his failure to follow through on his obligations. In October 1503, around the time he began the *Mona Lisa*, Leonardo was contracted to paint a mural, *The Battle of Anghiari*, on the wall of the council hall in the Palazzo Vecchio. He began painting in June 1505, using an experimental technique, but soon abandoned the work. Early sources blame everything from defective plaster and the inferior quality of the linseed oil, to the failure of the braziers to dry the paints (which apparently trickled down the wall) and even "some kind of indignation" on Leonardo's part—a repeat, perhaps, of the "scandal" that saw him leave his scaffold in Milan a few years earlier. Whatever the cause, the project came to what Paolo Giovio called an "untimely end."[9] In 1506 he left Florence and returned to Milan, leaving the city fathers disgruntled and accusing him of impropriety: "He received a large sum of money and has only made a small beginning on the great work he was commissioned to carry out."[10] But Leonardo was deaf to their entreaties, and *The Battle of Anghiari* would never be completed.

Bridges, canals, flying machines, numerous paintings: all left to languish on the drawing board or easel. Even Leonardo's beloved mathematical and geometrical studies eventually failed him. A forlorn entry in his notebooks records the sad end of his investigations: "St. Andrew's night. I am through with squaring the circle, and this is the end of the light, and of the night, and of the paper I was working on."[11]

The candle gutters, dawn light peeps through the shutters, and Leonardo, in nightcap and spectacles, blearily casts aside his pen.

<center>⚜</center>

"Tell me if anything was ever done," Leonardo used to doodle in the pages of his notebooks. Coming in the midst of so much dereliction and neglect, *The Last Supper* was the triumphant discharge of the debt that his genius owed to history. Over the course of three years he managed—almost for the only time in his life—to harness and concentrate his relentless energies and restless obsessions. The result was 450 square feet of pigment and plaster, and a work of art utterly unlike anything ever seen before—and something unquestionably superior to the efforts of even the greatest masters of the previous century.

The Last Supper combined intensity of color with subtlety of tone, storms of movement with a delicate grace of line, symbolic beauty with vivid narrative and distinctive characterization. Above all, it possessed more lifelike details—from the expressive faces of the apostles to the plates of food and pleats of tablecloth—than anything ever created in two dimensions. An entirely new moment in the history of art had been inaugurated. "The modern era began with Leonardo," declared the painter Giovanni Battista Armenini in 1586, "the first star in that constellation of greats to have reached the full maturity of style."[12]

The Last Supper is indeed a landmark in painting. Art historians identify it as the beginning of the period they used to call the High Renaissance: the era in which artists such as Michelangelo and Raphael worked in a magnificent and intellectually sophisticated style emphasizing harmony, proportion, and movement. Leonardo had effected a quantum shift in art, a deluge that swept all before it. This radical shift can be seen in the career of one of his contemporaries. In 1489 the men in charge of the decorations of the cathedral in Orvieto confidently declared the "most famous painter in all of Italy" to be Pietro Perugino. A decade later the wealthy Sienese banker Agostino Chigi could still claim that Perugino was "the best master in Italy," that Pinturicchio was second, and that there was no third. And yet when Perugino unveiled his latest altarpiece in 1505 he was ridiculed for his lack of ability and want of originality. The world, by 1505, had witnessed the staggering creative powers of Leonardo.[13]

It is difficult to overestimate the importance of *The Last Supper* for Leonardo's own life and legacy. It was responsible, far more than any of his other works, for his reputation as a painter. During his lifetime and for many decades, even centuries, after his death, the majority of his other paintings (and only fifteen survive, four of them unfinished) were seen by neither the public nor other artists. In the three centuries between his death and the early nineteenth century, many of the works we know today were widely dispersed, unrecognized, inaccessible to the public, or completely unknown.

Leonardo's *Mona Lisa* was for all intents and purposes invisible to the public before the nineteenth century. Remaining in Leonardo's possession throughout his lifetime, it was unseen by anyone except visitors to his studio. The Anonimo Gaddiano knew of it only through hearsay—and he thought it portrayed a man. Sold by Salai after Leonardo's death, the portrait ended up in the bathroom of the king of France and then, centuries later, in Napoleon's bedroom. It would become famous only after it was removed from the domestic environs of various French potentates and, at the beginning of the nineteenth century, placed on public display in the Louvre. Santa Maria delle Grazie was therefore one of the few places where one could indisputably see a Leonardo and appreciate the true scale of his genius.

"I wish to work miracles," Leonardo once wrote. Fittingly, the word most often used to describe the work during the sixteenth century was "miraculous."[14]

"This is the river that passes through Amboise," Leonardo wrote in one of his final notes, beside a sketch of the course of the Loire.[15] He and his patron, Lodovico Sforza, were both to die in the valley of the Loire, in France, twenty miles and eleven years apart: Lodovico in a dungeon, Leonardo in a royal château.

Lodovico's capture at Novara in April 1500 was, in the words of a chronicler, "a spectacle so abject that it moved even many of his enemies to tears."[16] The duke was ultimately imprisoned in the castle of Loches, 150 miles southwest of Paris. The chronicler eulogized his reign: "Thus within a narrow prison were enclosed the thoughts and ambitions of one whose ideas earlier could scarcely be contained within the limits of Italy."[17]

Lodovico was allowed the company of a jester and the occasional book or visitor, but otherwise the man who had commissioned one of history's greatest murals spent his time with pots of paint, decorating the vault of his prison with snakes, stars, and mottoes. After almost eight years of captivity he briefly escaped by bribing his guards, who smuggled him out of the castle in a cartload of hay. But, lost in the woods around Loches, he was quickly recaptured and then kept in stricter confinement. His health finally broken, he died in May 1508, two months shy of his fifty-sixth birthday. The location of his remains is unknown, but in Milan he was fondly remembered by the friars of Santa Maria delle Grazie who tried to have his body returned to Milan for burial next to Beatrice.[18]

By the time of Lodovico's death, Leonardo was back in Milan and in the pay of Lodovico's captor and enemy, King Louis XII. The wheel came full circle for him when in December 1511, a dozen years after his first escape from Milan, he was forced to flee a second time after an invasion force of Swiss mercenaries ousted the French. More restless wanderings ensued. After several years in Rome he left Italy forever, departing in 1516 for France, where he became the court painter to a new French monarch, François I. With him went his notebooks—some twenty thousand pages of scribblings and drawings—and a clutch of paintings, including the *Mona Lisa*.

Leonardo was given the manor house of Cloux at Amboise, only twenty miles north of the grim dungeon at Loches. The handsome red-brick château had a central tower, a spiral staircase, and views of the adjoining royal palace to which it was connected by means of an underground passageway: the better for an admiring François to pay "affectionate visits," as Vasari wrote, to his celebrated painter.[19] However, Leonardo no longer painted. Instead, he continued his geometrical studies, worked on designs for the king's new palace, studied the flow of the Loire, and was involved in various court theatricals. By 1517 he had suffered a stroke, and his health declined. In April 1519, "duly considering the certainty of death and the uncertainty of its time," he composed his last will and testament, making provisions for Salai, his assistants, and servants.[20] Nine days later, on 2 May, at the age of sixty-seven, he died at his manor house and was buried, according to his instructions, in the cloister of the church of Saint-Florentin at Amboise. Sixty poor men of the parish carried candles.

Word did not reach Leonardo's family in Florence until the following month. Then, sometime in June, a letter arrived from France, from Fran-

cesco Melzi, one of Leonardo's assistants, informing them: "Each of us must mourn the loss of a man such that nature is powerless to create another."[21]

"What is fair in men passes away," Leonardo once wrote, "but not so in art."[22] Alas, what is fair in art also passes away, as *The Last Supper* proves only too well. If Leonardo's style was superlative, his technique, sadly, was not. *The Last Supper* suffers from what the most recent conservator calls—with sublime understatement—the paint's "defective adhesion" to the wall.[23] Because Leonardo did not paint in fresco, the pigments were not permanently bonded to the plaster, which meant they began flaking within a matter of a few years. Montorfano's *Crucifixion*, in its good state of preservation apart from Leonardo's portraits of the Sforza family, which are now wholly obliterated, points accusingly from across the refectory at the tragic flaw in Leonardo's approach.

Added to Leonardo's ill-starred technique was a perfect storm of adverse conditions. The refectory sits on low ground, and Leonardo painted on the damp north wall, which was exposed not only to the steam and smoke of the convent's kitchen but also the soot from candles and braziers burned in the refectory. Finally, the refectory itself was shoddily constructed (as Goethe gloomily observed) from decaying bricks and "the rubbish of old buildings."[24]

The painting began disintegrating within twenty years of its completion. A visitor to the refectory in 1517, Antonio de Beatis, recorded in his diary that the painting, though "most excellent," was beginning to deteriorate, possibly, he speculated, due to the effects of humidity.[25] So began a familiar chorus: exclamations about the painting's stupendous power shot through with regrets about its poor legibility and seemingly eminent destruction. A generation after Beatis, Armenini reported that the mural was "half ruined," and in 1582 Lomazzo found it "in a state of total ruin."[26]

Things soon got worse. If at first the painting suffered only from technical deficiencies and antagonistic climatic conditions, eventually other even more destructive forces intervened. In 1652, the true indignities began when the friars of Santa Maria delle Grazie in their wisdom decided to cut a door into the north wall, amputating Christ's feet and loosening the paint and plaster with blows from their pickaxes. Several generations later, in 1726, the

work had become so dim and illegible that the friars were gulled into hiring a painter named Michelangelo Bellotti. He shared little in common with his famous namesake: Goethe called him "a man very deficient in skill and knowledge." Bellotti erected a hoarding in front of the work and then, concealed behind it, busied himself with his "nefarious proceedings."[27]

In 1770 it was the turn of another bungler, Giuseppe Mazza. He scraped the wall with iron tools and repainted the work according to his own tastes, taking his brushes to everything but the heads of Matthew, Thaddeus, and Simon. Under the impression that the painting was a fresco, he washed the wall in caustic soda. Scandal ensued. Mazza was sacked, while the prior responsible for the heavy-handed restoration found himself banished to another convent. Over the next two centuries the painting would be slathered with various agents—waxes, varnishes, glues, shellacs, resins, alcohol, solvents—in desperate attempts to halt the deterioration. The work was also repainted numerous times. One restoration turned Bartholomew's foot into a chair leg and Thomas's hand into a loaf of bread.

In 1796, the French once more arrived as conquerors, this time under Napoleon, one of whose generals chose to use the refectory as a stable. The horses steamed and stamped, and the soldiers pelted the apostles with pieces of brick. Four years later came a flood. For fifteen days the water stood two feet deep in the refectory, with moisture penetrating the walls and covering the painting in green mold. A few years afterward, a visitor described touching the work (a practice not, apparently, discouraged) and feeling "little flakes" of paint come away in his hand: the ultimate in souvenirs.[28] In 1821, a restorer named Stefano Barezzi, under the misconception that *The Last Supper* was a fresco, tried to remove all of the paint from the wall and transfer the entire work to a giant canvas. Failing in the attempt, he was reduced to trying desperately to glue the paint back on the wall.

The mural's obvious and dramatic decline made it a poignant emblem for the transience of earthly beauty. Keats turned out to be wrong: a thing of beauty was not a joy forever; rather, it decayed, perished, and threatened to pass into nothingness. In 1847 an English writer sighed that Leonardo's painting "will never more be seen by the eye of man . . . The greater part is perished for ever."[29] This resignation perhaps explains why ten years later the refectory was used to store hay.[30]

The Last Supper ultimately became as famous for its grievously impaired and imperiled existence—its status as art's most famous and tragic endan-

gered species—as it did for its artistic glories. The novelist Henry James called it "the saddest work of art in the world," comparing it to "an industrious invalid whom people visit to see how he lasts, with leave-taking sighs and almost death-bed or tiptoe precautions."[31] In 1901 the poet Gabriele d'Annunzio composed "For the Death of a Masterpiece," recording his distress at "the marvel that is no more."[32] Efforts to revive the work in the first half of the twentieth century involved a spa-style treatment of wax injections and invigorating rubdowns with rubber rollers.

The painting's most perilous moment came on 16 August 1943, when an RAF bomb struck Santa Maria delle Grazie, blowing the roof off the refectory and destroying a nearby cloister. *The Last Supper*, protected by sandbags and mattresses, miraculously survived, but for several months it was exposed to the elements with only a tarpaulin for protection. The refectory was hastily rebuilt, after which, as the painting began vanishing beneath mildew and dirt, came another restoration, this time using a coat of shellac to bind the flaking paint to the wall and (as one report enthused) such state-of-the-art 1950s technology as "heat rays, violet rays, laboratory tests, etc."[33] But with air unable to circulate under the layer of glaze, mold soon grew between the pigments and the wall.

In 1977 the latest campaign began, taking a total of twenty-two years to complete before the unveiling in May 1999. This high-tech conservation involved a life-support system of heat and moisture monitors, along with

The ruins of the refectory at Santa Maria delle Grazie after an RAF bomb during WWII miraculously spared The Last Supper

batteries of diagnostic tests done with sonar, radar, infrared, and miniature cameras inserted into bore-holes in the wall, from which microscopic core samples were taken. The wall was stripped back to Leonardo's pigments, with layers of shellac, grime, and the pigments of previous restorers removed using solvents applied with tiny blotters of Japanese paper. Passages where Leonardo's pigments were lost the conservators filled with neutral tones in watercolor.

Some critics have argued that *The Last Supper* is now 80 percent by the restorers and 20 percent by Leonardo.[34] The mural's restoration has become a puzzle of spatiotemporal continuity to match that of the ship of Theseus, the vessel carefully preserved by the Athenians, who eventually replaced every one of its rotting timbers and thereby caused philosophical disputes about whether or not it was still the same ship. What one sees after waiting in line today and then walking over dust-absorbing carpets and through a pollutant-sucking filtration chamber before entering the refectory for fifteen minutes of fame is a far cry, admittedly, from what Leonardo originally unveiled. However, the conservators' efforts in stabilizing the painting and returning it to its original condition—as far as is humanly and technologically possible—were highly sensitive. We now know infinitely more about Leonardo's technique (particularly his use of oils) and are better able to appreciate his virtuoso abilities: the transparency of the glasses, the plates of food, the ironed pleats of the tablecloth. More important, the faces of the apostles (which the restorers based, where possible, on Leonardo's drawings) are no doubt closer to Leonardo's original intentions, especially that of Judas, who is no longer the caricature of evil beloved of earlier restorers.

The restorers were assisted in their task by the many early copies of the painting that revealed details lost or damaged in the original: Judas's money bag, the overturned saltcellar, the expressions of the apostles, the colors of the robes. Most faithful is the large-scale oil on canvas version painted in about 1520 by Giampietrino, possibly for one of Lodovico Sforza's sons. Giampietrino seems to have worked with Leonardo in the 1490s, giving him impeccable credentials as an interpreter: he might even have assisted the master in the refectory. In 1987, his twenty-five-foot-wide canvas was sent from Oxford to Milan to aid with the restoration.

Giampietrino's was only one of numerous versions. Such was the fame of *The Last Supper* that a demand grew for reproductions almost before the paint had dried. Churches, monasteries, hospitals, cardinals, princes: everyone

wanted a copy, rather in the way that everyone wanted a relic of the True Cross or the finger bone of a saint. *The Last Supper* was engraved as early as 1498 by an unknown artist, and in the decades after its completion versions were done in fresco, panel, canvas, marble, terra-cotta, tapestry, and painted wood. Copies were produced in places as widely scattered as Venice, Antwerp, and Paris. The Certosa di Pavia even had two versions, one done in oils and another in marble.

These copies were the first artifacts in an industry that today encompasses everything from postcards and giclée prints to the seven versions found by Umberto Eco on the road between Los Angeles and San Francisco, all done in wax. Today you can get a *Last Supper* tattooed across your chest, or be buried in a coffin with Leonardo's scene carved on both sides. You can see a zoomable sixteen-billion-pixel version on your home computer, an online visualization that its creators, Haltadefinizione, claim to be "the highest definition photograph ever in the world." Even greater visual pyrotechnics were unveiled in 2010, when the British filmmaker Peter Greenaway created a multimedia installation at New York's Park Avenue Armory, complete with a life-sized "clone" not only of *The Last Supper* (produced by a inkjet printer) but of the entire refectory itself. Even copies of *The Last Supper* generate copies: Andy Warhol's silk screens were inspired not so much by Leonardo's painting itself (Warhol was unable to see the mural when he began work in 1985–86 due to the ongoing conservation) as by a whole range of copies: a famous nineteenth-century engraving by Raphael Morghen, children's books, religious kitsch, and no doubt also the version that hung in the kitchen of his family home in Pittsburgh.[35]

The Last Supper is arguably the most famous painting in the world, its only serious rival Leonardo's other masterpiece, the *Mona Lisa*. But the painting's tremendous fame is detached from what we see before us in the refectory. The world's most famous painting, an Athenian philosopher could argue, no longer exists. But this ghostly evanescence has only enhanced its fame, making it available for endless interpretations and reinventions. Not only does it tell a story from the Gospels: it has become its own story, one of Leonardo's miraculous triumph followed by centuries of decline, loss and—finally, five hundred years later—a kind of resurrection. Leonardo, perhaps, was right: what is fair in art does not entirely pass away.

ACKNOWLEDGMENTS

My thanks to everyone who provided me with material assistance and/or moral support as I researched and wrote. It was a pleasure and a learning experience, as always, to work with my editor in New York, George Gibson, whose patient, tactful, and astute queries made the book much better than it would otherwise have been. My other profound debt is to Martin Kemp, Emeritus Professor of the History of Art at Oxford University, who was extremely generous with both his time and his resources. He read the manuscript, answered various questions, and gave me access to the treasures of his Leonardo collection in the History Faculty Research Hall at Oxford University.

Several other people also read the book in manuscript form and offered comments and advice. My friend Dr. Mark Asquith proved, as ever, an alert and probing reader. Another friend, Tom Smart, likewise read the manuscript and gave counsel and encouragement, as did my faithful literary agent, Christopher Sinclair-Stevenson. Dava Sobel, Keith Devlin, and my brother, Dr. Bryan King, kindly responded to my questions about areas of Leonardo's expertise that go well beyond my own. Dr. Matthew Landrus generously permitted me to use his perpective drawing of *The Last Supper*. Nathaniel Knaebel at Bloomsbury efficiently handled the transformation of manuscript into book, and I thank Paula Cooper for her excellent and attentive copyediting. Lea Beresford tracked down the images used in the book and provided other valuable logistical support. My thanks, too, to Bill Swainson and everyone at Bloomsbury in London.

My indebtedness to Leonardo scholars is, I hope, adequately reflected in my notes and bibliography. I have been the beneficiary of the researches, writings, and insights of (to name only a few of the most prominent) Kenneth Clark, Martin Kemp, Charles Nicholl, and Carlo Pedretti. As well,

one of the pleasures of researching my book was reading Leonardo's own words—and glimpsing the frenetic stirrings of his marvelously inventive, magpie mind—in the edition of the notebooks first compiled and translated in 1883 by Jean-Paul Richter. For these and other volumes I am grateful to have had access both to the London Library and to Oxford University's Sackler Library.

Finally, thank you as always to my wife, Melanie, for her love, support, and patience during my Leonardo years. This book is dedicated to her father, Bunny Harris, on the occasion of his eightieth birthday. He has long been a reliable source of conversation and good-natured moral support—to say nothing of unstinting food and drink—to both of us.

NOTES

Chapter 1

1 Francesco Guicciardini, *The History of Italy*, trans. Sidney Alexander (New York: Macmillan, 1969), 32.

2 Ibid., 49.

3 Quoted in Julia Cartwright, *Beatrice d'Este, Duchess of Milan, 1475–1497: A Study of the Renaissance* (London: J. M. Dent & Sons, 1910), 314.

4 Philip de Commines, *The Memoirs of Philip de Commines, Lord of Argenton*, vol. 2, ed. Andrew R. Scoble (London: Henry G. Bohn, 1856), 151.

5 Quoted in Cartwright, *Beatrice d'Este*, 223.

6 Commines, *Memoirs*, vol. 2, 107–8.

7 Edoardo Villata, ed., *Leonardo da Vinci: I documenti e le testimonianze contemporanee* (Milan: Castello Sforzesco, 1999), 76.

8 Evelyn Welch, "Patrons, Artists and Audiences in Renaissance Milan," in Charles M. Rosenberg, ed., *The Northern Court Cities: Milan, Parma, Piacenza, Mantua, Ferrara* (Cambridge: Cambridge University Press, 2010), 46.

9 Villata, *Documenti*, 77.

10 Giorgio Vasari, *Lives of the Artists*, vol. 1, trans. George Bull (London: Penguin, 1965), 255; Kate T. Steinitz and Ebria Feinblatt, trans. "Leonardo da Vinci by the Anonimo Gaddiano," in Ludwig Goldscheider, *Leonardo da Vinci: Life and Work, Paintings and Drawings* (London: Phaidon, 1959), 32; Lomazzo, quoted in Carlo Pedretti, *Leonardo: Studies for "The Last Supper" from the Royal Library at Windsor Castle* (Florence: Electa, 1983), 134.

11 For the horseshoe: Vasari, *Lives of the Artists*, 270; for the mountaineering: vol. 2, Jean-Paul Richter, comp. and ed., *The Literary Works of Leonardo da Vinci*, 2 vols., (London: Phaidon, 1970), §1030.

12 Martin Kemp, *Leonardo da Vinci: The Marvellous Works of Nature and Man* (Oxford: Oxford University Press, 2006), 160.

13 Richter, ed., *The Literary Works*, vol. 2, §1018.

14 Ibid., vol. 2, §1340.

15 Niccolò Machiavelli, *The Prince*, trans. George Bull (London: Penguin, 1961), 21; and Christopher Lynch, ed. and trans., *The Art of War* (Chicago: University of Chicago Press, 2003), 1, 62.

16 Laura F. Banfield and Harvey C. Manfield, trans., *Florentine Histories* (Princeton: Princeton University Press, 1990), 313.

17 Villata, ed., *Documenti*, 44.

18 Richter, ed., *The Literary Works*, vol. 2, §1363.

19 Steinitz and Feinblatt, trans., "Leonardo da Vinci by the Anonimo Gaddiano," in Goldscheider, *Leonardo da Vinci*, 30.

20 See Caroline Elam, "Art and Diplomacy in Renaissance Florence," *Journal of the Royal Society of Arts* 136 (October 1988): 813–20.

21 Villata, ed., *Documenti*, 45.

22 Richter, ed. *The Literary Works*, vol. 2, §1384.

23 Steinitz and Feinblatt, trans., "Leonardo da Vinci by the Anonimo Gaddiano," in Goldscheider, *Leonardo da Vinci*, 31.

24 Richter, ed. *The Literary Works*, vol. 2, §§1190 and 796.

25 Villata, ed., *Documenti*, 44.

26 Ibid., 45–46.

27 Ibid., 46.

28 Ibid., 57–61.

29 Richter, ed., *The Literary Works*, vol. 2, §720.

30 Villata, ed., *Documenti*, 62–63.

31 Ibid., 78–79. The first poem, by Baldassare Taccone, states that Leonardo is still working on the clay horse, so the model was not finished, much less publicly exhibited, in 1493.

32 Jean-Paul Richter, ed., *The Literary Works of Leonardo da Vinci*, with a commentary by Carlo Pedretti, 2 vols. (Oxford: Phaidon Press, 1977), vol. 1, 9. Hereafter referred to as *Commentary*.

33 Richter, ed., *The Literary Works*, vol. 2, §§710, 711.

34 Ibid., vol. 2, §714.

35 Commines, *Memoirs*, vol. 2, 125.

36 Quoted in Cartwright, *Beatrice d'Este*, 256.

37 Commines, *Memoirs*, vol. 2, 133.

38 Luca Landucci, *A Florentine Diary from 1450 to 1516*, Alice de Rosen Jarvis, trans. (London: J. M. Dent, 1927), 22.

39 Richter, ed., *The Literary Works*, vol. 2, §1340.

40 Banfield and Manfield, trans., *Florentine Histories*, 309.

41 Bartolomeo Cerretani, *Storia fiorentina*, ed. Giuliana Berti (Florence: Leo S. Olschki, 1994), 201.

42 Pietro Bembo, *History of Venice*, ed. and trans. Robert W. Ulery Jr. (Cambridge, MA: Harvard University Press, 2007), 81.

43 Guicciardini, *The History of Italy*, 54.

44 Quoted in Cartwright, *Beatrice d'Este*, 231.

45 Villata, ed., *Documenti*, 85.

46 Thomas Tuohy, *Herculean Ferrara: Ercole d'Este (1471–1505) and the Invention of a Ducal Capital* (Cambridge: Cambridge University Press, 2002), 97.

47 Richter, ed., *The Literary Works*, vol. 2, §1514.

Chapter 2

1 Stenitz and Feinblatt, trans., "Leonardo da Vinci by the Anonimo Gaddiano," in Goldscheider, 31.

2 Quoted in Janice Shell and Grazioso Sironi, "Cecilia Gallerani: Leonardo's *Lady with an Ermine*," *Artibus et historiae* 13 (1992): 48; and Carlo Pedretti, *Leonardo: Architect*, trans. Sue Brill (London: Thames and Hudson, 1986), 77.

3 For a discussion of this story, see Alexander Nagel, "Structural Indeterminacy in Early Sixteenth-Century Italian Painting," in Alexander Nagel and Lorenzo Pericolo, eds., *Subject as Aporia in Early Modern Art* (Farnham, Hants.: Ashgate, 2010), 17–23.

4 Christiane Klapische-Zuber states that life expectancy in Renaissance Italy was "between twenty and forty years." See Lydia Cochrane, trans., *Women, Family and Ritual in Renaissance Italy* (Chicago: University of Chicago Press, 1985), 57, n45.

5 Richter, comp. and ed., *The Literary Works*, vol. 2, §1346.

6 Ibid., vol. 2, §§1365, 1366. Leonardo's friend, the poet Antonio Cammelli, is quoted in Charles Nicholl, *Leonardo da Vinci: The Flights of the Mind* (London: Allen Lane, 2004), 160.

7 Paolo Giovio, "The Life of Leonardo da Vinci," in Goldscheider, *Leonardo da Vinci*, 29.

8 Villata, ed., *Documenti*, 3. For the discussion of the tradition that assigns the farmhouse in Anchiano as Leonardo's birthplace, see Nicholl, *Flights of the Mind*, 18–19.

9 Villata, ed., *Documenti*, 102 and 87; Richter, ed., *The Literary Works*, vol. 2, §722.

10 Quoted in Iris Origo, "The Domestic Enemy: The Eastern Slaves in Tuscany in the Fourteenth and Fifteenth Centuries," in *Speculum: A Journal of Medieval Studies* 30 (July 1955): 321. Origo reports (p. 325) that domestic slaves were common in the villages and towns outside Florence. For the price of slaves, see Richard A. Goldthwaite, *The Economy of Renaissance Florence* (Baltimore: Johns Hopkins University Press), 377. On the possibility that Leonardo's mother was a slave, see Francesco Cianchi, *La madre di Leonardo era una schiava? Ipotesi di studio di Renzo Cianchi* (Vinci: Museo Ideale Leonardo da Vinci, 2008).

11 See Malcolm Moore, "Leonardo Da Vinci may have been an Arab," *Telegraph*, 7 December 2007; and the report by Marta Falconi: www.msnbc.msn.com/id/15993133/ns/technology_and_science-science/t/experts-reconstruct-leonardo-fingerprint/#.TwGqXRzCcrg.

12 Serge Bramly, *Leonardo: The Artist and the Man* (London: Michael Joseph, 1992), 242.

13 Elisabetta Ulivi, *Per la genealogia di Leonardo: Matrimoni e altre vicende nella famiglia da Vinci sullo sfondo della Firenze rinascimentale* (Vinci: Museo Ideale Leonardo da Vinci, 2008).

14 Thomas M. Izbicki, trans. Gerald Christianson and Philip Krey, *Reject Aeneas, Accept Pius: Selected Letters of Aeneas Sylvius Piccolomini (Pope Pius II)* (Washington, D.C.: Catholic University of America Press, 2006), 159–60.

15 Gino Arrighi, ed., *Piero Della Francesca: Trattato d'abaco* (Pisa: Domus Galileana, 1970), 51. For schooling in Renaissance Tuscany, see Ronald Witt, "What Did Giovannino Read and Write? Literacy in Early Renaissance Florence," *I Tatti Studies: Essays in the Renaissance* 6 (1995): 83–114; and Robert Black, *Education and Society in Florentine Tuscany: Teachers, Pupils and Schools, c. 1250–1500* (Leiden: Brill, 2007).

16 *Lives of the Artists*, 255.

17 Richter, ed., *The Literary Works*, vol. 2, §§1421 and 1525.

18 Quoted in Bramly, *Leonardo*, 117. For Ser Piero as Cosimo de' Medici's notary, see James Beck, "Leonardo's Rapport with His Father," *Antichità viva* 27 (1988), 5–12. For his professional association with the Jewish community, see Alessandro Cecchi, "New Light on Leonardo's Florentine Patrons," in Carmen C. Bambach, ed., *Leonardo da Vinci: Master Draftsman*, (New York and New Haven: Metropolitan Museum of Art and Yale University Press, 2003), 123.

19 Stefano Ugo Baldassarri and Arielle Saiber eds., *Images of Quattrocentro Florence: Selected Writings in Literature, History and Art* (New Haven: Yale University Press, 2000), 40 and 73. For the purveyors of luxury goods, see David Alan Brown, *Leonardo da Vinci: Origins of a Genius* (New Haven: Yale University Press, 1998), 12.

20 Vasari, *Lives of the Artists*, 256. For Ser Piero's association with Verrocchio, see Cecchi, "New Light," 124.

21 Ugolino Verino, quoted in Brown, *Origins of a Genius*, 34.

22 Maud Cruttwell, *Verrocchio* (London: Duckworth & Co., 1904), 27.

23 Vasari, *Lives of the Artists*, 258. Leonardo's involvement in the painting of this angel is widely accepted: see Brown, *Origins of a Genius*, 142.

24 Leonardo's participation in this work, first noted by William Suida in 1954 but widely dismissed, has more recently been recognized by David Alan Brown: see *Origins of a Genius*, 51. Brown further suggests (p. 54) that Tobias's head may also be by Leonardo.

25 Steinitz and Feinblatt, trans., "Leonardo da Vinci by the Anonimo Gaddiano," in Goldscheider, 32.

26 For Leonardo's list of clothes, see Pedretti, *Commentary*, vol. 1, 332. For fifteenth-century fashions, see Michael Baxandall, *Painting and Experience in Fifteenth-Century Italy* (Oxford: Oxford University Press, 1972), 14–15, and Carole Collier Frick, *Dressing Renaissance Florence: Families, Fortunes and Fine Clothing* (Baltimore: The Johns Hopkins University Press, 2002), 3.

27 Richter, ed., *The Literary Works*, vol. 2, §1369. On Leonardo's involvement with the

landscape background of Verrocchio's *Baptism of Christ*, see Brown, *Origins of a Genius*, 140.

28 Richter, ed., *The Literary Works*, vol. 2, §987.

29 Ibid., vol. 2, §721.

30 Cruttwell, *Verrocchio*, 37.

31 Francesco Sacchetti, *Il Trecento Novelle*, ed. Antonio Lanza (Florence: Sansoni, 1984), 44.

32 Quoted in Bramly, *Leonardo*, 123. I discuss Leonardo's pessimistic view of family life in *The Fantasia of Leonardo da Vinci: His Riddles, Jests, Fables and Bestiary* (Delray Beach, FL: Levenger Press, 2010), 47.

33 Steinitz and Feinblatt, trans., "Leonardo da Vinci by the Anonimo Gaddiano," in Goldscheider, 30.

34 D. A. Covi, "Four New Documents Concerning Andrea del Verrocchio," *Art Bulletin* 48 (March 1966): 97–103.

35 Steinitz and Feinblatt, trans., "Leonardo da Vinci by the Anonimo Gaddiano, in Goldscheider, 30. For evidence of Leonardo's participation in Lorenzo's garden, see Lodovico Borgo and Ann H. Sievers, "The Medici Gardens at San Marco," *Mitteilungen des Kunsthistorischen Institutes in Florenz*, 33. Bd., H. 2/3 (1989), 237–56; and Caroline Elam, "Lorenzo de' Medici's Sculpture Garden," *Mitteilungen des Kunsthistorischen Institutes in Florenz*, 36. Bd., H. 1/2 (1992), 41–84.

36 Richter, ed., *The Literary Works*, vol. 1, §663.

37 William Roscoe, *The Life of Lorenzo de' Medici* (London: Henry G. Bohn, 1847), 236.

38 Vasari, *Lives of the Artists*, 258.

39 For Ser Piero's Benci connections, see Cecchi, "New Light," 129.

40 For the contract for the altarpiece, see Villata, ed., *Documenti*, 13–14.

41 Baldassarri and Saiber, eds., *Images of Quattrocento Florence*, 209.

42 For a discussion of the "visual ungainliness" of the Christ Child in these two paintings, see Larry J. Feinberg, "Sight Unseen: Vision and Perception in Leonardo's Madonnas," *Apollo* (July 2004): 28–34.

43 Richter, ed., *The Literary Works*, vol. 1, §500.

44 Paolo Giovio, "Life of Leonardo da Vinci," in Goldscheider, 29.

45 Richter, ed., *The Literary Works*, vol. 2, §§1448 and 1432.

46 Other pioneers were Petrarch, who climbed Mount Ventoux in 1336, and Pietro Bembo, the future cardinal, who ascended Mount Etna in 1494.

47 Richter, ed., *The Literary Works*, vol. 2, §1060. See Nicholas and Nina Shoumatoff, *The Alps: Europe's Mountain Heart* (Ann Arbor: University of Michigan Press, 2001), 192–93.

48 This account, by Count A. G. Rezzonico, was published in 1780, and is quoted in Pedretti, *Commentary*, vol. 1, 175. Pedretti notes that the story is "puzzling" but also that Count Rezzonico may have had access to documents that no longer exist.

49 For these early designs, see Kemp, *Marvellous Works*, 58–66. For the springald, see Domenico Laurenza, *Leonardo's Machines: Secrets and Inventions in the Da Vinci Codices* (Florence-Milan: Giunti, 2005), 75–79. Laurenza dates the design to c. 1482.

50 Richter, ed., *The Literary Works*, vol. 2, §1154.

51 Claire Farago, "Aesthetics before Art: Leonardo Through the Looking Glass," in Claire Farago and Robert Zwijnenberg, eds., *Compelling Visuality: The Work of Art In and Out of History* (Minneapolis: University of Minnesota Press, 2003), 56.

52 For the contract, see Villata, ed., *Documenti*, 19–28. Hannelore Glasser discusses both the contract and the legal fallout at length in *Artists' Contracts of the Early Renaissance* (New York: Garland, 1977), 208–70.

53 Villata, ed., *Documenti*, 35.

54 Glasser, *Artists' Contracts*, 345. The authority to whom the painters appealed was addressed as "Most Illustrious and Most Excellent Lord," which almost certainly makes him Lodovico Sforza. However, the identity of the prospective buyer cannot be settled so easily.

55 Quoted in Baxandall, *Painting and Experience*, 6.

56 Ann Pizzorusso, "The Authenticity of *The Virgin of the Rocks*," *Leonardo*, 29 (1996): 197.

57 For an identification of the plants in the paintings, see Brian Morley, "The Plant Illustrations of Leonardo da Vinci," *The Burlington Magazine* 121 (September 1979): 559.

58 It is often assumed that Lodovico Sforza purchased the painting and presented it as a wedding gift to Maximilian. The hypothesis is feasible but unsupported by any documents except the Anonimo Gaddiano's assertion that Lodovico sent to Maximilian a "most beautiful and unusual work" painted by Leonardo. Steinitz and Feinblatt, trans., "Leonardo da Vinci by the Anonimo Gaddiano," in Goldscheider, 31.

59 *The Prince*, 54.

60 Richter, ed., *The Literary Works*, vol. 2, §§1356, 1357 and §1179; and Pedretti, *Commentary*, vol. 1, 309.

Chapter 3

1 Elizabeth McGrath, "Lodovico il Moro and his Moors," *Journal of the Warburg and Courtauld Institutes* 65 (2002): 85.

2 Cartwright, *Beatrice d'Este*, 246.

3 *The Memoirs of Philip de Commines*, 153.

4 Guicciardini, *The History of Italy*, 58.

5 Quoted in Jane Black, *Absolutism in Renaissance Milan: Plenitude of Power under the Visconti and the Sforza, 1329–1535* (Oxford: Oxford University Press, 2009), 70.

6 For Bianca Maria's table manners, see Cartwright, *Beatrice d'Este*, 219.

7 Commines, *Memoirs*, 137.

8 Quoted in Welch, "Patrons, Artists and Audiences in Renaissance Milan," 46.

9 Carlo Pedretti, "The Sforza Sepulchre," *Gazette des Beaux-Arts* 89 (1977): 121–31; and

S. Lang, "Leonardo's Architectural Designs and the Sforza Mausoleum," *Journal of the Warburg and Courtauld Institutes* 31 (1968): 218–33.

10 On this relationship, see Carlo Pedretti, "Newly Discovered Evidence of Leonardo's Association with Bramante," *Journal of the Society of Architectural Historians* 32 (October 1973): 223–227. For Leonardo and the German masons, see Lang, "Leonardo's Architectural Designs," 221. For his note on the book on Milan and its churches, see Richter, ed., *The Literary Works*, vol. 2, §1448.

11 Quoted in Henry Hart Milman, *History of Latin Christianity*, vol. 4 (London: John Murray, 1855), 251.

12 *Monumenta ordinis fratrum praedicatorum historica*, vol. 15 (Rome: Institutum Historicum Fratrum Praedicatorum, 1933), 90–91.

13 Michael M. Tavuzzi, *Dominican Inquisitors and Inquisitorial Districts in Northern Italy, 1474–1527* (Leiden: Brill, 2007), 255.

14 Jacobus de Voragine, *The Golden Legend: Readings on the Saints*, vol. 2, ed. William Granger Ryan (Princeton: Princeton University Press, 1993), 44–45.

15 St. Thomas Aquinas, *Summa theologiae*, vol. 1, ed. Thomas Gilby (Cambridge and London: Blackfriars, in conjunction with Eyre & Spottiswoode, 1964), 3.

16 Voragine, *The Golden Legend*, vol. 2, 44.

17 Aquinas, *Summa theologiae*, vol. 43 (1968), 115.

18 Richter, ed., *The Literary Works*, vol. 2, §1340.

19 Quoted in Baxandall, *Painting and Experience*, 26.

20 Louisa S. Maclehose, trans., and G. Baldwin Brown, ed., *Vasari on Technique* (New York: Dover, 1960), 222.

21 Richter, ed., *The Literary Works*, vol. 2, §1344. Carlo Pedretti dates this letter (found in the *Codex Atlanticus*, folio 315v) to approximately 1495. See Pedretti, *Commentary*, vol. 1, 296.

22 Guicciardini, *The History of Italy*, 66.

23 Quoted in Kenneth M. Setton, *The Papacy and the Levant, 1204–1571*, vol. 3 (Philadelphia: American Philosophical Society, 1984), 456.

24 Quoted in Setton, *The Papacy and the Levant*, vol. 3, 477.

25 Commines, *Memoirs*, 149.

26 Quoted in Ludwig Pastor, *The History of the Popes from the Close of the Middle Ages*, vol. 5, ed. F. I. Antrobus (London: Kegan Paul, Trench & Trübner, 1898), 454.

Chapter 4

1 Leonardo's record of his purchase is found in the *Codex Atlanticus*, folio 104 r-a. For a discussion, see Carlo Pedretti, *Leonardo: Studies for the Last Supper from the Royal Library at Windsor Castle* (Florence: Electa, 1983), 137. Leonardo's list of books is found in the *Codex Atlanticus*, folio 210r.

2 The Gospel accounts of the Last Supper are found in Matthew 26:1–29; Mark 14:1–25; Luke 22:1–30; and John 13:1–30.

3 Eusebius of Caesarea, *History of the Church*, in Philip Schaff and Henry Wace, eds., *Nicene and Post-Nicene Fathers*, vol. 1 (Grand Rapids: Wm. B. Erdmans, 1982), 153.

4 Quoted in R. Alan Culpeper, *John, the Son of Zebedee: The Life of a Legend* (Edinburgh: T&T Clark, 2000), 167.

5 Georgina Rosalie Galbraith, *The Constitution of the Dominican Order* (Manchester: Manchester University Press, 1925), 118.

6 Patrick Barry, trans., "The Rule of Saint Benedict," in *Wisdom from the Monastery: The Rule of Saint Benedict for Everyday Life* (Norwich: Canterbury Press, 2005), 59.

7 Giovanni Battista Giraldi, quoted in Martin Clayton, *Leonardo da Vinci: The Divine and the Grotesque* (London: Royal Collection, 2002), 130.

8 Richter, ed., *The Literary Works*, vol. 1, §571.

9 Leonardo da Vinci, *Treatise on Painting*, vol. 1, ed. A. Philip McMahon (Princeton: Princeton University Press, 1956), 55.

10 Quoted in Richard C. Trexler, *Public Life in Renaissance Florence* (Ithaca: Cornell Paperbacks, 1991), 461.

11 Quoted in Trevor Dean, *The Towns of Italy in the Later Middle Ages* (Manchester: Manchester University Press, 2000), 123.

12 For the benches and bench sitters in Renaissance Florence I am indebted to Yvonne Elet, "Seats of Power: The Outdoor Benches of Early Modern Florence," *Journal of the Society of Architectural Historians* 61 (December 2002): 444–69.

13 Quoted in Elet, "Seats of Power," 451. The anecdote of Leonardo and the bench sitters at the Palazzo Spini is found in "Leonardo da Vinci by the Anonimo Gaddiano," in Goldscheider, 32.

14 Richter, ed., *The Literary Works*, vol. 1, §594.

15 Pedretti has suggested that this sketch is Leonardo's "earliest idea for a Last Supper." See *Leonardo: Studies for "The Last Supper" from the Royal Library at Windsor Castle*, 32.

16 Richter, ed., *The Literary Works*, vol. 1, §§601, 602.

17 Ibid., vol. 1, §608.

18 Ibid., vol. 1, §§665, 666.

19 McMahon, ed., *Treatise on Painting*, vol. 1, §248.

Chapter 5

1 Richter, ed., *The Literary Works*, vol. 1, §509.

2 Quoted in Cecilia M. Ady, *A History of Milan Under the Sforza* (London: Methuen, 1907), 259.

3 Quoted in Paolo Galluzzi, ed., *Leonardo da Vinci: Engineer and Architect* (Montreal: Musée des Beaux-Arts, 1987), 6.

4 Quoted in Cartwright, *Beatrice d'Este*, 119.

5 McMahon, ed., *Treatise on Painting*, vol. 1, 37.

6 Vasari, *Lives of the Artists*, 267.

7 Richter, ed., *The Literary Works*, vol. 1, §494.

8 Ibid., vol. 2, §1344.

9 Ibid., vol. 2, §1460.

10 On Masini, see Scipione Ammirato, *Opuscoli*, vol. 2 (Florence, 1637), 242; Pedretti, *Commentary*, vol. 2, 377 and 383; and Nicholl, 141–45. For Leonardo's opposition to alchemists and necromancers: Richter, ed., *The Literary Works*, vol. 2, §§1207, 1208 and 1213.

11 Richter, ed., *The Literary Works*, vol. 2, §1459.

12 Ibid., vol. 2, §1461.

13 See Gene A. Brucker, *The Society of Renaissance Florence: A Documentary Study* (Toronto: University of Toronto Press, 1998), 2.

14 Richter, ed., *The Literary Works*, vol. 2, §1547.

15 Ibid., vol. 2, §1384.

16 Ibid., vol. 2, §1517.

17 Ibid., vol. 2, §1522.

18 Quoted in Stephen D. Bowd, *Venice's Most Loyal City: Civic Identity in Renaissance Brescia* (Cambridge, MA: Harvard University Press, 2010), 135.

19 Quoted in Sharon T. Strocchia, "Death Rites and the Ritual Family in Renaissance Florence," in *Life and Death in Fifteenth-Century Florence*, ed. Marcel Tetel, Ronald G. Witt, and Rona Goffen (Durham: Duke University Press, 1989), 121.

20 Richter, ed., *The Literary Works*, vol. 1, §494.

21 Richard A. Goldthwaite, *The Economy of Renaissance Florence* (Baltimore: Johns Hopkins University Press, 2009), 373.

22 Richter, ed., *The Literary Works*, vol. 2, §1458.

23 Ibid., vol. 2, §1458.

24 Ibid., vol. 2, §1458.

25 Pedretti notes that these sentences are not in Leonardo's handwriting. See *Commentary*, vol. 1, 342.

26 Goldthwaite, *The Economy of Renaissance Florence*, 371.

27 Richter, ed., *The Literary Works*, vol. 2, §1458.

28 Ibid., vol. 2, §§1516 and 1534.

29 Ibid., vol. 2, §1525.

30 Vasari, *Lives of the Artists*, 265.

31 See Pedretti, *Commentary*, vol. 1, 217.

32 Quoted in Carlo Pedretti, *Leonardo: A Study in Chronology and Style* (Berkeley and Los Angeles: University of California Press, 1973), 141.

33 Brucker, *The Society of Renaissance Florence*, 190.

34 Quoted in John M. Najemy, *A History of Florence, 1200–1575* (Oxford: Blackwell, 2006), 247.

35 Villata, ed., *Documenti*, 7–8.

36 Peter and Linda Murray, *The Art of the Renaissance* (London: Thames & Hudson, 1963), 230.

37 Sigmund Freud, "Leonardo da Vinci and a Memory of His Childhood," in *The Standard Edition of the Complete Psychological Works*, vol. 11 (London: Hogarth Press, 1968), 71.

38 Richter, ed., *The Literary Works*, vol. 2, §1383.

39 Quoted in Richard C. Trexler, *Public Life in Renaissance Florence* (Ithaca: Cornell Paperbacks, 1991), 389.

40 The letter is reproduced in Villata, ed., *Documenti*, 11–12. For a good discussion of Paolo, see Nicholl, *Leonardo da Vinci*, 131–32.

41 Vasari, *Lives of the Artists*, 256.

42 Richter, ed., *The Literary Works*, vol. 1, §680.

43 Giraldi, quoted in Clayton, *Leonardo da Vinci: The Divine and the Grotesque*, 130.

44 Cennino Cennini, *The Book of the Art of Cennino Cennini*, trans. Christiana J. Herringham (London: George Allen & Unwin, 1899), 9 and 11.

45 Richter, ed., *The Literary Works*, vol. 1, §§614, 616 and 617.

46 For the rarity of this technique, see A. E. Popham, *The Drawings of Leonardo da Vinci* (London: Jonathan Cape, 1946), 7.

47 Richter, ed., *The Literary Works*, vol. 1, §368.

48 See Paola Tinagli, *Women in Italian Renaissance Art: Gender, Representation, Identity* (Manchester: Manchester University Press, 1997), 48–49.

49 Pedretti, *Commentary*, vol. 2, 380.

50 For a discussion of this sheet, see Martin Kemp, *Leonardo da Vinci: Experience, Experiment and Design* (London: V&A Publications, 2006), 3–6.

51 Pietro C. Marani, "Leonardo's *Last Supper*," in *Leonardo: "The Last Supper,"* trans. Harlow Tighe (Chicago: University of Chicago Press, 2001), 8.

52 Cennini, *The Book of the Art of Cennino Cennini*, 29.

53 Quoted in Carmen C. Bambach, "Leonardo, Left-handed Draftsman and Writer," in *Leonardo da Vinci: Master Draftsman*, ed. Carmen C. Bambach (New York and New Haven: Metropolitan Museum of Art and Yale University Press, 2003), 32.

54 Richter, ed., *The Literary Works*, vol. 1, §110; Popham, *The Drawings of Leonardo da Vinci*, 10. The only evidence for Leonardo having a maimed right hand is the statement of Antonio de Beatis, the secretary of Cardinal Luigi of Aragon, made after a visit to Leonardo in France in October 1517, that "a certain paralysis has crippled his right hand." Noting this evidence, Popham does go on to state that there is no reason why Leonardo's left-handedness should not have been natural.

55 See Bambach, "Leonardo, Left-handed Draftsman and Writer," 51.

56 Marjorie O'Rourke Boyle, *Senses of Touch: Human Dignity and Deformity from Michelangelo to Calvin* (Leiden: Brill, 1998), 212.

57 Riccardo Gatteschi, ed., *Vita da Raffaello da Montelupo* (Florence: Polistampa, 1998), 120–21. It is Raffaello who writes that Michelangelo was originally left-handed, the only known source for this claim.

Chapter 6

1 *The Memoirs of Philip de Commines*, 153.

2 Quoted in Cartwright, *Beatrice d'Este*, 257.

3 Setton, *The Papacy and the Levant*, vol. 3, 474.

4 Quoted in Cartwright, *Beatrice d'Este*, 255.

5 Commines, *Memoirs*, 155.

6 Quoted in Cartwright, *Beatrice d'Este*, 266.

7 Guicciardini, *The History of Italy*, 86.

8 Ibid., 88.

9 Ibid., 108.

10 Quoted in Samuel Lane, "A Course of Lectures on Syphilis," *Lancet*, 13 November 1841, 220.

11 Quoted in Katherine Crawford, *European Sexualities, 1400–1800* (Cambridge: Cambridge University Press, 2007), 130.

12 Montorfano's fresco is signed and dated 1495. For the argument that the two paintings were begun at the same time, see Creighton Gilbert, "Last Suppers and their Refectories," in Charles Trinkaus and Heiko A. Oberman, eds., *The Pursuit of Holiness in Late Medieval and Renaissance Religion* (Leiden: Brill, 1974), 380.

13 Jacob Burckhardt, *Italian Renaissance Painting According to Genres* (Los Angeles: Getty Publications, 2005), 120.

14 Quoted in Creighton, "Last Suppers and their Refectories," 382.

15 Vasari, *Lives of the Most Eminent Painters, Sculptors and Architects*, vol. 3, trans. Gaston du C. de Vere (London: Philip Lee Warner, 1912–14), 188–89.

16 Evelyn Samuels Welch, "New Documents for Vincenzo Foppa," *The Burlington Magazine*, vol. 27 (May 1985): 296.

17 Commines, *Memoirs*, 174.

18 Ibid., 179.

19 Ibid., 183.

20 Quoted in Cartwright, *Beatrice d'Este*, 268.

21 Quoted in Setton, *The Papacy and the Levant*, vol. 3, 490.

22 Quoted in Pastor, *History of the Popes*, vol. 5, 472.

23 Quoted in Cartwright, *Beatrice d'Este*, 270.

24 Giovio, "The Life of Leonardo da Vinci," in Goldscheider, *Leonardo da Vinci*, 29.

25 Ibid., 29.

26 For this performance, see Kemp, *The Marvellous Works*, 153.

27 Cartwright, *Beatrice d'Este*, 142.

28 Quoted in Kemp, *Marvellous Works*, 154.

29 Vasari, *Lives of the Artists*, 259.

30 Bernard Berenson, *Italian Painters of the Renaissance*, vol. 2 (London: Phaidon, 1968), 32.

31 Richter, ed., *The Literary Works*, vol. 2, §1339.

32 For the full text, see Pedretti, *Commentary*, vol. 1, 307–8.

33 Joseph Conrad, *Heart of Darkness*, ed. Robert Hampson (London: Penguin, 1995), 20.

34 McGrath, "Lodovico il Moro and his Moors," 71.

35 Quoted in Kemp, *Marvellous Works*, 150.

36 See Larry J. Feinberg, "Visual Puns and Variable Perception: Leonardo's *Madonna of the Yarnwinder*," *Apollo* (August 2004): 38. For examples of Leonardo's rebuses, see Pedretti, *Commentary*, vol. 1, 388–94.

37 Commines, *Memoirs*, 228.

38 Ibid., 193.

39 Ibid.

40 Quoted in Cartwright, *Beatrice d'Este*, 271.

41 Commines, *Memoirs*, 198.

42 Quoted in Cartwright, *Beatrice d'Este*, 272–73.

43 Commines, *Memoirs*, 201.

44 Quoted in Cartwright, *Beatrice d'Este*, 284.

45 Commines, *Memoirs*, 214.

46 Ibid., 216.

47 Guicciardini, *The History of Italy*, 105.

Chapter 7

1 Palomino, quoted in Mary Philadelphia Merrifield, *The Art of Fresco Painting as Practised by the Old Italian and Spanish Masters* (London: Charles Gilpin, 1846), 70.

2 E. H. Ramsden, ed., *The Letters of Michelangelo*, vol. 1 (Stanford: Stanford University Press, 1963), §208. Barna's fate is recorded in Giorgio Vasari, *Lives of the Most Eminent Painters, Sculptors and Architects*, 10 vols., vol. 2, trans. Gaston du C. de Vere (London: Philip Lee Warner, 1912–15), 5.

3 Giorgio Vasari, *Lives of the Artists*, 268.

4 Quoted in Merrifield, *The Art of Fresco Painting*, 53.

5 Pedretti, *Commentary*, vol. 1, 21.

6 Pinin Brambilla Barcilon, "The Restoration," in *Leonardo: "The Last Supper*," trans. Harlow Tighe (Chicago: University of Chicago Press, 2001), 409.

7 Quoted in Merrifield, *The Art of Fresco Painting*, 53.

8 Quoted in ibid., 71.

9 Quoted in ibid., 55.

10 Quoted in ibid., 113.

11 On these fingerprints, see David Bull, "Two Portraits by Leonardo: *Ginevra de' Benci* and the *Lady with an Ermine*," *Artibus et Historiae* 13 (1992): 70 and 81.

12 Richter, ed., *The Literary Works*, vol. 1, §634.

13 See Charles Lock Eastlake, *Materials for a History of Oil Painting* (London: Longman, Brown, Green, and Longmans, 1847), 185. The account of Hubert's relics is found on pp. 191–92. For Vasari on the invention of oil painting, see Maclehose, ed., *Vasari on Technique*, 226.

14 Christopher Kleinhenz, ed., *Medieval Italy: An Encyclopedia*, vol. 2 (New York: Routledge, 2004), 834.

15 Eastlake, *Materials*, 46.

16 Quoted in Eastlake, *Materials*, 213.

17 Vasari, *Lives of the Most Eminent Painters, Sculptors and Architects*, trans. Gaston du C. de Vere, vol. 3, 104.

18 See Joseph Archer Crowe and Giovanni Battista Cavalcaselle, *The Early Flemish Painters: Notices of their Lives and Works* (London: John Murray, 1857), 211–12.

19 Leon Battista Alberti, *On the Art of Building in Ten Books*, trans. Joseph Rykwert, Neil Leach, and Robert Tavernor (Cambridge, MA: MIT Press, 1991), 177.

20 See Ladislao Reti, "Two Unpublished Manuscripts of Leonardo da Vinci in the Biblioteca Nacional of Madrid, Part II," *The Burlington Magazine* 110 (February 1968), 81.

21 Vasari is the main source for information on these works. While Vasari is not always reliable, John R. Spencer has written that he was obviously familiar enough with Castagno's paintings in Santa Maria Nuova to describe them in some detail. See Spencer, *Andrea del Castagno and His Patrons* (Durham, NC: Duke University Press, 1991), 81–84. Furthermore, the ledger for Santa Maria Nuova records payments made to Veneziano for linseed oil. See Hellmut Wohl, "Domenico Veneziano Studies: The Sant' Egidio and Parenti Documents," *The Burlington Magazine* 113 (November 1971): 636. Wohl is skeptical, however, about whether these payments verify Vasari's story.

22 Howard Saalman, "Paolo Uccello at San Miniato," *The Burlington Magazine* 106 (December 1964): doc. 7, 563.

23 Barcilon, "The Restoration," 416. Carlo Vecce describes this technique of mixing tempera and oil as "revolutionary": see Vecce, *Leonardo* (Rome: Salerno Editrice, 1998), 154.

24 Barcilon, "The Restoration," 411.

25 Mauro Matteini and Arcangelo Moles, "A Preliminary Investigation of the Unusual Technique of Leonardo's Mural *The Last Supper*," *Studies in Conservation* 24, no. 3 (August 1979): 125–33. See also Barcilon, "The Restoration," 336 and 412.

26 Morris Hicky Morgan, trans., *Ten Books on Architecture* (Cambridge, MA: Harvard University Press, 1914), 246.

27 See John F. Moffitt, "Painters 'Born Under Saturn': The Physiological Explanation," *Art History* 11 (1988): 195–216; and Piers Britton, "'Mio malinchonico, o vero . . . mio pazzo': Michelangelo, Vasari, and the Problem of Artists' Melancholy in Sixteenth-Century Italy," *Sixteenth Century Journal* 34 (Fall 2003): 653–75.

28 Ibid., 13.

29 Barcilon, "The Restoration," 412.

30 Ibid., 416.

31 Ibid., 416.

32 Quoted in Merrifield, *The Art of Fresco Painting*, 49.

33 Richter, ed., *The Literary Works*, vol. 1, §264.

34 Ibid., vol. 1, §280.

35 Chevreul's 1839 work, *De la loi du contraste simultané des couleurs*, was expanded by Charles Blanc in 1867. The theories were then popularized by the American physicist Ogden Rood, whose 1879 treatise *Modern Chromatics* was translated into French in 1881. Neither Chevreul nor his followers appear to have been aware of Leonardo's writings.

36 Richter, ed., *The Literary Works*, vol. 1, §265.

37 Hamlin Garland, "Impressionism," in Charles Harrison, Paul Wood, and Jason Gaiger, eds., *Art in Theory, 1815–1900: An Anthology of Changing Ideas* (Oxford: Blackwell, 1998), 930.

38 Richter, ed., *The Literary Works*, vol. 1, §626.

39 Ibid., vol. 2, §1540.

40 John Gage, *Color and Culture: Practice and Meaning from Antiquity to Abstraction* (Berkeley and Los Angeles: University of California Press, 1999), 131.

41 Richter, ed., *The Literary Works*, vol. 1, §§621, 622, 626, and 627. For Leonardo's purchases from San Giusto alle Mura, see Villata, ed., *Documenti*, 14.

42 Quoted in Marani, "Leonardo's *Last Supper*," 61, n 1.

43 Ascanio Condivi, *The Life of Michelangelo*, 2nd ed., trans. Alice Sedgwick Wohl, ed. Hellmut Wohl (University Park: Pennsylvania State University Press, 1999), 58. For Michelangelo's assistants, see William E. Wallace, "Michelangelo's Assistants in the Sistine Chapel," *Gazette des Beaux-Arts* 11 (December 1987): 203–16.

44 Quoted in Michael Baxandall, *Painting and Experience in Fifteenth-Century Italy* (Oxford: Oxford University Press, 1972), 23.

45 Richter, ed., *The Literary Works*, vol. 2, §§1466 and 1467.

46 Luke Syson et al., *Leonardo da Vinci: Painter at the Court of Milan* (London: National Gallery, 2011), 278.

Chapter 8

1 Commines, *Memoirs*, 227.

2 Quoted in Cartwright, *Beatrice d'Este*, 219.

3 David Nicolle, *Fornovo 1495: France's Bloody Fighting Retreat* (Oxford: Osprey, 1996), 80.

4 Commines, *Memoirs*, 234.

5 Ibid., 242.

6 Ibid., 244.

7 Cartwright, *Beatrice d'Este*, 279.

8 Quoted in Pedretti, *Commentary*, vol. 1, 55–56.

9 See Pedretti, *Commentary*, vol. 1, 174. On Leonardo's textile machines, see Kenneth G. Ponting, ed., *Leonardo da Vinci: Drawings of Textile Machines* (Bradford-on-Avon: Moonraker Press and Pasold Research Fund Ltd., 1979).

10 Vasari tells the story of this commission in his life of Cronaca, not in his life of Leonardo: see "Life of Simone, called Il Cronaca," in Giorgio Vasari, *Lives of the Most Eminent Painters, Sculptors and Architects*, 10 vols., vol. 4, trans. Gaston du C. de Vere (London: Philip Lee Warner, 1912–15), 270. Vecce suggests that Leonardo may have been called by Savonarola as a consultant: see *Leonardo*, 152.

11 Quoted in Vecce, *Leonardo*, 208.

12 Quoted in Lauro Martines, *Scourge and Fire: Savonarola and Renaissance Florence* (London: Jonathan Cape, 2006), 126.

13 Luca Landucci, *A Florentine Diary from 1450 to 1516*, trans. Alice de Rosen Jarvis (London: J. H. Dent, 1927). 89.

14 Quoted in Pastor, *History of the Popes*, vol. 5, 481.

15 Anne Borelli and Maria C. Pastore Passaro, eds., *Selected Writings of Girolamo Savonarola: Religion and Politics, 1490–1498* (New Haven: Yale University Press, 2006), 220.

16 Landucci, *A Florentine Diary*, 101. See also John M. Najemy, *A History of Florence, 1200–1575* (Oxford: Blackwell, 2006), 395–96. For Savonarola's attack on classical learning, see Vincent Cronin, *The Florentine Renaissance* (London: Collins, 1967), 272–73.

17 Commines, *Memoirs*, 234.

18 Ibid., 248 and 251.

19 Ibid., 254.

Chapter 9

1 Richter, ed., *The Literary Works*, vol. 1, §572.

2 Quoted in Clayton, *Leonardo da Vinci: The Divine and the Grotesque*, 130.

3 Giorgio Vasari, *Lives of the Artists*, 261.

4 Richter, ed., *The Literary Works*, vol. 1, §503.

5 Quoted in Clayton, *Leonardo da Vinci*, 13.

6 Ibid., 138.

7 Richter, ed., *The Literary Works*, vol. 2, §§1387 and 1404.

8 M. T. Fiorio, ed., *Le Chiese di Milano* (Milan: Electa, 1985), 308–9.

9 Richter, ed., *The Literary Works*, vol. 2, §1403.

10 One member of the family, Niccolò de' Carissimi da Parma, possibly Alessandro's father, had served as Francesco Sforza's envoy to Florence in the time of Cosimo de' Medici. See Rab Hatfield, "Some Unknown Descriptions of the Medici Palace in 1459," *Art Bulletin* 52 (September 1970): 232.

11 Richter, ed., *The Literary Works*, vol. 1, §667.

12 Carlo Vecce, *Leonardo*, 156.

13 Pastor, *A History of the Popes*, vol. 5, 285.

14 See Vecce, *Leonardo*, 156.

15 Antonio de Beatis, quoted in Pedretti, *Studies for "The Last Supper,"* 145. Beatis and Cardinal Luigi of Aragon visited Leonardo in Amboise before seeing *The Last Supper* in Milan in 1517.

16 Richter, ed., *The Literary Works*, vol. 2, §§ 716 and 717.

17 Quoted in Arnaldo Bruschi, *Bramante* (London: Thames and Hudson, 1977), 177.

18 Richter, ed., *The Literary Works*, vol. 2, §1427. Bramante's book is *Antiquarie prospettiche Romane*, a collection of four hundred verses on the antiquities of Rome composed about 1500. The author is identified only as "prospectiuo Melanese depictore" (Milanese perspective painter) but is widely regarded as having been Bramante, who often recited his poetry at the Sforza court. For an argument in favor of his authorship, see Carlo Pedretti, *Leonardo: Architect*, trans. Sue Brill (London: Thames and Hudson, 1986), 116.

19 Richter, ed., *The Literary Works*, vol. 2, §1427.

20 Charles Robertson, "Bramante, Michelangelo and the Sistine Ceiling," *Journal of the Warburg and Courtauld Institutes* 49 (1986): 105.

21 This proverb forms the basis for an insult by Michelangelo, who, shown a painting of a bull by an artist whom he disliked, replied, "Every painter paints himself well."

22 McMahon, ed., *Treatise on Painting*, vol. 1, 86.

23 For good discussions of automimesis, see Frank Zöllner, *Leonardo da Vinci, 1452–1519: The Complete Paintings and Drawings* (Cologne, London, Los Angeles, Madrid, Paris, Toronto: Taschen, 2003), 134–55; and Philip Lindsay Sohm, *The Artist Grows Old: The Aging of Art and Artists in Italy, 1500–1800* (New Haven: Yale University Press, 2007), 41–43.

24 Richter, ed., *The Literary Works*, vol. 1, §587.

25 Quoted in Zöllner, *Leonardo da Vinci*, 134. Zöllner writes that there can be "no doubt that Visconti's rhetoric is aimed directly at Leonardo." See also the discussion (and translation) in Martin Kemp, "Science and the Poetic Impulse," in Michael W. Cole, ed., *Sixteenth-Century Italian Art* (Oxford: Blackwell, 2006), 97–98. Kemp likewise argues that Leonardo is the butt of this "humorously critical poem" (p. 95).

26 See Pedretti, *Commentary*, vol. 1, 377.

27 Bramly, *Leonardo*, 24.

28 This latter self-portrait was first presented by the scientific journalist Piero Angela on the Italian television program *Ulysses*, broadcast on 28 February 2009. It has since found acceptance from scholars such as Carlo Pedretti.

29 For the dating, see Clayton, *Leonardo da Vinci*, 112.

30 Edward MacCurdy, *Leonardo da Vinci* (London: George Bell, 1908), 35.

31 Leonardo's drawing and descriptions of the play are found on a sheet of paper in the Metropolitan Museum of Art in New York, *Allegorical Design (recto), Stage Design (verso)* (17.142.2). For a description of Taccone's play, see Martin Kemp, *Leonardo da Vinci: The Marvellous Works of Nature and Man*, rev. ed. (Oxford: Oxford University Press, 2006), 154.

32 See Pedretti, *Leonardo: Architect*, 28–29. Pedretti dates Leonardo's submarine designs to 1483–85.

33 Domenica Laurenza, *Leonardo's Machines: Secrets and Inventions in the Da Vinci Codices* (Florence-Milan: Giunti, 2005), 31.

34 Laurenza, *Leonardo's Machines*, 34.

35 For a discussion, see Kemp, *Marvellous Works*, 105.

36 Richter, ed., *The Literary Works*, vol. 2, §1123.

37 See the discussion in Laurenza, *Leonardo's Machines*, 46–53.

38 See Laurenza, *Leonardo's Machines*, 54–61.

39 The pair of wings appears in *Codex Atlanticus*, folio 844r; see Laurenza, *Leonardo's Machines*, 62–69. Leonardo's plans for a test flight are given in *Codex Atlanticus*, folio 361v-b. For discussions of this passage, see Carlo Pedretti, ed., *Leonardo da Vinci, Codex Atlanticus: A Catalogue of Its Newly Restored Sheets* (Milan: Giunti, 1979), part 2, 232 ; idem., *Commentary*, vol. 1, 220–22; and Kemp, *Marvellous Works*, 105–6.

40 Quoted in Lynn White Jr., "Eilmer of Malmesbury, an Eleventh-Century Aviator: A Case Study of Technological Innovation, Its Context and Tradition," *Technology and Culture* 2 (Spring 1961): 98.

41 Quoted in White, "Eilmer of Malmesbury," 103.

42 Richter, ed., *The Literary Works*, vol. 2, §1484.

43 Quoted in Bramly, *Leonardo*, 286.

44 Quoted in Pedretti, *Commentary*, vol. 1, 221.

45 White notes (p. 103) that no account of this story predates 1648. If true, the episode can be dated to February 1498, since it supposedly took place during the wedding celebrations of the mercenary Bartolommeo d'Alviano and Pantasilea Baglioni, sister of the lord of Perugia.

46 Pedretti, *Commentary*, vol. 1, 220–21. Pedretti writes, "There seems to be no doubt that Leonardo had made some attempt to fly" (p. 220).

47 Richter, ed., *The Literary Works*, vol. 2, §1125.

48 Ibid., vol. 2, §1428). See the discussion of this passage in Domenico Laurenza, *Leonardo: On Flight* (Florence-Milan: Giunti, 2004), 64.

Chapter 10

1 Richter, ed., *The Literary Works*, vol. 1, §55.

2 Claire J. Farago, ed., *Leonardo da Vinci's "Paragone"* (Brill: Leiden, 1992), 207; Richter, ed., *The Literary Works*, vol. 1, §52.

3 Ibid., vol. 1, §102.

4 Alberti, *On the Art of Building in Ten Books*, 305; and Kim Williams, "Verrocchio's Tombslab for Cosimo de' Medici: Designing with a Mathematical Vocabulary," in Kim Williams, ed., *Nexus: Architecture and Mathematics* (Florence: Edizioni dell'Erba, 1996), 193–205.

5 Thomas Brachert, "A Musical Canon of Proportion in Leonardo da Vinci's *Last Supper*," *Art Bulletin* 53 (December 1971): 464.

6 Brachert, "A Musical Canon of Proportion," 464. See also Kemp, *Marvellous Works*, 185.

7 Quoted in Kemp, *Marvellous Works*, 166.

8 *Lives of the Artists*, 262–63. On Borso d'Este, see Baxandall, *Painting and Experience*, 1.

9 Vasari, *Lives of the Artists*, 263.

10 Ibid., 206.

11 Cited in Mrs. Charles W. Heaton, *Leonardo da Vinci and His Works* (London: Macmillan, 1874), 32, note 3.

12 Vasari, *Lives of the Artists*, 262. For the conservation, see Marani, "Leonardo's *Last Supper*," 18.

13 John F. Moffitt, *Painterly Perspective and Piety: Religious Uses of the Vanishing Point, from the 15th to the 18th Century* (Jefferson, NC: McFarland, 2008), 170.

14 On ultramarine, see Cennini, *The Book of the Art of Cennino Cennini*, 47 and 50; and Merrifield, *The Art of Fresco Painting*, xxxvi. For rents in Florence, see Richard A. Goldthwaite, *The Economy of Renaissance Florence* (Baltimore: The Johns Hopkins University Press, 2009), 462. For Leonardo's use of ultramarine, see Barcilon, "The Restoration," 424 and 426.

15 Quoted in Merrifield, *The Art of Fresco Painting*, 58. For Leonardo's technique of painting Christ's garment, see Matteini and Moles, "A Preliminary Investigation," 129 and 131.

16 See Rush Rhees, "Christ in Art," *Biblical World* 6 (December 1895): 490–503.

17 "Exposition on Psalm 133," §6, in *Nicene and Post-Nicene Fathers*, 1st ser., vol. 8, trans. J. E. Tweed, ed. Philip Schaff (Buffalo: Christian Literature Publishing Co., 1888).

18 Gerhard Wolf, "From Mandylion to Veronica: Picturing the Disembodied Face and Disseminating the True Image of Christ in the Latin West," in Herbert L. Kessler and Gerhard Wolf, eds., *The Holy Face and the Paradox of Representation: Papers from a Colloquium Held at the Biblioteca Hertziana, Rome and the Villa Spelman, Florence, 1996* (Bologna: Nuova Alfa Editoriale, 1998), 153–79. For a discussion of the face of Christ, see Martin Kemp, *Christ to Coke: How Image Becomes Icon* (Oxford: Oxford University Press, 2011), 13–43.

19 Quoted in Baxandall, *Painting and Experience*, 57.

20 Lorenzo Valla, *On the Donation of Constantine*, trans. G. W. Bowersock (Cambridge, MA: Harvard University Press, 2008), 60.

21 George Eliot, *Romola*, ed. Andrew Sanders (London: Penguin, 1980), 75; and Sarah Lipton, *Images of Intolerance: The Representation of Jews and Judaism in the Bible moralisée* (Berkeley: University of California Press, 1999), 20.

22 Quoted in Ottavia Niccoli, *Prophecy and People in Renaissance Italy* (Princeton: Princeton University Press, 1990), 93–94. On the beard as a sign of otherness, see Barbara Wisch, "Vested Interest: Redressing Jews on Michelangelo's Sistine Ceiling," *Artibus et Historiae* 24 (2003): 148. On Agyropoulos, see Deno John Geanakoplos, *Constantinople and the West* (Madison: University of Wisconsin Press, 1989), 111.

23 Richter, ed., *The Literary Works*, vol. 2, §§986, 987 and 837.

24 Aimé Guillon de Montléon, *Le cénacle de Léonard de Vinci rendu aux amis des Beaux-Arts dans le tableau aujourd'hui chez un citoyen de Milan* (Milan and Lyon: Dumolard, 1811), 70.

25 Richter, ed., *The Literary Works*, vol. 2, §1305.

26 Pedretti, *Commentary*, vol. 1, 384–85. Pedretti adds, "No such document is to be found in the archives of the church" (p. 384).

27 See Katharine Park, "The Criminal and the Saintly Body: Autopsy and Dissection in Early Renaissance Italy," *Renaissance Quarterly* 47 (Spring 1994): 1–33, and Antonio Benivieni, *De abditis nonnullus ac mirandis morborum et sanatorium causis* (Springfield, IL: Charles C. Thomas, 1954).

28 Stephen Jay Gould, *Leonardo's Mountain of Clams and the Diet of Worms: Essays on Natural History* (Cambridge, MA: Harvard University Press, 2011), 26, 28.

29 Richter, ed., *The Literary Works*, vol. 2, §910.

30 Ibid., vol. 2, §886.

31 Pedretti, *Commentary*, vol. 2, 127.

32 Richter, ed., *The Literary Works*, vol. 2, §858.

33 Pedretti, *Commentary*, vol. 2, 128.

34 Martin Kemp, personal e-mail communication, 1 January 2012.

35 Vasari, *Lives of the Artists*, 270.

36 Luke Syson, "The Rewards of Service: Leonardo da Vinci and the Duke of Milan," in Syson et al., *Leonardo da Vinci: Painter at the Court of Milan* (London: National Gallery, 2011), 36.

37 Quoted in Martin Kemp, "Dissection and Divinity in Leonardo's Late Anatomies," *Journal of the Warburg and Courtauld Institutes* 35 (1972): 211.

38 Kemp, "Dissection and Divinity," 212.

39 Quoted in Syson, "The Rewards of Service," 23.

40 Richter, ed., *The Literary Works*, vol. 2, §1209.

41 Ibid., vol. 2, §1296.

42 Quoted in Gordon Griffiths, "Leonardo Bruni and the 1431 Florentine Complaint Against Indulgence-Hawkers: A Case-Study in Anticlericalism," in Peter A. Dykema and Heiko A. Oberman, eds., *Anticlericalism in Late Medieval and Early Modern Europe* (Leiden: Brill, 1993), 133.

43 See my *The Fantasia of Leonardo da Vinci: His Riddles, Jests, Fables and Bestiary* (Delray Beach, FL: Levenger Press, 2010).

44 Richter, ed., *The Literary Works*, vol. 2, §1284.

Chapter 11

1 Richter, ed., *The Literary Works*, vol. 2, §§1434 and 1444.

2 Leonardo's word list is found in the *Codex Trivulzianus*, held in the Biblioteca del Castello Sforza in Milan.

3 Richter, ed., *The Literary Works*, vol. 1, §10.

4 Ibid., vol. 2, §§1448, 1488, 1496, 1501, and 1448.

5 Ibid., vol. 2, §1469. The equal balance between scientific and literary books is noted by Martin Kemp: see "Science and the Poetic Impulse," 95. Kemp's caveat is worth bearing in mind: Leonardo's list of books does not necessarily provide "a complete or even a balanced record of what he read and owned," and "the ownership of a book should not be taken as evidence that its owner has read it" (ibid.).

6 For the second list, see Ladislao Reti, "Two Unpublished Manuscripts of Leonardo da Vinci in the Biblioteca Nacional of Madrid, Part II," *The Burlington Magazine* 110 (February 1968): 81–91.

7 These purchases are recorded in the *Codex Atlanticus*, folio 90v.

8 On Leonardo's involvement in recruiting Pacioli to Milan, see R. Emmett Taylor, *No Royal Road: Luca Pacioli and His Times* (Chapel Hill: University of North Carolina Press, 1942), 206.

9 Quoted in John Henry Bridges, ed., *The "Opus Majus" of Roger Bacon* (Oxford: Williams and Norgate, 1900), vol. 1, xxv.

10 Quoted in Taylor, *No Royal Road*, 321, 320, and 283.

11 Quoted in Carlo Ginzburg, *The Enigma of Piero: Piero della Francesca*, trans. Martin Ryle and Kate Soper (London: Verso, 2000), 89.

12 On these monikers, see Michael J. Fischer, "Luca Pacioli on Business Profits," *Journal of Business Ethics* 25 (2000): 299.

13 Kenneth Clark and Carlo Pedretti, eds., *The Drawings of Leonardo da Vinci in the Collection of Her Majesty the Queen at Windsor Castle*, 3 vols. (London: Phaidon, 1969), vol. 3, p. 47.

14 *Leonardo da Vinci: The Madrid Codices*, vol. 5: *Transcription and Translation of Codex Madrid II*, ed. and trans. Ladislao Reti (New York: McGraw-Hill, 1974), 8.

15 Richter, ed., *The Literary Works*, vol. 2, §1444.

16 See the discussion in Jeremy Parzen, "Please Play with Your Food: An Incomplete Survey of Culinary Wonders in Italian Renaissance Cookery," *Gastronomica: The Journal of Food and Culture* 4 (Fall 2004): 26–27. *De viribus quantitatis* exists in a single manuscript in the Biblioteca Universitaria di Bologna.

17 Vasari, *Lives of the Artists*, 269.

18 Richter, ed., *The Literary Works*, vol. 1, §343.

19 Vitruvius, *Ten Books on Architecture*, 73.

20 Richter, ed., *The Literary Works*, vol. 2, §1471.

21 Vitruvius, *Ten Books on Architecture*, 72.

22 For references to Trezzo and Caravaggio, see Pedretti, *Commentary*, vol. 1, 234, 236, 239, 244, and 254.

23 Richter, ed., *The Literary Works*, vol. 1, §§310, 324, and 343.

24 Vitruvius, *Ten Books on Architecture*, 72.

25 Richter, ed., *The Literary Works*, vol. 1, §396.

26 For good discussions of Pacioli's thought on divine proportion, see Alberto Pérez-

Gómez, "The Glass Architecture of Luca Pacioli," in *Chora: Intervals in the Philosophy of Architecture*, vol. 4, ed. Alberto Pérez-Gómez and Stephen Parcell (Montreal and Kingston: McGill-Queen's Press, 2003), 245–86; and Mario Livio, *The Golden Ratio: The Story of Phi, the Extraordinary Number of Nature, Art and Beauty* (London: REVIEW, 2002), 128–37.

27 Pacioli's first quote is from his dedication in the 1509 edition of *De divina proportione*, the second from his unpublished manuscript of *De viribus quantitatis*.

28 R. D. Archer-Hind, ed., *The Timaeus of Plato* (London: Macmillan, 1888), 193 and 197.

29 Quoted in Kemp, *Marvellous Works*, 135.

30 Pacioli's description of Leonardo's illustrations comes from the introduction to the edition of *On Divine Proportion* printed in Venice in 1509.

31 Quoted in Livio, *The Golden Ratio*, 131.

32 See George Markowsky, "Misconceptions about the Golden Ratio," *College Mathematics Journal* 23 (January 1992): 2–19; Livio, *The Golden Ratio*, 72–75; and Keith Devlin, "The Myth That Will Not Go Away," *Mathematical Association of America* (May 2007), available online at www.maa.org/devlin/devlin_05_07.html.

33 Richter, ed., *The Literary Works*, vol. 2, §1157.

34 Ibid., vol. 2, §1504.

35 David Bergamini, *Mathematics* (New York: Time-Life, 1963), 96.

36 Matila Ghyka, *The Geometry of Art and Life* (New York: Sheed and Ward, 1946), 98. For a good survey of the golden section—and lack thereof—in Leonardo's work, see Livio, *The Golden Ratio*, 162–66; and Markowsky, "Misconceptions," 10–11.

37 Richter, ed., *The Literary Works*, vol. 2, §827.

38 Livio, *The Golden Ratio*, 134–35; Vitruvius, *Ten Books on Architecture*, 73.

39 *The Prince*, 49.

40 Pedretti, *Commentary*, vol. 1, 237 and 245.

41 Villata, ed., *Documenti*, 93.

42 See Nicholl, *Leonardo da Vinci*, 300–301. On annual salaries, see Gene A. Brucker, *The Society of Renaissance Florence*, 2.

43 Baxandall, *Painting and Experience*, 8.

44 For examples of Florentine real estate prices, see Patricia Lee Rubin, *Image and Identity in Fifteenth-Century Florence* (New Haven: Yale University Press, 2007), 6.

45 For Leonardo's portrait of Nani, see Irma A. Richter, ed., *The Notebooks of Leonardo da Vinci* (Oxford: Oxford University Press, 1998), 329. On Leonardo's plans for his altarpiece: Pedretti, *Commentary*, vol. 1, 387–88.

46 Villata, ed., *Documenti*, 94.

47 Commines, *Memoirs*, 191.

48 Guicciardini, *The History of Italy*, 113.

49 Quoted in Cartwright, *Beatrice d'Este*, 295.

50 Quoted in ibid., 302.

51 Richter, ed., *The Literary Works*, vol. 2, §1560.

52 The spelling of the painting varies: the Louvre's curators spell *ferronière* with a double *n*, virtually everyone else with a single *n*.

53 Zöllner, *Leonardo da Vinci*, 228.

54 Goldscheider, *Leonardo da Vinci*, 185.

55 See John Brewer, *The American Leonardo: A Tale of Obsession, Art, and Money* (New York: Oxford University Press, 2009).

Chapter 12

1 Dan Brown, *The Da Vinci Code* (New York: Doubleday, 2003), 243.

2 Michelle Pauli, "Vatican Appoints Official *Da Vinci Code* Debunker," *Guardian*, 15 March 2005.

3 For the text of the Gospel of Philip and the other Nag Hammadi codices, see James M. Robinson, ed., *The Nag Hammadi Library in English* (Leiden: E. J. Brill, and New York: Harper and Row, 1977); and subsequent reprints and revisions.

4 Brown, *The Da Vinci Code*, 246.

5 Voragine, *The Golden Legend*, vol. 1, 376 and 382.

6 Quoted in Katherine Ludwig Jansen, "Maria Magdalena: *Apostolorum Apostola*," in *Women Preachers and Prophets through Two Millennia of Christianity*, ed. Beverly Mayne Kienzle and Pamela J. Walker (Berkeley and Los Angeles: University of California Press, 1998), 57.

7 Phyllis Zagano and Thomas C. McGonigle, *The Dominican Tradition* (Collegeville, MN: Order of Saint Benedict, 2006), 2; Susan Haskins, *Mary Magdalen: Myth and Metaphor* (New York: Harcourt Brace, 1994), 135.

8 Jansen, "Maria Magdalena: *Apostolorum Apostola*," 57.

9 Quoted in Katherine L. Jansen, "Like a Virgin: The Meaning of the Magdalen for Female Penitents of Later Medieval Italy," *Memoirs of the American Academy in Rome*, vol. 45 (2000), 133.

10 Sarah Wilk, "The Cult of Mary Magdalene in Fifteenth-Century Florence and Its Iconography," *Studi medievali* 26 (1985): 685–98.

11 For the Aquinas quote and the Signorelli fresco, see Sara Nair James, *Signorelli and Fra Angelico at Orvieto: Liturgy, Poetry and a Vision of the End-Time* (Aldershot, Hants.: Ashgate, 2003), 57.

12 Among numerous other sources, see Laura Miller, "The Last Word: The Da Vinci Con," *New York Times*, 22 February 2004.

13 Brown, *The Da Vinci Code*, 243.

14 Quoted in Richard Turner, *Inventing Leonardo* (London: Papermac, 1995), 110.

15 Quoted in Ernest Samuels, *Bernard Berenson: The Making of a Legend* (Cambridge, MA: Harvard University Press, 1987), 215.

16 Nick Squires, "Mona Lisa 'was a boy,'" *Daily Telegraph*, 2 February 2011.

17 See Antoinette LaFarge, "The Bearded Lady and the Shaven Man: Mona Lisa, Meet *Mona/Leo*," *Leonardo* 29 (1996): 379–83.

18 Nicholl, *Leonardo da Vinci: The Flights of the Mind* (London: Allen Lane, 2004), 469–70. For a history of the sketch, see ibid., n26 on p. 562.

19 "The 'Angel in the Flesh,'" *Achademia Leonardi Vinci: Journal of Leonardo Studies and Bibliography of Vinciana*, ed. Carlo Pedretti, vol. 4 (Florence: Giunti, 1991), 35.

20 See Lorenzo Ghiberti, *I commentari*, ed. Ottavio Morisani (Naples: Riccardo Ricciardi, 1947), 55.

21 On these issues, see Giancarlo Maiorini, *Leonardo da Vinci: The Daedalian Mythmaker* (University Park: Pennsylvania State University Press, 1992), 110.

22 See Luke Syson et al. ed., *Leonardo da Vinci: Painter at the Court of Milan* (London: National Gallery, 2011), 268.

23 Barcilon, "The Restoration," 381.

24 Knut Schäferdiek, "The Acts of John," in Wilhelm Schneemelcher, ed., *New Testament Apocrypha*, vol. 2 (Louisville, KY: Westminster John Knox Press, 2003), 156. For the story of the "obedient bugs," see 190.

25 Schäferdiek, "The Acts of John," 203.

26 Quoted in David M. Bergeron, *King James and Letters of Homoerotic Desire* (Iowa City: University of Iowa Press, 1999), 104. Marlowe's assertion comes from "The Baines Note," British Library, MS Harley 6848, ff. 185–86.

27 Sjef van Tilborg, *Imaginative Love in John* (Leiden: E. J. Brill, 1993), 247. See also J. S. Peart-Binns, *Bishop Hugh Montefiore* (London: Blond/Quartet, 1990), 127; and Delbert Burkett, ed., *The Blackwell Companion to Jesus* (Oxford: Blackwell, 2011), 452.

28 Marsilio Ficino, *Commentarium in Platonis Convivium Initiation*, quoted in Giovanni Dall'Orto, "'Socratic Love' as a Disguise for Same-Sex in the Italian Renaissance," in Kent Gerard and Gert Hekma, eds., *The Pursuit of Sodomy: Male Homosexuality in Renaissance and Enlightenment Europe* (New York: Haworth Press, 1989), 37–38. For "educational homosexuality" in ancient Greece, see James Neil, *The Origins and Role of Same-Sex Relations in Human Societies* (Jefferson, NC: McFarland & Co., 2009), 144–85.

29 Quoted in Louis Crampton, *Homosexuality and Civilization* (Cambridge, MA: Harvard University Press, 2003), 265.

30 Pseudo-Bonaventure, *Meditations on the Life of Christ*, trans. Isa Ragusa and Rosalie B. Green (Princeton: Princeton University Press, 1961), 150.

31 Quoted in Carolyn S. Jirousek, "*Christ and St. John the Evangelist* as a Model of Medieval Mysticism," *Cleveland Studies in the History of Art* 6 (2001): 19.

32 Quoted in Culpeper, *John, the Son of Zebedee*, 166.

33 Quoted in Jirousek, "*Christ and St. John the Evangelist*," 17.

34 See John Boswell, *Christianity, Social Tolerance, and Homosexuality: Gay People in Western Europe from the Beginning of the Christian Era to the Fourteenth Century* (Chicago: University of Chicago Press, 1981), 202; and Jirousek, "*Christ and St. John the Evangelist*," 6–27.

Chapter 13

1 Quoted in Nicholl, *Leonardo da Vinci*, 42.

2 Richter, ed., *The Literary Works*, vol. 2, §§1521, 1519, 1535, 1544, 1545 and 1397. Richter dates the reference to "ears of corn" to about 1500.

3 Ibid., vol. 2, §1548.

4 Ibid., vol. 2, §§1295 and 845.

5 Ibid., vol. 2, §1295.

6 Vasari, *Lives of the Artists*, 2 vols., 257.

7 Quoted in Cartwright, *Beatrice d'Este*, 81.

8 Scipione Ammirato, *Opuscoli*, vol. 2 (Florence, 1637), 242.

9 Simon Tugwell, ed., *Early Dominicans: Selected Writings* (Mahwah, NJ: Paulist Press, 1982), 456.

10 Johann Wolfgang von Goethe, *Observations on Leonardo da Vinci's Celebrated Picture of the Last Supper*, trans. G. H. Noehden (London: J. Booth, 1821), 7–8.

11 Quoted in Leo Steinberg, *Leonardo's Incessant "Last Supper"* (New York: Zone Books, 2001), 50.

12 Vasari, *Lives of the Artists*, 262.

13 Quoted in P.A.P.E. Kattenberg, *Andy Warhol, Priest: "The Last Supper Comes in Small, Medium and Large"* (Leiden: Brill, 2002), 5.

14 Quoted in Nello Forte Grazzini, "Flemish Weavers in Italy in the Sixteenth Century," in Guy Delmarcel, ed., *Flemish Tapestry Weavers Abroad: Emigration and the Founding of Manufactories in Europe* (Louvain: Louvain University Press, 2002), 131.

15 Cartwright, *Beatrice d'Este*, 117.

16 On Flemish weavers in Milan, see Hillie Smit, "Flemish Tapestry Weavers in Italy, c. 1420–1520: A Survey and Analysis of the Activity in Various Cities," in Delmarcel, ed., *Flemish Tapestry Weavers Abroad*, 121.

17 See John Varriano, "At Supper with Leonardo," *Gastronomica: The Journal of Food and Culture* 8 (Winter 2008): 75–79.

18 Quoted in Albert Rapp, "The Father of Western Gastronomy," *Classical Journal* 51 (October 1955): 44.

19 Quoted in Mel Licht, "Elysium: A Prelude to Renaissance Theater," *Renaissance Quarterly* 49 (Spring 1996): 18.

20 Quoted in Cartwright, *Beatrice d'Este*, 82.

21 See Odile Redon, Françoise Sabban, and Silvano Serventi, *The Medieval Kitchen: Recipes from France and Italy*, trans. Edward Schneider (Chicago: University of Chicago Press, 1998), 119–21.

22 Quoted in Redon et al., *The Medieval Kitchen*, 121.

23 Tugwell, ed., *Early Dominicans: Selected Writings*, 128, 133–34. On the consumption of bread, see Richard A. Goldthwaite, *The Building of Renaissance Florence: An Economic and Social History* (Baltimore: The Johns Hopkins University Press, 1980), 346–47.

24 Goldthwaite, *The Building of Renaissance Florence*, 292; and Antonio Ivan Pini, *Vite e vino nel medioevo* (Bologna: CLUEB, 1989), 133–35.

25 Richter, ed., *The Literary Works*, vol. 2, §§1030, 1548 and 1520.

26 Quoted in Paul Murray, *The New Wine of Dominican Spirituality: A Drink Called Happiness* (London: Continuum, 2006), 152 and 129.

27 Thomas Gilby, ed., *Summa theologiae*, vol. 43 (1968), 137, 139.

28 Pedretti, *Commentary*, vol. 2, 382.

29 Quoted in Boyle, *Senses of Touch*, 65. On the fork, see Giovanni Rebora, *Culture of the Fork: A Brief History of Food in Europe*, trans. Albert Sonnenfeld (New York: Columbia University Press, 2001), 16–17.

30 Donald Strong, "The Triumph of Mona Lisa: Science and Allegory of Time," in Enrico Bellone and Paolo Rossi eds., *Leonardo e l'età della Ragione* (Milan: Edizioni di Scientia, 1982), 255–78.

31 Gilbert, "Last Suppers and their Refectories," 392.

32 Brown, *The Da Vinci Code*, 236.

33 Richter, ed., *The Literary Works*, vol. 1, §593.

34 For a discussion, see Steinberg, *Leonardo's Incessant "Last Supper,"* 19. I am indebted to Steinberg's work (especially chapters 1 and 2) in the survey that follows.

35 Goethe, *Observations on Leonardo da Vinci's Celebrated Picture*, 9.

36 Quoted in Steinberg, *Leonardo's Incessant "Last Supper,"* 31.

37 Quoted in ibid., 40.

38 Quoted in ibid., 40.

39 For Goethe's religious beliefs, and lack thereof, see Astrida Orle Tantillo, *Goethe's Modernisms* (London: Continuum, 2010), 87–88.

40 "Leonardo's *Last Supper*," *Art Quarterly* 36 (1973): 297–410. In 2001, Steinberg published this work, revised and enlarged, as *Leonardo's Incessant "Last Supper."*

41 *A History of Art: A Survey of the Major Visual Arts from the Dawn of History to the Present Day* (London: Thames and Hudson, 1962), 350.

42 Helen Gardener's 1970 version of *Art through the Ages* (New York: Harcourt, Brace, and World, 1970), quoted in Steinberg, *Leonardo's Incessant "Last Supper,"* 46.

43 Jack Wasserman, quoted in ibid., 48.

44 On these issues, see Miri Rubin, *Corpus Christi: The Eucharist in Late Medieval Culture* (Cambridge: Cambridge University Press, 1991), passim, especially 1–2 and 9.

45 Giacomo Filippo Besta, *Vera narratione del successo della peste che afflisse l'inclita città di Milano, l'anno 1576* (Milan: Gottardo, 1578), 30. For a discussion, see Farago, "Aesthetics before Art: Leonardo Through the Looking Glass," 55.

46 Vasari, *Lives of the Artists*, 266.

47 Frederick Hartt, "Leonardo and the Second Florentine Republic," *Journal of the Walters Art Gallery* 44 (1986), 100.

48 See Martin Kemp and Pascal Cotte, *La Bella Principessa: The Story of the New Masterpiece*

by Leonardo da Vinci (London: Hodder & Stoughton, 2010); and Dalya Alberge, "Is this portrait a lost Leonardo?" *Guardian*, 27 September 2011.

49 Quoted in Cartwright, *Beatrice d'Este*, 306; and Ady, 162.

50 Quoted in Cartwright, *Beatrice d'Este*, 310.

Chapter 14

1 Quoted in Allison Levy, "Framing Widows: Mourning, Gender and Portraiture in Early Modern Florence," in Allison Levy, ed., *Widowhood and Visual Culture in Early Modern Europe* (Aldershot: Ashgate, 2003), 217. On these issues, see Carol Lansing, *Passion and Order: Restraint of Grief in the Medieval Italian Communes* (Ithaca: Cornell University Press, 2008).

2 Goethe, *Observations*, 9.

3 See H. Colin Slim, "The Lutenist's Hand," *Achademia Leonardi Vinci: Journal of Leonardo Studies and Bibliography of Vinciana*, ed. Carlo Pedretti, vol. 1 (Florence: Giunti, 1988), 32—34.

4 *Treatise on Painting*, ed. McMahon, vol. 1, 105; and Richter, ed., *The Literary Works*, vol. 1, §593 and 653. On Leonardo and Cristoforo de' Predis, see Nicholas Mirzoeff, *Silent Poetry: Deafness, Sign and Visual Culture in Early Modern France* (Princeton: Princeton University Press, 1995), 13.

5 Quoted in Ernest Samuels, *Bernard Berenson: The Making of a Legend* (Cambridge, MA: Harvard University Press, 1987), 215.

6 Goethe, *Observations*, 11. For a survey of these disparate readings of Thaddeus, see Steinberg, 84.

7 Goethe, *Observations*, 9.

8 Andrea de Jorio, *Gesture in Naples and Gesture in Classical Antiquity*, trans. Adam Kendon (Bloomington and Indianapolis: Indiana University Press, 2000), 4.

9 Jorio, *Gesture in Naples*, 129, 291, and 214.

10 Ibid., 215 and 66.

11 H. E. Butler, ed. and trans., *The Institutio Oratoria of Quintilian*, vol. 4 (Cambridge, MA: Loeb Classical Library, 1920), book 11, chap. 3.

12 Carlo Pedretti, ed., *Leonardo da Vinci on Painting: A Lost Book (Libro A)* (Berkeley and Los Angeles: University of California Press, 1964), 133.

13 Pasquale Villari, *Life of Times of Girolamo Savonarola*, vol. 1, trans. Linda Villari (London: T. Fisher Unwin, 1888), 71.

14 Michael Baxandall, *Painting and Experience in Fifteenth-Century Italy* (Oxford: Oxford University Press, 1992), 61; and Angus Trumble, *The Finger: A Handbook* (Melbourne: Melbourne University Press, 2010), 85. Trumble notes that this practice developed at Cluny and spread to other monasteries, forming an "intermonastic language of gesture" (ibid.). The Dominicans of Santa Maria delle Grazie would have used a similar system.

15 For examples, see Anne D. Hedeman, "Van der Weyden's Escorial *Crucifixion* and

Carthusian Devotional Practices," in Robert Ousterhout and Leslie Brubaker, eds., *The Sacred Image East and West* (Urbana: University of Illinois Press, 1995), 197; and William Hood, "Saint Dominic's Manners of Praying: Gestures in Fra Angelico's Cell Frescoes at S. Marco," *Art Bulletin* 68 (June 1986): 195–206.

16 Carlo Pedretti, ed., *Leonardo da Vinci on Painting*, 54.

17 Jorio, *Gesture in Naples*, 263.

18 The fact that Peter's knife points to Bartholomew is pointed out and discussed in Steinberg, *Leonardo's Incessant "Last Supper,"* 101.

19 Quoted in Maud Cruttwell, *Verrocchio* (London: Duckworth & Co., 1904), 161. For Tuscan town halls, see John T. Paoletti and Gary M. Radke, *Art in Renaissance Italy* (London: Laurence King Publishing, 2005), 272.

20 Quoted in Martin Kemp, *The Marvellous Works of Nature and Man*, rev. ed. (Oxford: Oxford University Press, 2006), 111.

21 Janson, *A History of Art*, 370.

22 Barcilon, "The Restoration," 376.

23 James the Lesser's beard, difficult to appreciate in Leonardo's original mural, is unmistakable in the version by Giampietrino.

24 Friedrich Ohly, *The Damned and the Elect: Guilt in Western Culture*, trans. Linda Archibald (Cambridge: Cambridge University Press, 1992), 88.

25 Quoted in Boyle, *Sense of Touch*, 211. See also Michael Barsley, *The Left-Handed Book: An Investigation into the Sinister History of Left-Handedness* (London: Souvenir Press, 1966).

26 Quoted in Lauren Julius Harris, "Cultural Influences on Handedness: Historical and Contemporary Theory and Evidence," in Stanley Coren, ed., *Left-Handedness: Behavioral Implications and Anomalies* (Amsterdam: Elsevir Science, 1990), 198.

27 Joanna Woods-Marsden, "Portrait of the Lady, 1430–1520," in David Alan Brown, ed., *Virtue and Beauty: Leonardo's Ginevra de' Benci and Renaissance Portraits of Women* (Princeton: Princeton University Press, 2001), 69.

28 Guy Tal, *Witches on Top: Magic, Power, and Imagination in the Art of Early Modern Italy* (Bloomington: Indiana University Press, 2006), 110.

29 Jack Wasserman, "Leonardo da Vinci's *Last Supper*: The Case of the Overturned Saltcellar," *Artibus et Historiae* 24 (2003): 65–72.

30 "To Grosphus," in E. R. Garnsey, trans., *The Odes of Horace* (London: Swan Sonnenschein, 1907). On the *dirae*, see Charles Anthon, *A Classical Dictionary* (New York: Harper & Brothers, 1848), 237. On royal saltcellars, see Mark Kurlansky, *Salt: A World History* (New York: Walker & Co., 2002), 144–45.

31 Philip Gavitt, *Charity and Children in Renaissance Florence: the Ospedale degli Innocenti, 1410–1536* (Ann Arbor: University of Michigan Press, 1990), 187–88.

32 Michael D. Bailey, "The Disenchantment of Magic: Spells, Charms, and Superstition in Early European Witchcraft," *American Historical Review* 111 (April 2006): 397; and Philip F. Waterman, *Story of Superstition* (New York: Alfred A. Knopf, 1929), 123.

33 Colin Campbell, "Half-Belief and the Paradox of Ritual Instrumental Activism: A Theory of Modern Superstition," *British Journal of Sociology* 47 (March 1996): 153.

34 For examples, see Debra Higgs Strickland, *Saracens, Demons, & Jews: Making Monsters in Medieval Art* (Princeton: Princeton University Press, 2003), 108, 124, 141—43, 215, and 221.

35 Quoted in David L. Jeffrey, ed., *A Dictionary of Biblical Tradition in English Literature* (Grand Rapids: William B. Eerdmans, 1992), 418.

36 Quoted in Giacomo Todeschini, "The Incivility of Judas: 'Manifest' Usury as a Metaphor for the 'Infamy of Fact,'" in Juliann Vitullo and Diane Wolfthal, eds., *Money, Morality and Culture in Late Medieval and Early Modern Europe* (Farnham, Surrey: Ashgate, 2010), 34.

37 Strickland, *Saracens, Demons, & Jews*, 142.

38 Quoted in Nirit ben-Aryeh Debby, "Jews and Judaism in the Rhetoric of Popular Preachers: The Florentine Sermons of Giovanni Dominici (1356—1419) and Bernardino da Siena (1380—1444)," *Jewish History* 14 (2000): 186.

39 Barbara Wisch, "Vested Interest: Redressing Jews on Michelangelo's Sistine Ceiling," *Artibus et Historiae* 24 (2003): 147.

40 Quoted in Debby, "Jews and Judaism," 189.

41 Quoted in Marica S. Tacconi, *Cathedral and Civic Ritual in Late Medieval and Renaissance Florence: The Service Books of Santa Maria del Fiore* (Cambridge: Cambridge University Press, 2005), 165.

42 Vasari, "Life of Simone, called Il Cronaca," in *Lives of the Most Eminent Painters, Sculptors and Architects*, 10 vols. vol. 4, trans. Gaston du C. de Vere (London: Philip Lee Warner, 1912—15), 269.

43 Howard Adelman, "Review: Simonsohn's *The Jews in Milan*," *Jewish Quarterly Review* new series, vol. 77 (October 1986—January 1987): 200.

44 Cartwright, *Beatrice d'Este*, 128.

45 Carlo Pedretti, *Leonardo: Studies for "The Last Supper" from the Royal Library at Windsor Castle* (Florence: Electa, 1983), 110.

46 Quoted in Claude Blanckaert, "On the Origins of French Ethnology: William Edwards and the Doctrine of Race," in George W. Stocking, ed., *Bones, Bodies, Behavior: Essays on Biological Anthropology* (Madison: University of Wisconsin Press, 1990), 35.

47 Ernst Gombrich, "The Grotesque Heads," in *The Heritage of Apelles: Studies in the Art of the Renaissance* (Oxford: Phaidon, 1976), 61.

48 On the engraved portrait, see Steinberg, *Leonardo's Incessant "Last Supper,"* 80. Steinberg believes the supposed dissimilarity proves Vasari's story to be "sheer fabrication," but any dissimilarity actually seems to be the result of a difference in artistic media, level of detail, and level of skill.

49 Goethe, *Observations*, 37.

50 On the Jewishness of Judas in Italian paintings, see Brigitte Monstadt, *Judas beim Abendmahl: Figurenkonstellation und Bedeutung in Darstellungen von Giotto bis Andrea del Sarto*

(Munich: Scaneg, 1995). I am indebted to Steinberg's discussion of Monstadt's thesis on p. 93, n29. On Judas's red hair, see Paull Franklin Baum, "Judas's Red Hair," *Journal of English and Germanic Philology* 21 (July 1922): 520–29.

51 For Judas's costume, see Barcilon, "The Restoration," 382.

52 The story is traced to Chapman in Austin B. Tucker, *The Preacher as Storyteller: The Power of Narrative in the Pulpit* (Nashville: B&H Publishing, 2008), 196. For Davis's version, see *Commencement Parts* (New York: Hines, Noble & Eldredge, 1898), 475.

Chapter 15

1 Sabba da Castiglione, quoted in Pedretti, *Leonardo: Architect*, 80.

2 Villata, ed., *Documenti*, 102.

3 Ibid.

4 Quoted in Cartwright, *Beatrice d'Este*, 316.

5 For Peraudi's salary, see Setton, *The Papacy and the Levant*, vol. 3, 403 and 529. Bandello's story is found in Matteo Bandello, *Tutte le opere*, ed. Francesco Flora, 2 vols., vol. 1 (Milan: A. Mondadori, 1934), 646–50. For a good discussion of Bandello's story, see Norman E. Land, "Leonardo da Vinci in a Tale by Matteo Bandello," *Discoveries* (2006), available online at: http://cstlcla.semo.edu/reinheimer/discoveries/archives/231/land231pf.htm.

6 For Leonardo's persistence with the project, see Laurie Fusco and Gino Corti, "Lorenzo de' Medici on the Sforza Monument," *Achademia Leonardi Vinci: Journal of Leonardo Studies and Bibliography of Vinciana*, ed. Carlo Pedretti, vol. 5 (Florence: Giunti, 1992), 24.

7 Pedretti, *Leonardo: Architect*, 72–74.

8 Richter, ed., *The Literary Works*, vol. 2, §1523. For wages, see Goldthwaite, *The Economy of Renaissance Florence*, 294.

9 Quoted in Cartwright, *Beatrice d'Este*, 305.

10 Quoted in Setton, *The Papacy and the Levant*, vol. 3, 503.

11 Patrick Macey, *Bonfire Songs: Savonarola's Musical Legacy*, vol. 1 (Oxford: Oxford University Press, 1998), 75.

12 Villari, *Life and Times of Girolamo Savonarola*, 189.

13 Quoted in Pastor, *History of the Popes*, vol. 5, 523, and vol. 6, 16.

14 Quoted in Cartwright, *Beatrice d'Este*, 295.

15 Quoted in Ibid., 331.

16 Commines, 267.

17 Ibid., 482.

18 Ibid., 281.

19 Ibid., 283.

20 Ibid., 284.

21 Villata, ed., *Documenti*, 110. Leonardo is not actually mentioned in this document.

22 Quoted in Pérez-Gómez, "The Glass Architecture of Luca Pacioli," 262.

23 For a good discussion of this property, see Nicholl, *Leonardo da Vinci*, 312–14. Nicholl securely dates the gift of the land to August 1497, earlier than previously believed.

24 Richter, ed., *The Literary Works*, vol. 2, §1566.

25 Quoted in Lillian F. Schwartz, "The Staging of Leonardo's *Last Supper*: A Computer-Based Exploration of Its Perspective," *Electronic Art*, vol. 1 (1988), *Leonardo: Supplemental Issue*, 93.

26 *Observations*, 7.

27 Richter, ed., *The Literary Works*, vol. 1, §284.

28 For a good discussion of perspective in the painting, see Martin Kemp, *Leonardo da Vinci: The Marvellous Works of Nature and Man*, rev. ed. (Oxford: Oxford University Press, 2006), 182–86; and idem, "*'Fate come dico, non fate come faccio'*: Lo Spazio e lo spettatore nell' 'Ultima Cena,'" *Il genio e le passioni*, ed. Pietro Marani (Milan: Skira, 2001), 53–59.

29 Richter, ed., *The Literary Works*, vol. 1, §§543 and 544.

30 Kemp, *Marvellous Works*, 183–84.

31 See Pedretti, *Commentary*, vol. 2, 59.

32 See Carlo Pedretti, "Nec ense," *Achademia Leonardi Vinci: Journal of Leonardo Studies and Bibliography of Vinciana*, ed. Carlo Pedretti, vol. 3 (Florence: Giunti, 1990), 82–90; and Kemp, *Marvellous Works*, 167–76.

33 Richter, ed., *The Literary Works*, vol. 1, §680.

34 Ibid., vol. 1, §704.

35 Pedretti, *Leonardo: Architect*, 105.

36 Quoted in Frederic J. Baumgartner, *Louis II* (New York: St. Martin's Press, 1994), 9.

37 Quoted in Ady, *A History of Milan Under the Sforza*, 173

38 Ibid., 175.

39 Quoted in Setton, *The Papacy and the Levant*, vol. 3, 514.

40 Quoted in Nicholl, *Leonardo da Vinci*, 321.

41 Quoted in Cartwright, *Beatrice d'Este*, 346.

42 Richter, ed., *The Literary Works*, vol. 2, §1414.

43 Ibid., vol. 2, §1371.

44 Pedretti, *Commentary*, vol. 2, 11.

45 Sabba da Castiglione, *Ricordi overo ammaestramenti* (Venice, 1554), xiv.

46 Quoted in Cartwright, *Beatrice d'Este*, 354.

47 Giovio, "The Life of Leonardo da Vinci," 29.

48 Vasari, *Lives of the Artists*, 263.

49 Villata, ed., *Documenti*, 136.

50 Richter, ed., *The Literary Works*, vol. 2, §1379.

51 Ibid., vol. 2, §1448. For a good discussion of Perréal, see Kemp and Cotte, *La Bella Principessa*, 36.

52 Richter, ed., *The Literary Works*, vol. 2, §1379. See the discussion in Pedretti, *Commentary*, vol. 2, 326.

Epilogue

1 Quoted in Barbara Furlotti, *The Art of Mantua: Power and Patronage in the Renaissance*, trans. A. Lawrence Jenkins (Los Angeles: Getty Publications, 2008), 92.

2 Villata, ed., *Documenti*, 131–32.

3 Wilhelm Oechsli, *The History of Switzerland, 1499–1914*, trans. Eden and Cedar Paul (Cambridge: Cambridge University Press, 1922), 28.

4 Vasari, *Lives of the Artists*, 265. The specifics of Leonardo's involvement at Santissima Annunziata—whose altarpiece was eventually completed by Filippino Lippi and Pietro Perugino—are highly obscure. For a good survey of the situation, see Jonathan Nelson, "The High Altar-piece of SS. Annunziata in Florence: History, Form, and Function," *The Burlington Magazine* 139 (February 1997): 84–94. For Ser Piero's involvement, see Cecchi, "New Light on Leonardo's Florentine Patrons," 124.

5 Villata, ed., *Documenti*, 136 and 134.

6 McMahon, ed., *Treatise on Painting*, 266.

7 For the bridge, see Nicholl, *Leonardo da Vinci*, 353–55. For the canal, see Roger D. Masters, *Fortune is a River: Leonardo da Vinci and Niccolò Machiavelli's Magnificent Dream to Change the Course of Florentine History* (New York: Plume, 1999).

8 Vasari, *Lives of the Artists*, 266.

9 Goldscheider, *Leonardo da Vinci: Life and Work, Paintings and Drawings*, 29, 30 and 32.

10 Quoted in Bramly, *Leonardo*, 353.

11 Ibid., 346.

12 Armenini, *On the True Precepts of the Art of Painting*, trans. Edward J. Olszewski (New York: Burt Franklin & Co., 1977), 53.

13 Creighton Gilbert, *How Fra Angelico and Signorelli Saw the End of the World* (University Park: Penn State University Press, 2003), 63; and Michelle O'Malley, "Pietro Perugino and the Contingency of Value," in Michelle O'Malley and Evelyn Welch, eds., *The Material Renaissance* (Manchester: Manchester University Press, 2007), 108.

14 See Marani, "Leonardo's *Last Supper*," 39.

15 Richter, ed., *The Literary Works*, vol. 2, §1074.

16 Guicciardini, *The History of Italy*, 153.

17 Ibid., 155.

18 Cecilia M. Ady, *A History of Milan Under the Sforza* (London: Methuen, 1907), 184.

19 Vasari, *Lives of the Artists*, 270.

20 Richter, ed., *The Literary Works*, vol. 2, §1566.

21 Quoted in Bramly, *Leonardo*, 412.

22 Richter, ed., *The Literary Works*, vol. 1, §651.

23 Barcilon, "The Restoration," 336.

24 Goethe, *Observations*, 14.

25 Carlo Pedretti, *Leonardo: Studies for "The Last Supper" from the Royal Library at Windsor Castle* (Florence: Electa, 1983), 145.

26 Quoted in Steinberg, *Leonardo's Incessant "Last Supper,"* 16.

27 Goethe, *Observations*, 17.

28 Ibid., vi. The visitor was G. H. Noehden.

29 *Church of England Quarterly Review* 21 (1847): 500.

30 *Times*, 11 March 1857.

31 Henry James, *Collected Travel Writing: The Continent* (New York: Library of America, 1993), 372.

32 Quoted in Marani, "Leonardo's *Last Supper*," 32.

33 *The Times*, 31 May 1954.

34 James Beck, cited in Piero Valsecchi, "It's Art, but Is It Leonardo's?" Milan: Associated Press Wire, 28 May 1999.

35 For the versions in California: Umberto Eco, *Faith in Fakes: Travels in Hyperreality*, trans. William Weaver (London: Vintage, 1986), 16–18. For Peter Greenaway: Randy Kennedy, "*The Last Supper* for the Laptop Generation," *New York Times*, 2 December 2010. For the version in the Warhola family kitchen: Janet Daggett Dillenberger, *The Religious Art of Andy Warhol* (New York: Continuum, 2001), 80. Haltadefinizione's magnifier may be seen at www.haltadefinizione.com. Websites too numerous to document testify—in both words and photographs—to the tattoos and coffins.

SELECTED BIBLIOGRAPHY

Ady, Cecilia M. *A History of Milan Under the Sforza.* London: Methuen, 1907.

Alberti, Leon Battista. *On the Art of Building in Ten Books.* Trans. Joseph Rykwert, Neil Leach, and Robert Tavernor. Cambridge, MA: MIT Press, 1991.

Ammirato, Scipione. *Opuscoli,* vol. 2. Florence, 1637.

Armenini, Giovanni Battista. *On the True Precepts of the Art of Painting.* Trans. Edward J. Olszewski. New York: Burt Franklin & Co., 1977.

Bacon, Roger. *The "Opus Majus" of Roger Bacon,* vol. 1. Ed. John Henry Bridges. Oxford: Williams and Norgate, 1900.

Baldassarri, Stefano Ugo, and Arielle Saiber, eds. *Images of Quattrocentro Florence: Selected Writings in Literature, History and Art.* New Haven: Yale University Press, 2000.

Bambach, Carmen C. "Leonardo, Left-handed Draftsman and Writer." In *Leonardo da Vinci: Master Draftsman,* ed. Carmen C. Bambach, 31–57. New York and New Haven: Metropolitan Museum of Art and Yale University Press, 2003.

Bandello, Matteo. *Tutte le opere,* 2 vols. Ed. Francesco Flora. Milan: A. Mondadori, 1934.

Barcilon, Pinin Brambilla, and Pietro C. Marani. *Leonardo: "The Last Supper."* Trans. Harlow Tighe. Chicago: University of Chicago Press, 2001.

Baumgartner, Frederic J. *Louis II.* New York: St. Martin's Press, 1994.

Baxandall, Michael. *Painting and Experience in Fifteenth-Century Italy.* Oxford: Oxford University Press, 1972.

Beck, James. "Leonardo's Rapport with His Father." *Antichità viva* 27 (1988): 5–12.

Bembo, Pietro. *History of Venice.* Ed. and trans. Robert W. Ulery Jr. Cambridge, MA: Harvard University Press, 2007.

Benivieni, Antonio. *De abditis nonnullus ac mirandis morborum et sanatorium causis.* Springfield, IL: Charles C. Thomas, 1954.

Berenson, Bernard. *Italian Painters of the Renaissance,* vol. 2. London: Phaidon, 1968.

Besta, Giacomo Filippo. *Vera narratione del successo della peste che afflisse l'inclita città di Milano, l'anno 1576.* Milan: Gottardo, 1578.

Black, Jane. *Absolutism in Renaissance Milan: Plenitude of Power under the Visconti and the Sforza, 1329–1535.* Oxford: Oxford University Press, 2009.

Black, Robert. *Education and Society in Florentine Tuscany: Teachers, Pupils and Schools, c. 1250–1500*. Leiden: Brill, 2007.

Borgo, Lodovico, and Ann H. Sievers. "The Medici Gardens at San Marco." *Mitteilungen des Kunsthistorischen Institutes in Florenz*, 33. Bd., H. 2/3 (1989): 237–56.

Boswell, John. *Christianity, Social Tolerance, and Homosexuality: Gay People in Western Europe from the Beginning of the Christian Era to the Fourteenth Century*. Chicago: University of Chicago Press, 1981.

Bowd, Stephen D. *Venice's Most Loyal City: Civic Identity in Renaissance Brescia*. Cambridge, MA: Harvard University Press, 2010.

Boyle, Marjorie O'Rourke. *Senses of Touch: Human Dignity and Deformity from Michelangelo to Calvin*. Leiden: Brill, 1998.

Brachert, Thomas. "A Musical Canon of Proportion in Leonardo da Vinci's *Last Supper*." *Art Bulletin* 53 (December 1971): 461–66.

Bramly, Serge. *Leonardo: The Artist and the Man*. London: Michael Joseph, 1992.

Britton, Piers. "'*Mio malinchonico, o vero . . . mio pazzo*': Michelangelo, Vasari, and the Problem of Artists' Melancholy in Sixteenth-Century Italy." *Sixteenth Century Journal* 34 (Fall 2003): 653–75.

Brown, David Alan. *Leonardo da Vinci: Origins of a Genius*. New Haven: Yale University Press, 1998.

Brucker, Gene A. *The Society of Renaissance Florence: A Documentary Study*. Toronto: University of Toronto Press, 1998.

Bruschi, Arnaldo. *Bramante*. London: Thames & Hudson, 1977.

Bull, David. "Two Portraits by Leonardo: *Ginevra de' Benci* and the *Lady with an Ermine*." *Artibus et Historiae* 13 (1992): 67–83.

Buonarroti, Michelangelo. *The Letters of Michelangelo*, vol. 1. Ed. E. H. Ramsden. Stanford: Stanford University Press, 1963.

Burckhardt, Jacob. *Italian Renaissance Painting According to Genres*. Los Angeles: Getty Publications, 2005.

Burkett, Delbert, ed. *The Blackwell Companion to Jesus*. Oxford: Blackwell, 2011.

Cartwright, Julia. *Beatrice d'Este, Duchess of Milan, 1475–1497: A Study of the Renaissance*. London: J. M. Dent & Sons, 1910.

Castiglione, Sabba da. *Ricordi overo ammaestramenti*. Venice, 1554.

Cecchi, Alessandro. "New Light on Leonardo's Florentine Patrons." In *Leonardo da Vinci: Master Draftsman*. Ed. Carmen C. Bambach, 120–39. New York and New Haven: Metropolitan Museum of Art and Yale University Press, 2003.

Cennini, Cennino. *The Book of the Art of Cennino Cennini*. Trans. Christiana J. Herringham. London: George Allen & Unwin, 1899.

Cerretani, Bartolomeo. *Storia fiorentina*. Ed. Giuliana Berti. Florence: Leo S. Olschki, 1994.

Cianchi, Francesco. *La madre di Leonardo era una schiava? Ipotesi di studio di Renzo Cianchi*. Vinci: Museo Ideale Leonardo da Vinci, 2008.

Clark, Kenneth. *Leonardo da Vinci*, rev. ed. Introduction by Martin Kemp. London: Penguin, 1989.

Clark, Kenneth, and Carlo Pedretti, eds. *The Drawings of Leonardo da Vinci in the Collection of Her Majesty the Queen at Windsor Castle*, 3 vols. London: Phaidon, 1969.

Clayton, Martin. *Leonardo da Vinci: The Divine and the Grotesque*. London: The Royal Collection, 2002.

Commines, Philip de. *The Memoirs of Philip de Commines, Lord of Argenton*, vol. 2. Ed. Andrew R. Scoble. London: Henry G. Bohn, 1856.

Condivi, Ascanio. *The Life of Michelangelo*, 2nd. ed. Trans. Alice Sedgwick Wohl. Ed. Hellmut Wohl. University Park: Pennsylvania State University Press, 1999.

Covi, D. A. "Four New Documents Concerning Andrea del Verrocchio." *Art Bulletin* 48 (March 1966): 97–103.

Crampton, Louis. *Homosexuality and Civilization*. Cambridge, MA: Harvard University Press, 2003.

Crawford, Katherine. *European Sexualities, 1400–1800*. Cambridge: Cambridge University Press, 2007.

Cronin, Vincent. *The Florentine Renaissance*. London: Collins, 1967.

Crowe, Joseph Archer, and Giovanni Battista Cavalcaselle. *The Early Flemish Painters: Notices of Their Lives and Works*. London: John Murray, 1857.

Cruttwell, Maud. *Verrocchio*. London: Duckworth & Co., 1904.

Culpeper, R. Alan. *John, the Son of Zebedee: The Life of a Legend*. Edinburgh: T&T Clark, 2000.

Dall'Orto, Giovanni. "'Socratic Love' as a Disguise for Same-Sex Love in the Italian Renaissance." In *The Pursuit of Sodomy: Male Homosexuality in Renaissance and Enlightenment Europe*. Ed. Kent Gerard and Gert Hekma, 33–66. New York: The Haworth Press, 1989.

Dean, Trevor. *The Towns of Italy in the Later Middle Ages*. Manchester: Manchester University Press, 2000.

Devlin, Keith. "The Myth That Will Not Go Away." *Mathematical Association of America* (May 2007), available online at www.maa.org/devlin/devlin_05_07.html.

Dillenberger, Janet Daggett. *The Religious Art of Andy Warhol*. New York: Continuum, 2001.

Eastlake, Charles Lock. *Materials for a History of Oil Painting*. London: Longman, Brown, Green, and Longmans, 1847.

Elam, Caroline. "Art and Diplomacy in Renaissance Florence." *Journal of the Royal Society of Arts* 136 (October 1988): 813–20.

Elam, Caroline. "Lorenzo de' Medici's Sculpture Garden." *Mitteilungen des Kunsthistorischen Institutes in Florenz*, 36. Bd., H. 1/2 (1992): 41–84.

Elet, Yvonne. "Seats of Power: The Outdoor Benches of Early Modern Florence." *Journal of the Society of Architectural Historians* 61 (December 2002): 444–69.

Farago, Claire. "Aesthetics before Art: Leonardo Through the Looking Glass." In *Compelling Visuality: The Work of Art In and Out of History*. Ed. Claire Farago and Robert Zwijnenberg, 45–92. Minneapolis: University of Minnesota Press, 2003.

Feinberg, Larry J. "Sight Unseen: Vision and Perception in Leonardo's Madonnas." *Apollo* (July 2004): 28–34.

Feinberg, Larry J. "Visual Puns and Variable Perception: Leonardo's *Madonna of the Yarnwinder.*" *Apollo* (August 2004): 38–41.

Fiorio, M. T., ed. *Le Chiese di Milano*. Milan: Electa, 1985.

Fischer, Michael J. "Luca Pacioli on Business Profits." *Journal of Business Ethics* 25 (2000): 299–312.

Francesca, Piero della. *Piero Della Francesca: Trattato d'Abaco*. Ed. Gino Arrighi. Pisa: Domus Galileana, 1971.

Freud, Sigmund. "Leonardo da Vinci and a Memory of His Childhood." In *The Standard Edition of the Complete Psychological Works*, vol. 11, 63–137. Ed. James Strachey. London: Hogarth Press, 1968.

Frick, Carole Collier. *Dressing Renaissance Florence: Families, Fortunes and Fine Clothing*. Baltimore: The Johns Hopkins University Press, 2002.

Fusco, Laurie, and Gino Corti. "Lorenzo de' Medici on the Sforza Monument." In *Achademia Leonardi Vinci: Journal of Leonardo Studies and Bibliography of Vinciana*, vol. 5, 11–32. Ed. Carlo Pedretti. Florence: Giunti, 1992.

Gage, John. *Color and Culture: Practice and Meaning from Antiquity to Abstraction*. Berkeley and Los Angeles: University of California Press, 1999.

Galbraith, Georgina Rosalie. *The Constitution of the Dominican Order*. Manchester: Manchester University Press, 1925.

Galluzzi, Paolo, ed. *Leonardo da Vinci: Engineer and Architect*. Montreal: Musée des Beaux-Arts, 1987.

Gavitt, Philip. *Charity and Children in Renaissance Florence: The Ospedale degli Innocenti, 1410–1536*. Ann Arbor: University of Michigan Press, 1990.

Ghiberti, Lorenzo. *I commentari*. Ed. Ottavio Morisani. Naples: Riccardo Ricciardi, 1947.

Ghyka, Matila. *The Geometry of Art and Life*. New York: Sheed and Ward, 1946.

Gilbert, Creighton. "Last Suppers and their Refectories." In *The Pursuit of Holiness in Late Medieval and Renaissance Religion*, 371–402. Ed. Charles Trinkaus and Heiko A. Oberman. Leiden: Brill, 1974.

Ginzburg, Carlo. *The Enigma of Piero: Piero della Francesca*. Trans. Martin Ryle and Kate Soper. London: Verso, 2000.

Glasser, Hannelore. *Artists' Contracts of the Early Renaissance*. New York: Garland, 1977.

Goethe, Johann Wolfgang von. *Observations on Leonardo da Vinci's Celebrated Picture of the Last Supper*. Trans. G. H. Noehden. London: J. Booth, 1821.

Goldscheider, Ludwig. *Leonardo da Vinci: Life and Work, Paintings and Drawings*. London: Phaidon, 1959.

Goldthwaite, Richard A. *The Economy of Renaissance Florence*. Baltimore: The Johns Hopkins University Press, 2009.

Gombrich, Ernst. "The Grotesque Heads." In *The Heritage of Apelles: Studies in the Art of the Renaissance*, 57–75. Oxford: Phaidon, 1976.

Gould, Stephen Jay. *Leonardo's Mountain of Clams and the Diet of Worms: Essays on Natural History*. Cambridge, MA: Harvard University Press, 2011.

Grazzini, Nello Forte. "Flemish Weavers in Italy in the Sixteenth Century." In *Flemish Tapestry Weavers Abroad: Emigration and the Founding of Manufactories in Europe*, 131–62. Ed. Guy Delmarcel. Louvain: Louvain University Press, 2002.

Guicciardini, Francesco. *The History of Italy*. Trans. Sidney Alexander. New York: Macmillan, 1969.

Guillon de Montléon, Aimé. *Le cénacle de Léonard de Vinci rendu aux amis des Beaux-Arts dans le tableau aujourd'hui chez un citoyen de Milan*. Milan and Lyon: Dumolard, 1811.

Harris, Lauren Julius. "Cultural Influences on Handedness: Historical and Contemporary Theory and Evidence." In *Left-Handedness: Behavioral Implications and Anomalies*, 195–258. Ed. Stanley Coren. Amsterdam: Elsevir Science, 1990.

Hartt, Frederick. "Leonardo and the Second Florentine Republic." *Journal of the Walters Art Gallery* 44 (1986): 95–116.

Haskins, Susan. *Mary Magdalen: Myth and Metaphor*. New York: Harcourt Brace, 1994.

Heaton, Mrs. Charles W. *Leonardo da Vinci and His Works*. London: Macmillan, 1874.

Hood, William. "Saint Dominic's Manners of Praying: Gestures in Fra Angelico's Cell Frescoes at S. Marco." *Art Bulletin* 68 (June 1986): 195–206.

James, Sara Nair. *Signorelli and Fra Angelico at Orvieto: Liturgy, Poetry and a Vision of the End-Time*. Aldershot, Hants.: Ashgate, 2003.

Jansen, Katherine L. "Like a Virgin: The Meaning of the Magdalen for Female Penitents of Later Medieval Italy." *Memoirs of the American Academy in Rome* 45 (2000): 131–52.

Jansen, Katherine L. "Maria Magdalena: *Apostolorum Apostola*." In *Women Preachers and Prophets through Two Millennia of Christianity*, 57–96. Ed. Beverly Mayne Kienzle and Pamela J. Walker. Berkeley and Los Angeles: University of California Press, 1998.

Janson, H. W. *A History of Art: A Survey of the Major Visual Arts from the Dawn of History to the Present Day*. London: Thames and Hudson, 1962.

Jirousek, Carolyn S. "*Christ and St. John the Evangelist* as a Model of Medieval Mysticism." *Cleveland Studies in the History of Art* 6 (2001): 6–27.

Jorio, Andrea de. *Gesture in Naples and Gesture in Classical Antiquity*. Trans. Adam Kendon. Bloomington and Indianapolis: Indiana University Press, 2000.

Kattenberg, P.A.P.E. *Andy Warhol, Priest: "The Last Supper Comes in Small, Medium and Large."* Leiden: Brill, 2002.

Kemp, Martin. *Christ to Coke: How Image Becomes Icon*. Oxford: Oxford University Press, 2011.

Kemp, Martin. "Dissection and Divinity in Leonardo's Late Anatomies." *Journal of the Warburg and Courtauld Institutes* 35 (1972): 200–225.

Kemp, Martin. "'*Fate come dico, non fate come faccio*'": Lo Spazio e lo spettatore nell' 'Ultima Cena," *Il Genio e le Passioni*, 53–59. Ed. Pietro Marani. Milan: Skira, 2001.

Kemp, Martin. *Leonardo*. Oxford: Oxford University Press, 2004.

Kemp, Martin. *Leonardo da Vinci: Experience, Experiment and Design*. London: V&A Publications, 2006.

Kemp, Martin. *Leonardo da Vinci: The Marvellous Works of Nature and Man*. Rev. ed. Oxford: Oxford University Press, 2006.

Kemp, Martin. "Science and the Poetic Impulse." In *Sixteenth-Century Italian Art*, 94–114. Ed. Michael W. Cole. Oxford: Blackwell, 2006.

Kemp, Martin, and Pascal Cotte. *La Bella Principessa: The Story of the New Masterpiece by Leonardo da Vinci*. London: Hodder & Stoughton, 2010.

King, Ross, ed. *The Fantasia of Leonardo da Vinci: His Riddles, Jests, Fables and Bestiary*. Delray Beach, FL: Levenger Press, 2010.

Klapische-Zuber, Christiane. *Women, Family and Ritual in Renaissance Italy*. Trans. Lydia Cochrane. Chicago: University of Chicago Press, 1985.

Kleinhenz, Christopher. *Medieval Italy: An Encyclopedia*, vol. 2. New York: Routledge, 2004.

LaFarge, Antoinette. "The Bearded Lady and the Shaven Man: Mona Lisa, Meet *Mona/Leo*." In *Leonardo* 29 (1996): 379–83.

Landucci, Luca. *A Florentine Diary from 1450 to 1516*. Trans. Alice de Rosen Jarvis. London: J. M. Dent, 1927.

Lang, S. "Leonardo's Architectural Designs and the Sforza Mausoleum." *Journal of the Warburg and Courtauld Institutes* 31 (1968): 218–33.

Lansing, Carol. *Passion and Order: Restraint of Grief in the Medieval Italian Communes*. Ithaca: Cornell University Press, 2008.

Laurenza, Domenico. *Leonardo's Machines: Secrets and Inventions in the Da Vinci Codices*. Florence-Milan: Giunti, 2005.

Laurenza, Domenico. *Leonardo: On Flight*. Florence-Milan: Giunti, 2004.

Levy, Allison. "Framing Widows: Mourning, Gender and Portraiture in Early Modern Florence." In *Widowhood and Visual Culture in Early Modern Europe*, 211–32. Ed. Allison Levy. Aldershot: Ashgate, 2003.

Licht, Mel. "Elysium: A Prelude to Renaissance Theater." *Renaissance Quarterly* 49 (Spring 1996): 1–29.

Lipton, Sarah. *Images of Intolerance: The Representation of Jews and Judaism in the Bible Moralisée*. Berkeley: University of California Press, 1999.

Livio, Mario. *The Golden Ratio: The Story of Phi, the Extraordinary Number of Nature, Art and Beauty*. London: REVIEW, 2002.

MacCurdy, Edward. *Leonardo da Vinci*. London: George Bell, 1908.

Machiavelli, Niccolò. *The Art of War*. Ed. and trans. Christopher Lynch. Chicago: University of Chicago Press, 2003.

Machiavelli, Niccolò. *Florentine Histories*. Trans. Laura F. Banfield and Harvey C. Mansfield. Princeton: Princeton University Press, 1990.

Machiavelli, Niccolò. *The Prince*. Trans. George Bull. London: Penguin, 1961.

Maiorini, Giancarlo. *Leonardo da Vinci: The Daedalian Mythmaker*. University Park: Pennsylvania State University Press, 1992.

Markowsky, George. "Misconceptions about the Golden Ratio." *College Mathematics Journal* 23 (January 1992): 2–19.

Martines Lauro. *Scourge and Fire: Savonarola and Renaissance Florence*. London: Jonathan Cape, 2006.

Masters, Roger D. *Fortune is a River: Leonardo da Vinci and Niccolò Machiavelli's Magnificent Dream to Change the Course of Florentine History*. New York: Plume, 1999.

Matteini, Mauro, and Arcangelo Moles. "A Preliminary Investigation of the Unusual Technique of Leonardo's Mural *The Last Supper*." *Studies in Conservation* 24, no. 3 (August 1979): 125–33.

McGrath, Elizabeth. "Lodovico il Moro and his Moors." *Journal of the Warburg and Courtauld Institutes* 65 (2002): 67–94.

Merrifield, Mary Philadelphia. *The Art of Fresco Painting as Practised by the Old Italian and Spanish Masters*. London: Charles Gilpin, 1846.

Milman, Henry Hart. *History of Latin Christianity*, vol. 4. London: John Murray, 1855.

Mirzoeff, Nicholas. *Silent Poetry: Deafness, Sign and Visual Culture in Early Modern France*. Princeton: Princeton University Press, 1995.

Moffitt, John F. "Painters 'Born Under Saturn': The Physiological Explanation." *Art History* 11 (1988): 195–216.

Moffitt, John F. *Painterly Perspective and Piety: Religious Uses of the Vanishing Point, from the 15th to the 18th Century*. Jefferson, NC: McFarland, 2008.

Montelupo, Raffaello da. *Vita da Raffaello da Montelupo*. Ed. Riccardo Gatteschi. Florence: Polistampa, 1998.

Morley, Brian. "The Plant Illustrations of Leonardo da Vinci." *The Burlington Magazine*, 121 (September 1979): 553–62.

Murray, Paul. *The New Wine of Dominican Spirituality: A Drink Called Happiness*. London: Continuum, 2006.

Murray, Peter and Linda. *The Art of the Renaissance*. London: Thames & Hudson, 1963.

Nagel, Alexander. "Structural Indeterminacy in Early Sixteenth-Century Italian Painting." In *Subject as Aporia in Early Modern Art*, 17–23. Ed. Alexander Nagel and Lorenzo Pericolo. Farnham, Hants.: Ashgate, 2010.

Najemy, John M. *A History of Florence, 1200–1575*. Oxford: Blackwell, 2006.

Neil, James. *The Origins and Role of Same-Sex Relations in Human Societies*. Jefferson, NC: McFarland & Co., 2009.

Nelson, Jonathan. "The High Altar-piece of SS. Annunziata in Florence: History, Form, and Function." *The Burlington Magazine* 139 (February 1997): 84–94.

Niccoli, Ottavia. *Prophecy and People in Renaissance Italy*. Princeton: Princeton University Press, 1990.

Nicholl, Charles. *Leonardo da Vinci: The Flights of the Mind*. London: Allen Lane, 2004.

Nicolle, David. *Fornovo 1495: France's Bloody Fighting Retreat*. Oxford: Osprey, 1996.

Ohly, Friedrich. *The Damned and the Elect: Guilt in Western Culture*. Trans. Linda Archibald. Cambridge: Cambridge University Press, 1992.

Origo, Iris. "The Domestic Enemy: The Eastern Slaves in Tuscany in the Fourteenth and Fifteenth Centuries." *Speculum: A Journal of Medieval Studies* 30 (July 1955): 321–66.

Paoletti, John T., and Gary M. Radke. *Art in Renaissance Italy*. London: Laurence King Publishing, 2005.

Park, Katharine. "The Criminal and the Saintly Body: Autopsy and Dissection in Early Renaissance Italy." *Renaissance Quarterly* 47 (Spring 1994): 1–33.

Parzen, Jeremy. "Please Play with Your Food: An Incomplete Survey of Culinary Wonders in Italian Renaissance Cookery." *Gastronomica: The Journal of Food and Culture* 4 (Fall 2004): 25–33.

Pastor, Ludwig. *The History of the Popes from the Close of the Middle Ages*, vol. 5. Ed. F. I. Antrobus. London: Kegan Paul, Trench & Trübner, 1898.

Pedretti, Carlo. "The 'Angel in the Flesh.'" *Achademia Leonardi Vinci: Journal of Leonardo Studies and Bibliography of Vinciana* 4. Ed. Carlo Pedretti (Florence: Giunti, 1991): 34–48.

Pedretti, Carlo. *Leonardo: Architect*. Trans. Sue Brill. London: Thames and Hudson, 1986.

Pedretti, Carlo. *Leonardo: A Study in Chronology and Style*. Berkeley and Los Angeles: University of California Press, 1973.

Pedretti, Carlo, ed. *Leonardo da Vinci, Codex Atlanticus: A Catalogue of Its Newly Restored Sheets*. Milan: Giunti, 1979.

Pedretti, Carlo. *Leonardo: Studies for "The Last Supper" from the Royal Library at Windsor Castle*. Florence: Electa, 1983.

Pedretti, Carlo. "Nec ense." *Achademia Leonardi Vinci: Journal of Leonardo Studies and Bibliography of Vinciana* 3. Ed. Carlo Pedretti (Florence: Giunti, 1990): 82–90.

Pedretti, Carlo. "Newly Discovered Evidence of Leonardo's Association with Bramante." *Journal of the Society of Architectural Historians* 32 (October 1973): 223–27.

Pedretti, Carlo. "The Sforza Sepulchre." *Gazette des Beaux-Arts* 89 (1977): 121–31.

Pérez-Gómez, Alberto. "The Glass Architecture of Luca Pacioli." In *Chora: Intervals in the Philosophy of Architecture*, vol. 4, 245–86. Ed. Alberto Pérez-Gómez and Stephen Parcell. Montreal and Kingston: McGill-Queen's Press, 2003.

Piccolomini, Aeneas Silvius. *Reject Aeneas, Accept Pius: Selected Letters of Aeneas Sylvius Piccolomini (Pope Pius II)*. Trans. Thomas M. Izbicki et al. Washington, D.C.: Catholic University of America Press, 2006.

Pini, Antonio Ivan. *Vite e vino nel medioevo*. Bologna: CLUEB, 1989.

Pizzorusso, Ann. "The Authenticity of *The Virgin of the Rocks*." *Leonardo* 29 (1996): 197–200.

Ponting, Kenneth G., ed. *Leonardo da Vinci: Drawings of Textile Machines*. Bradford-on-Avon: Moonraker Press and Pasold Research Fund Ltd., 1979.

Popham, A. E. *The Drawings of Leonardo da Vinci*. London: Jonathan Cape, 1946.

Pseudo-Bonaventure. *Meditations on the Life of Christ*. Trans. Isa Ragusa and Rosalie B. Green. Princeton: Princeton University Press, 1961.

Rebora, Giovanni. *Culture of the Fork: A Brief History of Food in Europe*. Trans. Albert Sonnenfeld. New York: Columbia University Press, 2001.

Redon, Odile, Françoise Sabban, and Silvano Serventi. *The Medieval Kitchen: Recipes from France and Italy*. Trans. Edward Schneider. Chicago: University of Chicago Press, 1998.

Reti, Ladislao, ed. *Codex Madrid: Leonardo da Vinci: The Madrid Codices*, vol. 5: *Transcription and Translation of Codex Madrid II*. New York: McGraw-Hill, 1974.

Reti, Ladislao. "Two Unpublished Manuscripts of Leonardo da Vinci in the Biblioteca Nacional of Madrid, Part II." *The Burlington Magazine* 110 (February 1968): 81–91.

Rhees, Rush. "Christ in Art." *Biblical World* 6 (December 1895): 490–503.

Richter, Jean-Paul, ed., *The Literary Works of Leonardo da Vinci*, 2 vols. London: Phaidon, 1970.

Robertson, Charles. "Bramante, Michelangelo and the Sistine Ceiling." *Journal of the Warburg and Courtauld Institutes* 49 (1986): 91–105.

Robinson, James M., ed. *The Nag Hammadi Library in English*. Leiden and New York: Brill and Harper and Row, 1977.

Rubin, Miri. *Corpus Christi: The Eucharist in Late Medieval Culture*. Cambridge: Cambridge University Press, 1991.

Rubin, Patricia Lee. *Image and Identity in Fifteenth-Century Florence*. New Haven: Yale University Press, 2007.

Saalman, Howard. "Paolo Uccello at San Miniato." *The Burlington Magazine* 106 (December 1964): 558–63.

Sacchetti, Francesco. *Il Trecento Novelle*. Ed. Antonio Lanza. Florence: Sansoni, 1984.

Samuels, Ernest. *Bernard Berenson: The Making of a Legend*. Cambridge, MA: Harvard University Press, 1987.

Savonarola, Girolamo. *Selected Writings of Girolamo Savonarola: Religion and Politics, 1490–1498*. Ed. Anne Borelli and Maria C. Pastore Passaro. New Haven: Yale University Press, 2006.

Schneemelcher, Wilhelm, ed. *New Testament Apocrypha*, vol. 2. Louisville, Kentucky: Westminster John Knox Press, 2003.

Schwartz, Lillian F. "The Staging of Leonardo's *Last Supper*: A Computer-Based Exploration of Its Perspective." *Electronic Art* 1, *Leonardo: Supplemental Issue* (1988): 89–96.

Setton, Kenneth M. *The Papacy and the Levant, 1204–1571*, vol. 3. Philadelphia: American Philosophical Society, 1984.

Shell, Janice, and Grazioso Sironi. "Cecilia Gallerani: Leonardo's *Lady with an Ermine*," *Artibus et Historiae* 13 (1992): 47–66.

Slim, H. Colin. "The Lutenist's Hand." *Achademia Leonardi Vinci: Journal of Leonardo Studies and Bibliography of Vinciana* 1. Ed. Carlo Pedretti (Florence: Giunti, 1988): 32–34.

Smit, Hillie. "Flemish Tapestry Weavers in Italy, c. 1420–1520: A Survey and Analysis of the Activity in Various Cities." In *Flemish Tapestry Weavers Abroad: Emigration and the Founding of Manufactories in Europe*, 113–30. Ed. Guy Delmarcel. Louvain: Louvain University Press, 2002.

Sohm, Philip Lindsay. *The Artist Grows Old: The Aging of Art and Artists in Italy, 1500–1800*. New Haven: Yale University Press, 2007.

Spencer, John R. *Andrea del Castagno and His Patrons.* Durham: Duke University Press, 1991.

Steinberg, Leo. *Leonardo's Incessant "Last Supper."* New York: Zone Books, 2001.

Steinberg, Leo. "Leonardo's *Last Supper.*" *Art Quarterly* 36 (1973): 297–410.

Strickland, Debra Higgs. *Saracens, Demons, & Jews: Making Monsters in Medieval Art.* Princeton: Princeton University Press, 2003.

Strocchia, Sharon T. "Death Rites and the Ritual Family in Renaissance Florence." In *Life and Death in Fifteenth-Century Florence,* 120–45. Ed. Marcel Tetel, Ronald G. Witt and Rona Goffen. Durham: Duke University Press, 1989.

Strong, Donald. "The Triumph of Mona Lisa: Science and Allegory of Time." In *Leonardo e l'età della Ragione,* 255–78. Ed. Enrico Bellone and Paolo Rossi. Milan: Edizioni di Scientia, 1982.

Syson, Luke, et al. *Leonardo da Vinci: Painter at the Court of Milan.* London: National Gallery, 2011.

Tal, Guy. *Witches on Top: Magic, Power, and Imagination in the Art of Early Modern Italy.* Bloomington: Indiana University Press, 2006.

Tavuzzi, Michael M. *Dominican Inquisitors and Inquisitorial Districts in Northern Italy, 1474–1527.* Leiden: Brill, 2007.

Taylor, R. Emmett. *No Royal Road: Luca Pacioli and His Times.* Chapel Hill: University of North Carolina Press, 1942.

Tilborg, Sjef van. *Imaginative Love in John.* Leiden: Brill, 1993.

Tinagli, Paola. *Women in Italian Renaissance Art: Gender, Representation, Identity.* Manchester: Manchester University Press, 1997.

Trexler, Richard C. *Public Life in Renaissance Florence.* Ithaca: Cornell Paperbacks, 1991.

Trumble, Angus. *The Finger: A Handbook.* Melbourne: Melbourne University Press, 2010.

Tugwell, Simon, ed. *Early Dominicans: Selected Writings.* Mahwah, NJ: Paulist Press, 1982.

Tuohy Thomas. *Herculean Ferrara: Ercole d'Este (1471–1505) and the Invention of a Ducal Capital.* Cambridge: Cambridge University Press, 2002.

Turner, Richard. *Inventing Leonardo.* London: Papermac, 1995.

Ulivi, Elisabetta. *Per la genealogia di Leonardo: Matrimoni e altre vicende nella famiglia da Vinci sullo sfondo della Firenze rinascimentale.* Vinci: Museo Ideale Leonardo da Vinci, 2008.

Valla, Lorenzo. *On the Donation of Constantine.* Trans. G. W. Bowersock. Cambridge, MA: Harvard University Press, 2008.

Varriano, John. "At Supper with Leonardo." *Gastronomica: The Journal of Food and Culture* 8 (Winter 2008): 75–79.

Vasari, Giorgio. *Lives of the Artists,* 2 vols. Trans. George Bull. London: Penguin, 1965.

Vasari, Giorgio. *Lives of the Most Eminent Painters, Sculptors and Architects,* 10 vols. Trans. Gaston du C. de Vere. London: Philip Lee Warner, 1912–15.

Vasari, Giorgio. *Vasari on Technique.* Trans. Louisa S. Maclehose. Ed. G. Baldwin Brown. New York: Dover, 1960.

Vecce, Carlo. *Leonardo.* Rome: Salerno Editrice, 1998.

Villari, Pasquale. *Life and Times of Girolamo Savonarola*, 2 vols. Trans. Linda Villari. London: T. Fisher Unwin, 1888.

Villata, Edoardo, ed. *Leonardo da Vinci: I documenti e le testimonianze contemporanee*. Milan: Castello Sforzesco, 1999.

Vinci, Leonardo da. *Leonardo da Vinci on Painting: A Lost Book (Libro A)*. Ed. Carlo Pedretti. Berkeley and Los Angeles: University of California Press, 1964.

Vinci, Leonardo da. *Leonardo da Vinci's "Paragone."* Ed. Claire J. Farago. Leiden: Brill, 1992.

Vinci, Leonardo da. *The Literary Works of Leonardo da Vinci*, 2 vols. Comp. and ed. Jean–Paul Richter. London: Phaidon, 1970.

Vinci, Leonardo da. *The Literary Works of Leonardo da Vinci*, 2 vols. Ed. Jean-Paul Richter, with a commentary by Carlo Pedretti. Oxford: Phaidon, 1977.

Vinci, Leonardo da. *The Notebooks of Leonardo da Vinci*. Ed. Irma A. Richter. Oxford: Oxford University Press, 1998.

Vinci, Leonardo da. *Treatise on Painting*, 2 vols. Ed. A. Philip McMahon. Princeton: Princeton University Press, 1956.

Vitruvius. *Ten Books on Architecture*. Trans. Morris Hicky Morgan. Cambridge, MA: Harvard University Press, 1914.

Voragine, Jacobus de. *The Golden Legend: Readings on the Saints*, 2 vols. Ed. William Granger Ryan. Princeton: Princeton University Press, 1995.

Wallace, William E. "Michelangelo's Assistants in the Sistine Chapel." *Gazette des Beaux-Arts* 11 (December 1987): 203–16.

Wasserman, Jack. "Leonardo da Vinci's *Last Supper*: The Case of the Overturned Saltcellar." *Artibus et Historiae* 24 (2003): 65–72.

Welch, Evelyn. "Patrons, Artists and Audiences in Renaissance Milan." In *The Northern Court Cities: Milan, Parma, Piacenza, Mantua, Ferrara*, 21–70. Ed. Charles M. Rosenberg. Cambridge: Cambridge University Press, 2010.

White, Lynn Jr. "Eilmer of Malmesbury, an Eleventh Century Aviator: A Case Study of Technological Innovation, Its Context and Tradition." *Technology and Culture* 2 (Spring 1961): 97–111.

Wilk, Sarah. "The Cult of Mary Magdalene in Fifteenth-Century Florence and Its Iconography." *Studi Medievali* 26 (1985): 685–98.

Williams, Kim. "Verrocchio's Tombslab for Cosimo de' Medici: Designing with a Mathematical Vocabulary." In *Nexus: Architecture and Mathematics*, 193–205. Ed. Kim Williams. Florence: Edizioni dell'Erba, 1996.

Wisch, Barbara. "Vested Interest: Redressing Jews on Michelangelo's Sistine Ceiling." *Artibus et Historiae* 24 (2003): 143–72.

Witt, Ronald. "What Did Giovannino Read and Write? Literacy in Early Renaissance Florence." *I Tatti Studies: Essays in the Renaissance* 6 (1995): 83–114.

Wohl, Hellmut. "Domenico Veneziano Studies: The Sant' Egidio and Parenti Documents." *The Burlington Magazine* 113 (November 1971): 635–41.

Woods-Marsden, Joanna. "Portrait of the Lady, 1430–1520." In *Virtue and Beauty: Leonardo's Ginevra de' Benci and Renaissance Portraits of Women*, 63–87. Ed. David Alan Brown. Princeton: Princeton University Press, 2001.

Zagano, Phyllis, and Thomas C. McGonigle. *The Dominican Tradition*. Collegeville, Minnesota: Order of Saint Benedict, 2006.

Zöllner, Frank. *Leonardo da Vinci, 1452–1519: The Complete Paintings and Drawings*. Cologne, London, Los Angeles, Madrid, Paris, Toronto: Taschen, 2003.

ILLUSTRATION CREDITS

Interior images

1. *Lodovico il Moro in Prayer* detail of a painting by Master of the Pala Sforzesca 1490–1520/The Art Archive/Musée d'Orsay Paris/Collection Dagli Orti.
2. *Study for an Equestrian Monument*, c.1485–90 (metalpoint on blue prepared paper), Vinci, Leonardo da (1452–1519) / The Royal Collection © 2011 Her Majesty Queen Elizabeth II /The Bridgeman Art Library.
3. *Charles VIII, King of France* (1483–98), unsigned painting, contemporary. Photograph: akg-images.
4. *The Baptism of Christ by John the Baptist*, c.1475 (oil on panel), Verrocchio, Andrea (1435–88) and Vinci, Leonardo da(1452–1519) / Galleria degli Uffizi, Florence, Italy / The Bridgeman Art Library.
5. *Landscape in the Arno Valley*, Leonardo da Vinci, 1452–1519. Ink drawing, 19.4 × 28.6cm. Photograph: akg-images / Rabatti – Domingie.
6. *The Adoration of the Magi*, 1481–82 (oil on panel), Vinci, Leonardo da (1452–1519) / Galleria degli Uffizi, Florence, Italy / The Bridgeman Art Library.
7. NO CREDIT
8. *The Last Supper* (mosaic), Byzantine School, (6th century) / Sant' Apollinare Nuovo, Ravenna, Italy / The Bridgeman Art Library.
9. *The Last Supper*, 1480 (fresco), Ghirlandaio, Domenico (Domenico Bigordi) (1449–94) / Ognissanti, Florence, Italy / Alinari / The Bridgeman Art Library.
10. *A study of seated figures in conversation*, Leonardo da Vinci, Supplied by Royal Collection Trust / © HM Queen Elizabeth II 2012.
11. Study of figures for *The Adoration of the Magi* (pen and ink on paper), Vinci, Leonardo da (1452–1519) / Louvre, Paris, France / Giraudon / The Bridgeman Art Library.
12. Detail, *Two Heads in Profile*, c. 1500 (red chalk on paper), Vinci, Leonardo da (1452–1519) / Galleria degli Uffizi, Florence, Italy / Alinari / The Bridgeman Art Library.
13. Perspective study for the background of *The Adoration of the Magi* (pen and ink on paper), Vinci, Leonardo da (1452–1519) / Galleria degli Uffizi, Florence, Italy / Alinari / The Bridgeman Art Library.
14. Studies for *The Last Supper* and architectural geometric sketches, c. 1494 (pen & ink on paper), Vinci, Leonardo da (1452–1519) / The Royal Collection © 2011 Her Majesty Queen Elizabeth II / The Bridgeman Art Library.
15. The head of St. James in *The Last Supper*, and architectural sketches, Leonardo da Vinci, Supplied by Royal Collection Trust / © HM Queen Elizabeth II 2012.
16. Detail, *The Last Supper*, 1495–97 (fresco) (post restoration), Vinci, Leonardo da (1452–1519) / Santa Maria della Grazie, Milan, Italy / The Bridgeman Art Library.
17. *A Man Tricked by Gypsies*, Leonardo da Vinci, Supplied by Royal Collection Trust / © HM Queen Elizabeth II 2012.
18. The prophet Joel, from the Sistine ceiling (pre restoration), Buonarroti, Michelangelo (1475–1564) / Vatican Museums and Galleries, Vatican City, Italy / The Bridgeman Art Library.
19. The head of St. Bartholomew in *The Last Supper*, Leonardo da Vinci, Supplied by Royal Collection Trust / © HM Queen Elizabeth II 2012.
20. Caradosso medal, reversed.
21. Self portrait of Leonardo da Vinci from the codex on the flight of birds.
22. *Portrait of a Bearded Man*, possibly a self-portrait, c. 1513 (red chalk on paper), Vinci, Leonardo da (1452–1519) / Biblioteca Reale, Turin, Italy / The Bridgeman Art Library.
23. *Flying Machines*, fol. 83v from Paris Manuscript B, 1488–90 (pen and ink on paper) (see also 162317), Vinci, Leonardo da (1452–1519) / Bibliotheque de I'Institut de France, Paris, France / Alinari / The Bridgeman Art Library.
23a. © Matthew Landrus.
24. Detail, *The Last Supper*, 1495–97 (fresco) (post restoration), Vinci, Leonardo da (1452–1519) / Santa Maria della Grazie, Milan, Italy / The Bridgeman Art Library.
25. *Portrait of Fra Luca Pacioli*, mathematician, Barbari, Jacopo de' (1440–50-1516)/The Art Archive / Museo di Capodimonte, Naples / Collection Dagli Orti.

26. *Dodecahedron*, from *De divina proportione* by Luca Pacioli, published 1509, Venice (engraving) (b/w photograph), Vinci, Leonardo da (1452–1519) / Bibliotheque Nationale, Paris, France / Giraudon / The Bridgeman Art Library.

27, 28. *St. Jerome*, c. 1480–82 (oil and tempera on walnut), Vinci, Leonardo da (1452–1519)/ Vatican Museums and Galleries, Vatican City, Italy / The Bridgeman Art Library.

29. *The Last Supper*, 1495–97 (fresco) (post restoration), Vinci, Leonardo da (1452–1519) / Santa Maria della Grazie, Milan, Italy / The Bridgeman Art Library.

30. *The Last Supper*, 1495–97 (fresco) (post restoration), Vinci, Leonardo da (1452–1519) / Santa Maria della Grazie, Milan, Italy / The Bridgeman Art Library.

31. *Communion of the Apostles*, 1451–53 (tempera on panel), Angelico, Fra (Guido di Pietro) (c. 1387–1455) / Museo di San Marco dell'Angelico, Florence, Italy / The Bridgeman Art Library.

32. *St. John the Baptist*, 1513–16 (oil on canvas), Vinci, Leonardo da (1452–1519) / Louvre, Paris, France / The Bridgeman Art Library.

33. The head of St. Philip in *The Last Supper*, Leonardo da Vinci, Supplied by Royal Collection Trust / © HM Queen Elizabeth II 2012.

34. *The Last Supper*, 1495–97 (fresco) (post restoration), Vinci, Leonardo da (1452–1519) / Santa Maria della Grazie, Milan, Italy / The Bridgeman Art Library.

35. *The Last Supper*, 1495–97 (fresco) (post restoration), Vinci, Leonardo da (1452–1519) / Santa Maria della Grazie, Milan, Italy / The Bridgeman Art Library.

36. *Studies of hands*, Leonardo da Vinci, supplied by Royal Collection Trust / © HM Queen Elizabeth II 2012.

37. *The Last Supper*, 1495–97 (fresco) (post restoration), Vinci, Leonardo da (1452–1519) / Santa Maria della Grazie, Milan, Italy / The Bridgeman Art Library.

38. Jorio, Andrea de. *La Mimica degli antichi investigata nel gestire napoletano*. Plates 19 and 20 (classmark: Lib.5.83.21) reproduced by kind permission of the Syndics of Cambridge University Library.

39. The hands of St. John in *The Last Supper*, Leonardo da Vinci, supplied by Royal Collection Trust / © HM Queen Elizabeth II 2012.

40. *The Last Supper*, 1495–97 (fresco) (post restoration), Vinci, Leonardo da (1452–1519) / Santa Maria della Grazie, Milan, Italy / The Bridgeman Art Library.

41. *The Last Supper*, 1495–97 (fresco) (post restoration), Vinci, Leonardo da (1452–1519) / Santa Maria della Grazie, Milan, Italy / The Bridgeman Art Library.

41a. *A Portrait of Leonardo in Profile*, c.1515 (red chalk), Melzi or Melzo, Francesco (1493–1570) (attr. to) / The Royal Collection © 2011 Her Majesty Queen Elizabeth II / The Bridgeman Art Library

42. The head of Judas in *The Last Supper*, c.1495 (red chalk on pale red prepared paper), Vinci, Leonardo da (1452–1519) / The Royal Collection © 2011 Her Majesty Queen Elizabeth II / The Bridgeman Art Library.

43. NO CREDIT.

44. Louis XII, King of France, c. 1490 (oil on panel), Perréal, Jean (c.1455–1530) (workshop of) / The Royal Collection © 2011 Her Majesty Queen Elizabeth II / The Bridgeman Art Library.

45. Drawing for stage design (detail of one of two semicircular elements placed in cavity of stage), from *Atlantic Codex (Codex Atlanticus)* by Leonardo da Vinci, folio 669 recto, Vinci, Leonardo da (1452–1519) / Biblioteca Ambrosiana, Milan, Italy / De Agostini Picture Library Metis e Mida Informatica / Veneranda Biblioteca Ambrosiana / The Bridgeman Art Library.

Color insert

1. Giampietrino's (Giovanni Pietro Rizzoli) copy of *The Last Supper* after Leonardo da Vinci © Royal Academy of Arts, London; Photographer: Prudence Cuming Associates Limited.

2. *Madonna of the Rocks*, c. 1478 (oil on panel transferred to canvas), Vinci, Leonardo da (1452–1519) / Louvre, Paris, France / The Bridgeman Art Library.

3. Map of Milan, from Civitates orbis terrarum by Georg Braun (1541–1622) and Frans Hogenburg (1535–90), c. 1572 (colored engraving), Hoefnagel, Joris (1542–1600) (after) / Private Collection / The Stapleton Collection / The Bridgeman Art Library.

4. *The Last Supper*, 1495–97 (fresco) (post restoration), Vinci, Leonardo da (1452–1519) / Santa Maria della Grazie, Milan, Italy / The Bridgeman Art Library.

5. *Crucifixion*, 1495 (fresco), Montorfano, Giovanni Donato (1440–1510) / Cenacolo di Santa Maria delle Grazie, Milan / Mauro Ranzani/Alinari Reproduced with the permission of Ministero per i Beni e le Attivita Culturali / The Bridgeman Art Library.

6. *The Lady with the Ermine* (Cecilia Gallerani), 1496 (oil on walnut panel), Vinci, Leonardo da (1452–1519) / © Czartoryski Museum, Cracow, Poland / The Bridgeman Art Library.

7. *Portrait of a Lady from the Court of Milan*, c. 1490–95 (oil on panel), Vinci, Leonardo da (1452–1519) / Louvre, Paris, France / Giraudon / The Bridgeman Art Library.

8. *The Proportions of the Human Figure* (after Vitruvius), c. 1492 (pen & ink on paper), Vinci, Leonardo da (1452–1519) / Galleria dell' Accademia, Venice, Italy / The Bridgeman Art Library.

9. Andy Warhol, *The Last Supper*, 1986. Screenprint and colored graphic art paper on collage on paper. 23 5/8 × 31 1/2 inches. © 2012 The Andy Warhol Foundation for the Visual Arts, Inc. / Artists Rights Society (ARS), New York.

INDEX

Ross King is the highly praised author of *Brunelleschi's Dome*, *Michelangelo and the Pope's Ceiling*, *The Judgment of Paris*, *Machiavelli: Philosopher of Power*, *Defiant Spirits*, and two novels, *Ex Libris* and *Domino*. He lives outside Oxford, England.